MODERN ARCHITECTURE AND THE END

BRITISH ART AND VISUAL CULTURE SINCE 1750
New Readings
General Editor: David Peters Corbett, University of York

This series examines the social and cultural history of
British visual culture, including the interpretation of individual
works of art, and perspectives on reception, consumption and display.

In the same series:

The Emergence of the Professional Watercolourist
Contentions and Alliances in the Artistic Domain, 1760–1824
Greg Smith

The Quattro Cento and *Stones of Rimini*
A Different Conception of the Italian Renaissance
Adrian Stokes

Difficult Subjects
Working Women and Visual Culture, Britain 1880–1914
Kristina Huneault

Memory and Desire
Painting in Britain and Ireland at the Turn of the Century
Kenneth McConkey

The Cultural Devolution
Art in Britain in the Late Twentieth Century
Neil Mulholland

Art and its Discontents
The Early Life of Adrian Stokes
Richard Read

British Artists and the Modernist Landscape
Ysanne Holt

Modern Architecture and the End of Empire

Mark Crinson

Routledge
Taylor & Francis Group

LONDON AND NEW YORK

First published 2003 by Ashgate Publishing

Reissued 2018 by Routledge
2 Park Square, Milton Park, Abingdon, Oxon OX14 4RN
711 Third Avenue, New York, NY 10017, USA

Routledge is an imprint of the Taylor & Francis Group, an informa business

The publisher gratefully acknowledges the support of the Graham Foundation for Advanced Studies in the Fine Arts. The publisher also acknowledges the generous support of the Paul Mellon Foundation.

A Library of Congress record exists under LC control number: 2002038261

Typeset in Palatino by Bournemouth Colour Press, Parkstone, Poole.

ISBN 13: 978-1-138-03992-6 (hbk)
ISBN 13: 978-1-138-03965-0 (pbk)
ISBN 13: 978-1-315-19809-5 (ebk)

Contents

List of figures

Colour Plates

Black and white figures

Preface

This book is concerned with the relation between architecture and those events and processes that make up the so-called 'end of empire': including imperial decline, decolonization, independence and its aftermath. No attempt is made to survey a period or to present a synoptic picture of architecture's relation to the end of empire. Instead the book consists of a series of set pieces or new sections through the subject, each with some elements that are exemplary of the broader topic and others that are exceptional. Apart from the first chapter, which offers a number of vantage points from which to look across the twentieth century, the rest of the book is arranged thematically and geographically with certain issues and strands of argument recurring across it, but with moves back and forth across the period much as the end of empire itself was a group of changes occurring with different tempos, sometimes doubling back, rehearsing, repeating and restarting.

Architecture in the middle decades of the twentieth century has usually been seen as an uneven negotiation or dialogue between indigenous movements and traditions on the one hand and international imperatives (modernization) and influences (modernism) on the other. But this international perspective tends to take in only so much of the landscape. The most common way, for instance, that British architecture's relation to wider developments is understood in this period is through its relation to modernism. This is usually measured by such milestones as the translation of Le Corbusier's *Vers une architecture*, the adoption of Bauhaus-type methods of teaching, the movements of émigré and refugee architects, the international recognition of British modernism through exhibitions at the Museum of Modern Art in New York, the convening of Congrès Internationaux d'Architecture Moderne (CIAM) meetings on British soil, and so on. Such an international modernist perspective is powerful and compelling. It can draw into itself accounts of how vanguard modernism became corporate modernism, how a cosmopolitan architectural culture emerged together with moments of critical difference from it, and how modernism itself always implied that the project of modernization – whether as collective social hope or as the spread of capital – was itself incomplete.

In this book I want to set up a different optic, one in which modernism and other aspects of modern architecture are refracted through the prism of British imperialism and its dissolution and aftermath. It seems at first, despite the occasional well-known modernist monument to independence, to be a strange coupling, although it would not now be regarded as such in, say, studies of literary modernism.[1] Architecture as an arm of imperialism is seen, and seen episodically at best, as an embarrassment to modernism and part of what it ostensibly contests and triumphs over. In architecture, at least, modernism rises as imperialism fades – there must be something more than coincidence in this. That may be part of the story but this book attempts to bring into play a number of other issues that inflect, deepen or question this. These issues are discussed through a range of cases that, if unsystematic, nevertheless enable discussion of the unravelling of imperial institutions and structures in the metropolis and in the colonies, and also address the incomplete hopes and patched-together cultural formations of the emergent Commonwealth, the open discursive play between modernism and nationalism, or modernism and tradition, in newly independent countries, and the 'discrepant cosmopolitanism' of post-imperial immigration. The landscape to be viewed needs to take in both the old 'heart of empire' and its far-flung colonial possessions; a global formation must be recognized without assuming an indivisible whole. The very antagonism between terms like 'empire', 'decolonization' and 'neocolonialism', and terms like 'commonwealth', 'cosmopolitanism' and 'internationalism', points to a dynamic across the metropolis and the wider world, and one that needs to be treated as complex and unresolved rather than merely polarized.

So what is meant by the 'end of empire'? In this book it indicates a rather flexible group of crisis moments and processes of willing or unwilling relinquishment rather than a precise period in history. It might cover Indian Independence, the Malayan Emergency, the Suez Crisis (and its harbinger, the nationalization of the Iranian oil industry), the sudden spate of new African nations in the late 1950s and early 1960s, even stretching to the handover of Hong Kong. The 'end of empire' cannot help but play on the 'end' as an aim or an ideal at least as much as a termination, and therefore it must include some sense of what an imperial architecture tried to be. It also refers to far more than the formal relinquishment of imperial rule. As for the aftermath of empire, this has even less internal integrity than the 'end'; it is both of the old empire *and* of the globalization to come. Endings as markers are, anyway, sometimes formalized while business continues as usual, and sometimes hidden or ignored because business (in this case architecture) is taken to be irrelevant to or at least separate from them. Architecture has played a role in both scenarios, as well as several in-between. Much of the architecture that is discussed in this book was considered as a kind of barometer of a nation's power in the world: a cultural artefact by which nations defined themselves and projected influence and a means by which their cultural capital was assessed. But it was also a form for the veiling and naturalizing of violence and a way by which new counter-imperial and post-

imperial identities were given form: the streets and edifices that marked the 'heart of empire' as well as the headquarters building of a nationalist party or a new national museum, to use the most obvious examples. Much of this architecture was advocated as a matter of 'development', a more-or-less technical commonsense whose practices and forms were understood as neutral and independent of political forces and even of the existing social production of buildings. One of the in-between scenarios here is the use of modernism to identify the British with the nationalist urban middle classes rather than the more conservative, even 'loyal', elements in the social structure. Another, and related, one is in the very title of a 1962 lecture by Nikolaus Pevsner, 'Architecture in the Modern Commonwealth'; in other words, the promotion of the idea that there could be something shared by the post-imperial countries and discernible in their architecture, but that this commonality also rose above issues of economic dominance and cultural power. Yet another is that critical moment of modernism itself in the 1950s and 1960s as its new hegemony, forged at the moment of empire's sudden dissolution, threatened to eclipse the forms of the 'heart of empire' itself.

Author's note

Parts of the book have appeared in other publications. Some of the Abadan material in Chapter 3, 'Oil and architecture', appeared as 'Abadan: Planning and architecture under the Anglo-Iranian Oil Company', in *Planning Perspectives*, 12:3, July 1997. Chapter 5, 'The commonwealth of architecture', includes work that was published as 'Imperial Story-lands: Architecture and display at the Imperial and Commonwealth Institutes', *Art History*, 22:1, March 1999.

Acknowledgements

Like all academic books, this one is indebted to many people who have given their time, opened their collections or buildings, read parts of early drafts, or shared their memories, views and information. It is a pleasure to acknowledge their help: Bruce Aitken, Dato Hisham Albakri, James Anquandah, Dana Arnold, Lal Balasuriya, Marie Bastiampillai, the late Peter Beauchamp, Josephine Berry, Peter and Hetty Brackley, Dato Dr Kamarul Baharin Buyong, Chen Voon Fee, L. B. Crossland, Rebecca Duclos, Diane Ewer, Rebecca Foote, Ron Fuchs, Michael Gasson, Joe Gazari, Michael Given, Bill Grimwade, Alan Hagdrup, Michael Hebbert, Gilbert Herbert, W. F. Hill, Helen Hills, Robert Home, Raymond Honey, Tim Insoll, Sian Jones, Dato Lim Chong Keat, Peter Kohane, the late Sir Denys Lasdun, Jules Lubbock, Malcolm McLeod, A. K. Maitra, Mohamed Makiya, Nazar-e-Mustafa, Peter Newnham, Ruth Northall, John Owusu-Addo, Yaw Owusu-Frempong, Tristan Palmer, Anne Perrett, Marcia Pointon, Michael Pollard, Helen Rees, Mary Roberts, Andrew Saint, Cyrus Samii, Hannah Schreckenbach, Joseph Sharples, Charles Thurstan Shaw, Peter Shinnie, Ivor Shipley, Kenneth Sowah, Janet Tee, Derek Trillo, Ola Uduku, David Vickery, Elain Vinten, David Williams, J. A. Wilson, Peter Woods, Ken Yeang, and Ali Asghar Zainuddin. Thanks, too, to everyone at Ashgate: Pamela Edwardes, Lucinda Lax, Kirsten Weissenberg and Jan Cutler.

I have also been fortunate in the support I have had for the research and writing of this book from three institutions: the British Academy for a grant from their Research Leave Scheme, the Leverhulme Trust for a Research Fellowship, and the Arts and Humanities Research Board for a grant towards my travel in Malaysia and Ghana.

Abbreviations

AA – Architectural Association

AIOC – Anglo-Iranian Oil Company

APOC – Anglo-Persian Oil Company

BP – British Petroleum

CIAM – Congrès Internationaux d'Architecture Moderne

CPP – Convention People's Party

OHBE – W. R. Louis, ed., *The Oxford History of the British Empire*, Oxford: Oxford University Press, 1998–9, 5 vols

PRAAD – Public Records Archives and Administration Department, Accra

PRO – Public Record Office, Kew

PWD – Public Works Department

RIBA – Royal Institute of British Architects

UAC – United Africa Company

UMNO – United Malays National Organization

UST – University of Science and Technology, Kumasi, Ghana

TO KATY AND EVA

Frontispiece Gordon Cullen, 'African Experiment'. *Architectural Review,* 113, May 1953

Imperial panorama: panorama of architecture

Travelling between any two cities in the world, passing through airports along ring roads and into business districts or tourist hotels, seems, at least in part, always to be a return home. In the main this is because modern architecture is a global phenomenon and what contains and helps to define or frame our experiences are usually buildings of familiar appearance. How it came to be that way is one of the underlying concerns of this book. But it is more than just modern architecture that is ubiquitous. More specifically, it is modernist architecture: that embrace of technology, that imagined escape from history, that desire for transparency and health, that litany of abstract forms, the product of a group of related movements in architecture, art and design seeking to fathom and give form to modernity. But modernism arose at the peak of European colonial empires, even if its own histories barely acknowledge this and even if empire seems like one of those things it consigns to history. What, then, was the relation between this modernism and other architectures of empire? Did modernism mark the end of empire or its continuation by other means?

Modernism, it is said, spread from Europe to the USA where it was acclaimed as international. How it got from these areas to the rest of the world, and what the causes and consequences of these translations were, have only been recounted in a piecemeal way. Furthermore, what this term 'international' means has largely been taken as *a priori* or implied rather than articulated: perhaps a world culture unconstrained by national ties, perhaps a realization of globalism immanent in technological development. The standard histories of modern architecture tend to ignore the non-western world, to treat it as simply and instantaneously encapsulated by modernism's global reach – a dialect suddenly become a lingua franca – or to place its new buildings as a belated addition to the canon of modernism and reactions to modernism, as if architecture had at last achieved its Greenwich Mean Time. In several recent accounts, prestigious modernist set pieces, such as Brasilia or Chandigarh, act as bridges from the West in the mid-twentieth century and then certain approved non-western architects (Geoffrey Bawa,

Charles Correa, Kenzo Tange) figure in the narrative, if still marginally. The code word for this forced bridging operation is 'dissemination'.[1] In many mid-century accounts modernism was seen as a kind of salvation for underdevelopment. Henry-Russell Hitchcock's version epitomizes the paradoxes here: 'while the West was more and more losing political control of Africa and Asia, its cultural influence on those continents did not necessarily decline, indeed as regards architecture it probably increased'. According to Hitchcock this was because an architecture that was originally developed to exploit advanced technology 'was found to serve especially well also in areas where technology was least advanced'.[2]

Imperialism figures hazily if at all in most surveys of modern architecture, even those specifically devoted to British modernism.[3] Where it does appear, imperialism plays the role of opposite to what modern architecture stands for and its decisive symbol is a different kind of architecture, as with Lutyens's design of New Delhi – a scheme in which political control, urban space and monumental architectural form are presented as inseparable.[4] There has, however, been a move to study modern western urbanism in this wider imperial context, a move reinforced by the idea – deriving from Edward Said and Raymond Williams – that western cities and their cultures cannot be comprehended without understanding their mutually constitutive relation with colonial cities. Nonetheless this insight and its implications has tended to stop with the so-called 'imperial city' – the city developed in the age of high imperialism – with its modern versions of classical architecture and town planning, and its preserved and distilled, museum-worthy 'traditional city' nearby. The insight has hardly been carried over into consideration of the modernist city and modernist architecture even though most formal European empires continued into the 1960s, long after modernism had attained its ascendancy.[5] There seem to be two implications here. One is that the values of modernist architecture are understood to transcend issues of national power and sovereignty over other peoples; modernist architecture, according to its practitioners, was autonomous and semantically silent, and so it can remain for its historians in relation to imperialism.[6] The other is that modernism's advocates were anti-imperialist because their architecture broke out of the convention-bound, authoritarian, national or eurocentric hierarchies by which other forms of architecture were compromised. Yet if this opposition to imperialism was there it was subconscious at best: there are few anti-imperialist statements by modernist architects, and where we do find them they tend to be voiced by only a few non-western clients. Perhaps it might be better to speculate that where modernism was not a disavowal of imperialism, it was actively deployed as a way of improving the functions of the colonial city, treating the colonies as a laboratory of modernity, elaborating the new rhetorics of hygiene and health and the dualistic narratives of the traditional and the modern, even epitomizing the benevolence of the West. It also follows that two other issues – decolonization and neocolonialism – have hardly figured in surveys of modern architecture or even in more focused studies.

If the relation between imperialism and the modern is far more complex than has often been assumed, so too is the relation between modernism and tradition. This has particular relevance within colonial contexts where local or national cultures were often classified as 'traditional' and where a refusal of (colonial) modernity was sometimes part of a reclamation of indigenous culture. This refusal of modernity in the name of tradition was also, of course, often contested by anticolonialists who saw no necessary connection between colonialism and modernity.[7] Modernism was curiously positioned here. Modernity itself was often seen as posed at the other end of what Ananya Roy has called a 'dualistic narrative' from tradition, and some forms of modernism gloried in this, formalizing change as progressive and enlightened, aiming to make modernism a world culture. As Marshall Berman has described it, this 'modernism of underdevelopment is forced to build on fantasies and dreams of modernity, to nourish itself on an intimacy and a struggle with mirages and ghosts … a desperate incandescence'.[8] But other versions of modernism have questioned this Faustian model of modernization, aligning their notions of authenticity alongside alternative traditions, marked by an ambivalent but 'desirous mimicry'.[9] And yet other versions of modernism have sought to preserve tradition, setting the distinct forms of modernity apart from a distilled and sealed past. The point for the historian is surely to see modernism and tradition not as distinct and immutable but as claims on priority and temporality: plural, contested and political.

My concern in this chapter is to sketch out a constellation of reference points for what follows in the rest of the book. I turn first to the 'heart of empire', London, to explore how imperialism was represented in architecture and urban form. Then I adumbrate the great set pieces of New Delhi and Chandigarh, separated by only two decades yet seeming to stand for opposed polarities of classic imperialism and post-imperial modernism. Somewhere in their opposition a line seemed to be drawn but there was also a new cluster of images and ideals. The analysis of those ideals is taken further through discussion of a lecture given by a colonial emissary for modernism, and then the images of modernism are pursued in passages from two novels that take the ending of empire as their setting. Finally I use a modernist building at the end of the century in one of Britain's last formal colonies, in order to begin to explore how architecture manifests the links between the old order of imperialism and the new one of globalization.

Empire as image

When we try to picture empire we might end up with a group of acts, objects and events – tracts of land, biscuit tins, administrative regimes, ceremonies and processions, military conquests and displacements of peoples – no single one of which can be taken to stand for empire in itself although some might be separated out as the 'hard facts' of colonialism.[10] The reason why it is

difficult to capture this heterogeneous assortment of things in an image is because empire is an abstraction, or at least as much of an abstraction as words like 'nation' or 'heritage'; empire might be used as the name of a typewriter or a music hall. But, like 'nation' or 'heritage', empire is an overarching ideological construct; it is a particular way of drawing together a host of disparate things so that their collective meaning is made apparent. The collective can never be understood as a whole until the work of representation is brought to bear on it. Architecture offers a particularly complex relation to empire, which can be conceptualized in three ways. First, architecture defines the built spaces in which imperialism and colonialism are lodged and enacted. Second, architecture is able to redefine and represent beliefs and values, but it can only do this in relation to communities that recognize its intentional semiotic functions. Third, architectural production (financial, material, intellectual) echoes, inflects and is integral to many of the other economic practices and relationships that empire requires for its furtherance; its buildings are both the result of social production and one of the ways in which empire is produced. It needs to be emphasized that there is no pre-existing 'empire' before architecture and therefore no simple model of representation whereby architecture can be said to reflect empire; rather each can be shaped by the other. The intersections between architecture and empire therefore have a discursive power. Together they make for a discursive field of events, practices, objects and texts;[11] a field that encompasses very particular and heterogeneous moments and places.

British towns and cities had a symbiotic relationship with the British Empire. The great expansion of these places in the nineteenth and twentieth centuries was funded by wealth created as a result of Britain's role at the centre of a vast if variegated network of industry and trade. Highly capitalized municipal and governmental commissions provided the focus for this expansion, readjusting urban spaces to cater for the new demands on their services, providing the offices for the vast numbers of colonial administrators,[12] and establishing the civic values that were to guide the aspirant imperial subject. Many of the new planning jobs were held by ex-colonial officials or by technocrats who were consulted widely across the empire. Big business also paid into this new urbanism, underwriting major development schemes to create and recreate expanded and newly styled spaces for new forms of production, marketing and consumption. The government bodies that managed the empire, the institutions and societies that dealt in its knowledge, the financial houses and commercial concerns that traded on it, the hotels and travel agencies that catered for its traffic, all required to be housed.[13] In suburbia and seaside resorts the bungalow became the popular modern form of housing: a ubiquitous colonial residential type of transcultural derivation now imported from India as the home of choice for the rentier classes of the expanded empire.[14] Imperialism as a domesticating enterprise, inherent to family life, was also espoused in the poster campaigns of the Empire Marketing Board.[15] Beyond the green belt, itself a colonial conception,[16] the land took on new productive dynamics

as well as the expanded leisure capacities of an enlarged wealth-owning class, both of which were focused on country houses, which were economically underwritten by imperial investments and also 'willed amnesias of empire'.[17] But if empire is, as I have argued, as much an idea as it is a set of power relations and their effects, as much an expanded geographical consciousness as an insistent pressure, what form or image did empire adopt in architecture and urbanism? In other words, beyond claims of self-confidence and ascriptions of 'the heart of empire', 'second city of the empire' or similar, what difference did imperial symbiosis actually make to the architecture of the British city in the early twentieth century? Where was empire figured? What form did it take in architecture? What were its attributes or signs, tokens or traces? Who was able to register or to recognize them?

Historians and cultural geographers have usually answered these questions by pointing to the imperial metropolis and the great regional cities, and within them to certain new parts of these cities added to the existing symbols and monuments of empire of the previous centuries. These have come to represent a canon of imperial architecture as well as the urban expression of the period of high imperialism. Certain kinds of architecture, certain buildings erected for certain purposes, are often taken as, in some way, inherently imperial, though what it might mean to be imperial is usually left curiously unargued.[18] Thus in early twentieth-century London any new building that was designed in an English baroque style or any new urban scheme that adopted the formal repertoire of Haussmannian Paris or the 'city beautiful' movement in the United States of America (wider boulevard-type streets, axial vistas centred on monuments or significant buildings, the architecture of monumental classicism) is identified as an updating of early nineteenth-century architecture or even seventeenth-century classicism, both often self-consciously evoked as similarly important moments in the development of British imperialism.[19] But these were not the only possible styles of British imperialism; indeed gothic, representative of an English medieval past, and even non-western styles had been used in the nineteenth century, and in the colonies a number of different styles, often inflected towards local traditions, were used. The image of empire was mutable but everywhere it appropriated the past in order to establish its hold on time, its inevitability. This, at least, is what it sought to signify, but what it erased or sought to conceal was empire's transience, its dynamic of exploitation and its contingent modes of control.

New planning schemes such as the Kingsway–Aldwych scheme and The Mall have often been described as imperial and were certainly designed partly so that London might have a suitable public face for its imperial power, even if this public face was not universally desired by the public.[20] Kingsway–Aldwych, executed between 1900 and 1905, was imagined as one way in which to formalize or modernize links between the City and Westminster, the former of which had already established its claims as 'heart of empire' and renewed these with the rebuilding of the Bank of England

from 1919 and many new classical bank buildings in the following two decades.[21] Kingsway–Aldwych's new north–south axis cut a swathe through an area notorious for its slums and licentiousness – the obscene, disordered, other side of the imperial image.[22] Kingsway's axis was closed by the 'big-business classicism' of Bush House (1925–35) with its massive entrance niche screened by Corinthian columns establishing a focus on the view down Kingsway and an explicitly Roman look to the scheme's main set piece (fig. 1.1).[23] The set piece was continued at this end of Kingsway, around Aldwych, by India House (1928–30) designed by Sir Herbert Baker (with A. T. Scott), perhaps the most ubiquitous imperial architect of the time in terms of gaining important commissions around the empire. Baker used Indian details in his classical scheme and the interior was decorated by Indian artists 'sent at Baker's suggestion for special training to London and Rome'.[24] Further around Aldwych was Australia House (1912–18), again with Roman classical allusions but this time with two complex sculptural groups framing its entrance, the whole meant to symbolize 'the wealth and importance of Australia as an Imperial unit'.[25] At the southern end of Kingsway, then, were located the London headquarters of two of Britain's most important imperial possessions as well as one of its most influential communicative nodes – the overseas service of the British Broadcasting Corporation at Bush House. But the inscription on Bush House's façade, 'To the Friendship of English Speaking Peoples', was not straightforwardly imperial. The irony is that Bush House was designed by American architects on a site developed as a trade centre by the American developer Irving T. Bush.[26] Kingsway was itself cut as a straight north–south link between Holborn and the Strand in 1905, and then, in the subsequent fifteen years, lined with a group of stylistically

1.1 Bush House, Aldwych, London (Helmle & Corbett, 1925–35)

similar classical buildings, all with uniform plot lines and building heights. Their names alone evoke an imperial world-view: Imperial, Regent, Windsor, York, Alexandra, Victory, Princes and Africa Houses.[27] The building that is normally considered separately here is Kodak House (1911), designed by Sir John Burnet and Thomas Tait in a remarkably bald unornamented manner (fig. 1.2). The reasons for its appearance are worth speculating about. Kodak seems to have been looking for a distinct commercial niche. Whereas Kingsway's planners imposed tight and uniform guidelines on the shape and size of developments in the street, if one could work within these and produce a stylistically distinct building, as Kodak seems to have realized, then one could have prestige of location, alignment with the imperial image of continuity and power and the distinction of contemporary American styling.

By contrast, The Mall was less a municipally driven commercial development with imperial trimmings than a reaffirmation through urbanism of the relevance of the monarchy to imperial power. Extending and

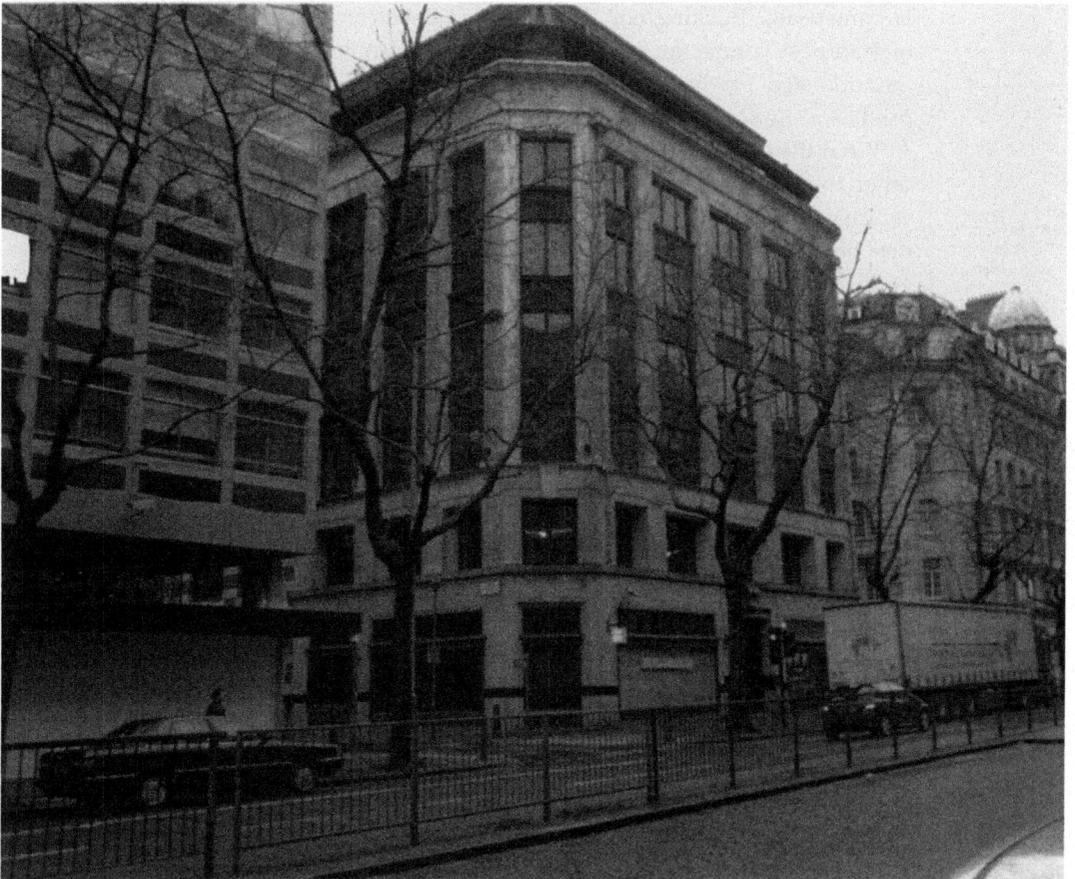

1.2 Kodak House, Kingsway, London (Sir John Burnet, 1911)

upgrading what had first been an avenue laid out by Charles II, then added to by the southernmost elements of John Nash's Regency scheme, the Edwardian additions to The Mall linked it to Trafalgar Square via the triumphal arch of Sir Aston Webb's new Admiralty building. The axis was reinforced at its other end by a grand new roundabout (1900–01, in Beaux Arts terms a *rond-point*), the Queen Victoria Memorial (1911) and a refacing of Buckingham Palace (1913) (fig. 1.3).[28] The Mall's 'upgrading' was devised to emphasize the relevance of the place of the monarch within the urban theatrics of London. Here an explicitly processional way connected the royal palace, via the monumentalized image of the empress-Queen, to the square commemorating naval power, and then to the Cenotaph, the seat of government in Whitehall (itself having major new buildings erected in this period), and finally to that of religious authority at Westminster Abbey. This, for instance, was the exact route taken by the first great procession commemorating the First World War which culminated in the unveiling of the Cenotaph on 11 November 1920.[29] The procession was presented as an act that acknowledged the participation of the empire itself in the war, and the route was demarcated as distinct from the 'workaday' areas of London.[30] Urbanistically, Buckingham Palace could be seen as another hub in the circuit of grandiose connections that London was becoming, but this was not always monopolized for imperial effect. Trafalgar Square, for instance, was long used as a site for antigovernment protest.

What the newly developed Kingsway and the rejigged Mall did, amongst other things, was to concretize and re-emphasize the notion of London as centre or 'heart of empire', a phrase that was becoming increasingly used to describe London in these decades. The metaphor did not just imply flows of goods and peoples around a larger body, it also suggested that without a heart or centre there could be no empire, and so the establishment of the image of centrality was as important as the fact of London as an economic and political hub. Much of this was public rhetoric, necessary, perhaps, but hardly reflective of London's status in the network of *international* capital that was of greater significance than imperial finance in the City until at least the Crash of 1929.[31] It was this international nature of London's financial markets that attracted not just South African diamond magnates and other white colonial investors, but also a gamut of cosmopolitan financiers and American millionaires, who built their stucco and stone mansions in the West End.[32] Thus, although schemes like The Mall and Kingsway would gesture at a greater imperial consciousness, their message was aimed mainly at London's own citizens and at competitor nations, and the conveyance of this message was bound up with symbols of historically sanctioned authority combined with the urbane contemporaneity of a certain architectural image.

In sum, architectural classicism was regarded as both authoritative and modern and there was little contradiction between these terms in an age when plutocracy and imperial expansion could be taken as two of the defining conditions of the modern.[33] Derived from a long tradition of French architectural theory, Beaux Arts planning enabled the rational layout of

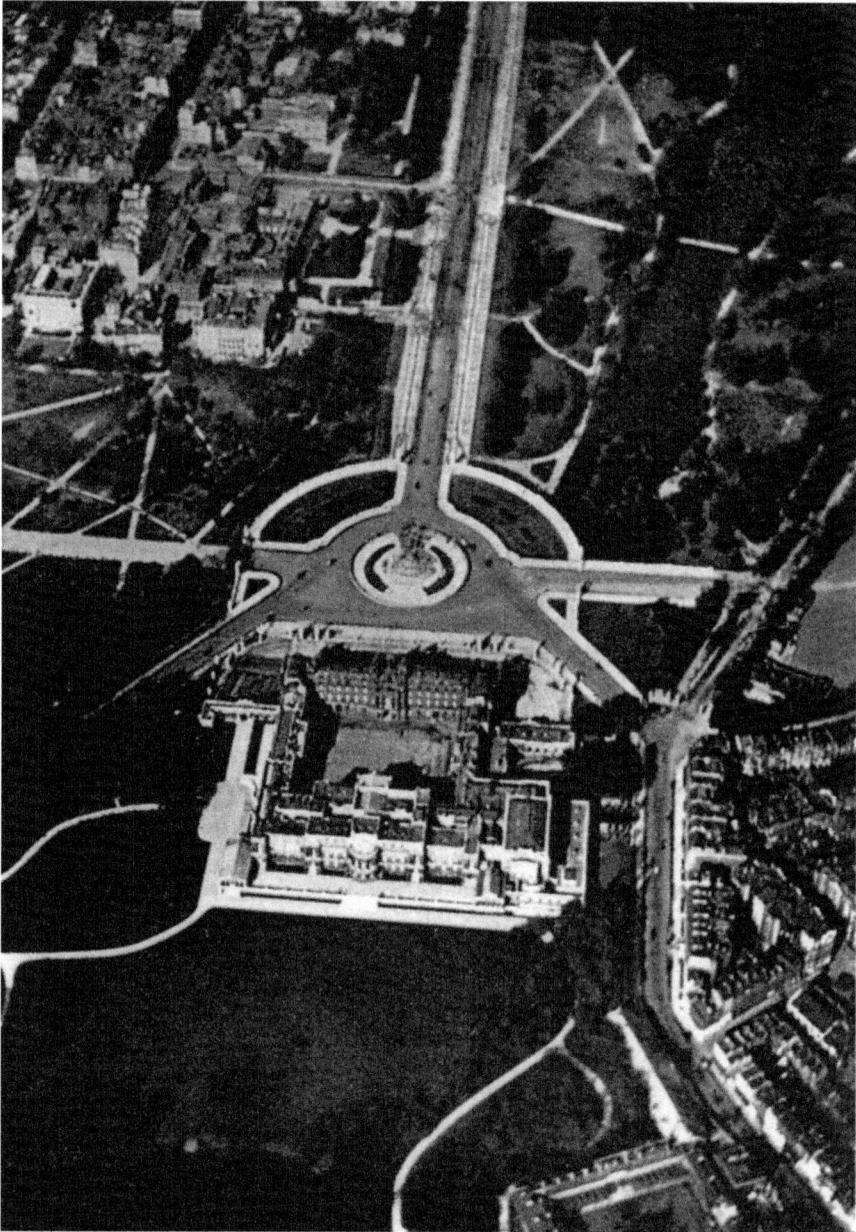

1.3 'The Heart of the Empire' (Buckingham Palace), frontispiece to Aston Webb, ed., *London of the Future*, 1922

space, classical form could be married with modern construction and the best of modern conveniences, and modern urban circulation on Beaux-Arts principles would enable emphatic demonstrations of the co-operative alliance of institutions in the empire's premier city. By these means an identity was created, its visibility based on rules of recognition: this was what

the heart of empire looked like; this was what it felt like to be a privileged subject of that empire; these were the images to be conjured up when the imperial city was evoked. Incapacity in the arts of representation was understood as a sign of weakness in imperial ability. As one commentator put it:

When Great Britain is incapable of setting an example of architectural achievement to her dependencies other nations more virile will slowly but surely take advantage of her relapse – step into the breach, undermine her prestige, and bring about an imperial disaffection more effectual in its consequences than the ravages of internal feuds.[34]

The monumental buildings of architects like Lutyens, Aston Webb and Baker seemed to have the capacity to span the world, or at least that part of it painted pink on the map, by suggesting continuities of vision between London and New Delhi, Pretoria and Hong Kong, and their buildings represented, for this moment at least, a necessary sense of unity, spatial order and destiny. But for all their trappings and rhetoric these schemes and their buildings hardly represented the colonies at all, and certainly not the less august side of imperial power.

Empire could also be described as contiguously present in British cities or, to put it differently, both centre and periphery could be found in proximate and interdependent spaces. Considerable Irish populations in London, Glasgow and Manchester were the most obvious evidence of this, but there were also significant Chinese communities in the port areas and growing Indian and Afro-Caribbean populations.[35] These migrants, with other waves of migrants from central Europe, tended to live in the worst housing, and they acquired their own places of worship, their own clubs or gathering places, and often their own shops and businesses. Is there a case here for calling this also the 'architecture of empire'? Certainly the areas where these migrants lived and worked, as of course with the working classes in general, were increasingly subject to spatial mechanisms of surveillance and control in ways similar to developments in the colonies.[36] But at the turn of the century public discourse regarded these areas as chaotic and even as a threat to the establishment and maintenance of the imperial image.[37] They were not a legitimate part of modernity and of the public sphere, and they were incapable of representing empire unless they were 'improved' – as with the Kingsway–Aldwych development – involving replanning, architectural reconfiguration and often the relocation of residents.

If it can be accepted, however disputable the effects and however complex the operation, that empire achieved material representation in Britain's cities and towns, then it follows that decolonization and the end of formal empire later in the century also need assessment in terms of their architectural impact. Can we talk of a commonwealth architecture or an architecture of independence in the same way that an imperial architecture has been deployed? These are the subjects of later chapters as also is the emergence of a distinct but in-between architecture, neither entirely transplanted from the colonies nor solely the product of British practices.

Imperial and post-imperial paragons

Architecture in the British Empire in the early twentieth century is dominated by the image and example of New Delhi to which an answering term, the post-independence city, was provided by Chandigarh in the mid-century. The example of Lutyens's and Le Corbusier's buildings and urban designs in India hung inspiringly or oppressively, depending upon one's architectural or political inclinations, around many imperial or post-independence projects for much of the century. They provided the backdrop for what happened in West Africa and South-east Asia, as we will see in Chapters 6 and 7.

One of the main reasons for New Delhi's impact was the power and subtlety with which Lutyens embodied Britain's self-image in India (fig. 1.4).[38] The early arguments for a regionalist style or combination of styles that would embody the political doctrine of trusteeship, demonstrating British sympathy for and understanding of Indian cultures through the use of motives from India's architectural heritage, were superseded in Lutyens's city plan and in his design of the Viceroy's House, which presented a commanding example of modern India under British rule (see plate I). New Delhi (inaugurated in 1931) was envisioned as a modern outpost of Rome, with nods in the direction of the Acropolis and Persepolis. Its architectural language was predominantly classical and therefore it could be used to make claims for being modern, humanist and universal, but it also involved playful and knowledgeable (if abstracted) Indian features even in its central building, the Viceroy's House. Its urban form was a grandiose choreography of monuments expressing the primacy of executive over representative power; residential layouts and locations pinpointing hierarchical differences based on socio-economic status, occupation and race; routes like the main Rajpath for processions; lavish traffic facilities and, overall, a garden city-like spaciousness. But the plan also reconfigured the terms of the preservationist argument: by separating the new city clearly from the older medieval city and providing vistas onto Mogul monuments in the surrounding landscape,

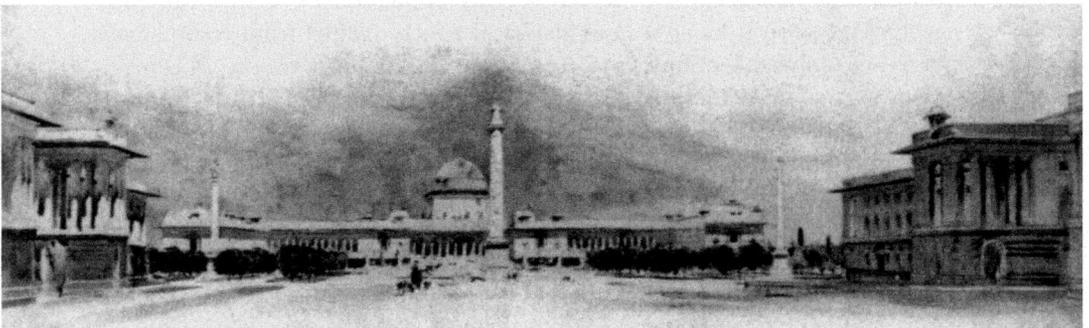

1.4 New Delhi – watercolour view looking towards the Viceroy's House.
Architectural Review, June 1924

it seemed symbolically to subsume that older empire within the new locus of power.

The imperial impact of New Delhi can be seen across the empire in as widely disparate and distant examples as the relationship between the High Commissioner's Residence in Jerusalem and the historical sites around it, the elemental domes of Wembley Stadium in London and of the Baghdad Railway Station, the marrying of monuments and graded residences in the planning of Abadan, and the ambitious planning of the colonial administrative capital of Lusaka in then Northern Rhodesia.[39] To many, New Delhi offered the model of a coherent, empire-pervading style; one that could harness the 'volatile medium' of cosmopolitanism, but that was also distinct to the British Empire; a tropicalized form for Englishness.[40] The set of differential and deferential relations laid out at New Delhi might be seen in Homi Bhabha's terms as a 'process of disavowal that denies the chaos of its intervention … in order to preserve the authority of its identity in the teleological narratives of historical and political evolutionism'.[41] Thus the old city, separated from the new by open spaces, was largely left to its own distinct urban systems, including vastly different living standards, death rates and residential densities.[42] The older cosmopolitanism of Delhi, like other pre-colonial cities, was simply bypassed or rendered subsidiary by the new Delhi which incarnated the new global circuits of imperialism. New Delhi would be *new* but it would also invoke the universal. Its enunciation might demonstrate 'respect' for old India and 'understanding' of its history, but these would not affect the central imperial narrative that it reiterated – an unbounded, unitary and non-dialogic one.[43]

Before independence, in India as elsewhere, modernism was mostly either a dream or a modish addition; it seems hardly to have been associated with, let alone the means towards, a reorientation of India's relation to the world.[44] There were therefore few more symbolic moments in the rise of modernism at the end of empire, few acts that better stood for the vanquishing of imperial architecture, as the invitation given to Le Corbusier in 1951 to design Chandigarh (fig. 1.5). And that is why it is worth brief discussion here in relation to New Delhi rather than for its more often discussed successes or failures as a new city.[45] Le Corbusier was appointed by Prime Minister Jawaharlal Nehru to open a new historical epoch distinct from colonialism and to help solve one of India's post-imperial legacies of partition. Of course, Le Corbusier was neither British nor a purveyor of historicist architecture.[46] If the claims of New Delhi to embody the universal and manifest respect for the local, and the myths that it conjured of Anglo-Indian co-operation, had long been dubious, with independence they seemed also to have become outdated. Chandigarh, the new capital of the divided state of Punjab, was to be a national symbol and a new beginning: 'the first large expression of our creative genius flowering on our newly earned freedom', as Nehru expressed it.[47] It would be monumental without New Delhi's rigid ceremonial axialities, and without its classical forms or its relegation of the Indian past to ornament.[48] Instead Chandigarh was a garden city organized as an

1.5 Chandigarh – Assembly and High Court. *Architectural Design*, October 1965

anthropomorphic grouping of the four urban functions codified by Congrès Internationaux d'Architecture Moderne's (CIAM's) Athens Charter of 1933, the most influential statement of modernist urbanism, with a highly specified set of zoning codes determining single-use development. The government buildings were placed on higher ground as the 'head' of the city; commercial businesses ringed a vast open square at its 'stomach' or 'heart'; a 'spine' or central avenue linked the commercial district and capitol and a hierarchy of roads acted as the city's circulatory systems. With the university and museum to the west and industries to the east, low-rise housing (carried out by Le Corbusier's collaborators), arranged in sectors, filled in the body of the city.

Yet there were curious echoes of New Delhi at Chandigarh: some ironic and deliberate, some implicit in its conception. The capitol was laid out as an informal relation of buildings remote from the city in a huge pedestrianized precinct, with the Secretariat framing one edge rather than acting as a propylaeum as at New Delhi. These buildings were linked by teasing off-centred axialities rather than the monumental symmetries of Lutyens, as if the spatial symbolism of democratic power in relation to executive power was being reconfigured rather than reconceived. The planned, but never built, Governor's Palace was placed, like the Viceroy's House, at the head of the complex but underplayed this position with reflecting pools mediating its relation to the south while the building itself would have faced across the axis rather than down it. Furthermore, the building was designed to be surmounted not by a dome, as with the Viceroy's House, but an inverted concrete arch. Like the incurvated hyperboloid shell housing the assembly hall in the Palace of Assembly this arch seems to invoke the dome and its imperial resonances only to parody it at the same time. In the other capitol buildings Le Corbusier adopted Indian parasol roof-shapes or vaulted bays over box-like containers (see plate II), fronted by concrete pillars and blade-

like columns, as ways of representing climatic adaptation and giving his government buildings monumental profiles that might match the huge porticoes of New Delhi. But in the Palace of Assembly, despite a stoa-like screen, the entrance was displaced and the assembly hall inside positioned off-centre within a grid of columns. Whilst he used colour, internally and externally, in an informal and playful way, concrete itself was admired by Le Corbusier as honest, courageous and sound, unlike the cosmetics of marble.[49] The Indian identity of the buildings was indicated by forms abstracted from the local landscape and livestock rather than Lutyens's *chattris* (freestanding turrets) and *chajjas* (wide-projecting cornices), derived from Indian architecture. And, in an inversion of the conditions of the bazaar but a reprise of Connaught Place in New Delhi, the commercial district was a huge plaza surrounded by buildings designed with repeated elevational treatment.[50]

The more implicit relations of Chandigarh to New Delhi have links to the ambivalence of its architecture. It was claimed that it established a non-hierarchical urban life, yet in fact it was merely a new elite that was favoured rather than the old colonial one: Le Corbusier's relation to Nehru had many echoes of Lutyens's to the viceroy, and although the new regime was Indian it sustained many of the autocratic styles of the Raj. There was 'a positively feudal … ironclad separation of rulers from ruled … in the caste-ridden pattern of its sectors',[51] and, like Brasilia, little provision for the residences of unskilled manual workers; hence the unplanned squatters' settlements that should be understood as an inherent part of these modernist cities.[52] Furthermore, the scale of Chandigarh – the distance between its institutions, the width of its streets, and its oversized public spaces – echoed the scale of military cantonments and was predicated on unrealistic notions of either the pleasures of walking or the technological future of mass car ownership, and thus open to the same accusations of western grandiloquence as New Delhi. It was probably only in the conditions of a new ex-colony that modernism could find the scale of canvas to match its imaginings: less now a laboratory of modernity than a broad landscape.

The watershed

The commission to Le Corbusier to work on Chandigarh marked a kind of watershed beyond India as well. Few architects or architectural commentators would talk explicitly or for long about architecture and empire after this. Although most of her pre-war colonial possessions still remained in British hands, Indian independence in 1947 marked the way ahead for the rest of the empire even if decolonization was understood as a more gradual process than in fact happened, and even if the idea of a British Commonwealth, whose architectural implications will be examined in a later chapter, seemed to ensure continuities of practice and favour. In the new talk of transfers of skills and technologies, of welfare and development, and of partnership with new young nations, modernism had a privileged place.

Among the antonyms that it seemed to push away were 'style', 'tradition' and, less acknowledged, 'imperialism' itself.

As colonial liaison officer for the Building Research Station from 1948, a post set up by the Colonial Office, G. A. Atkinson was in a good position to comment on these changing relationships between architecture and empire. In a lecture given in London in 1953, but reported as far away as Malaysia, Atkinson outlined what was becoming a canonical account of the relation between architecture and imperialism, but he also went much further.[53] Although Atkinson's lecture is mired by the formulas of its time it also conveys a remarkable breadth of geography, work and activity in the architectural field that probably only a colonial liaison officer could encompass. Atkinson was keen that the designing opportunities for British architects should continue, especially given the exotic fare that was on offer compared with the 'undernourished, starchy, English diet of schools and housing' that was available in postwar Britain. And there was no reason in the declining years of empire and the emergence of the Commonwealth for this not to happen: 'we' are responsible for 'their' good government, Atkinson asserted; 'we' need 'their' raw products whilst 'they' need 'our' technology, manufactures and technical expertise. The particular expertise that architects could bring to colonial and former colonial countries would be in town planning, social housing, architectural education and building research; but in the new relationships that were emerging, architects 'have to work there as equals only privileged because of [their] special knowledge',[54] rather than by dint of imperial control. Since New Delhi's completion in the early 1930s, a new kind of relationship had been established between architects and developing countries. Epitomized by Le Corbusier's work in South America and Algiers, and Oscar Niemeyer and Lucio Costa's work in Brazil, new images of modernity like the 'sun-breaker façade', entirely fitted with horizontal or vertical fins casting shadows over window openings, had sprung up in these countries, free of the appurtenances of imperialism. Similarly, Atkinson continued, the 'sculptural monuments of British sovereignty' were now anachronistic and a new generation of British architects was serving the colonies with new attitudes, if not necessarily in a new capacity: he singled out the work of Robert Gardner-Medwin and Leo De Syllas in the West Indies, and William Holford's appointment as honorary town-planning advisor to the Secretary of State for the Colonies. Atkinson also pointed to the attendance of overseas students at British architectural schools, the high interest shown in a conference on tropical architecture (initiated, he pointed out, by a Nigerian student), the exportation of eight million pounds worth of prefabricated buildings in 1952, and the scope for the setting up of new schools of architecture in the tropics. The three kinds of buildings that illustrated the talk exemplified a tripartite identity between historical epochs and architectural form: first, pre-colonial indigenous architecture; second, imperial architecture epitomized by a Palladian church in Penang, the Indo-Saracenic railway station at Kuala Lumpur, and the colonial gothic cathedral in Singapore; and, third, contemporary modernist

buildings (what Atkinson called 'architecture for development and welfare') like the University College of the West Indies, flats built by the Singapore Improvement Trust, and the new engineering block at the Kumasi College of Technology in the Gold Coast. As Holford, one of the respondents to Atkinson's talk, put it, there was a 'new spirit ... in colonial building', and the British were at last catching up with France's approach in its North African colonies[55]

Salient in Atkinson's account was the notion that a watershed had been reached and passed over. On one side of this watershed was British sovereignty with its implied economic modes of extraction and exploitation, and its architectural signifiers of the monument and, specifically, New Delhi. On the other side was the 'tropics', a word that largely stood in place of the word 'colonies' in Atkinson's article, indicating a huge global zone as if it were a problem of climate, ignoring its multifarious cultures and ignoring, too, the continuing imperial control of most of them. Attention to the tropics, as a set of irreducible conditions, would supersede any need to pay attention to 'the forms and patterns of some local style'.[56] In the tropics the desired modes of relationship were technology transfer, aid, 'cooperation' and 'partnership', and the signifiers were socially responsible projects housed and enabled by an inventory of modernist buildings. What was separated by this watershed was apparent: sovereign imperialism from 'a new phase' of benevolent late colonialism. What happened to effect this separation in Atkinson's history is clear: the depression of the 1930s and the Second World War. Economic crisis had caused the appointment of a West India Royal Commission (reporting in 1945) which in turn inspired the setting up of the Colonial Development and Welfare Fund for technical assistance to the colonies,[57] and then the colonial liaison arm of the Building Research Station. It was with the arrival of this new set of colonial institutions and technologies, and the acceptance of modernist architecture for tropical building, that the watershed had been passed. British colonialists were now nation builders, preparing their charges with the outlines of a new civil society, as the rhetoric put it, knowing the needs of the future better than their charges and instilling a sense of debt – literal and emotional – that might bind the colony to the motherland beyond formal rule. Modernization was the way ahead, with modernism as its partner not its critic, and modernization meant forgetting oneself, 'the wholesale import of [non-indigenous] scenarios and solutions':[58] a new imperialism of 'development'.

Utopian and dystopian modernism

Just as administrations and officials in the imperial centre often justified their colonial work by pointing to new civil institutions so too did the new transitional and post-imperial regimes, and what better embodiment of these was there than the buildings they occupied? They represented an apologia for colonialism, an 'architecture for development and welfare', as Atkinson

had called it, or an architecture that found a harmony between the machine and the Indian past, as with Chandigarh. To begin to explore this architecture and its impact further, I want to turn to a different source of commentary – the novel. In George Orwell's *Burmese Days* (1935) the tensions between modernization, colonialism and architecture are dramatized in an encounter between the pro-British Indian doctor, Veraswami, and the reluctant imperialist, Flory. When Flory asks what British law and order really amount to ('more banks and more prisons') Veraswami's response is to point to what is in front of them: 'Look merely out of this verandah – look at that hospital, and over to the right at the school and that police station. Look at that whole uprush of modern progress!' Flory responds that modernization means the wrecking of 'the whole Burmese national culture' and that in 200 years there will be nothing but 'pink villas fifty yards apart; all over those hills, as far as you can see, villa after villa, with all the gramophones playing the same tune'. But still Veraswami comes back at him: 'your civilisation at its very worst iss for us an advance ... all is better than the horrible sloth of the Oriental ... I see the British ... ass torchbearers upon the path of progress'. Flory is not convinced: 'I don't. I see them as a kind of up-to-date, hygienic, self-satisfied louse. Creeping round the world and building prisons. They build a prison and call it progress.' And so the conversation continues.[59]

Veraswami ventriloquizes the utopian vision of colonial modernization, what Holford and Atkinson were to call the 'new spirit' in colonial policy and what the French had already named *la mission civilisatrice*. But Veraswami, whom the British nickname 'very slimy', has his credibility undercut as he speaks: 'his voice was eager and bubbling with a hissing of the s's'.[60] He articulates a dream of post-Enlightenment civility through an architecture of rationality, social welfare and rectitude, but his problem with the mechanics of articulation make apparent that as a witness he is only what Homi Bhabha has called 'the effect of a flawed colonial mimesis'.[61] Flory, on the other hand, gestures against colonial policing and moral codes with the reiterated image of the prison, but he is also used to ventriloquize the dystopian conservative vision of a land taken over by the repetitive sprawl of suburbanites, effeminate ('pink villas') and in thrall to passing fashions ('the same tune'). This was a vision often articulated in 1930s Britain as the alien invasion of a 'beast' or an 'octopus' swallowing up villages with linear bungaloid development and spreading its tentacles over the hallowed national landscape.[62] In the colonies, accordingly, Flory's position entails a defence of what is perceived as local and historical – 'the whole Burmese national culture' – while Veraswami's admiration for modernization offers an unstable identity, in part colonial but without the associated images of Englishness. We will find a similar opposition when we examine modernism in Malaysia in Chapter 7.

Related images of modernist architecture are used in A. K. Armah's novel of post-colonial Ghana, *The Beautyful Ones Are Not Yet Born* (1969).[63] In its opening pages the novel presents an unreachable, mocking image of modernity and an all-too-present dystopia, each symptomatized by a building. The first is a new international hotel:

On top of the hill, commanding it just as it commanded the scene below, its sheer, flat, multistoried side an insulting white in the concentrated gleam of the hotel's spotlights, towered the useless structure of the Atlantic-Caprice. Sometimes it seemed as if the huge building had been put there for a purpose, like that of attracting to itself all the massive anger of a people in pain … Perhaps then the purpose of this white thing was to draw onto itself the love of a people hungry for just something such as this. The gleam, in moments of honesty, had a power to produce a disturbing ambiguity within. It would be good to say that the gleam never did attract. It would be good but it would be far from the truth.[64]

The second is 'the Block', a government office building erected during the colonial period:

The building never ceased to amaze with its squat massiveness. It did not seem possible that this thing could ever have been considered beautiful, and yet it seemed a great deal of care had gone into the making of even the bricks of which it was made. Each brick had on it the huge imprint of something like a petal of the hibiscus flower slanted diagonally across it. Where the individual blocks met, a clear groove ran between them, so that from some angles the whole building looked like a pattern of vertical and horizontal lines. But this impression was to be had from certain chosen angles only. From most other points the picture made by the walls of the Block was much less pleasant. For years and years the building had been plastered at irregular intervals with paint and with distemper, mostly of an official murk-yellow colour. In the intervals, between successive layers of distemper, the walls were caressed and thoroughly smothered by brown dust blowing off the roadside together with swirling grit from the coal and the gravel of the railroad yard within and behind, and the corners of the walls where people passed always dripped with the engine grease left by thousands of transient hands. Every new coating, then, was received as just another inevitable accretion in a continuing story whose beginnings were now lost and whose end no one was likely to bother about.[65]

The association of white building, white race, intangibility and distance are further reinforced later by images of bungalows and new university buildings: 'out on the hills the white men's bungalows were so far away, so unreachably far that people did not even think of them in their suffering … shiny white bungalows. Fences and hedges. Fences white and tall with wooden boards pointed and gleaming in the sun.'[66] And again: 'Out in the distance, far away but clearly visible, a group of shining white towers, having the stamp of the university tower at Legon and the sheer white side of the Atlantic-Caprice. They are going there, the two of them, the man and his companion, happy in the present and happy in the image of the future in the present.'[67] This is exactly the 'fantastic character' that Marshall Berman has described as typical of modernism under colonialism: the offering up of a mere 'spectre of modernization'.[68] The future that 'the man' finds at the end of Armah's book, however, is closer to the everyday materialities of the Block: a plunge through a latrine to save a corrupt minister from the soldiers of the coup, followed by an escape by boat across the sea.

Built spaces thus have a powerfully, even brutally, emblematic role in Armah's novel. On the one hand they represent tantalizing but unreachable visions: guarded, behind walls and up hills, white and dazzling in the sun. Although not all of these buildings are modernist (the University of Ghana at

Legon was actually neo-Moorish in appearance and Beaux Arts in planning) the formal distinction is unimportant. They represent foreignness and modernity, symbolizing a life of leisured refinements, of hygiene, and of greater geographic connections: the hotel's very name, 'Atlantic-Caprice', encompasses all of these. On the other hand, in the Block, tangibility and repetitive physical immediacy are rendered in a cloying, overworked materiality that does not draw attention so much to the historical past and its transformative moments, but instead simply to habitual, purposeless and clogged-up movements, and the official disinterest and torpor emblematized by the 'murk-yellow' colour associated with dirt and indeterminacy. The beginnings of the building's story, presumably in colonial governance and Public Works Department (PWD) labour, were forgotten, and the future of the building, as well as what it served, was smothered by bureaucratic neglect and corruption. This imposing but meaningless materiality is embodied by another name 'made deeper by the unnecessary boldness of the cement relief lettering out in front:

RAILWAY AND HARBOUR ADMINISTRATION BLOCK MCMXXVII'.[69]

A recent critic has written that 'when modernity, and with it modernism, was imposed on the colonized world, the colonized accepted it at its face value, its progressive and enlightened ideas, and equipped themselves to get rid of colonialism'.[70] But in fact modernism's rise in the colonial world was more complex and contradictory than this, and Orwell's and Armah's novels point to several other reactions to the image of modernism and the prospects it offered in colonized countries. There was Veraswami's idea that modernism brought enlightenment and improvement, Flory's contempt for it as homogeneous and controlling, and the 'fantastic character' of the image of the Atlantic-Caprice in Armah's novel as both an attracting and an insulting vision of whiteness, planted in the African city but unreachable for its citizens more familiar with the turgid modern but pre-modernist immediacy of the Block. Modernism could be all of these things. It might be welcomed as a promise of development, happiness borne by functionalism and new aesthetic possibilities; submitted to as an inevitable panoptic project of housing the world; or resisted as the imposition of an alien and culturally specific set of values as if they were universals. It might be a citadel of hope or oppression.[71]

Late modernism and empire

This last section will be used to speculate about the relations between empire, globalization and architecture. These rather bald abstractions will be given more substance in later chapters, but for now they will be introduced by a discussion of the Hongkong and Shanghai Bank, now HSBC, designed by Norman Foster in 1986.

What the HKSB were looking for in their new headquarters was a building that could reassert the bank's importance to Hong Kong as both image and financial powerhouse, and also a building that could renew Hong Kong's relevance to what has been called the 'new geographies of centrality at the interurban level'.[72] Two previous headquarters buildings had been built in the city, in 1886 and 1935. Recent research has shown how the first version of the bank mediated the relation between imperial financiers closely linked to Hong Kong's political circles and the Chinese merchant community.[73] Located in the European commercial sector and signifying its imperial links by its classical style, the building had two elements: a four-storeyed, verandahed building facing the riverfront, with offices on the ground floor and living and reception accommodation for European staff above, and a domed banking hall with a giant columned screen facing inland. The latter elements, of course, were architectural signs that attempted to dignify the maximization of profit that was the bank's real purpose. When finished the bank was the tallest building along the waterfront. As one proceeded through the public entrance on the inland side, through the banking hall with its racially distinct zones for Chinese and European staff and into the offices beyond it, so one homed in on the 'core of power'.[74] Social, architectural and financial distinctions were reinforced by the quality and expense of building materials, fittings and conspicuous technology. The bank was a crucial arm in Britain's far-eastern colonial interests, effectively bringing about Chinese financial dependence through loans served by a network of branches in the region.[75]

How much has changed with the most recent headquarters building? By 1986 the financial circuit had long been reconfigured from the model of 'gentlemanly capitalism' of the late nineteenth and early twentieth centuries, and the symbiosis between the bank and the Foreign Office had been breaking down since the war.[76] With the decline of empire in the postwar decades and the end of the Sterling Area in 1972 a new fiduciary corporatism had taken over the bank, as it became a multinational financial business, even though Hong Kong remained a British possession. Parochial internal organization was replaced by internal transnational diversity. Colonial status, however, was still apparent in the continuing autocratic nature of politics in Hong Kong where the bank was closely absorbed into the island's administrative structure. The impending prospect of the handover of the colony to China in 1997 meant that the bank, and Hong Kong itself, needed a public statement of confidence as well as to be firmly bound into the circuit of financial centres in 'world cities': from Frankfurt and London, to New York, Tokyo and Singapore.[77] The development is related to capitalist development within imperialist systems but also distinct from it: historic and colonial connections have been crucial to Hong Kong's status but so too has its strategic location and its economic and political stability.[78] By the late twentieth century multinational and transnational industrial and financial corporations, of which the HSBC was now one, had moved away from 'the imposition of abstract command and the organisation of simple theft and unequal exchange', as Michael Hardt and Antonio Negri put it, and they had

moved away partly because their financial interests were less geographically precise than they had been: they had loosened their old imperial ties to fit with the new forms of non-territorial imperialism. Instead, 'the transnational corporations directly distribute labor power over various markets, functionally allocate resources, and organize hierarchically the various sectors of world population'. This is the new global dynamic, a linking of diverse markets through globally focused financial centres and a new integration of power into everyday life, that Hardt and Negri have (perhaps confusingly) called 'Empire', as opposed to the old imperial location of power in the metropolis and in its colonial branches.[79] But one curious and ironic feature of this rejigging of market and power relations, to bring the discussion back to architecture, is that where previously the HSBC employed British architects with extensive practices based in the region (Wilson and Bird for the 1886 headquarters building, Swan and Maclaren for the 1922 branch in Singapore, Palmer and Turner for the 1935 headquarters in Hong Kong, and so on), in 1986 the bank commissioned Norman Foster, an architect with a global reputation and, at that time, developing a global practice to go with it. The newly expanded and distributed financial interests, crossing the old geography of empires and nation-states, were to have their flagship building designed by a practice with empire-building propensities headed up by a sovereign architect–designer who was British to boot. Yet empire, as we have already found in other cases, is a curiously forgotten element in the commentary around Foster's building.

The 1986 building conforms to, indeed in many ways is the apotheosis of, the architectural style called 'High-Tech' (fig. 1.6). The style is identified with the rhetoric of flexibility, used here to signal rapid response to dynamic commercial change and the mutating needs of the constantly 'rationalizing' workplace. But the most characteristic aspect of the style is the use and architectural display of the most developed construction and engineering technology whose elements are manufactured around the world and shipped in for assemblage: aluminium cladding cut by 'smart tools', a computer-controlled sunscoop (a bank of adjustable mirrors), automated environmental controls, prominent rooftop cranes, and escalators and elevators visible throughout the building.[80] All of these could be compared to the choice of materials and fittings in the 1886 building. But the overwhelming technological look to the new building was calculated to reinforce the bank's specialist niche in the financing of electronic technology. The single most visible signature of this approach is the repeated external suspension structure. This was deliberately likened by the architects to the stacked timber structures of Buddhist temples.[81] Together with certain other acclaimed references – to, for example, traditional Japanese houses in the screens and panelling of the interior, or the use of a geomancer's compass to determine the angled entrance to the banking hall, and even to the yin and yang of opposites – these allusions have encouraged the claim that the building is 'Oriental', and certainly enabled its easy absorption into the myth of Hong Kong as an East–West city.[82]

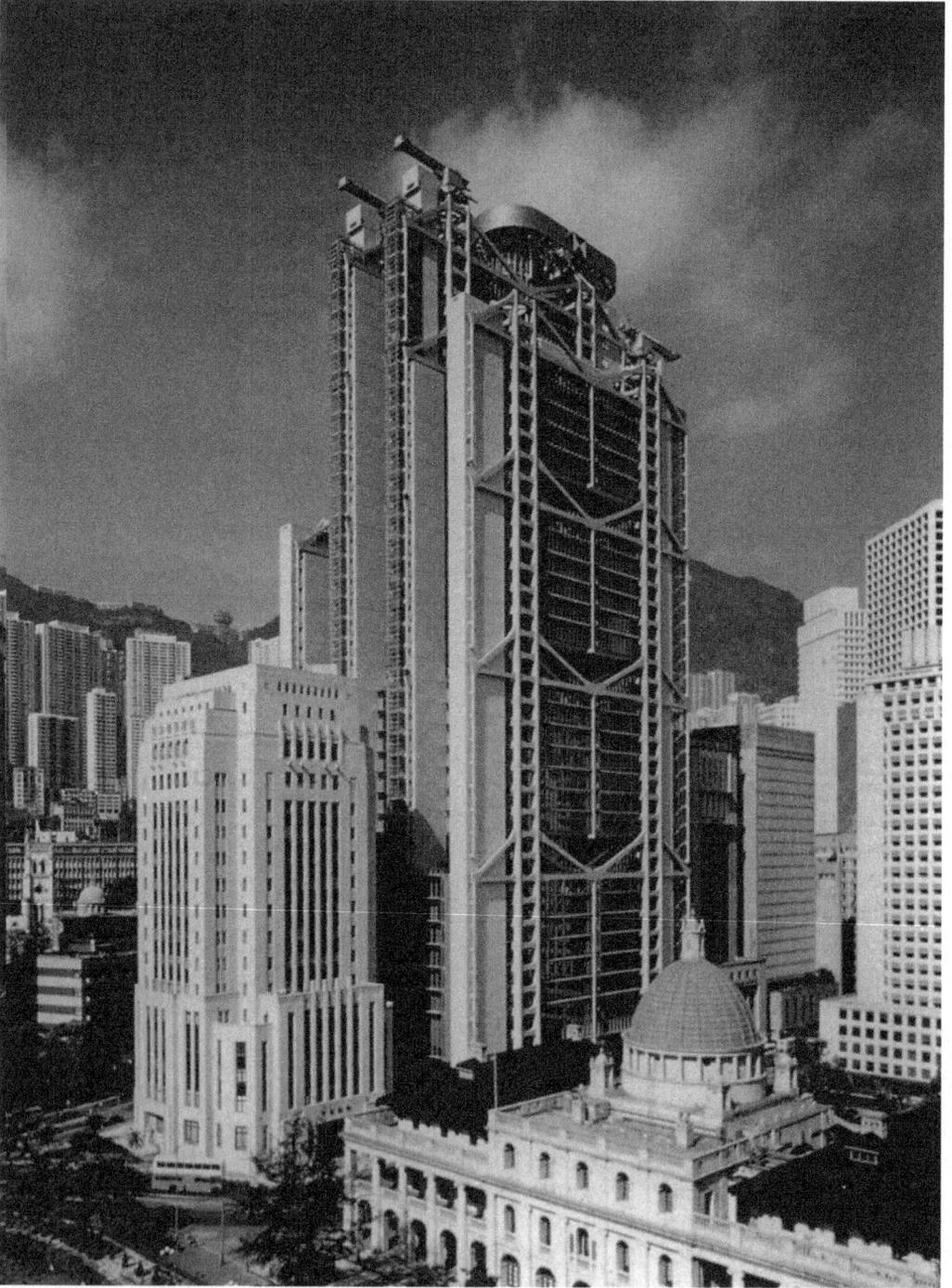

1.6 Hongkong and Shanghai Bank (Foster Associates, 1986)

In its spatial organization the bank building made much of its multistorey banking hall, the public plaza that runs beneath it, and the working 'villages' further up. The monumental height of the banking hall, with sunlight reflected down through it and onto the plaza below by the sunscoops, is the single most spectacular space of the building and the equivalent of the domed space of the 1886 building (fig. 1.7). The plaza reinforces the building's axial link across Statue Square (with its Cenotaph by Lutyens and its statue of Queen Victoria) to the ferry terminal. Historically, Statue Square had always been Hong Kong's most symbolic colonial space, a space of monuments and ceremonies, framed by the City Hall, the Law Courts and the Hong Kong Club. In fact, the square was actually owned by the HSBC,

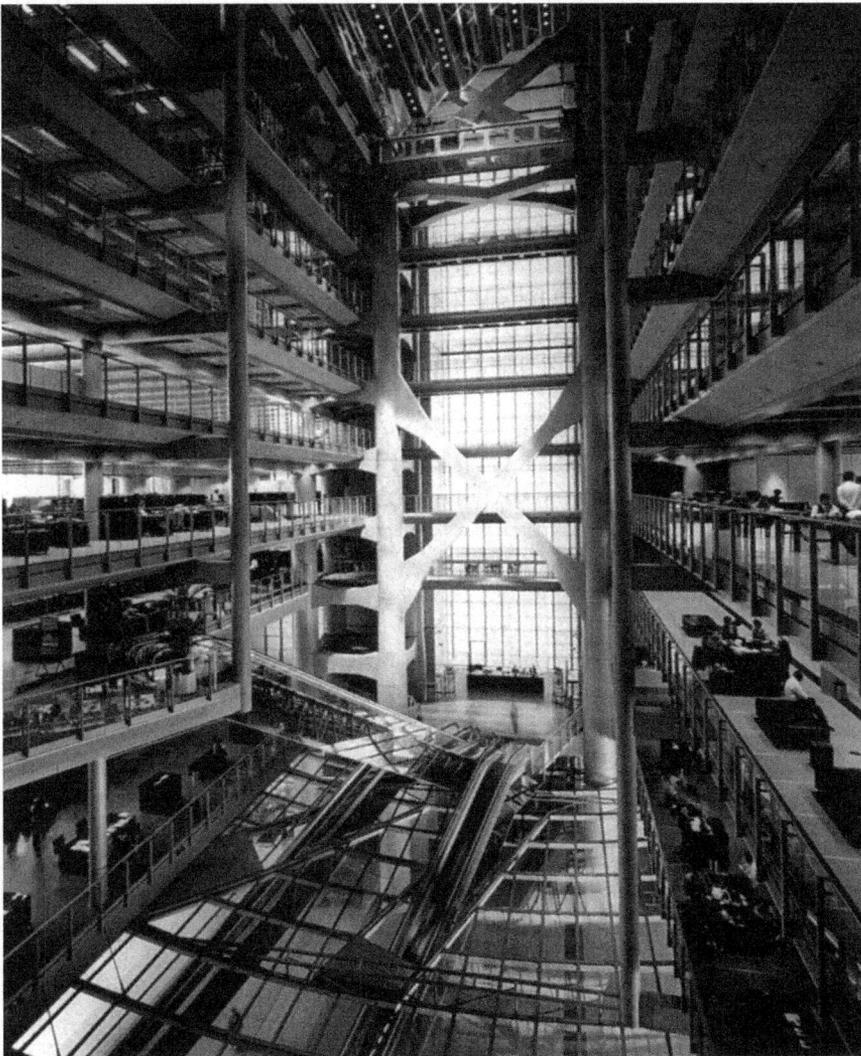

1.7 Hongkong and Shanghai Bank (Foster Associates, 1986)

whose provision of a public space enabled the bank building to maintain its visibility from the harbour and its centrality to the institutions that ran Hong Kong.[83] Thus Foster's extended and spectacularized plaza reaffirmed the bank's potent relationship to the Square and the waterfront, as the 1886 building had done, even though in the intervening century the site had been left three blocks away from the harbour by land reclamation.

By contrast with the hierarchic spatial ordering and graded visual access of the 1886 building, the visibility of the 'villages' has a different if not unconnected function like the related but distinct movement that has occurred between imperialism and 'Empire'. The villages are the five vertical zones of the building, each with its own social focus provided by a double-height space likened to a high street or community hall.[84] Each space also contains the interchange level for the building's circulation system. The transparency of walls enables both the spectacular visibility of the building's workings and workforce, its apparent access to the public, and also the panoptic control or 'accountability' of that workforce.[85] There is hierarchy in the 1986 building, but it is entirely vertically aligned. From the public access of the ground-floor plaza, and the spectacle of openness in the banking hall, the villages become more exclusive as they move upwards: 'local main branch operations down near street level; electronic data processing further up; the international operations and senior executive offices; and finally special services and the chairman's apartment on the uppermost floors. A smaller, streamlined block of VIP dining rooms with a helicopter pad on the roof tops the building out.'[86]

Perhaps Hong Kong is exceptional as the last major territory to be under formal British control, a place where the senior directors of the bank had a direct say in the running of the colony. Perhaps Foster's new bank building was especially needed as a means of bypassing transfers of sovereignty and catapulting the bank into the newer forms of economic power that the 'hyperspace of international business' represented.[87] Buildings like Foster's may make reference to local historic cultures and may reinforce local hierarchies of power, but the space that they serve is also trans-territorial and this is made explicit by an architecture coded for an international audience – the global rhetorics of High-Tech. Such nodal points, scattered in the major centres of capital around the world, serve principally to enable the 'space of flows', a network of exchanges or simultaneous practices independent of locales and their specific ways of constituting place.[88] And, of course, a practice like Foster's is integrated into this 'space of flows'. Unlike practices such as Wilson and Bird, responsible for the 1886 building, or even Herbert Baker, who exploited the connections and common elite cultures of the empire, Foster's practice is built upon networks that cut across nation-states, cultures and old empires, and has become part of this 'new network of power'.[89] Hong Kong is not now subservient to the old 'heart of empire' and its historical forms linked with authority, ceremony and politics.[90] Instead, it looks to a 'new architecture of centrality' that affirms its place within the new

forms and geographies of economic power.[91] But while Hong Kong maintains its place in a post-imperial 'Empire' through buildings like Foster's, other cities and indeed whole regions once part of the circuitry of the British Empire are now subject to the new unevenness and insecurities of globalism, becoming tributary economies and cultures at best.

The double end: training architects for the empire

As Baghdad railway station emerged from its construction site in 1949, its architects probably envisaged it as something even more grandiose than a terminus to a long-imagined railway line.[1] Here, they might have thought, was a synthesis of the regional and the imperial, the realization and resolution of different geographical loyalties (fig. 2.1). Its 21-metre (70-foot) diameter dome was constructed using both indigenous building methods (revolving templates, quick-setting local mortar) and modern technology. In form the dome was clearly pre-Islamic in inspiration, possibly Sassanian, more likely derived from the Pantheon in Rome, while its central range of

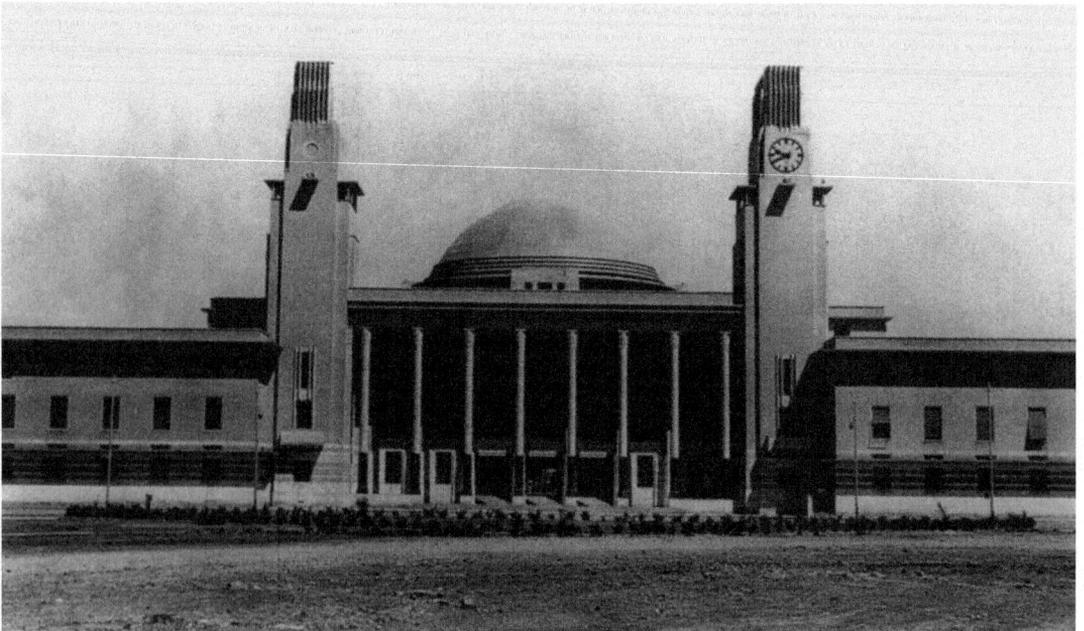

2.1 Baghdad Railway Station, Iraq (Wilson & Mason, 1949)

columns, capped with orientally inspired ornament, derived from centuries of European reworking of the classical temple as well as recent attempts to synthesize tokens of other cultures within this schema. In this resolution of different traditions the Baghdad railway station (see plate III) aspired to be a kind of nephew of the Viceroy's House in New Delhi, whose dome was one of several features borrowed from Indian architecture.[2] Shaded by deep stone cornices, like the *chajja* in Lutyens's building, the station's brick ranges and wings reached out to embrace generous forecourts and courtyards, while its dome and towers massively overlooked the intended new axial roads around it. The expansiveness and confidently hybrid aspects of the exterior were focused inside by the domed booking hall. Encapsulating a new world, a secular temple to the rites of transit, the booking hall symbolized the connection of region to region, from Istanbul to the Persian Gulf and beyond. Its decorative forms characterized Iraq as a locality within the world-system at a time when empire was giving way to a new global order. The station was, therefore, a part of Baghdad and its postwar rebuilding, but it was also part of larger symbolic and communicational networks: the completion of an older German imperial dream (the Berlin to Baghdad railway) by the British, but also the last years of Britain's 'moment in the Middle East', the newly emerging Pan-Arabism, and the first years of the Cold War.

However, the station's articulation of a particular view of the organization of space, and the place of architectural monuments within that space, might have seemed anachronistic to many other architects at this time. It looks back to that vision of imperial architecture that achieved its defining expression in New Delhi. As we have seen in the previous chapter, for this expression to be reproduced depended on the idea that it might have certain principles at its core – as much political, and even moral, as architectural – and that these might claim to have universal relevance and, therefore, to be capable of iteration and emulation through a deeply embedded set of procedures common to the architectural profession, wherever it might practise. In short, while it had particular ways of acknowledging its locality, the station also reached out to claim its place in a universal canon of architectural moves and strategies, space-making gestures that were never merely local in their significance. The station was one of the last buildings to epitomize an approach to architecture that had wide relevance to the British Empire in the early decades of the twentieth century. But it is also possible to argue that this approach – or at least its foundational beliefs – remained largely in place under many of the new forms of internationalism that replaced that empire. That, at least, will be the argument of this chapter.

The same approach can be seen in two very different cases. The first occurs in a 1934 review of a bank building in Colombo, Sri Lanka. Seizing on the way that the building fused eastern and western elements, the reviewer, Charles Reilly, ascribed this to the need to represent a moral example: 'our consciences compel us to make some sort of compromise in our architecture just as they do in our methods of government'.[3] For Reilly the great model for this, as with the Baghdad railway station, was the architecture designed by

Edwin Lutyens at New Delhi. Lutyens's method in the Viceroy's House, and likewise the method of the Colombo bank, was 'to adopt the general form and spirit of Indian architecture for the main outline of the building and to incorporate European detail where it is needed for functional reasons'.[4]

The second example comes from the papers of a now long-forgotten meeting, the Commonwealth Conference organized by the Royal Institute of British Architects (RIBA) in 1960. By this date the RIBA had decided that its old position as the central body for the regulation of the profession of architecture in the empire was no longer tenable; the 'maturing' of the Commonwealth meant that the 'burden' could now be lifted off the RIBA. How, though, could architectural education be administered in the former colonial territories? What model could be devised that would ensure a continuity of professional principles without the old centralization? One suggestion was that a division could be made between those subjects deemed 'universal' and those defined as 'local': the former would include theory of structures, building science, sociology and economics; the latter would cover building construction, the history of architecture, professional practice and the law.[5] Training in the former subjects could then be standardized, whilst those in the latter would be particular to the country concerned. The student would be kept in touch with developments within a global culture of architecture whilst able to practise these within more localized conditions.

Obviously these are very different kinds of statements and they span a period of nearly thirty years, yet they share two contexts: first, they were made by architects thoroughly involved in architectural training; and second, they were made in the context of Britain's relation to the rest of the world, whether that world was imperial or post-imperial. The very obscurity of these examples and the difference between their immediate audiences attest to a continuity of thinking at a much deeper level than architectural theory; a level where the regional and the universal are seen to be inherent to architectural production, but their relationship is understood as a delicately balanced issue of mutual dependence and moral responsibility; a level where to ignore the regionalist side of the equation is to open up the possibility of naked political motivation, but to give it more than token credence is to present a threat to the very nature of professionalism. Clearly one could not contend that this form of thinking is specific to imperialism, but it was a particularly serviceable equation within imperial and post-imperial frameworks; indeed, it might be suggested that it acts as a form of allegorical working through of Britain's relationship to its empire.

To take this dialectic between the local and the universal further, this chapter will look at architectural education in Britain and the empire in the first half of the twentieth century. In this discussion the field of architectural education, a subject with its own semi-autonomous history, becomes expanded so that it is seen as part of an imperial cultural economy much more extended than the national boundaries, which have tended to limit it within architectural history. Later, in Chapter 6, the impact of independence

on architectural education will be assessed as part of the discussion of Ghana in the 1950s and 1960s.

During the period of the height of imperialism in the early decades of the twentieth century and often lasting much longer, training programmes in most colonies were limited to producing technicians; colonial students would come to the West to study, the West would regulate the establishment of a few architectural schools in colonial countries according to a differentiated hierarchy of educational development,[6] and those schools would teach a western curriculum.[7] Architectural education, therefore, is a particularly eminent case of 'that subtle, half-concealed transformation', as Benedict Anderson has described it, 'of the colonial-state into the national-state, a transformation made possible not only by a solid continuity of personnel, but by the established skein of journeys through which each state was experienced by its functionaries'.[8] The cultural imbalance is still maintained long after decolonization. Overseas students in Britain continue to come predominantly from the ex-colonial countries;[9] local knowledge of the country of origin is denied by the rites of passage into architectural culture;[10] few ex-colonial architects teach in the West unless they are from the old 'white dominions'; and few, if any, western graduate students will take graduate programmes outside the West, even when the subject of those studies (say, tropical architecture) is largely non-western.

Baghdad and Liverpool

James Mollison Wilson and Harold Mason, the architects of the Baghdad railway station, had been working in succession in Iraq since the First World War as government architects under the British Mandate (which ended in 1932) and then in partnership ranging across both Iraq and Persia. Although Wilson had no academic training, serving first a pupillage then a period as assistant to Lutyens in Delhi, Mason had attended the Liverpool School of Architecture between 1909 and 1911. Liverpool was just then emerging as the outstanding and internationally the best-connected architectural school in the British Empire, a position that it held until the late 1930s. Mason's student work, consisting mainly of a collection of designs for tombs and monuments, but also with several office buildings inspired by the latest American classical models,[11] is typical of Liverpool at that time (fig. 2.2). Following two years furthering his classical knowledge at the British School in Rome, itself an important postgraduate institute for students from the empire, Mason's career was interrupted by the First World War, which he served out as a Royal Engineer in India and the Middle East. He then stayed on in Iraq as that country became a British Mandate with the dismantling of the Ottoman Empire. He was on hand, therefore, to take on the job of government architect in Iraq in 1921 at the age of 29. Between them, Mason and Wilson designed all the major government buildings and most of the major civil buildings in Iraq until 1935.

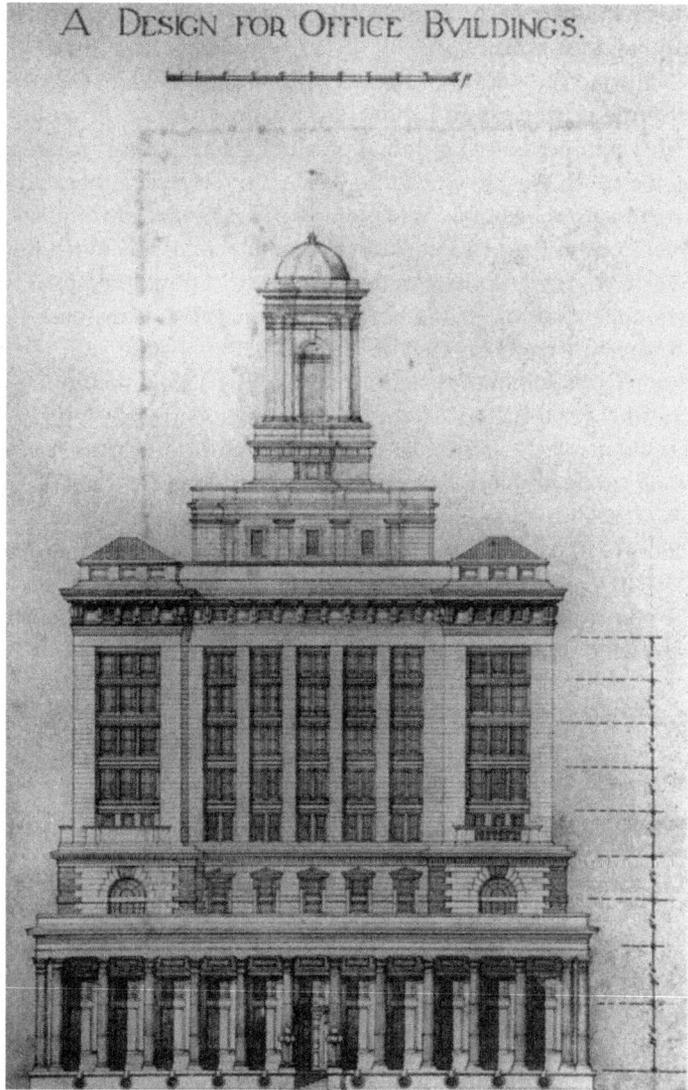

2.2 'A Design for Office Buildings' (Harold Mason, 1910)

Mason's practice in Iraq veered between a self-effacing classicism and a neo-Islamic style,[12] neither carried out with particular conviction until he teamed up with Wilson in 1935. Perhaps what is most interesting about Mason's career is the sense that he did not want to ignore indigenous architecture or to impose an imperial style regardless of commission or context, and indeed was actively interested in the vernacular brick tradition of building in certain parts of the country.[13] He shared this approach with other British-born Liverpool graduates who were all given important roles in the empire at an early age, and to a greater or lesser degree responded to the architecture of their localities: Maurice Lyon, who worked for the Ministry of

Public Works in Egypt; A. L. Mortimer at the Public Works Department of the Indian United Provinces; P. C. Harris in Zanzibar's Public Works Department (fig. 2.3); Clifford Holliday, city architect and civic adviser on town planning in Jerusalem (fig. 2.4); R. P. C. Hubbard who worked in Palestine and Malta; R. W. H. Vallis, architect to the North-Western State Railway in India; and R. D. Jones, assistant director of town planning in Northern Rhodesia. Many of their buildings featured prominently when the school celebrated its achievements through *The Book of the Liverpool School of Architecture* (1932). Their legacy was continued after the war with the modernist work of Maxwell Fry in West Africa and Robert Gardner-Medwin in the West Indies, and as architectural educators, by Quentin Hughes in Malta and Carl Pinfold in Nairobi, to name only four.

In the mid-1930s it was to the Liverpool School that Mohamed Saleh Makiya was recommended by Harold Mason, much as a decade before he had recommended another young Iraqi, Ahmed Mukhtar.[14] When Makiya left Iraq for Liverpool in 1936 he had no knowledge of indigenous Middle Eastern architecture, indeed his own interest in the regional variations of Islamic architecture dates from the measured-drawing exercises set at Liverpool.[15] Liverpool's training made no particular concession to its foreign students; it was thought to have universal relevance whatever background students came from and wherever they might practise. So Makiya drew the Orders, studied church design and chose a recreation centre for Antibes as his final-year project: 'all I knew of Islamic architecture was from Bannister

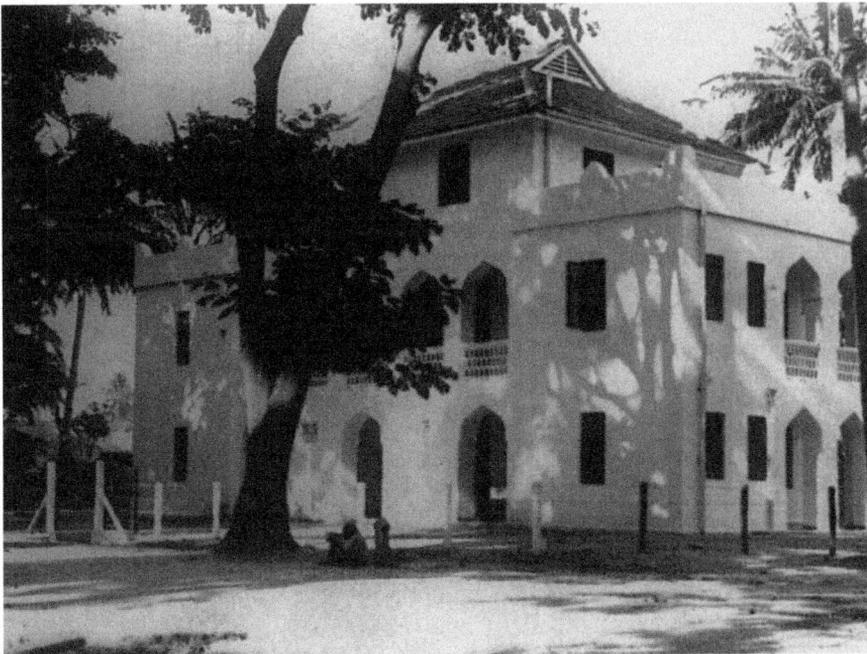

2.3 Maternity Clinic, Zanzibar (P. C. Harris, 1925)

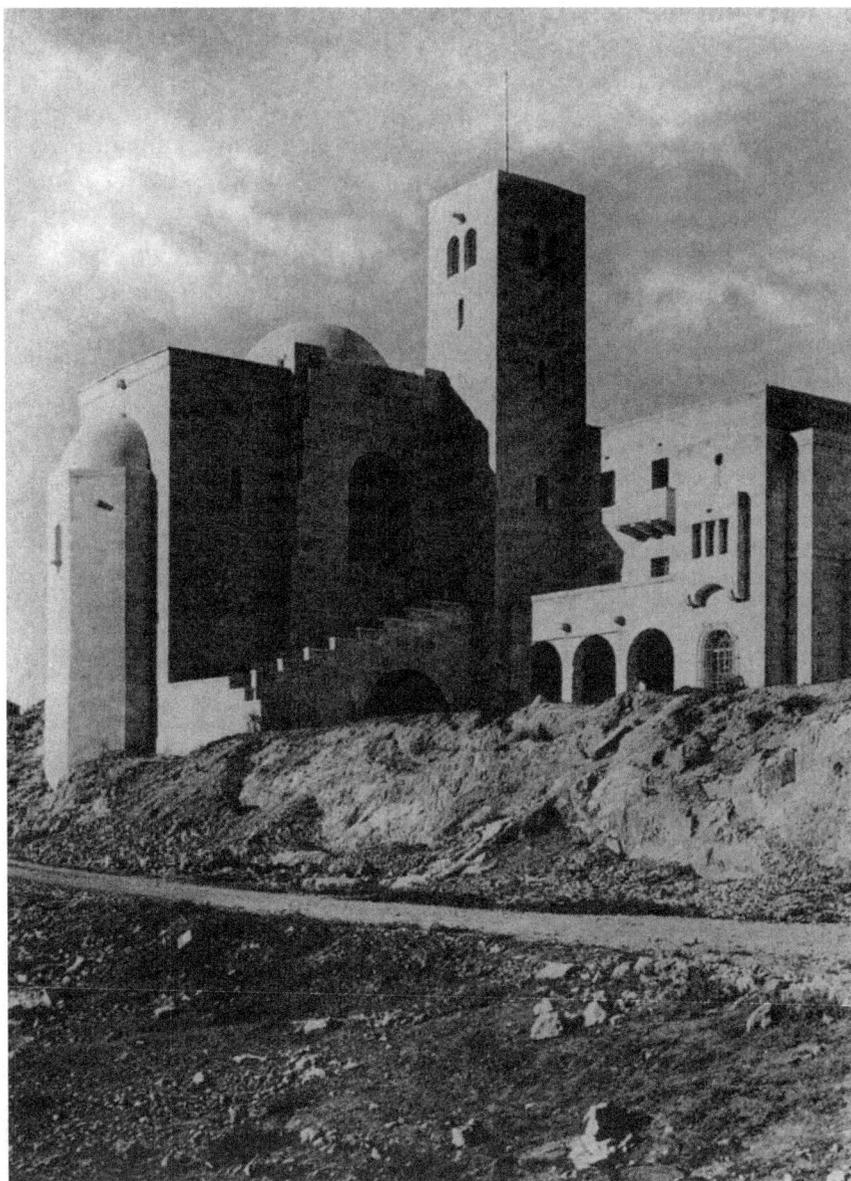

2.4 Church of St Andrew and Hospice, Jerusalem (Clifford Holliday, *c.* 1920).
Lionel Budden, *Book of the Liverpool School of Architecture*, 1932

Fletcher', he recalls.[16] Whilst the classical pedagogy taught him design discipline, Liverpool's measuring and drawing exercises showed Makiya how to look at historic buildings and how to appreciate variations in vernacular architecture. A crucial experience, for example, was a group trip to study the Cotswold village of Chipping Campden in 1939. Although the intention behind the trip was to study the organic pattern of street architecture and village development as a model for contemporary practice,

it clearly also had the potential – as Makiya's case attests – to stimulate interest in vernacular architectural form.[17] Later, when he returned to Baghdad and established the School of Architecture at Baghdad University in 1959, he set the same kind of measured-drawing work for his Iraqi students, though his aim seems to have been to foster urban conservation and an Arabic identity in contemporary architecture, free of foreign influences but adjusted to contemporary needs.[18]

Makiya had arrived in Liverpool at a particularly interesting moment for its School of Architecture. Among Liverpool's attractions for Makiya was its Department of Civic Design, whose courses were a common bridge for architects to take into town planning. Liverpool's pedagogic disciplines still revolved around the rationalized classicism of the Ecole des Beaux Arts, but many of its teachers by the mid-1930s were encouraging an interest in modernism. These elements, together with the attention to vernacular variations, clearly offered a potent mixture. While some architects in the 1920s and 1930s – like Makiya's fellow Iraqi Mukhtar or the Egyptian Mahmoud Riad – emerged from Liverpool as modernists, and others continued to practise as classicists, there had always been scope to develop regional sensitivities in students like Makiya, or even P. C. Harris and Clifford Holliday some twenty years previously. Training at Liverpool needs to be understood not so much as providing a kind of kitbag of design tools or a set of attitudes for the architect which were then carried through directly into practice, but rather, especially when we consider why its architects seemed particularly well-equipped or well-placed for imperial work, in terms of a broader set of relations concerning the Liverpool School's strategic place within the reproduction of an architectural culture for the British Empire. To explain this entails a consideration of the nature of the training given at Liverpool, and then of some of the circumstances of those architects who came to Liverpool from different parts of the British Empire.

Liverpool

Liverpool's prominent place in the history of architectural education in Britain in the first half of the twentieth century is now as firmly established in architectural history as it was to its contemporaries.[19] What has not been explored is its role within the architectural culture of the empire, and the conditions that made that role so pre-eminent. At first, what was crucial to Liverpool's emergence from merely national significance was its change of allegiance from the Arts and Crafts Movement to the international classicism of its time, and especially its adoption of a mixture of American institutional structure and French pedagogic methods. Following on from this, it was the professional ethos of the architect–planner, developed and taught at Liverpool, that gave its students a scope and ambition that well suited the opportunities given by the empire. The links that Liverpool offered to a circuit of influence across the world ensured that a self-perpetuating dynamic

was installed. Finally, and perhaps the most difficult factor to trace accurately, Liverpool offered two tantalizing promises that came together and separated out several times as the school evolved: one was of a monumental architecture, impressing its image across the empire; the other was of an architecture that sought regional affiliations or traces of the locality.

It was at Liverpool, in 1895, that Britain's first full-time course in architecture was established. At first this was conceived of as a preparation for pupillage, and then from 1901 as a full-time degree course. In both cases it envisaged the architect as a master-builder, emphasizing the variety of architectural disciplines, and teaching its students to understand the building crafts so as to guide the workmen under them. From 1906, however, under the direction of Charles Reilly, who quickly became the most influential architectural educationalist of his day, a new curriculum was installed. Although the change did not happen overnight, indeed some Arts and Crafts elements were retained, it was in its way radical, prescient and far-reaching; it could be seen at the same time as both a distinct marketing device and an ethical move to a form of training that recognized the proper conditions of the academy, as opposed to the compromise that the Arts and Crafts Movement had made.[20] Only once Liverpool had adopted Beaux Arts teaching could its course claim a universal relevance, though it must be said that this rested on a contested notion of professionalism in the modern world as much as on an extremely limited conception of rational procedures in design. From this point, like the Ecole, Liverpool could start to attract significant numbers of foreign students.

Following the Beaux Arts model, Liverpool's training was now centred on the studio where most of the students' time was spent practising the ideal designing powers of an architect, while those lectures and classes in subjects intended to support studio work were more peripheral in the curriculum. Design was treated as a systematic, studio-based set of procedures based on a repertory of precedents, rather than the picturesque and empirical affair that Reilly disliked in Victorian architecture. Design skills were developed through exercises of progressive difficulty but divorced from the constraints and contingencies of practice.[21] The design concept that best brought forth the fundamentals of the programme would be developed rapidly, based on codes of decorum appropriate to the building typology. Simple geometric forms, composed symmetrically around axes, would form the armature of any design: the thinking that generated the plan of Baghdad railway station was typical of this. The ideal for the student to aspire to was of the architect as a distinct professional whose intellectual abilities in the conceptualization of a project were backed up by drawing skills so as to give form to the concept of the project. This ethos and its accompanying practice remained largely intact at Liverpool until after the Second World War, indeed its sympathetic reception of modernist ideas in the 1930s was possible because it regarded modernism as continuous with its own rational and abstract urbanistic ethos.[22]

Of equal importance as Liverpool's adoption of Beaux Arts pedagogy, and

augmenting its new professional ethos, was the idea of the architect–planner. This was developed at Liverpool and taught there directly through its Department of Civic Design, the first of its kind in the world, but it also imbued the whole school. The department was founded on the basis of a grant from the soap magnate W. H. Lever, whose fortune was derived from colonial raw materials. Reilly's and Lever's belief that town planning was 'architecture on a big scale',[23] and that therefore the architect was the person best suited to formulate the design of large-scale town-planning schemes, gave Liverpool students a scope and ambition that well matched the opportunities provided by the empire, both at its height and in its waning. They were given a constant example of this in the work of the department's main lecturers (Stanley Adshead, Patrick Abercrombie, J. H. Brodie and J. W. Mawson) who all became active in the colonies.[24] This expanded vision for architecture offers a parallel with that generation of French architects who, in the first decade of the century, extended Beaux Arts theory 'moving beyond the individual building to the city as an object to be harmoniously ordered, and moving beyond the primacy of aesthetically dictated principles of order'.[25] In this new *urbanisme*, the term itself devised as part of a concerted attempt to foster national competitiveness, the beauties of Beaux Arts composition and an attention to the details of local cultures would be combined with the new technological advances and the lessons of the social sciences.[26] Several among these architects, notably Ernest Hébrard and Henri Prost, found the best field to practise these ideas was the colonies, which were to be treated as a kind of laboratory of modernity.

The very title of the new department set up at Liverpool in 1909 – 'Civic Design' – indicates its approach and what it shared with French *urbanisme*. 'Civic' implied both classical models of city form, to match the new monumental architecture being taught in the architecture courses, and, as Stanley Adshead, the first professor of Civic Design, put it, 'a well organised society [which] expresses its existence in a well directed and well planned way'.[27] 'Design' indicated from where this direction might best come, for, as Adshead again expressed it, 'a dignified city must have formal planning at its core'.[28] As envisaged by Adshead, and later developed by Patrick Abercrombie, civic design students would work in studios alongside architecture students during the day, and in the evenings would attend lecture courses on landscape art, engineering, law, town planning, the aesthetics of towns and the outlines of town planning. Of these the last, also known as 'social civics' and taught by Adshead and Abercrombie, was regarded as the most important. As its rather Geddesian alternative title suggests, 'social civics' was a primer in the role of social science within urban design though without the radical edge that the great Scottish sociologist and planner Patrick Geddes brought to his practice.[29] Abercrombie, the department's professor from 1915 to 1935, gave an enhanced prestige to the department by moving it in a direction that enlarged the 'social civics' side, lessened its 'design' aspect and made it even more ambitious: '[he developed] a style of planning which, concerned as it was with zoning regulations, administration, social and

geographical survey and regional planning, extended well beyond the boundaries of "architecture writ large"'.[30] William Holford, who succeeded Abercrombie in 1935, described the method of civic design as 'the economic and skilful shaping of material to achieve order and beauty out of disjointed elements', illustrating his point with the diploma work of F. A. S. Hassan – 'An Agricultural Settlement on the Nile, Egypt' (fig. 2.5).[31]

Amongst the department's early students were Clifford Holliday (active in Palestine and Malta), William Holford (active in South Africa and elsewhere), Linton Bogle (responsible for replanning Lucknow) and a large number of planners and educators who worked in Australia.[32] By 1930 the Colonial Office had recognized the key role played by Liverpool, as well as the newer department at University College London, in supplying planners for the colonies, and in 1938 Reilly could make the only moderately exaggerated claim that 'there is hardly a town of any importance, or a country, which has not consulted Adshead or Abercrombie, and where they have not been consulted men they have trained have been'.[33]

The prospects of large tracts of empire to design and build upon, and of authority not just over a building team but over a whole array of town-planning specialists, were highly attractive promises to architects and planners, and Liverpool's architecture and civic design courses drew students not just from across Britain but also from the British dominions, mandated territories and colonies: from India, Hong Kong, South Africa, Sri Lanka, Thailand, Iraq, Egypt, Canada and Malaysia, most notably. At the period of Liverpool's greatest influence, the 1920s, an average of five or six overseas students studied there each year, a sizeable proportion at that time.[34] Some were enticed by Liverpool's publications, which Reilly sent out to parts

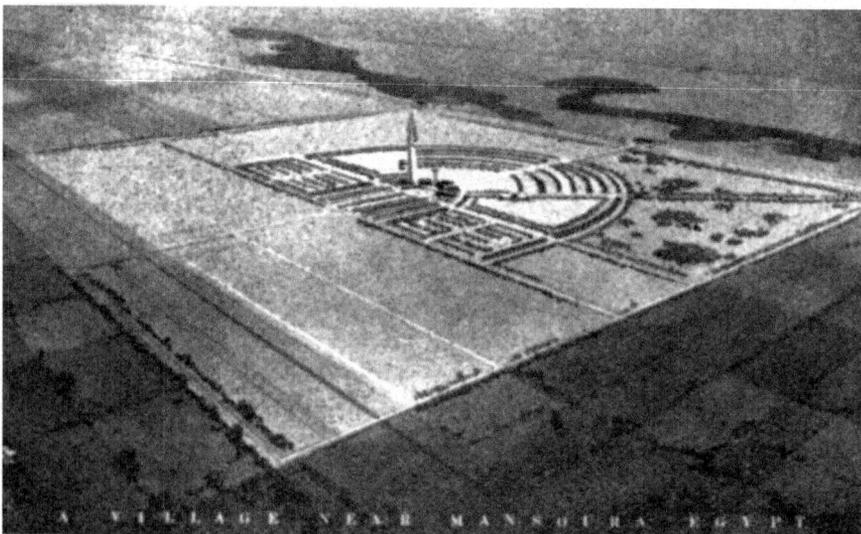

2.5 'An Agricultural Settlement on the Nile' (F. A. S. Hassan, 1938).
Journal of the Town and Country Planning Institute, 25, November 1938

of the empire, and others were encouraged by Liverpool graduates working across the world. But to understand the deeper attractions we need also to look at Liverpool from the perspective of a British-ruled territory.

Egypt and Liverpool

The most regular flow of colonial students to Liverpool came from Egypt, and the reasons for this reach back deep into the country's nineteenth-century history. Egypt had been under a British Protectorate since 1882 and amongst the functions of the British role in the dual system imposed on Egypt – whereby British 'advisors' effectively determined government policy – was the overseeing of the development of professional and technical education. In the early and mid-nineteenth century, Egypt had established its own European-style professional schools in fields like medicine, engineering and veterinary science, and a network of other technical colleges. However, under the British, educational and professional development atrophied. As consul-general for a quarter of a century after the British Protectorate had been imposed, Lord Cromer's priority was to keep Egypt servile, a minor cog in the great machine of empire.[35] Little would be spent on education because Egypt must repay its creditors, and because the British regarded their role in education as 'merely advisory'.[36] Besides, as one historian has recently argued, 'Cromer's Indian experience had convinced him that Westernized schools manufactured nationalist malcontents, particularly among those who failed to obtain the government posts to which they aspired.'[37] Britain's attitude to Egyptian modernization was, then, at best ambivalent but more commonly deliberately neglectful. As well as local drives to modernize and British policy, there is a third factor that needs to be remembered when we consider architectural education, and that is the traditional or Islamic education that provided a separate and parallel system. Effectively, an 'institutionalized cleavage' had already been created by the late nineteenth century between the modern and the traditional and it was not in British interests to intervene in this on the side of the modernizing movement, despite the fact that the secular elite believed that modernization was essential.[38] The British opted out of educational reforms, reduced government spending, and cast the area as a private responsibility.[39] Where the British did intervene it was in order to bolster the lower echelons of the civil service and the more rule-bound professions. Examinable knowledge was thus prized, and education was directed at enabling students to gain the certificates that served as passports into the junior ranks of the bureaucratic and technical services, such as law, medicine and engineering. After 1922 Britain's political dominance was relaxed and the educational straitjacket was loosened: the first substantial university was established in Cairo in 1925, to be followed by two others in Alexandria (1942) and again at Cairo (1950).

Architectural education had an unformed and indistinct position in all this. A school of engineering had been running at Bulak since 1820 and,

although it was remodelled on French lines in 1836 to accommodate an architecture course, this was to serve the training of civil engineers.[40] A school of architecture was opened in 1858 and architectural engineering was taught at a military training establishment at al-Abbasiyah from 1866.[41] Despite these schools, Europeans occupied most of the teaching positions as well as the senior posts in the Ministry of Public Works until at least the First World War.[42] It was certainly true that, given the high valuation of design skills in the emerging modern conception of the architect, there was no place – no atelier or architectural school – where an aspirant architect could be taken all the way through a westernized professional training in Egypt, and there was not likely to be one as long as the British maintained their suspicion of a highly educated Egyptian elite: in effect, until the 1940s. Behind this we should also reckon in the knowledge that in the late nineteenth century Britain itself offered no single model of architectural training, indeed it was not until the early years of the twentieth century that it began to formulate full-time architectural training in university-level schools as a properly modern alternative to, and then replacement of, other methods of entering the profession.[43] Anyway, in Egypt most ordinary architecture was built regardless of professionalized architectural culture. Where more formal commercial and civic structures were needed, architects were to be found particularly among the resident Italian community but also occasionally from more itinerant French and British architects either passing through the country, residing for a few years, requested from afar for designs, or brought in for a one-off commission. If native Egyptians were to be trained in architecture, as with other branches of higher education in the humanities, then they had to be either sent abroad and financially supported by their upper-class families or sponsored by the government.[44] More than two-thirds of these Egyptian students studying abroad were taking humanities courses, such was the dearth of them in Egypt.[45]

When Mohamed Raafat, the son of the ex-Under Secretary of State for War, arrived in 1920 he was the first Egyptian student to study architecture at Liverpool. He was followed in the next twenty years by at least thirty-four other Egyptian architectural students.[46] For most of them this period in Liverpool was the only way that they could enter into a prestigious practice back in Egypt. The majority arrived in England in their mid-twenties already holding a diploma in architecture or engineering, based on a four-year course, and often with at least a year's experience in the architecture department of the Egyptian Ministry of Public Works.[47] Mohammed El Hakim, for instance, had graduated in 1929 from the Fouad 1st University in Cairo with a diploma in architecture. A scholarship enabled him to take his Bachelor of Architecture in Liverpool, which he completed with a first class degree in 1932. After practising for a while in Liverpool he returned to Egypt in 1934. Basing his practice initially on private houses and mosque designs for the Wakf (Endowments) Ministry, El Hakim began to teach in architectural schools from 1944 and then to gain major public commissions in the 1960s.[48] Like El Hakim and Raafat, Ali Rabib Gabr already had a diploma

before he went to Liverpool, from the Cairo School of Engineering, and so like them he was excused the first two years of the Bachelor of Architecture. He returned to a lucrative practice designing houses for middle-class Egyptians in the suburbs of Cairo (fig. 2.6). Mahmoud Riad's student career was a variation on this pattern: he joined the third year in 1928 and worked for a summer at a New York firm. After finishing his first class degree in 1931 he briefly worked for the Wakf Ministry in Egypt, and then returned to Liverpool to take the Diploma in Civic Design in 1933.[49] With none of these architects can it be said that their Liverpool training determined the form of buildings they went on to design in Egypt. Nevertheless, what Liverpool undoubtedly gave them was competence in performing the functions of the newly professionalized architect, including sovereign control over a certain rapidly changing sector of the construction industry.

Typically, the education these Egyptians received at Liverpool – and the education, it should be said, they largely expected and desired – was one that paid no heed to their country of origination and future practice and, as with Makiya and other colonial students, largely presumed that students would return to similar building conditions the world over. It was only with their final fifth-year thesis that students were given the chance to make their own choice of subject, which for Egyptian students usually meant an attention-

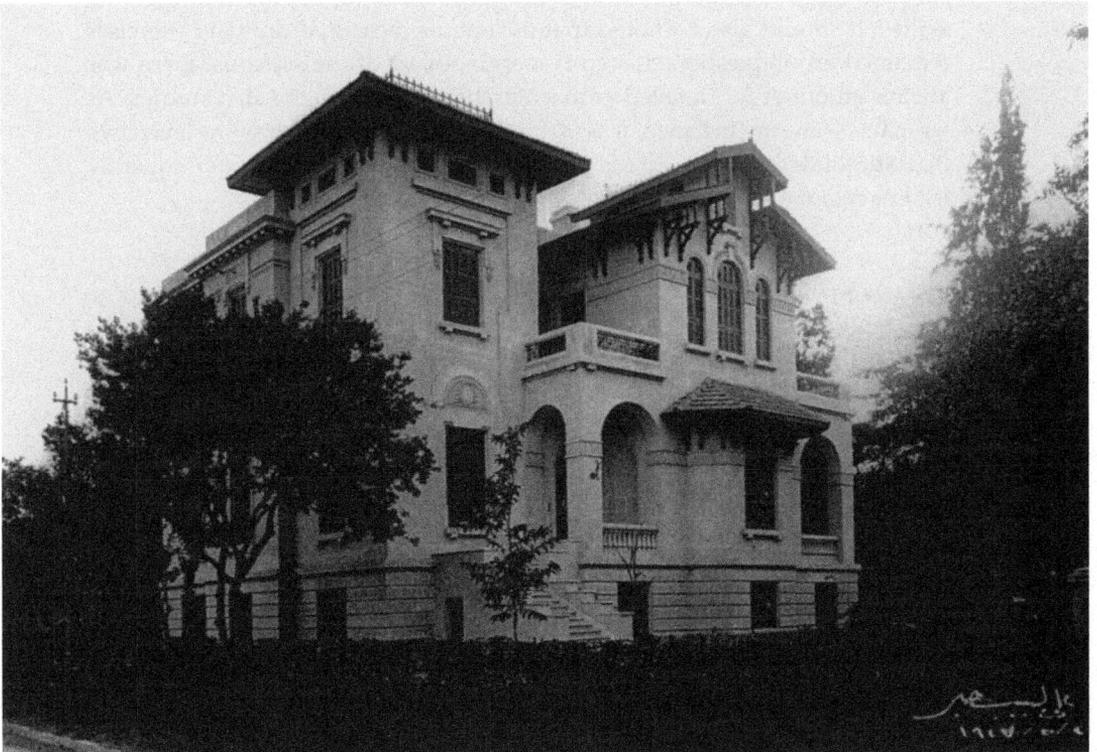

2.6 House for Muhammed Sabry Bey, Meadi near Cairo (Ali Rabib Gabr, 1927)

grabbing if imaginary complex for Egypt. In 1927-8, for instance, Mohammed Cherif Neumann chose to design an opera house for Cairo; three years later Mahmoud Riad designed a railway terminus for Alexandria; while in 1939 Tawfik el-Gawad's final thesis was 'A Students' Union for the University of Cairo'.[50] In the years leading up to this, their work was expected to be no different from that of any of their contemporaries. Their architectural history might start with ancient Egypt but then it would mostly steer a European course, west of Athens and north of Rome. The rest of the curriculum is well, if ideally, described in the *Prospectus* for 1921–2, the year that Gabr started at Liverpool. The course was self-confessedly based on that at the Ecole des Beaux Arts and its American counterparts, but its devisers believed that it had a specifically British, or rather English, cast:

> while the student is taught design on a basis of monumental planning in order to equip him with the means by which to approach with confidence the larger problems architecture presents, every effort is also made to give him that intimate knowledge of detail, materials and construction which distinguishes the best English work.[51]

It was with what they called this 'double end' in view – both monumental and English, universal and regional – that the student successively studied simple construction and the 'elements of architectural form' in the first year, followed in later years by 'a progressive series of designs both of a constructional and monumental character', including appropriate drawing skills.[52] It should also be noted that as long as measured-drawing exercises remained an unquestioned even if marginal part of the syllabus, there was always an outlet for detailed vernacular, historical or regionalist studies. As we have seen, for instance, it was Liverpool's measured-drawing exercises that stimulated Mohamed Makiya's interest in English and subsequently Islamic regional architecture.[53]

The double end

Architectural historians have sometimes accused Liverpool's pedagogy of adopting only the superficial aspects of its French model and especially of mistaking the French attitude to style. It has been argued, for instance, that 'Reilly and other British admirers of the Ecole des Beaux Arts in Paris misinterpreted what they saw as being a system based on classicism, rather than a rationalist system whose principal manifestations were classical.'[54] Apart from making the Ecole seem more eclectic than it was and diminishing Liverpool's own eclecticism,[55] what the 'double end' indicated in the *Prospectus* and in the experience of students like Makiya attests to is that, although Liverpool might not have aspired to the thoroughgoing rationalism of the French method, regardless of style, its approach was not rigidly classical but in practice usually promoted rationalist methods whilst other parts of its syllabus at least aspired to regionalist sensitivity.

For the Egyptian student, then, as indeed for any foreign student or any

British student heading for a position in the empire, Liverpool's training offered the elements of a synthesis of two architectural modalities even if this synthesis was usually unbalanced and deliberately imperfect. One of these modalities was 'monumental architecture': building on a grand scale and with a formal sense of order that dictated the disposition of masses, the planning of circulation routes, the design of exterior forms to accord with ideas of propriety, and the organization of space within hierarchies appropriate to the idea of the building. The other modality was architecture as a geographically specific form of building drawing on regional formal traditions, materials available in the locality, and construction methods that suited the climate and the skills of the local builders. If not a complete synthesis, this new approach at least suggested that regionalism was a modality that had relevance to monumental architecture. On this basis the 'double end' of Liverpool's courses might well satisfy the aspirations of an architect wishing to return to Hong Kong, Pretoria, Colombo or Baghdad, that he had not only become a part of a profession with its own distinct set of skills (drawing), conceptual processes (design), and understanding of building (sovereign control of the building team), but also that he could bring these to bear in a way that accorded with the particular conditions of his homeland.

This Janus-faced aspect of architecture – epitomizing the local and embodying the universal at the same moment – can be situated as an epistemic condition of much modern western architecture. Alan Colquhoun has recently argued in an important essay that the universalist and regionalist tendencies were at the heart of avant-garde modernism and that they were an inheritance from Enlightenment rationalism and Romantic empiricism:[56] hence, for instance, Le Corbusier's attachment both to the forms of the Mediterranean vernacular and to the ideal of industrial standardization. Regionalism, Colquhoun further argues, was formulated as a reaction against 'the problems of the rationalization of social life under industrial capitalism ... [and] precisely at the moment when the phenomena that it described seemed to be threatened and about to disappear'.[57] And in architecture, as elsewhere, regionalism essentialized, taking as the irreducible aspects of a local culture such matters as geography, climate and customs as these were embodied in local materials, local styles, local scale, and sometimes even local technology and locally encoded space. Architectural regionalism depends on what Colquhoun calls the '[correlation of] cultural codes with geographical regions'.[58] Of course, whilst this argument castigates regionalism for essentializing by seeing autochthonous traditions as ultimately determining, it fails to recognize that it locates technological or economic structures as having the same determining role for universalism.

This same duality, resolved or recombined to different effect, can be seen in many different currents of nineteenth- and twentieth-century western architecture, of the *arrière-garde* as much as of the avant-garde. It was not only a symptom of modernist anxieties, and it did not take over a hundred years for this sometimes tormented, sometimes brash attempt to master this

dualism to carry over into the design and production of architectural space. Indeed, as I have been demonstrating in this chapter, the duality can be observed particularly clearly at the heart of the professional identity and practices moulded and refined by architectural education, and these seemed to be especially well suited to the conceptualization of imperial architecture. It can be found perhaps most influentially in the teaching programmes and pedagogies of the French Ecole des Beaux Arts from early in the nineteenth century onwards, particularly as the systematic rationalist design processes of the likes of J.-N.-L. Durand, the idealist theory of types of Quatremère de Quincy and the Romantic historicism of Labrouste, Vitet and others came into contact and tense synthesis: history, cultural difference and rationalism were the key elements in any architectural debate. Here the binaries, represented also by the German opposition of *Zivilisation* and *Kultur* (civilization and culture) or *Gesellschaft* and *Gemeinshaft* (society and community), were presented not as distant irresolvable opposites but as dynamic if often unequal forces within the production of architecture and its civic and historical functions. The inequality resided in the way that universalism was seen as belonging within western classical traditions, whilst regionalist elements were given a lower estimation as belonging to the domain of the Other: they had a legitimizing function, but they were always only a representation of an 'authentic thing', and even modernism only instituted a 'deeper level of mimesis'.[59] For example, in the Abbé Laugier's writings, the 'primitive hut' was always an epitome of architecture's origins or its relations to nature, never of its contemporary co-existing vernacular. There is, therefore, a great deal of continuity between modernism and the so-called 'historicist' forms of nineteenth-century architecture in this concern with both the universal and the regional: we need only look to the way that Le Corbusier's early Art Nouveau and Ruskin-inspired mix of geographic determinism and cultural nationalism helped to form his 'mature ideology'.[60] Once a utilitarian rationalism emerged, based on 'instrumental efficacy rather than metaphysics',[61] then both sides of the universal–regional dichotomy could be written into nineteenth-century architecture and theory, and from here there always lurked the possibility of relativism in cultural matters. On the one hand, as it were, the reconciliation of architecture, technology and use; on the other, the reconciliation of architecture and sentiment.[62]

In many aspects of the architectural history of the last two centuries, a claim to rationalism seems to be pulling regionalism in its train, the one the inevitable corollary of the other. The same duality could be found in the empire. In their various ways the Indo-Saracenic style of late nineteenth-century British India, and the neo-Moorish style of early twentieth-century French Morocco, were both seen as vehicles of a new modern combination of politics and rationality.[63] Under the aegis of a policy of association or trusteeship, the details of the region were subsumed into the hegemony of imperial planning: regionalism would rarely extend to a thorough examination of pre-industrial vernaculars.[64] The central block of Baghdad

railway station also epitomizes this, for while it might defer to a regional tradition of domical structures and regional details of decoration, it takes its geometric organization from the standardized compositions inaugurated by J.-N.-L. Durand in the late eighteenth century,[65] and its very freedom in adapting a dome for a booking hall ultimately from the Durand-led rationalist critique of *caractère* in architecture, a denial of architectural form as an embodiment of memory.[66]

The question, to bring this discussion back to the issues of this chapter, is really whether the regionalism–universalism binary works in quite the same ways within the operations and discourses of colonialism. Even Colquhoun recognizes that in the Third World, for whatever reason – 'different historical times exist together', he submits – the turn to regionalism can be a valuable matter of 'strategy rather than essence'.[67] It could be argued further that just as in late nineteenth-century nationalism the call to *Kultur* could legitimize the claims of an emerging nation-state, so in the twentieth century the strategic deployment of regional forms and styles could visualize and concretize the aspirations of anti-imperial and nationalist movements (this, in the Malaysian context, will be the subject of much of Chapter 7).[68] There could, in effect, be a 'strategic use of essentialism' in contesting a universalism increasingly revealed to be partial and interested: thus nationalism, secularism and culturalism could become alibis for decolonization used by the class that negotiated with colonialism and emerged as its successor.[69]

Professionalization

To summarize at this point. Within the practice of architectural education, or at least as it was exemplified by the most influential school in the British Empire, architecture was regarded as a universal discipline, an international culture of professionals trained in rationalist methods of design but able to specialize in the perception of regional conditions and localized solutions. Effectively, the skills to design and supervise the building of 'monumental architecture' were defined as the province of the 'architect', and the 'architect' could only be produced in a professional architectural culture with, at least, traditions of pupillage and, at best, full-time architectural schools. Because access to professional architectural education was controlled by the colonial power, it could also be seen as a part of what Gayatri Spivak has called the larger 'epistemic violence' of imperialism, an interruption fracturing plural and hybrid practices in favour of alien disciplinary and professional formations. Architectural education promised both to alienate indigenous architects from their cultural experiences, drawing colonized subjects into the western codes and practices of architectural production and professional discourse, and to distance the field of architecture itself from the experience of the vast majority of the population, despite regionalist gestures and ethnic self-makeovers.[70] We now need to look at two other areas, the first at what

was rhetorically and institutionally constructed as 'central' to architectural production, the RIBA in London. The second, architectural education in India, as it was placed in this construction as a satellite to that centre.

In its extra-national role the RIBA was also guided by the notion of architecture as a universal discipline. Established in 1834 as the professional body for architects in Britain – shaping their relation to the state and other professions, acting as a learned society, increasingly defining the terms of entry into the profession and therefore actively shaping architectural education – the RIBA inevitably came to assume the same functions for the British Empire at the turn of the new century just as architects began to take on a more prominent role in shaping the empire. It was effectively, therefore, one of the most influential architectural bodies in the world, straddling an empire-wide network of professional architectural bodies, though there were substantial detours taken by settler colonies to its protocols. Under its guidance the four most typical markers of professionalization were developed: the establishment of university-based training; the rise of specialist journals; the growth of numbers in the profession; and, lastly, the founding of syndicates, in this case the 'allied societies'.[71]

A sense of this RIBA-overseen network can be gained from the maps published in the *RIBA Kalender* in 1934–5. These depict a Britain divided into a myriad of local societies, and then huge chunks of the world – Canada, East and South Africa, India, New Zealand and Australia – partitioned to represent great zones of professional responsibility, all 'allied' to the RIBA in London. Compared with the *Kalender* for 1892–3, which listed no overseas allied societies, these maps attest to a remarkable efflorescence of professional bureaucracies. Membership of these allied societies had also risen sharply, from a few hundred at the turn of the century to 4760 in 1934.[72] Each allied society acted as a kind of mini-RIBA: each was 'the accredited centre of a district and the agent of that district in its relations with the heart of the system in London'. Consequently each favoured those forms of training – articles, indentureship or university-based education – that it could best control or for which it could act as a relay-station for RIBA control.[73] The idea of the RIBA as the centre of a global web was relatively new and was bound up with the idea of the RIBA acting as something more than just a metropolitan club, but a 'professional parliament with world-wide representatives and jurisdiction'.[74] A conference in Liverpool in 1893 had established the policy of dividing Britain into 'architectural provinces', each with its own local centre. There were several aims here: '[to] bring into harmonious and united action the scattered and disorganized members of the profession, strengthen the position of all local practitioners both professionally and socially, and enable arrangements to be made for extending throughout the country the advantages of the Progressive Examinations now established by the RIBA'.[75] The professionalization of architecture, therefore, proceeded from the division of land into 'provinces' relative to a metropolitan centre, through an enhancement of professional self-identity (serving on planning panels, negotiating with local authorities)

and public recognition (setting up prizes and scholarships, lectures and exhibitions), to the regulation of entry into the profession via an increasingly systematic control of a specifically architectural training.[76] Having territorialized Britain in this way the logic compelled extending the system into the empire, the extension dependent of course on the right professional components being in place. Provincial and colonial societies would gain influence through being recognized as part of a co-ordinated network, whilst the RIBA would gain representative power as the centre of 'national and imperial jurisdiction'.[77] We find the RIBA, for instance, adjudicating on the standing of architects and their fees in India and East Africa, and on their conditions of practice in Rangoon.[78]

In the profession of architecture, then, the relationship between colonies and metropolis could be seen as a more regularized, more benevolent and more modern version of the relation between colonial governments and parliament. More regularized because the RIBA could be seen as equating standards in one part of the empire with those in another; more benevolent because latent cultural conflict might be neutralized within the decorum of professional behaviour; and lastly, more modern because what better instrument of enlightenment could there be than a disinterested organization, a professional body, disseminating codes of practice and examining and inspecting standards, adherence to which was one of the very conditions of universality? Indeed the RIBA's official chronicler, E. Bertram King, presented it in this way in 1934:

An analogy has often and aptly been drawn between the British Empire and this autonomous association of professional units ... Before the nineteenth century colonial administration was entirely centralized and frequently degenerated into the exploitation of the colonies for the aggrandizement and enrichment of the Mother Country ... A more enlightened age has preferred the loyal association of self-governing and mutually independent dominions with the Mother Country ... Similarly in this professional alliance we who are of the same race and who are accustomed to conduct our affairs under the influence of the same loyalties and ideals however infrequently defined, need hardly be surprised to find ourselves adopting similar policies and principles to those which have consolidated the British Empire. Neither was deliberately planned in advance in its present form but both have adapted themselves to the changing needs and conditions of the time and appropriate legislation has followed in their train.[79]

It also followed that, by the late 1930s, in addition to the overseas allied societies the RIBA 'recognized for exemption' – in other words, inspected and certified – some ten schools of architecture in Bombay, Montreal, Toronto, Sydney (Sydney Technical College and University of Sydney), Manitoba, Johannesburg, Cape Town, Auckland and Melbourne. Each school represented differing stages of development within the RIBA's conception of architectural culture: for instance, while McGill University, Montreal, had been recognized for exemption from the highest level of RIBA exams – the final examination – since 1923, the school of architecture at the Sir Jamsethji Jijibhai School of Art in Bombay only had recognition to intermediate level (since 1920) though it was the first school outside Britain to gain it. Again the

development had been rapid. Whereas in 1925 only two schools had final exemption (McGill and Sydney), by 1933 a further six had joined them.[80] The RIBA recognized that in terms of developing a complete academic education, architectural training in Canada and Australia, because of America's influence, might even be more advanced than in Britain.[81] Accordingly the RIBA had initiated a 'Devolution Scheme' granting architectural institutes in the white settler colonies (Australia and South Africa were first in 1930) the right to set their own exams and recognize their own schools, thereby opening the door to quite considerable differences in training from the metropolis.[82] By the late 1950s the RIBA, recognizing a 'maturing' of the Commonwealth, sought a federal relationship with the ex-colonial allied societies.[83] In developing countries, though, it still sought to foster its own brand of architectural education until well into the 1960s.[84]

Where the 'parent body' approved,[85] there one would find something very like Liverpool's 'double end' reproduced, with universal procedures of architectural conception encompassing, where need be, the odd inflection to local conditions. 'There is no need for specialization in the Colonies', wrote the Liverpool-trained Professor Cyril Knight in 1937, 'special problems like the New Zealand problem of earthquake-resisting construction can be covered by the necessary bias in the general course. Students with special aptitude should be sent to special schools in England or the US.'[86] Similarly, when a new School of Indian Architecture was proposed in 1934 in Calcutta, the RIBA insisted that it regarded the 'study of Indian architecture as an essential basis for the teaching of architecture in any School in India'.[87] And the same 'double end' can be seen in the 1950s when the University of Hong Kong, at that time the only architectural school between Bombay and Brisbane (Japanese schools did not admit foreigners), applied for RIBA recognition. While its architectural history could have been taught anywhere in Europe, following a western current after Egypt and Mesopotamia from the Greeks to the Modern Movement, its curriculum faced two ways:

teaching is based, both in method and in general content, on the practice of leading departments of architecture in the UK ... We say 'general content' because the nature of the problems studied naturally gives the course a regional basis, and it is worth remembering that the department is the only school of any standing in the British Commonwealth which produces architects trained in the special problems of tropical areas.[88]

India

The development of the architectural profession and architectural education in India was earlier described as a satellite of imperial architectural culture because it can be placed as a smaller centre within the larger map of an imperial and then a globalized architectural culture. At the beginning of the twentieth century, architecture in India was in the hands

of Indian master-builders, the Public Works Departments (PWDs), and Anglo-Indian firms led by architects trained in Europe but with increasing numbers of Indians working for them who had been given a route into architecture via a training as draughtsmen in colleges of civil engineering.[89] But although Anglo-Indian architects dominated professional architectural culture in India, a professional form of architectural training in the RIBA mould only became available in India in the 1920s, and even then this was initially restricted to one school, the Sir Jamsethji Jijibhai School of Art in Bombay.

From the beginning the Sir J. J. School, as it became known, had been envisaged as part of the Arts and Crafts revival in India, and it was hoped that its students would provide the ornamental skills for the Gothic Revival and then the Indo–Saracenic movement in the late nineteenth century.[90] In other words, whilst thoroughly regional and indeed antimodern in its conception of the building team and of the related role of traditional crafts, its beliefs worked in harmony with the rising idea that imperial government might best manage dissent by selective inclusion. From the last years of the century the school had begun to supply assistants for offices run by architects and engineers trained in Britain, but as the need for architects increased in the first three decades of the twentieth century, with the rapid expansion of Bombay's population and the passing of town planning legislation in 1915, so the school developed a more extensive architecture programme: first providing draughtsmen's courses so its students could enter the lower echelons of PWDs, then setting up four-year courses, then in 1913 establishing the five-year diploma that gained RIBA recognition in 1920.[91] By 1930 it was teaching a curriculum based on the RIBA syllabus that took students all the way through to qualification.[92] It long prided itself on its teaching of the history and design of traditional Indian architecture but, perhaps unsurprisingly given the need for RIBA recognition, its students' work was very similar in its design procedures and its drawing methods to that of their British contemporaries, once Hindu temples were expected rather than gothic churches.[93] This gave a distinctive stamp to the work of many Bombay students: a domed 'Tomb to a Great Indian Patriot' worked out with stress diagrams (fig. 2.7); Hindu and Parsee temple designs carried out in ravishing Beaux Arts drawings; and a 'Maharajah's Music Garden' developed rapidly as a timed study (fig. 2.8).[94]

Sir J. J. School's Indian graduates took jobs with the growing number of architectural firms, formed the Architectural Students Association, and then provided most of the members of the Bombay Architectural Association (affiliated with the RIBA in 1925), which in turn became one of the constituent bodies of the Indian Institute of Architects (recognized as an allied society in 1929).[95] Eventually the Sir J. J. School was joined by other architectural schools, starting with Delhi Polytechnic in 1941, followed by the Architectural Academy also in Bombay (1956) and the Royal Engineering College (1956). Understandably in 1947, the year of independence, the

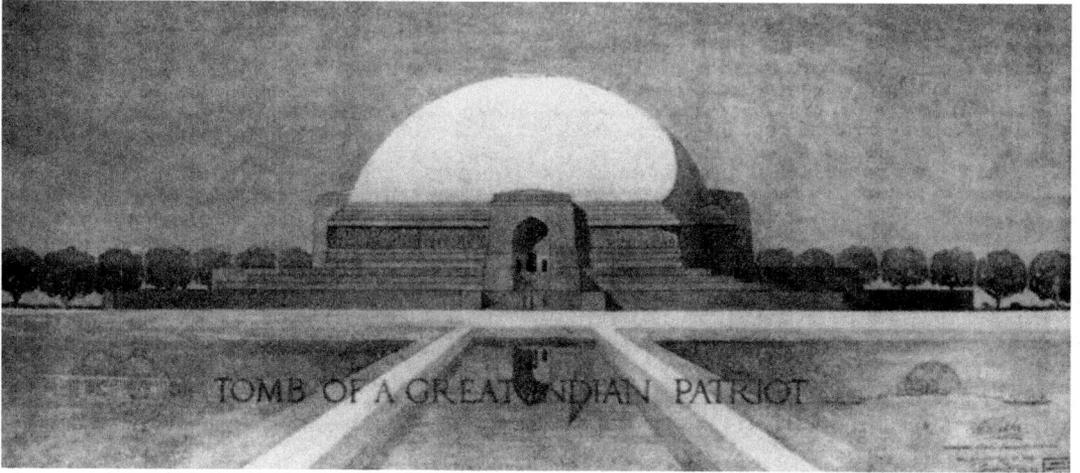

2.7 'Tomb to a Great Indian Patriot' (J. K. Mehta, Sir J. J. School 5th year, 1928).
Journal of the Royal Institute of British Architects, 21 June 1930

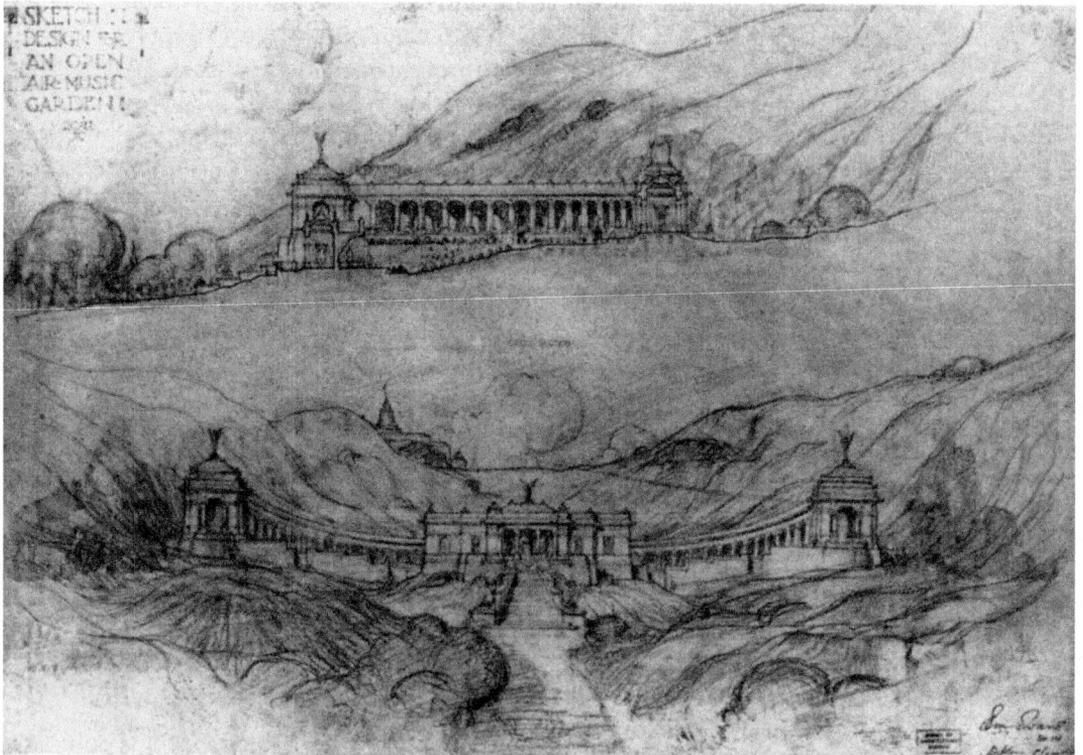

2.8 'A Maharajah's Music Garden in the Hills' (E. V. Vidwans, Sir J. J. School
5th year, 1930). *Journal of the Royal Institute of British Architects*, 21 June 1930

editors of the modernist architectural journal *Marg* deplored the state of things bequeathed them by the British: one architect for every million people (compared with one for every 4000 people in England), only two architectural schools and these using 'methods discredited in the world twenty-five years ago', teaching historical styles rather than 'subjects peculiar to India' such as its climate, and with only a few score students who were not even trained highly enough for exemption from the RIBA's final exams.[96]

These developments paralleled and often intersected with a progressive 'Indianization' of architectural culture in the subcontinent. The rewards of affiliation and recognition were given to mark the phases of professional emergence, but it was also through the forms of professionalism that Indian-born architects could take over modernized architectural culture in India. By the 1930s, Indian architects were challenging the hegemony exerted over Bombay architecture by British firms, and by 1940 90 per cent of the Indian Institute of Architects were Indians; by 1942 almost half of the presidents of the Institute had been Indians.[97] Their heritage was complex, with Beaux Arts and Bauhaus elements, British professional models and pedagogies, and aspirations towards modernist internationalism.

As with other parts of the British Empire, Indian independence brought with it neither an architectural independence and a sundering of the professional culture of architecture, nor an attempt at a fully realized regionalism. Cultural colonialism persisted due to the shortage of professional skills, and the continuation of inherited professional ideas, within the larger frameworks of development models and a more globalized economy.[98] For some time, of course, modernism had been staking a claim as an international architecture, something more than a set of forms but rather, by turns, an ethical, pedagogical and technological attitude towards the production of space. It would be wrong to argue, as I will show at more length in later chapters, that modernism simply bypassed imperialism, leaving it stranded as part of a world of nations, styles and ideologies considered incompatible with the modern world. Modernism did not necessarily hive off the unequal aspects of decolonization because it too exerted a kind of 'epistemic violence' on decolonized cultures. There was also no sundering of the culture of architecture precisely because of the policies of 'devolution' in the regulation of the profession and the 'double end' of architectural education. Indeed this 'double end' could have other uses than the imperial one of hegemonic control. It could, for instance, be taken to represent a newly liberated national consciousness that also aspired to the universal, but now post-imperial, conditions of modernity. To put this differently, there were ways in which both essentialism and specificity could be used strategically, though the gestures of repudiating the one in favour of the other would from time to time be made.[99]

After independence in 1947, the orientation towards western models in architectural culture still persisted in India. The Indian Institute of

Architects remained affiliated to the RIBA, architectural schools continued along western lines, if anything finding other European and American models than the British ones (and responding faster to them than the British schools were at this time), and many British architects stayed on, some continuing with the same influence that they had come to expect under imperialism.[100] Liverpool still exerted its influence: both the Department of Architecture and Town and Country Planning created at Bengal Engineering College in 1949, and the Department of Architecture and Regional Planning set up in 1955 by the Indian Institute of Technology at Kharagpur, were based on the means devised at Liverpool to produce the architect–planner.[101]

What we see in these developments is the extraordinarily close relationship, embodied in architectural education and professionalization, between Britain and its empire in the first half of the twentieth century. The professional framework was defined and regulated by the RIBA in London, while the most influential pedagogic model was to be found at Liverpool. As with other professions, the kind of knowledge that the RIBA sought in its approved schools and wanted to see promoted by its allied societies was primarily formulated as a way of advancing the interests of professional specialization in a projected globalized building industry, rather than, for instance, discovered and refined as some objectively demonstrable 'truth' about architectural production. A truly equal balance between regionalism and universalism in professional practice, let alone a critique of the very terms of this binary, would therefore threaten a conflict of roles: one of those 'crises of legitimation' described by Jurgen Habermas that promised to expose dominant beliefs as neither rational nor disinterested.[102] In architectural education and professional practice the RIBA sought to establish and institutionalize an unequal balance between regionalism and universalism, and it did this by defining and then policing the boundaries of the profession, ensuring internal observance of the conditions of professional conduct, and propagating public awareness of the nature of the profession. As one symptom of this, its various committee minutes give a picture of an institution constantly trimming and fussing over the nature of the profession across the empire: adjudicating on the standing of architects and the level of fees in India and East Africa, determining the conditions of practice in Rangoon, assessing a new degree in Malta, and so on.[103]

Therefore, regardless of local conditions, a homogeneous professional identity was being promoted and regulated across the world. The paradoxes are acute. Whilst professionalism had to be seen as uniform, unbiased and disinterested, architectural education was often encouraging regionalist approaches in its neophyte professionals. Whilst modernized pedagogic and professional practices were to be seen as disseminated from the British 'centre', increasingly the 'peripheries' were either modernizing their institutions more quickly or looking elsewhere for their models.[104] And, finally, whilst the 'centre' was struggling to re-invent its practices as the pace

of modernization in architecture elsewhere seemed to quicken, so the 'periphery' was engaging in a far more dynamic conflict between calls for traditional identities and those for modern internationalism.

Oil and architecture

In winter the earth flooded and became a flat, perspiring lake ... [in summer] the dwellings of Kaghazabad, cobbled from rusted oil drums hammered flat, turned into sweltering ovens ... In the British section of Abadan there were lawns, rose beds, tennis courts, swimming pools, and clubs; in Kaghazabad there was nothing – not a tea shop, not a bath, not a single tree.[1]

Manucher Farmanfarmaian, a Persian aristocrat who worked as an engineer for the Anglo-Iranian Oil Company in Abadan, is describing a scene that might belong to some setting at the height of empire. There is a lot of liquid implied in these few phrases. Some of it is the sweat of labour and the thirst of deprivation; some the water of nourishment, refreshing dips and cool drinks. But the liquid that is the reason for this unequal relationship with its Manichaean contrasts is oil. The discarded oil drums have become the actual walls of the shacks in Kaghazabad, but equally the British section is dependent on oil for its very existence in this place. Though oil might have no obvious presence in their settlement, oil was the only reason why the British had come to Abadan and it was the profits from its extraction that funded their style of life there. But Farmanfarmaian was describing neither a nineteenth-century scene nor a colonial setting, at least not colonial in any formal sense. This was the mid-1940s and Persia, now Iran, was an independent country.

This chapter takes a different tack from the overviews presented thus far. In it I want to explore Abadan and its development as a case study in the role of architecture and planning in the relation between a major British company and a locale that it perceived as a place of extraction. For many Persians, oil seemed to define the country's future: 'it was the blood of its earth and the means to catapult its people into the twentieth century'.[2] How could those 'oil drums hammered flat' and those well-watered lawns have come to exist contiguously? An answer, though specific to Abadan, will also draw in several of this book's concerns. Abadan exemplifies the changing state of many colonial towns and cities in the first half of the twentieth century. It evolved from an ad hoc collection of buildings to the polarized, separate but symbiotic worlds of expatriate suburb and 'native town', to some of the first attempts at an 'architecture of welfare and development'. And as part of this evolution the company's public image in the 'heart of empire' also needs to be addressed as a form for the veiling and naturalizing of economic violence.

The early development of Abadan

The company that built most of Abadan had been founded as the Anglo-Persian Oil Company (APOC) in 1909, but changed its name to the Anglo-Iranian Oil Company (AIOC) in 1935, British Petroleum in 1954, and then the name by which it is currently known, BP, in 2001. From the beginning the company had been protected and aided by the British government, and in 1914 the government bought half shares in it. It was, therefore, a curious hybrid: a private company that conducted itself as an autonomous fiefdom, it was also a semi-nationalized industry upon which the British navy depended for its fuel and a company whose senior managers had often moved from important colonial civil-service jobs. From the Persian point of view they had given a mining concession to a private individual in 1901 only to discover that within fifteen years they had virtually a colonial mini-state on their doorstep. After 1919 British control of Persian oil inevitably also meant a great influence on the Persian army and Persian finances.[3]

Abadan was 'the jewel in the company's empire',[4] but from the 1920s until 1951, Abadan might best be described as a collection of urban forms gathered around an oil refinery, hardly a town at all. Certainly, in the eyes of the company and its British employees it had no unitary character; though there was a 'town' (also referred to as the bazaar) this was not the Abadan that they knew but an overcrowded insalubrious area, the supplier of non-European labour, the ubiquitous 'native city' of the colonial imagination. Abadan's refinery was the end of a pipeline, collecting the liquid and passing it through plants for all stages of refining before pumping it onto tankers to be sent round the world. The refinery was an ever-expanding industrial zone of tank farms, distillation units, electrical pylons and cracking plants. It was the preeminent fact of life in Abadan, the one reason why urbanism had come to this salty infertile island in the south-west of Persia. By the late 1940s it had become the largest refinery in the world, with the AIOC's assets in Abadan representing Britain's single most significant overseas investment.[5]

The origins of Abadan must be dated to around 1910. Oil had first been struck in reasonable quantities at Masjid-i-Sulaiman, in the hills of south-west Persia, in 1908. Soon after this the APOC was formed, and by 1911 a pipeline was completed, carrying oil from the wells in the hills 210 kilometres (130 miles) away to the island of Abadan on the Shatt-al-Arab River, some 13 kilometres (8 miles) south of the Persian town of Korramshahr. When the first British oilmen had investigated Abadan in 1909 they discovered that almost all building resources and facilities would have to be imported, including trained artisans, sand, stone and lime, and even, to a great extent, bricks. Effectively a construction industry would have to be created to serve the new oil industry. And in the 1930s Costain, the large contracting and civil engineering firm, began to meet this challenge mainly by importing building materials on a large scale.

By 1910 the refinery had already been established and an area laid out for bungalows. The first building to be erected was an iron structure lined with

wood. The 'first pukka bungalow' followed soon after: a brick building 'constructed in the local style, and having a mat and "chandle" roof, that is, a roof constructed of poles of small diameter placed close together and overlaid with mats (made from date palm leaves) covered with earth'.[6] The upper part of this was used for senior staff, the lower for a general office and dispensary. After a few years this was replaced by 'No. 1 Bungalow', the first building of any permanence in Abadan. Early maps show a simple layout of areas. The refinery, the main reason for making these maps, was represented as a grouping of tanks and other structures spreading out in regular formation from the side of the Shatt-al-Arab. The materials for the plant itself were shipped from Britain. Offices and other works buildings were positioned in the narrow strip between the refinery and the river. Labourers lived in tents and mud huts in the barrack-like 'coolie-lines' located to the south-east. The British 'bungalow area', also known as Braim, bordered the refinery to its north-west.

By the early 1920s Braim had become a subtropical Metroland, a prim suburban estate of low densities. From a sprinkling of buildings an extendable pattern of roads had developed, serving bachelor barracks (built in 1923) and large two-storey dwellings for the more senior officials nearer the river. Typically these buildings countered the heat with thick walls, shutters and wide arcaded verandahs. There were also the beginnings of a set of communal buildings such as the Gymkhana Club, as well as many gardens. Indeed, the establishment of Braim as a green oasis was a major and typically imperial undertaking involving the transportation of materials and extensive labour for irrigation and planting as well as the employment of professional gardeners who had worked at Kew and New Delhi.[7]

'Abadan Town' is first indicated on a map of 1928, a little way to the south-west of the refinery and separated from the older 'coolie-lines' by a newly laid-out park (fig. 3.1). It was established, and seems to have developed, in an ad hoc manner as a high-density concentration both of indigenous elements that pre-existed the refinery and of new dwellings needed to house the labourers working in and around the refinery and inadequately provided for by the company. Contact between the 'town' and Braim was largely made via servant intermediaries. Both residential areas served the refinery but they were also separated by it: the 'bungalow area' spaciously laid out to the north-west in favour of the prevailing winds; the 'town' as a compact yet increasingly stifled area to the south-east, the 'open sore within our operations' as one APOC official described it.[8] The refinery, in-between Braim and the 'town', both was the physical focus of Abadan and, by the nature of residential development, also formed a curtain or cordon sanitaire between these ill-matched twins. There was an almost complete segregation of accommodation, as well as of the use of buses, clubs and cinemas. The function, character, location and materials of three of Abadan's four major built elements had been established from the beginning. The fourth element – the professionally planned layout of residential estates – was to be introduced in the 1930s.

It has been remarked that the British commonly denied any unitary character

3.1 Map of Abadan, 1928

to Abadan. Their view of it was partial, as was that of the non-European labourers, and it was partial both because of the forms of spatial and social segregation in place and because of the unavoidable centrality of the ever-expanding refinery. Vital also to the expatriates' disavowal of Abadan's urbanity, however, was the adoption of the bungalow as the dominant building type in the European area. Anthony King, the bungalow's sociologist–historian, has analysed the diffusion of the bungalow type as symptomatic of the social and spatial division of labour within colonial urban development:

It was part of the built environment of a colonial political economy: the planter's bungalow, part of a system of cash-crop production operated by representatives of a particular culture in which local labour ('natives') lived in self-built huts and managers lived in an evolved culture-specific dwelling form known as a 'bungalow'.[9]

Originally the bungalow had developed as a specialized Anglo-Indian dwelling type in colonial India. With its plantation, or agro-industrial, origins, it had arrived in Britain from the 1890s 'as a cultural model of living in *non-urban*, or *ex-urban* areas'. As it became a suburban dwelling in Anglophone countries, so also, from the last years of the nineteenth century onwards, it was re-exported 'for the managers of mines, railways, plantations, managing British capital and exporting raw material to industrial economies at the core'.[10] Abadan typifies this development, with the proviso that here the plantation model prevailed rather than that of developed industrial production epitomized by the refinery. The logic of location in Abadan was to situate both the managerial/technical elite and the labour power close to the refinery, if at opposite sides of it. Subsequently, as I will show later, bungalow construction took on a mass-producible form through the planning of garden suburb extensions to Abadan, though now a small range of housing types, including the bungalow, were the attempted solution to both elite and labour housing provision.

Company town

From the 1920s when it became a boom town until the final banishment of the AIOC from Persia in 1951, Abadan expanded exponentially, drawing in labour both directly and through subcontractors from south-west Persia, the Persian Gulf and India. By 1950 its population had been swollen by these migrations of international labour to 200,000.[11] Although the 'town' remained nominally under local municipal control, Abadan as a whole might fairly be described as a company town: 'everything here was stamped AIOC'.[12] Most of Abadan was owned and operated by the AIOC, and those parts of it under ostensibly autonomous local control owed their livelihood to the company's activities. As the town developed so the company began to provide patchy educational, transport, health and leisure facilities; even its own traffic police. There was a complete segregation of facilities, 'parallel worlds side by side'.[13] But while the works dominated the site, as with most definable company towns, they were given no symbolic dimension; beyond a functional office building the company felt no necessity to establish architectural representations of the unity of its enterprise centred on the place of industry. Indeed before the 1930s there were no such intended representations anywhere in Abadan. When the company did sponsor such architecture its efforts were trammelled by two factors: on the one hand, the knowledge that while the company's de facto influence in Abadan was predominant, it had, *de jure*, a shared responsibility with the Persian authorities; on the other hand,

the company's development of facilities in Abadan heavily favoured the small European section of its population and indeed its policy towards Abadan as a whole was largely to treat the town as a place divided by race, with Persians regarded as second-class citizens in their own country.

The company's initial policy in Abadan can be situated somewhere between the paternalist ideology of company towns in Britain, like Bourneville, and the absolute power exerted in those company towns that developed following the great mineral rushes in South Africa.[14] Janet Abu-Lughod has called this a 'rent-a-slave' mode of production:

> It was an extra-territorial mining operation. Concessions were held by foreigners who controlled the rate of removal, who supervised the transfer to and the exchange on the world market, and who handled all technical and business operations. A subset of 'natives' provided cheap, unskilled labor as needed. In an enclave economy, it is assumed that profits will be repatriated, that the concession area will be a 'world unto itself', and that there will be little local spillover to affect the indigenous economy.[15]

The drive for production and profit in Abadan was softened by several considerations. First, if Persia was economically weak, industrially undeveloped and militarily vulnerable, it was nevertheless no colonial backyard, and the terms of the company's concession (dating back to the first oil exploration in 1901), although highly favourable, were still a negotiated privilege (following a long quarrel, the terms were renegotiated in 1933 to stipulate welfare provision). Second, the Europeans who worked in Abadan were employed for their high level of managerial expertise or specialist technical skills. For them the attractions of living in Abadan were a combination of relatively generous levels of pay, good recreational facilities and a culturally contained colonial way of life – the 'colonial third culture' – connected in its habits and beliefs with white societies across the empire.[16] To the mores of a cocooned yet spacious middle-class life were added the odd token of Persian culture. But more evident were the environmental adaptations and language of Anglo-India: there were memsahibs and sahibs, tiffin and chota-hazry, godowns, ayahs and punkahs.

While the company acted as a combination of welfare state and British Raj for its European employees – *imperium in imperio* as one observer put it[17] – its responsibilities for the huge majority of its non-European employees were based on less substantial expectations on both sides, and were a regular matter for bargaining with the Persian government. Insofar as a social order was defined for the non-Europeans beyond a tiny Persian technical elite, it was centred on the labour disciplines deemed necessary for the transformation of large numbers of rural people into an industrial proletariat, and the company-imposed rules that followed on from accepting the privileges of health care, education and housing. This situation served the company reasonably well, but the best expression of its peculiar imbalance of resources and rewards can be seen in the development of urban space and housing form in Abadan. The company's resources were directed in favour of the construction of housing and other facilities for its senior staff. Housing,

like the company's employees, was divided into three classes: fully furnished accommodation for British staff and the few senior Persians; partly furnished accommodation for non-European junior staff; and unfurnished facilities for wage-earning labour.[18] In the early years senior staff housing predominated, and housing for labour and often even junior staff was left as a matter for the market or the municipality.[19] There was also a fourth class: the large numbers of contract labourers who were not regarded by the company as its responsibility and lived in shanty towns like Kaghazabad on the edges of company and municipal areas. In effect, though there was little formal segregation, racial segregation was exerted through zoning of residence. Later, even when this policy was bitterly attacked by the Persian government, the company's investment in housing schemes was still modest relative to the size of the problem. By the end of the Second World War there were 65,461 AIOC employees in Abadan, only 2357 of whom were British.[20] Even as late as 1948 new senior-staff housing was still as high as half the total for both junior staff and labour together, and by 1951 only 18.5 per cent of labour lived in company quarters.[21] The company defended its policy as one geared to produce a good general quality of housing rather than a rapid production of quantity.[22] 'Quality' here may be taken to stand for a culturally-specific set of values objectified in the form of excessive spending on modern ancillary infrastructure (electricity, sewers, roads and, for some, air conditioning) at the expense of realistic housing solutions for the swollen and stifled non-European areas. The company's propaganda machine favoured these items, and especially the provision of sports facilities, medical services and education, though in fact the latter two were nowhere near adequate.[23]

Projecting the company in London

I want to turn now from considering the dynamic of urban development in Abadan briefly to consider the APOC's contemporary image in Britain. There are two obvious architectural sources for this: the APOC Pavilion designed by Sir Charles Allom for the British Empire Exhibition, Wembley, in 1924–5 and the APOC headquarters building, Britannic House, completed in 1924 to the designs of Edwin Lutyens. Together these buildings may be taken to represent the spectrum of values and activities with which the company wanted to be associated.

The APOC Pavilion was described as a *khan*, or wayside hotel, and contained within it an exhibit showing the processes and stages involved in the refining of oil (fig. 3.2). Clearly a pavilion such as this, like the other commercial pavilions in the exhibition, was intended as a piece of public relations: it was 'dignified and attractive', in the company's view, '[to impress] on the popular mind the unique and most important role [the company] plays in the oil resources of the empire'.[24] One way of understanding this pavilion, as with Britannic House, is to see it as part of an ideology of gentlemanly authority and tradition. Here was a business,

3.2 APOC Pavilion, Empire Exhibition, Wembley (Sir Charles Allom, 1924).
 Naft-i-Iran, July 1924

responsible for the relocation of tens of thousands of people across the
Persian Gulf and the Indian subcontinent, as well as the extraction of oil
using the most modern mining and refining processes, content to present
itself via a pastiche of a medieval Persian building. But to associate a Persian
khan with this enterprise was to reassure the British public that modernity
and a distinct and essentially traditional society could co-exist. As there was
no exhibitable commodity – oil drums clearly not coming into this category –
what was displayed instead was a spectacle of the technology of production.
And this spectacle itself was housed in a building type and style that were
signalled to its visitors as associated with the nomadic hospitality of the
desert.

A different form of disavowal can be found in Britannic House in the mid-
1920s, one of the two largest commercial developments in the City of
London (fig. 3.3). We have already seen in Chapter 1 how the notion of
London as 'heart of empire' depended upon the deployment of certain
forms of architectural order and their association with both modernity and
the Roman Empire. Rather than the triumphal procession of Admiralty Arch
or the secular temple of Bush House, Britannic House evoked a baroque

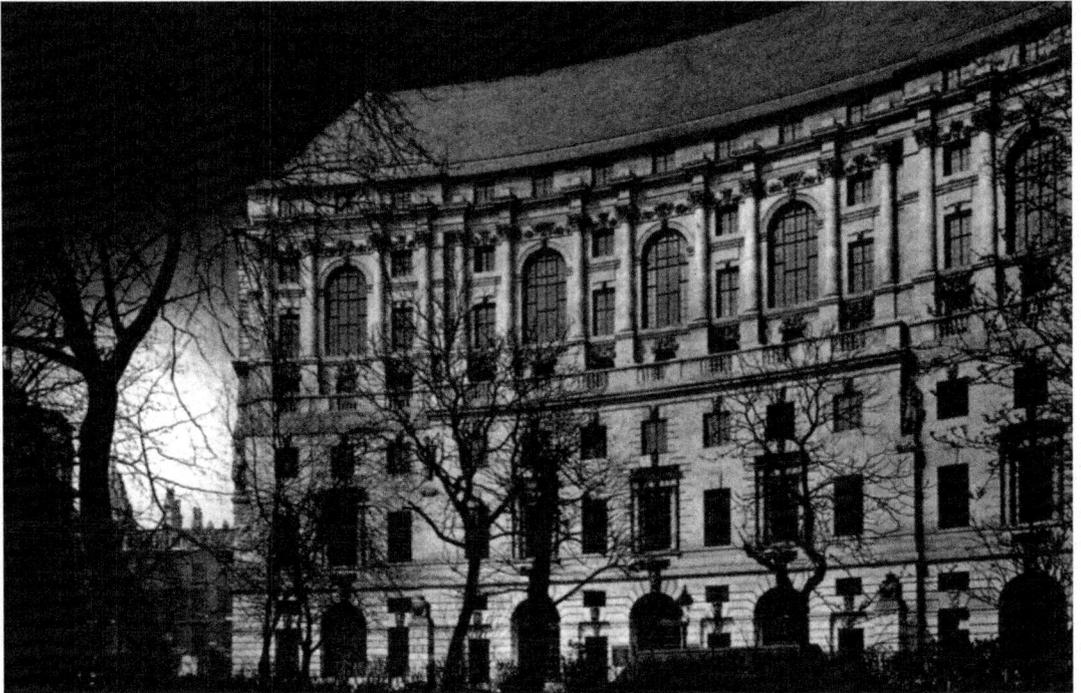

3.3 Britannic House, London (Sir Edwin Lutyens, 1924). *Architectural Review*, May
1925

palace: '[it] is a palace upon a dainty cliff, and from its arched windows aloft
you feel that the great lords of oil may step forth and throw from the
balconies largesse to the crowds below'.[25] This impression is created on the
main curving front by devoting most of the architectural attention to the top
floors, which are made to seem even more lofty by Lutyens's device of
setting the building back progressively from the front plane as it rises. These
top floors are emphasized with double-height arches, an attached
Corinthian order, and rich sculptural decoration. Inside, they are reached by
a sequence of barrel-vaulted staircases like the staircases in the Viceroy's
House, surfaced with marble and light-coloured Brescia stone. This grand
and dramatic ascent leads to the directors' rooms, the board room and the
chairman's room on the top floors, and these are not so much offices as state
rooms, spaces where the occupants might think themselves as much
ministers in a government department as princes of industry. This sense of
lofty authority, of great affairs happening well above the street, would have
been taken even further had Lutyens's scheme for a sixteen-storey tower
with a concave hemicycle front been realized.[26] The completed sculptural
decoration represents the seasons, the continents, the monarchy and the
peoples of the empire (fig. 3.4), and includes an Indian water carrier and a
dancing girl abutting the central section of the main front, which echo the
figures of Britannia on the corners of the subsidiary façade.[27] But this

3.4 Britannic House, sculpture. *APOC Magazine*, July 1925

sculptural programme is a kind of false consciousness: it alludes to the company's global reach and the peoples that depend on it but it makes no direct reference to where the wealth that funds a building like this comes from, and the facts of industry and industriousness both in the building and in the company that it represents are entirely absent.

The longest contemporary review of Britannic House can be found in the company's own journal, the *APOC Magazine*. Illustrated with twenty photographs, ranging from sculptural details to views of offices and the boiler room, the magazine presented the building as 'the company's new home' in the context of articles on visits to Persia and Argentina, motor racing and rugby matches. 'A great company', the article asserted, 'is ... a great family', and familial pride would be inspired by this new building as a symbol of the power and wealth of the collective and of its part in a larger collective: the nation.[28] The article quotes and 'translates' the views of architectural writers for the APOC employees, and what this does is to enable an understanding of the building as a metaphor for the company. Britannic House is a combination of beauty, exemplary business practice and utility, but above all it is a manifestation of high intelligence organizing the building and its technologies (even making astute deals in the purchase of materials), and of concentrated manual skill carrying out specialized tasks and ornamenting the product. The building is a highly efficient machine but one that is also finely tuned to its occupants' needs: twenty-eight telephone exchange lines serve communication, 250 clocks are synchronized by a master clock, a thousand radiators heat the building and a thousand cups of

tea slake the employees' thirst. This intelligence, prudence and skill is in the very nature of the company, the article intimates, and the building is the exemplification of its larger purpose.

Designing Abadan

The professional design skills that had moulded the company's architectural image in London were not considered necessary in Abadan for nearly another decade. The moment when these skills were first introduced into Abadan can also be seen as the moment when the company, under pressure from both Persian nationalists and the British government, augmented its efforts to ensure political stability and to offset the disruption consequent upon rapid social and industrial change. These efforts included, after the 1933 Concession, the greater 'Iranianization' of the workforce and the training of a small but regular number of Persians in Britain,[29] and the provision of schools, hospitals and other modern facilities. There also seems to have been some implicit recognition by the company of the need for a new propaganda through architecture and urbanism. The architect who was given this job, which involved an extraordinary responsibility for town-planning schemes as well as large numbers of buildings in Abadan and elsewhere, is hardly known today.

James Mollison Wilson was one half of the partnership that went on to design Baghdad Railway Station and, as we saw in the last chapter, he was one of a number of young architects who were given considerable scope for their professional skills in the British Empire, particularly in the 'bargain basement' of the Middle East after the First World War.[30] Following war service in the Middle East, Wilson had stayed on in the newly mandated territory of Iraq, first organizing the PWD and then, from 1920 to 1926, acting as its director of public works. The guiding experience that Wilson brought to these jobs, apart from his obvious presence on the spot as part of an occupying army, was his work as an assistant to Lutyens at New Delhi from 1913 to 1916, responsible for site administration and detail drawings.[31] From 1935 he partnered Harold C. Mason but most of the new firm's work for the APOC seems to have been designed by Wilson (rather belatedly, in 1944 he was formally recognized as the company architect). In fact Wilson had received commissions from the company since 1927, the work rapidly mushrooming in the 1930s from the design of individual buildings to the planning of new large residential areas especially for Abadan but also in other company areas at Masjid-i-Sulaiman, Agha Jari, Gach Saran, Kermanshah and Bandar Mashur. In addition he produced town plans for the Iraq Petroleum Company at Arrapha, Kirkuk, and for the Kuwait Oil Company at Ahmadi; both companies were jointly owned subsidiaries of the APOC and funded by its Persian profits.[32] According to the categories that Robert Home has devised for architect/planners in the colonies, Wilson was neither in colonial service (like W. H. McLean) nor a 'peripatetic

propagandist' (like Patrick Geddes or Charles Reade). Rather he fitted the type embodied by H. V. Lanchester in India or Albert Thompson in Nigeria: 'a consultant architect brought out either for specific assignments or longer periods'.[33] The use of such consultants was typical of areas under indirect rule, and especially for mining, railway and administrative towns in less urbanized parts of the empire.[34]

Before Wilson's arrival on the scene, the town's more substantial buildings were built by company engineers usually employing a serviceable formula of arcaded verandahs surrounding brick structures or steel-girdered godowns (warehouses).[35] In Persia Wilson developed a distinct architectural language that sought a middle line between Britannic House and the APOC Pavilion at the British Empire Exhibition, Wembley. Wilson had shown in his APOC offices in Tehran (1930–1) that he was quite capable of working regional details into his designs when the urban context was a matter of delicate political association (fig. 3.5).[36] Here the offices stood in a central location between the Customs and Postal Building and the National Museum and near the arch built in 1922 to commemorate the reorganization of the Persian army. Wilson developed a 'Mohammedan Persian Renaissance style' to meet these contextual demands.[37] The façade consisted both of a range of square columns and of two end pavilions evoking Islamic precedents in their tile decoration and pointed arches. But elsewhere, as we will see with the Abadan Technical Institute but especially in his Abadan housing, Wilson generally adapted his classicism to absorb more abstracted versions of local styles. This

3.5 APOC Tehran offices (James Mollison Wilson, 1930–1). *APOC Magazine*, March 1932

was characterized, throughout all grades of housing and whether for one- or two-storey bungalows, by flat roofs, uninflected *chajjas*, courtyards at the rear for Persian accommodation, deep-set clerestories for ventilation, small but telling variations in the laying of brickwork, and, surprisingly often at least in the lower-grade housing, an absence of verandahs (fig. 3.6). Occasionally, as in the tower houses at Bawarda or the Dutch-style houses that faced onto its garden circles, or even the barn-like stepped gables of some artisan housing in Bahmashir, Wilson deployed other housing types or styles at strategic points in his urban layout.

The planned new areas in Abadan were to be treated as dormitory estates effecting the dispersal and discipline of social pathologies. In origin and intention these estates go back to the late 1920s when the company devised a scheme to answer the threat of social disorder posed by the overcrowded 'town'. This pressure-cooker effect, with the 'town' inhibited from expanding in most directions, inevitably calls to mind what happened to both the Indian areas of the old city of Delhi and the medinas in North African towns like Rabat and Casablanca.[38] The planned solution in Abadan would take the form of:

3.6 Housing at Bahmashir, Abadan (James Mollison Wilson, *c.* 1938)

nuclei of small townships in several (four or five) distinct areas, well separated from one another, and on Company leased in preference to State ground. A small township is more easily and efficiently controlled than a large one ... Being far removed from the present town, [political] activities within the latter will gradually wither.[39]

It is quite clear, then, that professional planning and design skills were part of the company's new policies of dissuasion and dispersal by which it wished to continue its 'powerful hold' over its non-British labour.[40] Only belatedly did Wilson or the company even begin to realize that these problems required a regional planning vision and by then they either lacked the will or were too far out of step with the Persian government to seek such a solution.[41]

By the late 1940s Abadan's new estates were being laid out and constructed all over the island, filling the space between the two waterways, but assuming motorization and thus forcing a dependence upon company bus transportation into the refinery. There was no overall scheme to link up these estates, indeed their patchwork placement across the island seemed to imply that Abadan could develop additively, piece-by-piece across the desert as needs and resources arose. For non-European staff Segoush-i-Braim and Amirabad were newly planned and located to the north and Bawarda-i-Shemali to the south. For non-European labour, Bahar and Ferahabad were sited beside the Bahmashir River; Ahmedabad and Bahmashir just east of the town; and Jamshid to the south-east. To the north-west an extension of Braim was laid out for European staff. All of these areas, apart from Jamshid and Ahmedabad, took a garden suburb form with grandiose road layouts, and all apart from Ahmedabad (built by the Karun Engineering Company for the municipality) were designed by Wilson using a variety of different house types, sizes and styles.

But the first planned estate in Abadan remains the most interesting demonstration of Wilson's and the company's attitudes towards the whole town. In 1934 Wilson presented a report on Abadan together with a design for a new housing development at Bawarda, on the other side of the bazaar from the refinery (fig. 3.7). 'Since the War', Wilson reported, 'a very great and widespread spirit of Nationalism has been introduced and fostered throughout the Middle East ... Though the Company probably incurs less of this [jealousy] than the political services do elsewhere, it must introduce measures to meet it.'[42] If the new concession of 1933 was one such measure then housing was to be another. Wilson pointed particularly to the disparities in housing provision as contributing most to the dangerous divide between the Persian and British employees. He proposed to meet this problem with a new residential area, to create Bawarda as a kind of model environment of racial harmony, an experiment in non-segregation whose very design would 'afford that link or bridge over the present gulf between these two groups of individuals'.[43]

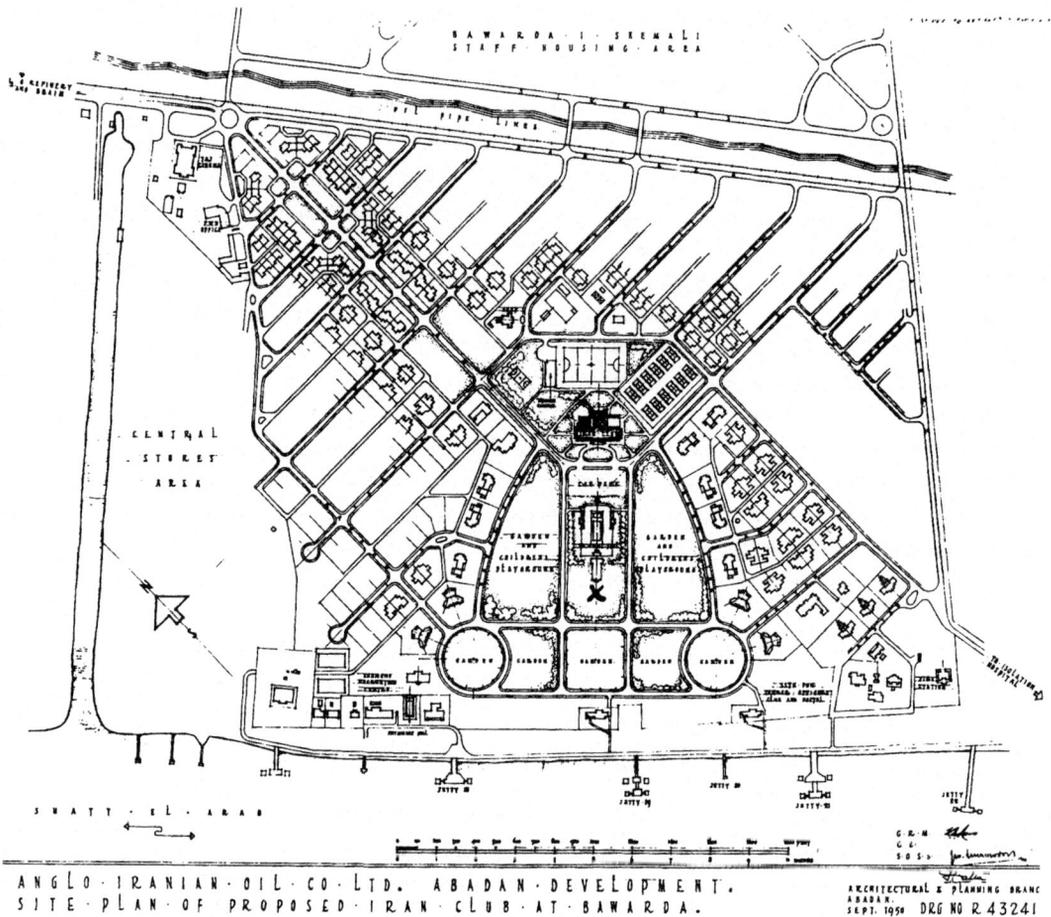

3.7 Bawarda, Abadan (James Mollison Wilson, 1950)

Garden suburb

Bawarda's primary inspiration was Lutyens's remodelling of the garden city
and city beautiful ideas at New Delhi. Lutyens had already been party to a
mutant form of Ebenezer Howard's original garden city idea in the garden
suburb at Hampstead. Here Howard's central concepts of new satellite
towns, surrounded by rural belts, combining the best of urban and rural
values, self-managed and self-governed, and elevating the pursuit of 'health,
light and air' above other communal imperatives, were already betrayed. At
New Delhi Wilson would have seen and participated in a further
mistranslation of the original, one where, as we have seen in Chapter 1, the
garden city was married to an unlikely partner in the modern American
version of the baroque city: the city beautiful. By the 1930s the garden city
was a well-established international planning model. Howard's
internationalist aspirations had been smoothly realized in various national

and international garden city associations, conferences and journals, and garden cities and garden suburbs could be found worldwide, not only in British imperial possessions but also in the USA, Japan, Europe and Australia. But with its widespread influence so an increasingly amorphous, open-ended group of socio-political aims and aesthetic forms had come to dilute Howard's prototype. New Delhi was also Stanley Adshead's model at Lusaka (from 1931 onwards) in Northern Rhodesia. Here garden city concepts guided the functional planning of the new capital city into zones but failed to cater for the African labour force upon which the city depended.[44] Like Wilson, Adshead worked with three classes of housing and spread his low-density European bungalow estates expansively and somewhat incoherently across the land. In Haifa and elsewhere in Palestine, garden cities were established to forward the aims of Zionist colonization. Such Levantine cities avoided the Arts and Crafts forms associated with their original inspiration in Britain in favour of German modernism.[45]

In using the garden city as his model Wilson was, in part, returning to one of its original ideas as an engine of social harmony. He may have been reminded of Raymond Unwin and Barry Parker's garden city ideals by Braim's clubby, vigorously outdoor life and relaxed low densities. But as Robert Home has pointed out, 'a major conflict of philosophy existed between the garden city ideal of efficient, harmonious communal living and the segregation principles upon which colonial rule relied'.[46] For a brief moment in late imperialism, it seems, Wilson was attempting to resolve this conflict in his planning for Abadan.

At Bawarda Wilson proposed and then laid out a showcase vision of company paternalism, a model if necessarily fragmented addition to the town that was intended to present an architectural solution to perceived injustices, a propaganda of benevolent intentions. The area was already defined on all four sides by the Shatt-al-Arab to the south-west, a creek to the north-west, oil pipelines to the north-east, and a road and tank farm to the south-east. In effect these formed a kind of cordon sanitaire around Bawarda, helping particularly, as Wilson observed, to prevent the 'risk' of the town 'overflowing' into the new area.[47] Its crucial orientation was to the north-east where the road running parallel to the pipelines led out past the 'town' and refinery to Braim, the British bungalow area. Wilson established a new axis leading from this point diagonally across to the centre of the area. He marked this junction point with the 'town', as Lutyens had used Connaught Place to mark the transition from old to New Delhi, with a scaled-down *rond-point* (fig. 3.8). Furthermore, the entry point significance of this junction – this was the only road into Bawarda – was also indicated by locating the Taj Cinema (completed in 1939) beside it and by creating a gateway effect through the location of tower houses at the beginning of the new diagonal road. The tower houses and many of the other houses were distinguished by their cubical silhouettes, their gestures at a regional approach that included high-ceilinged rooms and flat roofs with belvederes, and an Art Deco attitude to detail which enabled them to encompass decorative tile work and brick

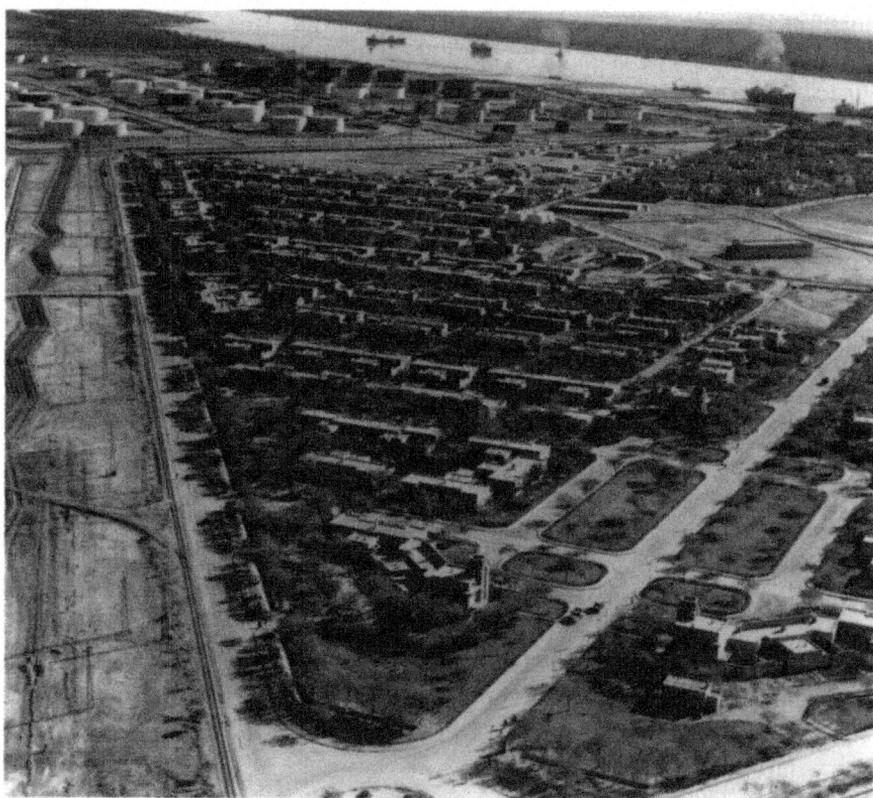

3.8 Bawarda, Abadan (James Mollison Wilson, *c.* 1950)

detailing as well as highly simplified *chajjas* and porches. The steel-framed Taj Cinema formalized its relation to the 'gateway' into Bawarda by the use of four externalized Corbusier-like concrete ribs, clasping the front of the building and shading its foyer space. The other residential roads were laid out running east–west at right-angles to this diagonal axis, with housing initially of three types and placed within generous gardens and other markers of open space. Differentiation between European and Persian housing would be made by size of sites rather than their location.[48] In the centre and shielding Bawarda from the Shatt-al-Arab, Wilson located gardens, playgrounds and sportsgrounds, all arranged symmetrically but at forty-five degrees to the main axis. A triangular circuit of gently curving roads and circuses marked out this garden area. Intended for senior Persian staff, large 'Dutch'-style houses with gables faced onto these circuses (fig. 3.9), part of a deliberate policy of introducing greater variety into house styles and types perhaps partly to counter the effect of one architect designing everything.[49]

Bawarda's most curious feature, especially by comparison with New Delhi and Hampstead, was the absence of any climactic focus in the form of monumental buildings and, consequently, no overt public meaning to its

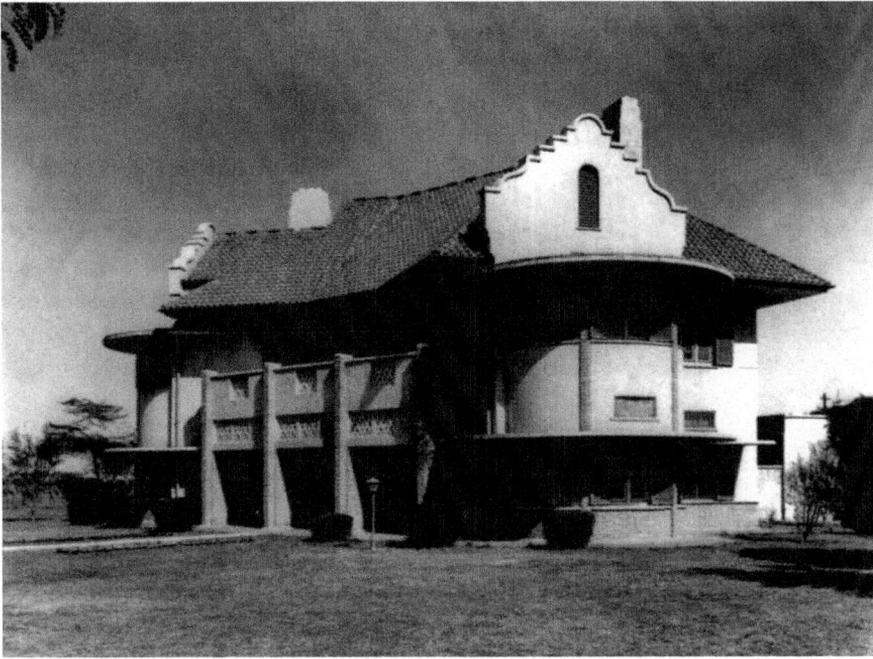

3.9 House at Bawarda, Abadan (James Mollison Wilson, late 1940s)

processional routes, no visible authority or embodiment of community. Bawarda's baroque spatial gymnastics and portentous symmetries closed on no consummating institutions but merely a hopefully significant space. Genealogically, the *ronds-points* of Versailles had become circular gardens or slow-turning roundabouts. No apparent reason would exist for Bawarda's symmetries until in 1950 Wilson proposed placing a new Persia Club (for Persian clerical staff) at the junction of the main diagonal and the area of gardens. Belatedly, Wilson had borrowed this idea, via Hampstead, from the garden village, New Earswick, and even perhaps the earliest garden suburb, Bedford Park. But, significantly, the siting of social and public buildings, insofar as they were needed at Bawarda, had played no part in the planning of the estate.[50] The Abadan Technical Institute, placed to the north-east and beyond the pipelines, was designed by Wilson in 1938 after Bawarda had been laid out (fig. 3.10). The Institute was established to train Persians to fill graded posts and quickly established itself as one of the foremost educational institutions in the country.[51] It was laid out as four blocks linked to a main administration block by covered walkways. Its clock tower, an elegant monument to the new temporal disciplines, would have been visible for some distance, yet the Institute seems to have been deliberately misaligned with Bawarda's garden axis. Inevitably, this nearly-but-not-quite alignment evokes those monuments of past Indian empires that New Delhi's axes pointed to but often, by virtue of geometric priorities, just missed.

Wilson intended there to be no planned differentiation in terms of sites

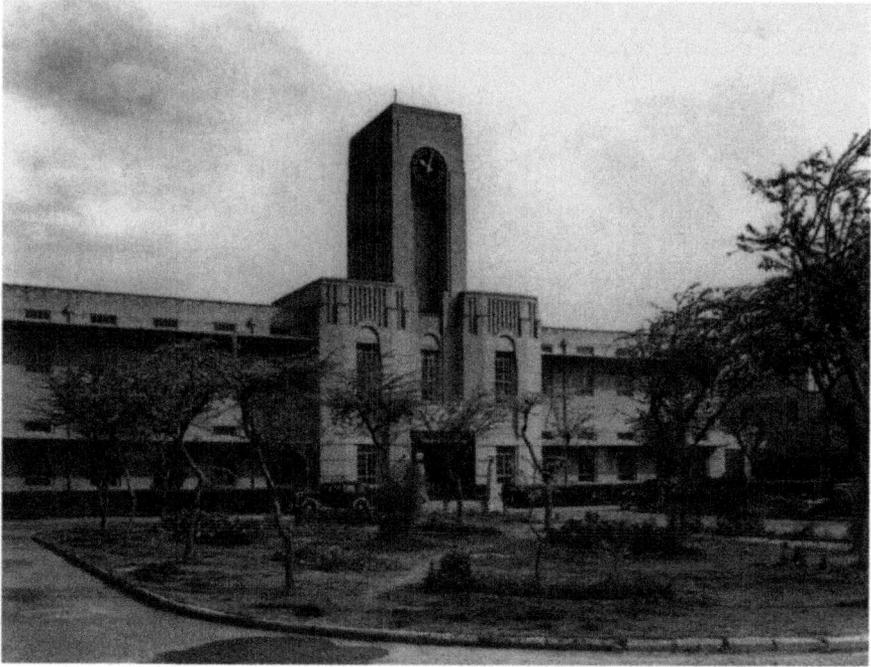

3.10 Abadan Technical Institute, Abadan (James Mollison Wilson, 1938)

between European and Persian residences. He designed three house types to cater for the three classes of employees intended to be housed in Bawarda.[52] Of these a high proportion were intended for middle grades of married Persians. But in fact the only Persians who lived in Bawarda were those few, generally educated in British universities, who had attained senior positions in the Abadan hierarchy and become part of the company's 'great machine'.[53] The reason for this, according to the skewed logic of one of the company's managing directors, was that 'in order to popularise the Bawarda area amongst senior Persians we purposely allocated accommodation built for the Persians to married British staff'.[54] Wilson assumed that any Persian living in Bawarda would desire British conventions of domestic life: 'In all my considerations on this matter', he wrote, 'I have assumed that the purdah system will be abandoned and the houses in the new area will be designed along the lines of a European house with such modification as climatic conditions impose.'[55] Persians would have to be Europeanized before they could live in Bawarda. In any case, the unreformed points system, by which company housing was allocated largely by seniority rather than longevity of service or basic rate of pay,[56] continued to ensure an implicit apartheid with a few token exceptions.

Bawarda never exerted the miraculous powers that Wilson had imagined for it. In 1951, at the same time as the Festival of Britain was celebrating Britain's postwar welfarist consensus, Dr Muhammad Mussadiq's Persian nationalist

movement boiled over, demanding democracy and national control of the oil industry. The 1933 agreement was annulled, and Bawarda's British citizens were cut off for some time from their co-nationals in Braim by groups of protestors coming from the 'town' and rioting around its symbolic entry point at the Taj Cinema.[57] The existence of some senior Persian staff living in the same development as their British counterparts was now manifestly an insufficient token of the company's good intentions. In fact the very spaciousness of the plots in Bawarda and its generous and largely redundant road provision could only be provocative to Persians still living in tents and huts, in the overcrowded 'town' or in the shacks of shanty towns like Kaghazabad.[58] In the face of potential violence, the company, without military support from the Labour Government in Britain, could hardly trust to the allegiance of the Persian army. Its withdrawal from Abadan in 1951 drew to an end forty years of exclusive oil exploitation in south-west Persia. In this time Abadan had become one of the most important towns in the production of oil globally. An empire within an empire was now transformed in Persia first into a nationalized industry and then into part of an international consortium. For the company, however, expulsion from Persia was only the spur to renewed oil exploration in the Persian Gulf and elsewhere – so much so that the years from 1955 to 1965 have often been referred to as the company's 'golden decade'. Nor did British architectural work for the oil industry in Persia cease – in 1959 Fry, Drew & Partners designed the new town of Gach Saran for the consortium. Wilson also returned to work in Persia for the consortium, but for political reasons it was felt that a joint practice should be established with a Persian architect. Ironically, it was with Aziz Farmanfarmaian, Manucher's brother, that an association was formed in 1958 under the name Wilmafar.[59]

A half-century after the expulsion of the British, Braim and Bawarda seem marginal and destined to fade away. This is partly because of the Iran–Iraq war in the 1980s when much of the island was subjected to Iraqi artillery fire, but more fundamentally – at a time when the construction industry is booming in the area and when the 'town' itself is modernized and well cared for – the housing in Braim and Bawarda is simply unpopular. Many residences are unoccupied and others neglected; they seem either not to fit local styles of living or to have been bypassed by newer urban requirements.[60]

The national pavilion: 'A Building Which Needs No Name'

Ever since the Great Exhibition of 1851, international exhibitions have made some claim to represent the world, whatever the exclusions and different emphases there might be in that claim. Architecture played a fundamental role in this, either in the form of an all-encompassing single exhibition hall sheltering the world's goods (as at the Crystal Palace or in Paris in 1855) or in the form of a range of smaller structures housing a compartmentalized résumé of the world's cultural and economic production (as in Paris in 1867 and 1889). These latter came to be called national pavilions and, whether they were in the hands of autonomous national governments, administered by colonial regimes or directed from an imperial centre, they took on the role of displaying what was indigenous and characteristic as an integral aspect of what was international or encyclopedic or even universal. This is by now a familiar theme in this book but in this chapter it is treated by pursuing this very particular building type through a sequence of exhibitions held between the wars.

The idea of the national pavilion derived from an innovation introduced in 1855: 'a government-built structure separate from the rest of the exhibition housing much of the imperial produce, as well as providing a centre for dignatories to gather'.[1] Such structures were laid out in relation to the main building and in arrangements and sequences that were understood to have significance. Occupying a prime position, standing beside or facing a pavilion of comparable status, relegated to the periphery or a minor route – all these would proclaim the nation's relative importance. Likewise the form and style of the pavilion: whether it was a historic style taken to be characteristic of the culture, a classical building that affirmed the nation's aspirations or a new approach that might imply change and modernizing ambitions.

This chapter looks at a group of British national pavilions that were designed for major international or colonial exhibitions between the two world wars: notably those at Wembley (1924–5), Paris (1925 and 1937), Antwerp (1930), Johannesburg (1936) and Glasgow (1938).[2] The concern is therefore with a certain genre of exhibition pavilion and, within that, in the

pavilions of one nation. Accordingly, the emphasis is on what could be called an overt form of imperial self-representation, rather than the representation of others, and it was a self-representation aimed at national publics, colonial elites and other imperialist powers.[3] The chapter examines the contesting claims made within these pavilions, and in their relationship with other national pavilions and the layout of exhibitions as a whole, for an architecture of what came to be called 'national projection'.

There were various and variously discrepant interests invested in defining imperial identity between the wars, but two important groupings can be distinguished: those concerned with the durability of the weld between nation and empire, and those that felt a new alliance might be made between national projection and the emerging forms of modernism. It would seem, looking across these interwar government pavilions, that they progressively re-articulate Britain's image from imperial centre to an island member of a family of democratic nations. But perhaps the story is more complex than this. For instance, in one of the principal focuses of the chapter, the British Pavilion at the 1937 Paris International Exhibition, the building was an ambivalent and controversial response to the prestige and politically charged polemics of the moment. Was it and its displays 'comely, pleasant … a liberal conspectus of our English life', or was there 'nothing distinctly British about it', a building which 'might be anywhere, a riding school, an aerodrome, or a factory on or off the Great West Road'? And what had happened to the image of Britain as imperial centre? Where could that be found in the geometric white walls of the building or the various displays within it?

Wembley, 1924–5

The exhibition that opened at Wembley in 1924, and was extended into 1925, was as much an act of reaffirmed self-belief and renewal as it was a triumphalist demonstration of a nation victorious in war and an empire now at its territorial peak. It was also an economic bid, a promotion of emigration and trade, and one of the first media events.[4] Most visitors, if we take the published reviews as a guide, were eventually convinced by the exhibition's effects. Walter Bennington, critic of the *Architectural Review*, voiced his doubts before finding them groundless: 'Was not Wembley a mere ebullition of jingoism, in dreadful contrast to the dire starkness of the war, an exhibition of megalomania inflated by impossible promises and sustained by pinchbeck purposes?' But after his visit Bennington was exhilarated: 'Wembley is a great place, the abode of a great idea.'[5] So what was this great idea and where was it to be found?

Many visitors to Wembley travelled on the Metropolitan Railway and arrived at the newly built Wembley Park Station just outside the north entrance to the exhibition grounds (fig. 4.1). This was the grandest entry. From here beyond a large semi-circular formal garden they would see the

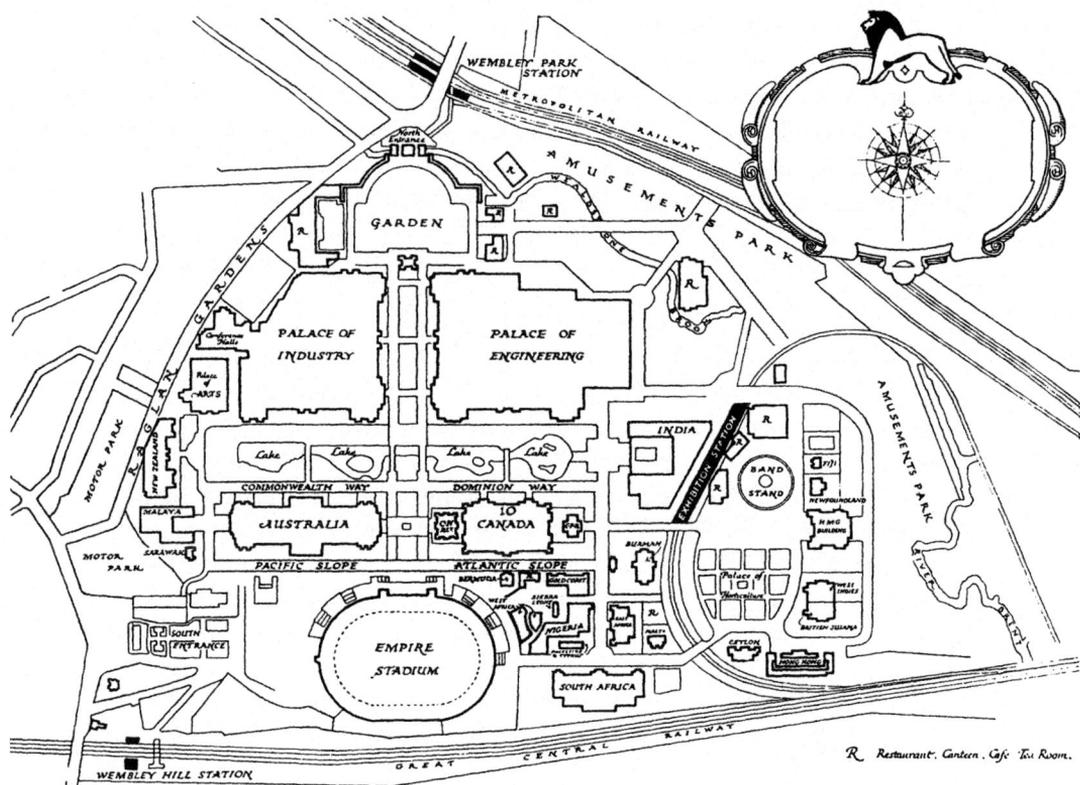

4.1 Empire Exhibition, Wembley – plan (1924). *Architectural Review*, June 1924

parallel paths of King's Way stretching southwards eight hundred metres (half a mile) to the twin domed towers of the Empire Stadium. For its first 300 metres this path was flanked by the huge low concrete Palace of Engineering and the Palace of Industry, the main exhibition halls for British displays – more hangars than palaces. The size of these exhibition halls and the distances between parts of the exhibition (see plate IV) are significant; an imperial scale was established, the scale if not of New Delhi then at least The Mall. Crossing this axis either side of a serpentine lake were two other paths, the Fairway of the Five Nations and the Commonwealth Way, which became Dominion Way to the east. The central position in the exhibition grounds, then, was Unity Bridge. From here the visitor could look south of the lake to the Canadian and Australian pavilions and the Empire Stadium, westwards to the New Zealand Pavilion that faced down the lake and eastwards to the Indian Pavilion that returned its gaze. A host of other pavilions could be glimpsed: Malaya to the south-west, the Palace of Arts to the north-west, and Burma and perhaps South Africa and a number of other colonial pavilions to the south-east. The huge diversity of status in the empire – dominions, crown colonies, protectorates, mandates, naval bases – were thus brought together, transformed from a ragbag of bits and pieces, to an

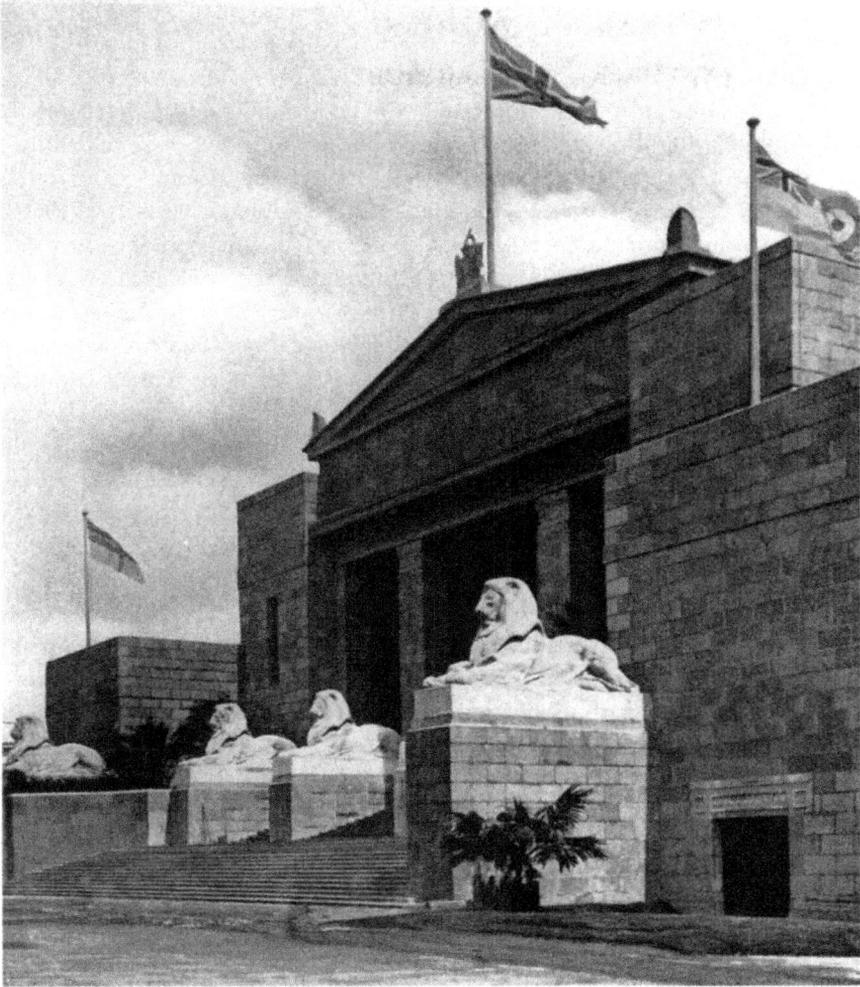

4.2 Government Pavilion, Empire Exhibition, Wembley (1924). *Architectural Review*, June 1924

apparent order, a world bound together under one nation. Here was Wembley's 'great idea'.

But there was one notable building that could certainly not be seen from this central point; this was the British Government Pavilion (fig. 4.2). To find this the visitor would have to walk eastwards along Dominion Way, turn right at its end along Imperial Way, take the first left down Chittagong Road and continue for another 300 metres past a bandstand on the left and the Palace of Horticulture on the right before arriving in front of the government's own pavilion, itself flanked by the Newfoundland Pavilion and the combined pavilion for West Indies and British Guiana. This was certainly not the location suggested by the official guide, whose cover represented the Government Pavilion in front of the domes and minarets of the Indian

Pavilion. Nor was the location consonant with the amount of coverage that the pavilion received.[6]

Professor Patrick Abercrombie, chair of Liverpool's Department of Civic Design, was one prominent commentator who found the placement of the Government Pavilion baffling. Abercrombie regarded the exhibition planning as a 'symbolical lay-out' – it would 'typify the empire' – and in that much he agreed with those guidebooks that claimed it was 'the British Empire in miniature' and would make London a 'microcosm of the world'.[7] But Abercrombie's appreciation of this typifying quality was laced with irony for the parallelism he perceived was with an empire that might have a great idea but this was smothered by a 'mist of illogicalities, anachronisms, and haphazards'.[8] Thus for Abercrombie the great idea was the avenue flanked by the palaces of industry and engineering and leading to the new national stadium as realizing 'the end and object of all the business activity of the Empire ... outdoor sport and games'. But intrusions occurred – the pavilions for Lloyds Bank and *The Times* inappropriately located on the central way, which in turn reminded Abercrombie of the inscription for Bass beer over the gateway to the northern entrance ('this antithesis of "abandon hope all ye who enter here"'). The exhibition sinned against architectural decorum: on the one hand were the exhibition buildings, 'concrete, frank and grim, suggesting an iron inflexibility of purpose', on the other were the 'fussy kiosks' dotted about, the loose plan, and the 'intrusion of the pavilions of national (and, therefore, architecturally discordant) architecture into every view'.[9] And what could be more symptomatic of this than the fact that in the backwaters to the south-east, where 'all logical planning is thrown to the winds', might be found the Government Pavilion? Instead of being the focus of the whole exhibition, this pavilion's severity of appearance was surrounded by frippery: 'to the left all is gaiety, a bandstand and eating-houses of differing degrees of delicacy; to the right, in the midst of the beds of the horticultural section, rises the graceful pavilion of Messrs. Crosse and Blackwell'.[10] Other commentators understood this position in a more literal-minded way. 'Nothing could be more suggestive', wrote one, 'more consonant with the whole history of this British Empire than the modest aside of position ... the same unobtrusive position as the Crown has in the Constitution, detached, retired, and yet the key to all.'[11] Nevertheless there is a kind of accord between these readings: whether it resulted from haphazard deflation or modest withdrawal this was not a commanding position and it needed explanation.

For all that its position might have baffled, the Government Pavilion in itself seems to have struck the right notes, even if praise was respectful rather than fulsome. Designed by J. W. Simpson and Maxwell Ayrton, the main exhibition architects, outwardly it used the same vocabulary of a heavy and simplified classicism carried out in concrete as the Palace of Engineering and the Palace of Industry, and to this it added six concrete lions guarding the main entrance. The pavilion had two storeys, with the front of the upper storey given over for royal state apartments. It was intended to evoke dignity

and 'austere beauty' in pointed and planned contrast, it was claimed, despite Abercrombie's comments, with the 'decorative Oriental pavilions'.[12] The ideal visiting experience was described in the official guidebook:

The visitor enters the building by a flight of steps with splendid sweep and easy majestic ascent, between huge symbolic lions ... The interior gives an impression of grave strength, a grey severity slashed with gorgeous colour notes. The piers and walls of naked concrete are grim and huge, and in the red and gold splashed on beam and ceiling there is something of the splendour of the ancient buildings of Assyria and Egypt.[13]

Several of the pavilion's display concepts were adopted by other British national pavilions between the wars. Essentially it was a space where efficiency of administration, solidity of tradition, and imperial interconnectedness were displayed and promoted, and these were arranged, broadly speaking, in concentric zones. In the middle, in a well lit by a stained-glass roof, was a Court of Honour housing a large relief map of the world with 'tiny ships ploughing their way through real water on all the trade routes of the Empire' (fig. 4.3).[14] On the balustrade surrounding the well were hung banners embroidered with the arms of the dominions and colonies, as well as the royal arms, and around it were placed figures in armour,

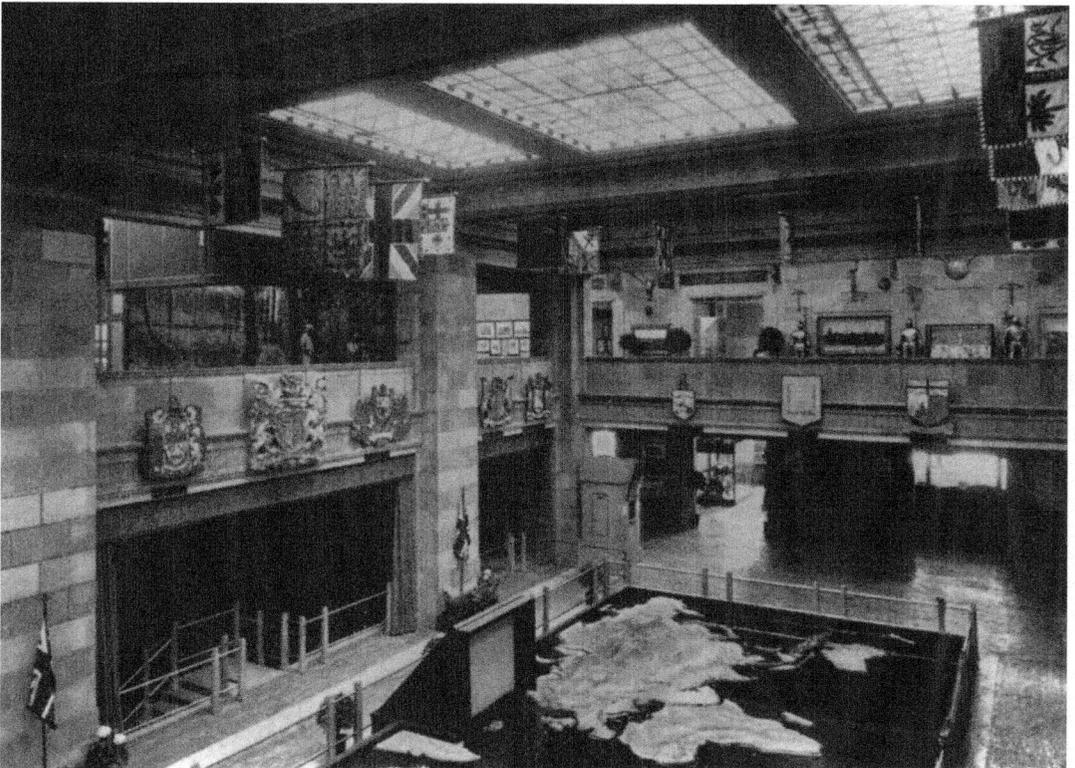

4.3 Inner Court – Government Pavilion, Empire Exhibition, Wembley (1924).
Lawrence Weaver, *Exhibitions and the Arts of Display*, 1925

weapons, trophies and pictures.[15] The other displays, grouped around this court on two floors, were intended to show the various activities of those government departments that administered imperial business: government ministries and subdepartments, research institutes, even the Victoria and Albert Museum. In 1925 the upper floor was rearranged so a 'Court of Heroes', devoted to 'illustrating those noble qualities of both men and women who have done so much to build up our Empire' and focused on a bronze figure of St George, looked down on the Court of Honour.[16]

The visitor might certainly regret that the Government Pavilion had not been built in a style that was more particular to Britain,[17] but this would be to miss the point, to ignore the contrapuntal dynamic of the exhibition. Britain was not to be figured as a culture like any other: it was not West Africa that had the walls of Kano reproduced for its boundaries, or Palestine with its 'street in Jerusalem' or even Malaya that in its alleged absence of indigenous architecture had a 'Saracenic' pavilion. Nor was Britain the sum of the commercial cacophony of stands within the Palace of Industry, each designed by a different architect to display the company's wares and their associated values. Instead the Government Pavilion identified Britain wholly with empire, and empire had to have 'dignity', signified of course by that pediment and those pillars and plinths and lions. Dignity was not youthful or new, it was not a virtue associated with the minor, the relativistic or the peripheral. Furthermore the pavilion's function was neither to embody Britishness nor to illustrate a branch of industry but to act as a 'key to all … the index to the volume [the visitor] is to read'.[18] A visit to the pavilion would be an education in the official version of the imperial dynamics of governance, trade, emigration, climate, communications and defence. Here was located the logic of the exhibition and its three purposes: to exploit the raw materials of the empire, to foster inter-imperial trade and open new world markets; to create harmony between the different parts of the empire; and to demonstrate its 'almost illimitable possibilities' to the British.[19]

But not all visitors could find renewed belief or triumphalism in its exhibits or suspend their belief sufficiently to follow the logic of its purposes. In her essay 'Thunder at Wembley' (1924) Virginia Woolf found 'nature' constantly undermining the efforts of the organizers and designers.[20] By contrast with pre-war exhibitions at White City and Earls Court, Wembley seemed overly artificial and yet also insufficiently a part of the city. It lacked the power of transformation: everything was too sober and plain, everything was 'six and eightpence', neither expensive nor cheap but moderate. The same with the architecture: 'as for the buildings themselves, those vast, smooth, grey palaces, no vulgar riot of ideas tumbled expensively in their architect's head; equally, cheapness was abhorrent to him, and vulgarity anathema'.[21] Yet just as Woolf finds herself fumbling with 'those two fine words – democracy, mediocrity', nature intrudes itself into the exhibition. First it appears in the form of the visitors who, 'against the enormous background of ferro-concrete Britain, of rosy Burma', seem reverent, respectful, curious and surprisingly dignified; but how can they 'bring

themselves to believe in that'?[22] Then nature intrudes in the form of a thrush singing regardless of the gramophones, fairy lamps and scenic railways of the amusement compound. Next a woman 'in the row of red-brick villas outside the grounds, comes out and wrings a dish-cloth in her backyard'.[23] But beyond all these there is a refusal from above. At first the sky seems to '[lend] itself with exquisite tact to show off to the best advantage snowy Palestine, ruddy Burma, sand-coloured Canada, and the minarets and pagodas of our possessions in the East'. But then the wind rises and as the massed bands of empire march into the stadium 'some appalling catastrophe is impending':

The sky is livid, lurid, sulpherine. It is in violent commotion. It is whirling water-spouts of cloud into the air; of dust in the Exhibition. Dust swirls down the avenues, hisses and hurries like erected cobras round the corners. Pagodas are dissolving in dust. Ferro-concrete is fallible. Colonies are perishing and dispersing in spray of inconceivable beauty and terror which some malignant power illuminates. Ash and violet are the colours of its decay.[24]

As visitors rush into the Canadian Pavilion's 'frail tent of shelter' and huddle around the sculpture of the Prince of Wales made from butter, 'cracks like the white roots of trees spread themselves across the firmament. The Empire is perishing; the bands are playing; the Exhibition is in ruins. For that is what comes of letting in the sky.'[25]

Woolf's 'nature' is the servant of doubt, possibly conscience, and certainly hubris. 'Nature' all too easily reveals the formalities of the exhibition to be groundless, its amusements to be sham and inadequate distractions, and as a consequence empire itself is disclosed as a matter of ephemeral representation. The storm bursts on all this like an eruption on some latter-day decadent Pompeii, perhaps even a reprise of the war, and the apocalypse sweeps up the complacent and mediocre, and with them the empire itself. Certainly there was enough anti-imperial sentiment around to have fuelled the revenge of Woolf's 'nature'. If we take the case of India alone, in the early 1920s alienation from the Raj was focused by Gandhi's Congress Party into a boycott of British goods and institutions (including the visit of the Prince of Wales in 1921). There was direct opposition to participation in the exhibition, especially in Bengal where it was thought that 'the exploitation of Indian resources would be intensified and the few "lingering" Indian industries be choked out by competition'.[26] The Central Provinces and Assam did not participate, as well as several of the Indian princely states. Furthermore the publication of the Kenya White Paper (also known as the Devonshire Declaration) in 1923, which refused equal rights to Indian settlers in Kenya, gave offence in India and a complete boycott of the exhibition was proposed. In the event there were a few resignations from the advisory committee and several private exhibitors withdrew.[27] Against the backdrop of these events it seemed that Woolf's 'nature' would break out over the Government Pavilion too: its position was haphazard and suggestive of self-doubt, perhaps because there was little logic in its role. Hubris would also await other national pavilions over the next decade and a half.

Paris, 1925

At first sight the British Pavilion at the 1925 Exposition des Arts Décoratifs might be considered an interruption to, if not a diversion away from, the dialogue between empire and national identity that this chapter has set out to discuss. Certainly the pavilion that was organized by the Department of Overseas Trade was not intended to represent Britain as imperial centre, nor was the exhibition itself concerned with colonial display (although there was a Palestine section in one of the main exhibition buildings). Nevertheless, many comparisons were made with Wembley at the time. If Wembley's Government Pavilion with its lions, plain piers and severe outline was unmistakeably gendered as masculine, the pavilion designed for Paris by Howard Robertson and J. Murray Easton was coded as feminine (fig. 4.4). Here was an extraordinary confection, as difficult to categorize today as it was then, the architects striving to avoid pastiche at all costs but seeming to attempt to translate historical forms into novel equivalents rather than rethink them entirely.

Tag Gronberg has argued convincingly that the Paris 1925 exhibition, more overtly than any other international exhibition, took on the qualities of a shop window and orchestrated its visitors' experience into a contemporary form of urban looking as window-shoppers.[28] The exhibition displayed commodities and it showed them relentlessly in the context of luxury consumption. The exceptions to this were few and identified mainly in those avant-garde modernist creations such as Le Corbusier's Pavillon de L'Esprit Nouveau or Konstantin Melnikov's Soviet Pavilion, which directed viewers to cities as sites of visionary transformation through their dynamic spatial layouts. By contrast, according to Gronberg, the 1925 exhibition was largely concerned with another kind of modernity, a modernity of illusion, spectacle and decoration, identified as the 'object of woman's desire'.[29] The British Pavilion was certainly closer to this consumerist optic, though it interpreted it in terms of interior settings somewhere between the decorum of a department store and an urban salon. Nevertheless, the shift for British critics from the reinforced concrete virilities of imperial representation at Wembley was sudden, though perhaps less shocking than if the Wembley exhibition had not been extended for another year so that it coincided with the Paris show – the national image was less at stake than it might otherwise have been.

The pavilion was located on a prime site on the northern bank of the Seine adjoining the west side of the Pont Alexandre III, and it used its neighbouring river terrace site for a tent-covered restaurant. The pavilion itself was designed as one long hall parallel to the river with a central axis passing through its various spaces: entrance hall, exhibition galleries and central hall. On the outside these were articulated as three distinct volumes: the entrance block with a tall parabolic arched doorway, rounded corners and decorative niches on its sides; the central galleries as a lower volume with a range of plain windows; and the ecclesiastical hall with an open lantern rising above

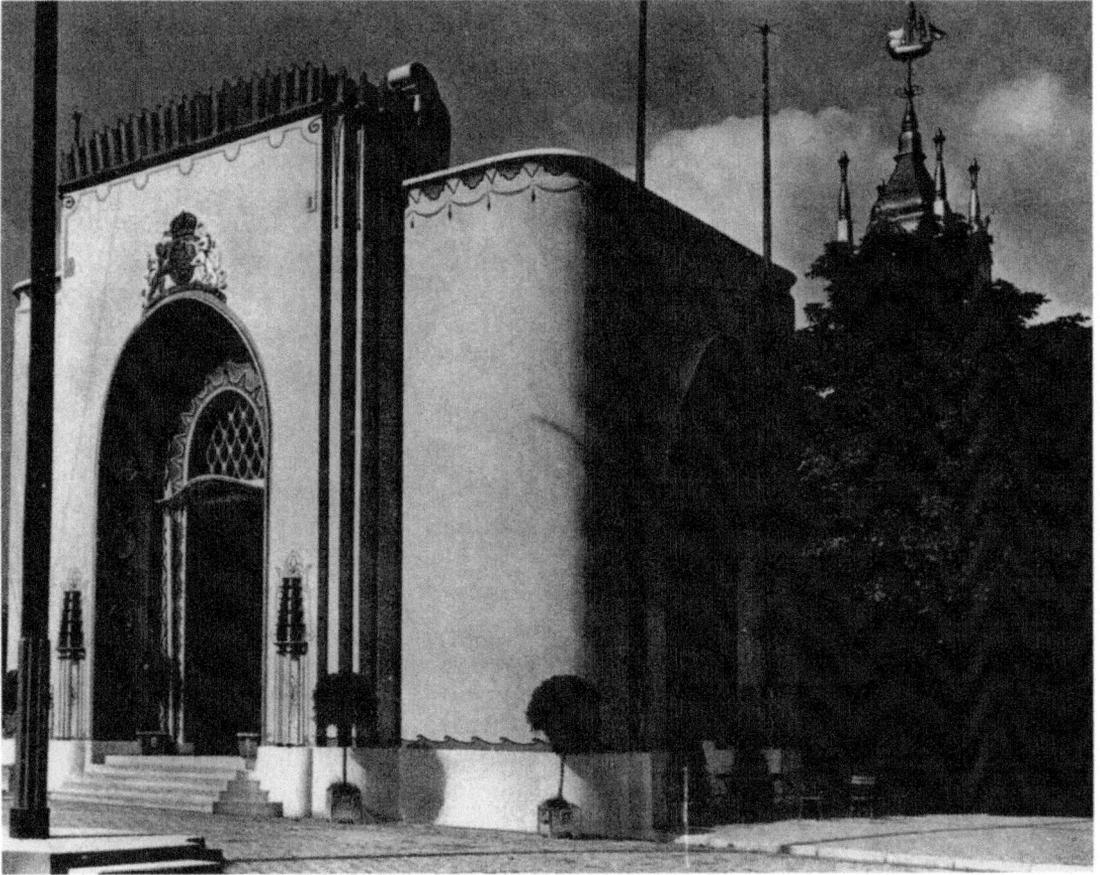

4.4 British Pavilion, Exposition des Arts Décoratifs, Paris 1925 (Easton & Robertson).
Architectural Review, July 1925

it. The plain plaster walls of the pavilion had various painted ornaments of a lightly allusive character added as framing devices to their surfaces.

As was widely remarked at the time, there was little or nothing to indicate the nationality of the British Pavilion beyond the conventional attributes of royal arms over the entrance and Union Jack on the flag mast. This was partly because the French organizers insisted that the pavilions be designed in modern rather than traditional styles and the result was a medley of all that was considered new. If the British Pavilion is any indication, what 'modern' meant to British architects in 1925 was unclear and certainly was not reconcilable with what was accepted as 'national'. 'It is probably prophetic ... a certain Scandinavian influence shows itself';[30] '[it] embodies all that is most representative and vital in modern recreational expression';[31] 'it comes hot from the Architectural Association pantomime; and appears incomplete without the full A. A. Beauty Chorus rampant on the front step';[32] and it drew upon other qualities than the 'heavy or stolid' such as 'grace, gaiety, colour, harmony of composition'.[33] These reactions, admittedly all from the

architectural press, all focus on a kind of experimental playfulness in the pavilion, and all accepted that exhibition architecture was its own genre for which certain kinds of allowances could be made. The references to the Architectural Association (AA) were probably justified by Robertson's role as its principal, indeed Robertson has often been acknowledged as a pivotal figure at this period in bringing contemporary European and American ideas into British architecture. This new kind of architectural adventure, as these quotes indicate, was also newly associated with 'foreign influences' and 'an international advance',[34] and typified by architectural students' desire to travel on the continent to see contemporary buildings. In short, it was cosmopolitan.

This effort towards cosmopolitanism was weak and unconvincing but perhaps that was inevitable; it is easier to say what it tried to avoid than what it was. It was not conventionally imperialist, it was not a League of Nations type of internationalism, but neither was it aligned with the emerging forms of avant-garde internationalism that had barely touched Britain as yet. Instead we might say that it tentatively reached for a blending of multiple elements, a polychromatic culture brought about by the international traveller or the consumer of luxury goods, those that aspired to cultivate a transcendence of the national, a revolt against the traditional and a literacy in the international contemporary. Nevertheless this literacy was also at the same time inherently imperial, as it was rooted in the assumption of the imperialism of free trade and of access to different cultures.[35] Certainly Easton & Robertson's pavilion was not avant-garde but what I am suggesting is that it might be understood as part of an attempt to fix and take on an image of cosmopolitanism in the context of the consumption of luxury goods. As E. M. Forster had recognized already in *Howards End* (1910), 'the Imperialist prepares the way for cosmopolitanism'.

Antwerp, 1930, and Johannesburg, 1936

The next pavilion after Paris, the British Pavilion at the Belgian Colonial Exposition held in Antwerp in 1930, returned to the rhetorics of Wembley. Lutyens's building dominated an island site surrounded by the moat of the old city fortifications, and looked down to the central *rond-point* of the exhibition grounds around which the Belgian pavilions were grouped (fig. 4.5). At the bend itself, providing a fulcrum to his L-shaped building, Lutyens placed a version of his dome for the Viceroy's House in New Delhi, smaller and simpler but unmistakable with its stepped drum and smooth low cupola. There was to be no doubting of the bind between nationality and empire here. 'It looks solid and British', the *Builder*'s critic wrote and a Belgian observer was impressed by its 'lasting impression of the majesty and strength of the British Empire'.[36] This materialization of Britain's imperial role was also evident in the interior arrangements of the building, designed by Richardson & Gill. Most of the gallery space was taken over by a display on shipping; in the side galleries there was a large scale model of the Tyne, a

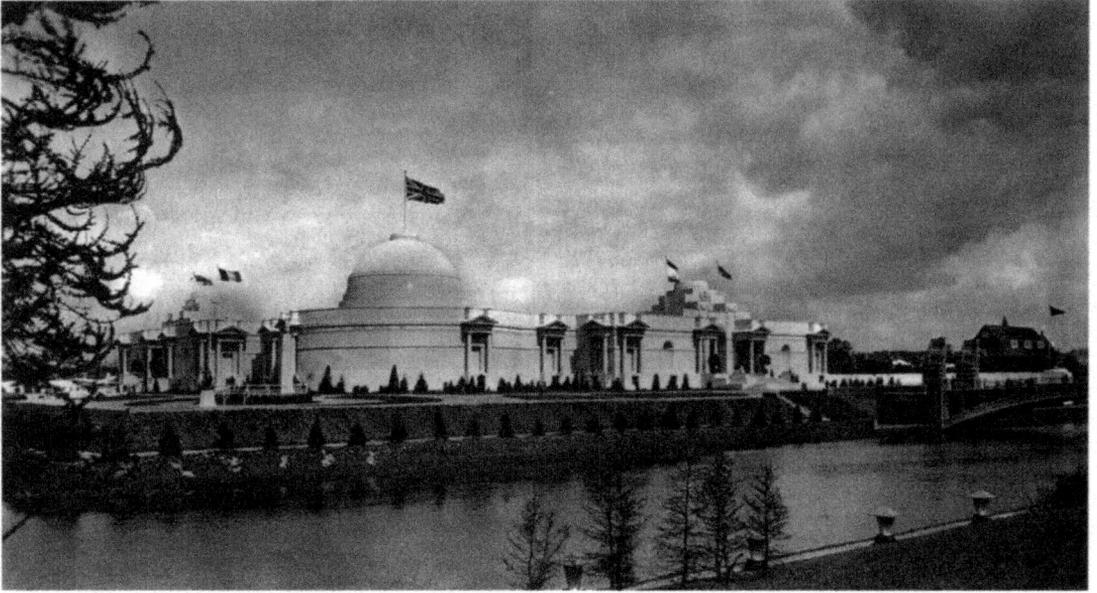

4.5 British Pavilion, Belgian Colonial Exposition, Antwerp 1930 (Sir Edwin Lutyens)

diorama of 'the origin of the British race', dioramic views of 'typical scenes in various parts of the British Empire' and displays on aeronautics and tropical health.[37] The domed space at the angle of the building housed a Court of Honour (fig. 4.6); here, as in the Government Pavilion at Wembley, visitors could look down on a map of the world and up to a painted frieze of scenes from the empire and in the centre a suspended Elizabethan ship. This space was now positioned as an area off the main network of galleries in the pavilion, a point of pause to enable contemplation of the vastness and connectedness of empire, and orientation within it. If not quite the Durbar Hall housed by the dome at New Delhi, the space seemed to imply another kind of rite of allegiance.

Britain did not contribute to the Paris Exposition Coloniale in 1931, perhaps the most spectacular of all the colonial exhibitions.[38] The French exposition was initially planned for 1925, too close to the Wembley exhibition, and then when it was moved to 1931 it was reasoned that Britain had just contributed to the Antwerp exhibition, though it is more likely that they saw they could not but appear diminished in an exhibition primarily about the French colonial empire.[39] Although it had a pavilion at the Universal and International Exhibition at Brussels in 1935, the next major display of Britain's relation to its empire was in South Africa the following year.

The 1936 Empire Exhibition in Johannesburg marked that city's fiftieth anniversary and sought to promote its place as 'the most prosperous city in the world'.[40] The exhibition was to be a 'symbol of progressiveness' and a

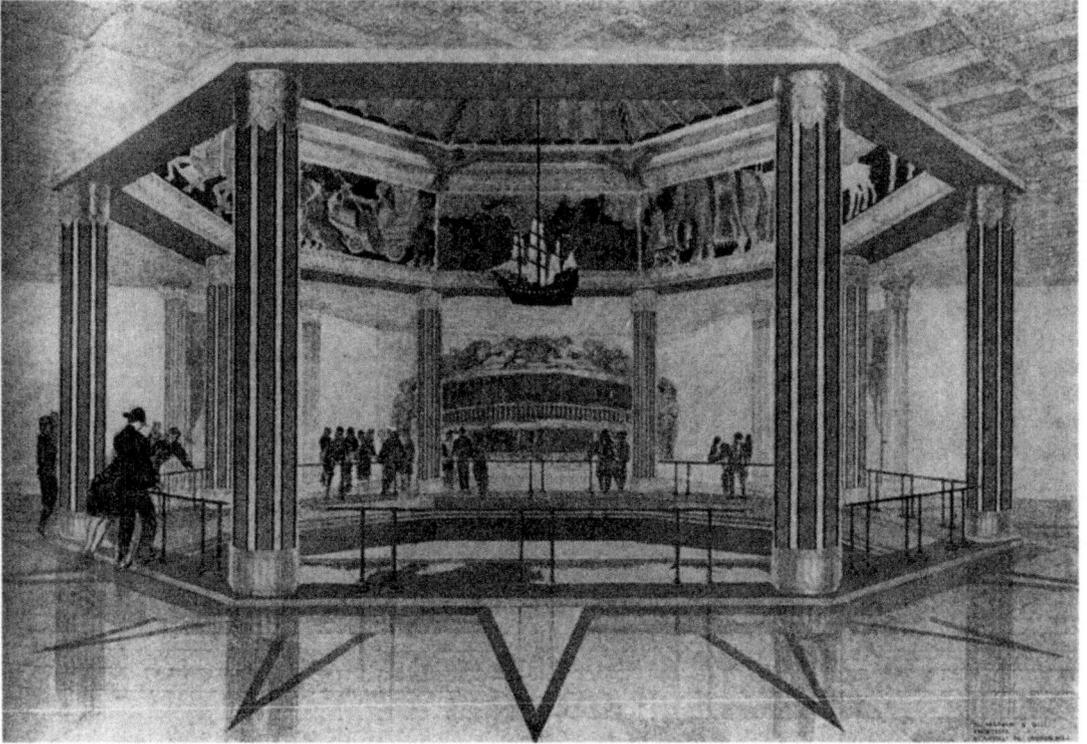

4.6 Court of Honour, British Pavilion, Belgian Colonial Exposition, Antwerp 1930
(Richardson & Gill). *Builder*, 7 February 1930

Tower of Light proclaimed 'the degree of interdependence of the various
component parts of the Commonwealth'.[41] Certainly the dominant interests
in South Africa in the mid-1930s were anxious to project the country as
modern and successful. After the rise in world gold prices in 1933, the
country's economy boomed, and the Afrikaner population's anti-
imperialism was calmed by a nationalist coalition and the temporary
acceptance that dependence on imperial finances was necessary. All this was
underwritten by a cheap and disenfranchised African labour force.[42]

The United Kingdom Pavilion was second only in size to the South
African Pavilion and, at 27 metres (90 feet), was the tallest pavilion in the
exhibition. It was also given a prominent position on a wedge-shaped site
between two of the main avenues. Designed by Howard Robertson, one half
of the partnership responsible for the 1925 Paris Pavilion, it might be
understood as an attempt to modernize the approach embodied by the
Government Pavilion at Wembley (fig. 4.7). Here again was the display
concept, also found in Antwerp, of the central Court of Honour as the major
architectural element, and here too that court housed a large world map.
Furthermore Robertson had turned against the long sequence of rooms in his
Paris Pavilion as well as the whimsical but undoubted novelty of their
architectural carapace. Instead the pavilion had all the required elements of
'dignity' but within an even simpler concept than Wembley. It could be

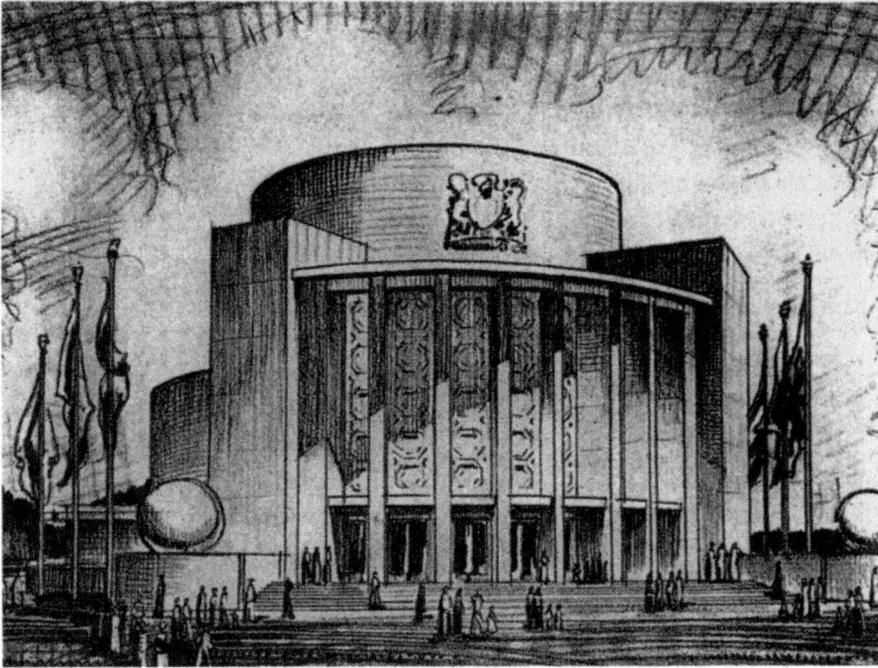

4.7 United Kingdom Pavilion, Empire Exhibition, Johannesburg 1936
 (Howard Robertson). *Architects' Journal*, 6 August 1936

understood, then, as both classical and modern and although there was a prominent royal arms on the rotunda this was now the only traditional attribute of British identity.[43] The pavilion was circular with two massive plaster globes set on plinths to announce its entrance and frame a flight of steps. And this entrance itself, in a coffered screen wall, was housed under a curved colonnade of elongated pillars, with the rotunda of the main exhibition space rising behind. All these volumes were treated as simple geometric units – spheres, cylinders and cuboids – and all the external surfaces of the building were painted white and left unornamented.

Inside, the central display space was thematized more as a theatrical event than a gallery tour, with the map taking up the main space in a sunken well and a royal dais and concentric gallery spaces rising beyond it.[44] Above the map was a dome painted with constellations of the northern hemisphere, with waxing and waning electric bulbs as the stars.[45] The theme for all the displays was modern transport, showing the historical development of cars, planes, locomotives and ships, but the theme was given an imperial tilt by focusing on the prominence of the 'British peoples' in developing transport, as well as transport's role 'in welding together the peoples which constitute the British Empire'.[46] On the map itself model boats ploughed across real water and electric tubes showed imperial air routes. The whole pavilion and its displays, therefore, were given over to the image of empire as a modern global system, a mapping of links and nodal points through the most

advanced means of transport. Mobility was the main theme just as it was one of the leitmotivs of modernism, and the circular design and dynamic planning of the pavilion can be seen as an attempt to epitomize this theme in architectural form. There was of course nothing here about economic relations, finance or governance, though the royal niche with the bust of the king showed where the symbolic centre of empire still lay.

While reviews of Lutyens's pavilion for the Antwerp exhibition had been polite and appreciative, the United Kingdom Pavilion in Johannesburg, as indeed the exhibition as a whole, was lavished with praise. Many echoed the pavilion's aims in what they praised. The *Rhodesia Herald*, for instance, wrote, 'somehow the United Kingdom pavilion, although as modern and up to date in design as any other building in the exhibition, has added more dignity in its line and looks on the pavilions of the Commonwealth around it with a wise, paternal, almost maternal air'.[47] Several commented on the fact that the pavilion had no title: 'The United Kingdom Pavilion has been well and significantly named in its namelessness', wrote Laurens Van Der Post in the *Star*, 'for it expresses in the clear terms of its own design what it is and what it symbolizes with greater dignity than anything else could have done ... [here was] the reduction of a vast idea to one central and essential theme, and on a magnanimous modesty'.[48] For another paper it was simply 'A Building Which Needs No Name'.[49] Few dissenting voices were recorded: one was a teacher who, as reported by the *Rand Mail*, directed his class away from the United Kingdom Pavilion complaining that it was 'but another attempt at the glorification of the Empire'.[50]

Paris, 1937

One of the visitors to the 1937 exhibition in Paris was the editor of the *New Statesman*, Kingsley Martin. As with most accounts of this exhibition Martin was forcibly impressed by its worlds on display, most notably and unavoidably the face-off between the German and Soviet pavilions, and the modernist Spanish Pavilion housing Picasso's *Guernica*. But Martin also noted the more self-effacing British Pavilion (fig. 4.8):

Britain was modestly housed in something that looked like a white packing-case. When you went in, the first thing you saw was a cardboard Chamberlain fishing in rubber waders and, beyond, an elegant pattern of golf balls, a frieze of tennis rackets, polo sets, riding equipment, natty dinner jackets and, by a pleasant transition, agreeable pottery and textiles, books finely printed and photographs of the English countryside. I stared in bewilderment. Could this be England? If so, it was the England of the cultivated rich or perhaps of the England foreseen by Bernard Shaw when Britain's economy would depend on the export of chocolate creams. An entirely upper-class England. Almost all the photographs were of pastoral scenes and old churches, not a single factory chimney, not a gun or battleship or aeroplane, not a hint that Britain had a colonial empire, not a sign anywhere of a proletariat. A nice England, unlike any that had existed or could exist; England as seen by guests in a country house-party where the servants were unobtrusively in the background, where all nature smiled and every luxury appeared as if by magic.[51]

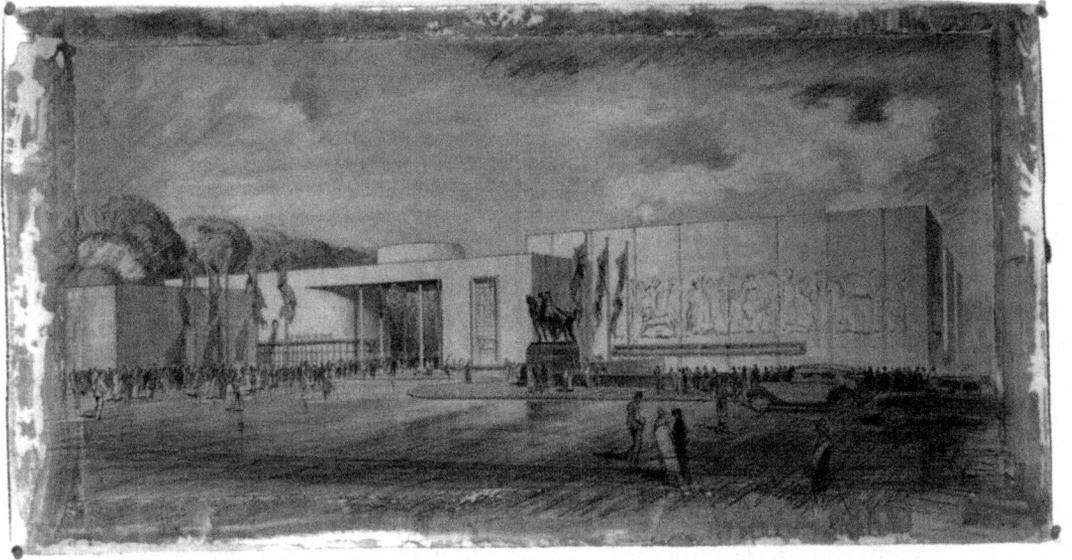

4.8 British Pavilion, International Exposition, Paris 1937 (Oliver Hill)

Martin's response was not uncommon amongst liberal commentators: a certain bafflement about the building itself, and a wry amusement if not embarrassment about the content of the displays. More trenchant criticism came from other quarters, focused on a sense that much had been elided in favour of a rather one-eyed vision of Britishness. Indeed the government itself was much exercised about the criticisms made of the pavilion. In what follows, I want to explore in particular the seeming omission of Britain as an imperial centre and the form of the building itself, the 'white packing-case'.[52]

The British Pavilion was given a site on the corner of the Place d'Honneur in a small group of foreign pavilions, opposite the Belgian Pavilion, beside the Canadian and Swedish Pavilions, and close to the Eiffel Tower and the French regional section.[53] Responsibility for planning the pavilion was given by the Department of Overseas Trade to the Council for Art and Industry newly formed in 1934 and chaired by Frank Pick.[54] Pick's idea of the pavilion was that it should be based around certain English words adopted in French and supposedly representative of British institutions: tennis, bridge, tea, sport, the weekend, and so on. This was the peg for a display of functional objects created in a British tradition of craftsmanship and linked by having accepted connotations of British culture: they would be 'comely and pleasant … a liberal conspectus of our English life'.[55] Objects like sports rackets and bats would demonstrate the fitness for purpose that Pick had learned to admire from Arts and Crafts theorists like William Lethaby,[56] while the 'week-end house' would be a chance to display contemporary British architecture through a typically British institution.[57] Democracy had an important place here: 'to us [it] means more than a mode of government: it means a fashion

of living which leaves men and women free to express themselves'.[58] Charles Reilly was one of the few to support this linkage: '[the pavilion] has exactly the right attitude for a democratic country which still cultivates free and open discussion'.[59] These are obviously very different kinds of sentiments than might have been possible in a pavilion that sought to represent Britain as 'heart of empire'; indeed Pick explicitly opposed the use of the pavilion for 'advertisements of Royalty or of the Empire'.[60]

The architect for the pavilion was Oliver Hill, certainly not amongst the most advanced modernists in Britain at this time (he had no affiliation with the Modern Architecture Research (MARS) Group, for instance) but aware of contemporary developments and skilled at eclectic compromises, and a member of Pick's stable of architects and artists versed in the Arts and Crafts but keen to see them married with the machine and the machine aesthetic.[61] The main body of the pavilion (see plate V) was a rectangular volume painted predominantly white but with red details and a blue lower level, its length hardly enlivened by a long spray-painted frieze by John Skeaping. This main volume was attached to a smaller entrance cube and, via a bridge over the Quai d'Orsay, to a buttery. These three smaller units each had strong circular features: a circular ceiling within the entrance cube, a drum over the bridging section, and the circular plan of the buttery with a curved wall projecting under the bridge. Although it had no Court of Honour and no imperial map, Hill's design did encompass several of the features found in previous British pavilions even if they tended to be both more abstract in form and, despite the smooth white surfaces, more piecemeal. Where the 1925 pavilion in Paris had a freestanding and distinctly designed restaurant, Hill's pavilion was linked by a bridge to a buttery beside the river but presenting a windowless wall to it. Most interesting, perhaps, in this respect was the circular drum that rose above the porte cochère over the Quai d'Orsay with long pillars flanking it and the royal arms beneath. Here was a reminiscence of the drums, domes and colonnades of the pavilions at Johannesburg, Antwerp and Wembley, but reduced to the simplest shapes and the most basic honorific role; converted effectively into the language of Corbusian modernism. Nevertheless in other respects Hill's pavilion drew back from a thoroughgoing modernism, perhaps in accord with Pick's own growing antipathy towards it.[62] A narrow line was to be walked, treating the building as a shell expressive of simplicity and directness but not evocative of 'continental tricks', Pick's term for uncompromising modernism.[63] Indeed it is tempting to see the pavilion as an attempt at appeasement: the use of various artists working in various mediums to decorate the inside and outside of the building evoked Arts and Crafts ideals, the tall vertical windows had enough of the Georgian about them to offset some of the abstract modernist geometries elsewhere, and the traditional symbols of royalty and nationality were still present. This appeasement continued inside, where the pavilion's most prominent feature was a grand spiral ramp at the far end of the main hall from the entrance, which led down to a lower riverside hall (fig. 4.9). A large photomural was arranged around the ramp showing English landscape scenes and with giant pictures of traditional figures, including Prime Minister Neville

Chamberlain as a fisherman, suspended in front of it. Transport, the central and sometimes the exclusive subject of British pavilions since 1924, was allotted merely a shallow window between textiles and weekend houses. Nothing directly attested to Britain's imperial role.[64]

Many architects in the late 1930s would not have been unhappy to have one of their buildings called a 'white packing-case'. Perhaps for anyone who had read Le Corbusier the phrase might suggest a purposefulness and simplicity, a lack of pretension, even perhaps a purity of intent. For others, and even if his comments are retrospective Kingsley Martin seems one of them, 'white packing-cases' might be useful but they were not to be looked at, they were not decorous, and they implied not just a cheap and tossed-off object but an attitude that was far too contingent and rough and ready. There was undoubtedly a risk in using modernism for a national pavilion in 1937; we might say that its semiotics were too open-ended. Whilst the Spanish Pavilion could be understood as standing for embattled antifascist democracy and internationalism, because of what the Spanish Republic was identified with, this message was reinforced by what was inside the pavilion, from its photomontages of the new woman, to its work by artists who had died in the defence of Madrid, and most of all its rapidly iconicized *Guernica*.[65] But modernism had no established linkage with Britain's national image nor was

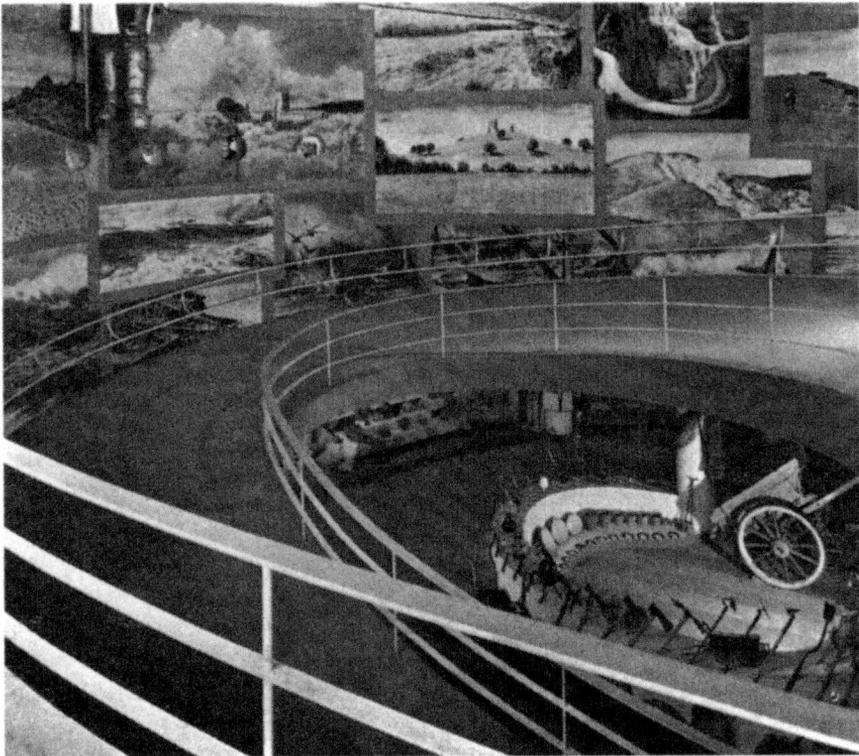

4.9 British Pavilion, International Exposition, Paris 1937 (Oliver Hill). *Architectural Review*, September 1937

the idea of it as a symbol of internationalism appealing to the organizers, certainly not by comparison with the way this link was being forged by other modernist national pavilions like those of Finland, Czechoslovakia and Sweden. Furthermore modernism did not have ties at this time with Britain's imperial image, where the closest approximation was Robertson's design for the pavilion at the Johannesburg exhibition the previous year, modernist perhaps only in its undecorated geometric volumes. By contrast Hill's design was making the wrong kind of compromises. It was extraordinarily daring because what he produced was a building that had none of the conventional attributes of that key concept in these circumstances: 'dignity'. The *Daily Express* described it as 'a grey-white, practically square structure. Its walls from the outside look like great advertisement hoardings ... it is one of the ugliest buildings in the exhibition.'[66] *The Times* declared 'it might be anywhere, a riding school, an aerodrome, or a factory on or off the Great West Road',[67] and the *Journal of the RIBA* gained the impression 'of a stutterer saying nothing very important'.[68] The *Marseille Libre* exclaimed '*Pauvre Angleterre!*', and even Pick confessed to finding the exterior of the building 'dull'.[69]

So the main perceived problems with the British Pavilion were that it was indecorous or undignified and insufficiently British. This was commented upon even by French critics who were surprised by the light-hearted display and even more by the lack of nationalism in the building.[70] Attacks on the pavilion tended not to distinguish its exhibits from their container: 'dignity' was at stake in both. The *Daily Express* found the pavilion too commercial, 'cheap, tawdry, inadequate, a shop display, a one-class exhibition', for the *New Statesman* it was 'penurious ... a mere box', and for the *Southern Daily Echo* 'every Briton feels humiliated at the sorry figure cut by his own country'.[71] The point here is that where these qualities were suitable for an exhibition devoted to the decorative arts, as in 1925, they were out of step with what had become an exhibition of national industrial power in 1937. When even the Prime Minister was drawn into the controversy the Council for Art and Industry was forced to conduct an inquest.[72] A number of points were made about the way in which the pavilion had been perceived. There was felt to be a problem deriving from the comparisons inevitably made at the exhibition: the pavilion was smaller than Belgium's opposite it, contrasted with the German and Italian Pavilions the British could hardly look other than insipid and indecisive, and compared with the Soviet display Britain appeared pampered and idle.[73] Nevertheless, for a few it was a relief to get to the British Pavilion with its 'friendly, unostentatious and even whimsical atmosphere'.[74] In his review, Howard Robertson even suggested that simplicity was a national characteristic 'for the English tradition is always of external reticence'.[75] This defence echoes the defence of the Government Pavilion at Wembley for its modesty of position, and it seems equally tendentious precisely because of the narrowness, or class-interested nature, of the 'atmosphere' or 'character'. If democracy was to be defined, as it had been by Pick, as more a 'fashion of living' than a mode of government, then it might easily seem class-specific, smug and insubstantial.

To gloss the issues raised by the British Pavilion in 1937 and their relation to imperialism, they might be seen as centred on what one critic called 'The Problem of National Projection'.[76] 'National projection' was a phrase brought into currency by Sir Stephen Tallents in his book *The Projection of England* (1932). As Secretary of the Empire Marketing Board, Tallents wanted to see England and the empire marketed in a much more modern way; as his supporter, Leo Amery, Secretary of State for the Dominions, explained it, 'what we wanted to see was … the Empire as a co-operative venture … a society for mutual help'.[77] What Tallents called 'the art of national projection' was a combination of new kinds of subject matter (industry, tourism, universities, scientific research) as well as older and more iconic subjects (the monarchy, London buses, the Boat Race, the English countryside, and so on). Tallents wanted more attention paid to the central research stations and bureaux for the colonies and dominions which were like 'hospitalries of the Order of St John … happily absorbed in the deft and keen-eyed study of the problems which belong unto our Imperial peace'.[78] (We have already seen an example of Tallents's vision in the 'architecture for development and welfare' advocated by G. A. Atkinson for the colonies in 1953, as discussed in Chapter 1, and indeed the Building Research Station was to be a perfect example of what Tallents meant by these 'hospitalries'.) Tallents regarded international exhibitions as particularly important to the competitive projection of national values and he held up the German Pavilion designed by Mies van der Rohe at the Barcelona Exhibition of 1929 as an example to emulate. In this pavilion Tallents found 'a gesture rather than a building, deriving its effects from that sense of spacious and efficient simplicity more commonly associated with an up-to-date hospital or a modern power house' and in the other German pavilions at Barcelona he found a spaciousness, simplicity and absence of irrelevant detail that 'enforced a sense of the industrial power of modern Germany'.[79] Similarly, England must find the means to 'spread throughout the world a sense of English industrial quality and ambition, an impression of English adaptability and modernity no less than of English craftsmanship and thoroughness and finish'. We might say that what Tallents wanted was a distinct and sharp move away from the appurtenances of the 'heart of empire', and as part of this move there would be both a new imagery added to the old and a turn to modernism. It was not so much a denial of empire, certainly not an anti-imperialism, as the absorption of empire within an aesthetic that spoke of the future at least as much as the past.

The resonances of Tallents's views with the British Pavilion in 1937 are obvious. Whilst the range of subjects did not accord with Tallents's prospectus, there was the same desire for a contemporary modernist image, and the same link between the Arts and Crafts and the machine.[80] Indeed they were implicitly associated by the kinds of criticisms made of the pavilion's functional, hygienic and even industrial look. However, as J. M. Richards had put it, there was a 'problem of national projection' in 1937. Britain had moved a step away from using a national pavilion as a trade show, in the sense of renting out its space to commercial firms, and instead had substituted committees of experts which selected the displays. Nevertheless the pavilion, beyond the eccentric attempts

to represent Britain as a sporting and tweed-clad nation, remained essentially a trade show. In other words, for Richards there were none of the modernizing projects (the London Underground, the BBC, even the National Trust) that Tallents had argued for and that were such a feature of most of the best pavilions in 1937. To interpolate, there was no bald choice between maintaining the weld between nation and empire or making a new alliance between national projection and the emerging forms of modernism. What Tallents had laid out and Hill and Pick had begun to visualize, if in a compromised way, were the forms and fixtures by which Britain might be seen as part of a modern group of nations, international in outlook, and yet still the centre of an empire.

Glasgow, 1938

The last of the pavilions to be discussed in depth in this chapter is the United Kingdom Pavilion at the Empire Exhibition held in Glasgow in 1938.[81] The exhibition was laid out by Thomas Tait, who designed many of the buildings and commissioned Scottish architects to design others, and the result was one of the most aesthetically consistent of exhibitions, ruled by a distillation of many elements from continental modernism and Art Deco but arranged according to Beaux Arts planning principles. The exhibition was, of course, intended to celebrate the empire and foster its trade, and was the last avowed exhibition on this theme in Britain, but more specifically it portrayed the empire as essentially peaceful, the same appeasing theme that had been part of the agenda of the British Pavilion in Paris. It also attempted to project Scotland as an important part of imperial renewal under contemporary conditions. Scotsmen were thus presented as key personnel in the operation of empire, Glasgow as the 'Metropolis of Empire' sending out commodities across the world, and the exhibition itself was described as a 'University of Empire'.[82] This section will examine what modernism and empire were doing together in Glasgow, and will especially explore Glasgow's resonances with Wembley and the other exhibitions discussed here.

The main entrance into the exhibition grounds was from the south, from where the visitor came onto one of the main axes of the grounds, fronted by the Palace of Engineering and the Palace of Industry at either end (fig. 4.10). Facing onto this axis – a combination of two boulevards (Dominions Avenue and Colonial Avenue), pylons, bandstand and formal pool with fountains – on the north side were the pavilions of white-settler dominions like Canada, South Africa, New Zealand, Australia, and even Independent Ireland. On the south side were the colonial territories: the pavilion shared by Malaya and the West Indies, Southern Rhodesia and East Africa, and the West Africa Pavilion, with the Empire Tea Pavilion in the middle. India, which had declined to participate, was a prominent absentee, only represented at all in the Tea Pavilion and largely unmentioned in the official literature.[83] The Amusement Park was tucked away behind the Palace of Engineering beyond the ceremonial areas of the exhibition. It was off this axis, on Kingsway the major

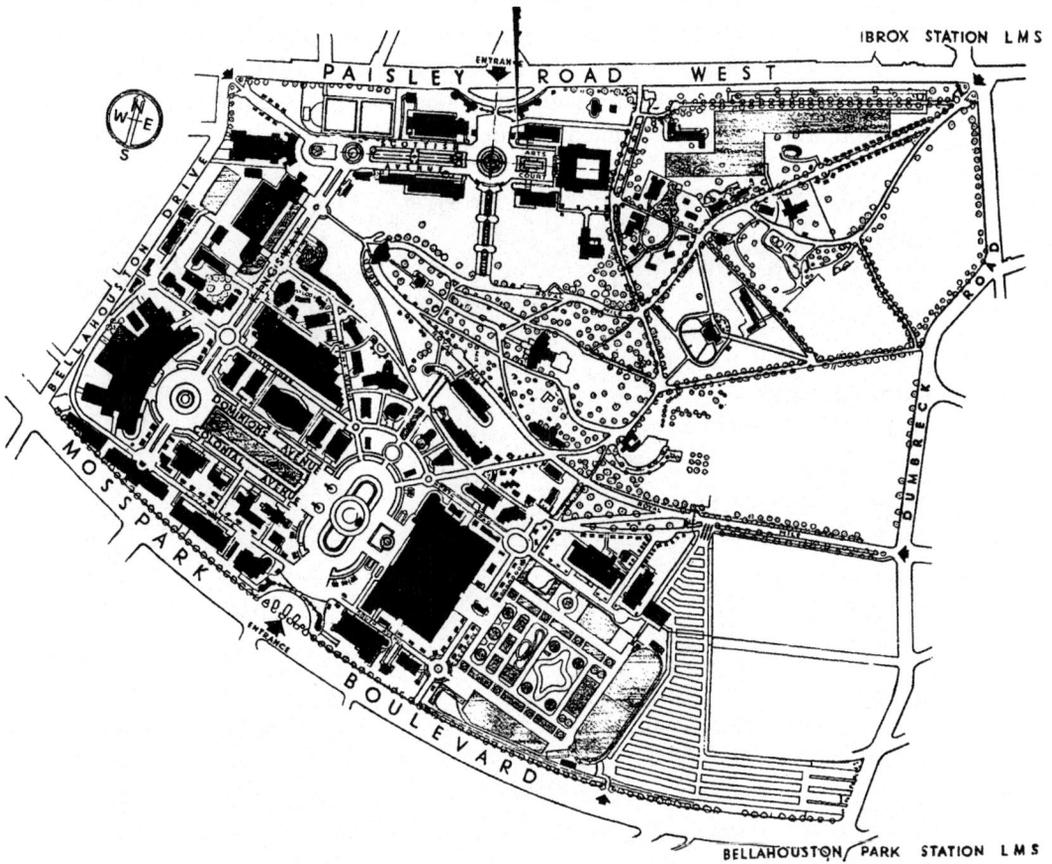

4.10 Plan of Empire Exhibition, Glasgow 1938. *Empire Exhibition, Scotland – 1938. Official Guide*, Glasgow, 1938

connecting avenue of the exhibition, that the United Kingdom Pavilion could be found together with the Women of Empire Pavilion. Kingsway in turn led to Scottish Avenue, another major axis that formed the northern section of the exhibition with its own entrance and on which the two main Scottish Pavilions were located. Overlooking all of this on the hill that dominated the centre of Bellahouston Park was the Tower of Empire, the tallest and most reproduced building in the exhibition and the one that proclaimed its modernist credentials most loudly in its spectacular structure and its formal debts to the Tourism Pavilion, designed by Robert Mallet-Stevens, at the 1925 Paris Exposition.[84] The beauty of Tait's exhibition layout was that whilst he was forced to circumvent the ridge in the centre of the park and to establish a main ceremonial area, he still managed to create an arrangement that had several locations of equal spatial significance. The exhibition had the wide grand vistas that were demanded of empire exhibitions, but unlike Wembley they were not stretched and overblown. The ruse of wrapping the three main avenues around the hill created three relatively equal areas, so that the United

Kingdom Pavilion, for instance, was neither symbolically overdominant nor reduced to the indecorous location off a minor tributary that was its fate at Wembley. It also meant that the exhibition had a visual focal point – the Tower of Empire – which, unlike the stadium at Wembley, was separate from both the axial and symbolic arrangements of the exhibition (fig. 4.11). From this

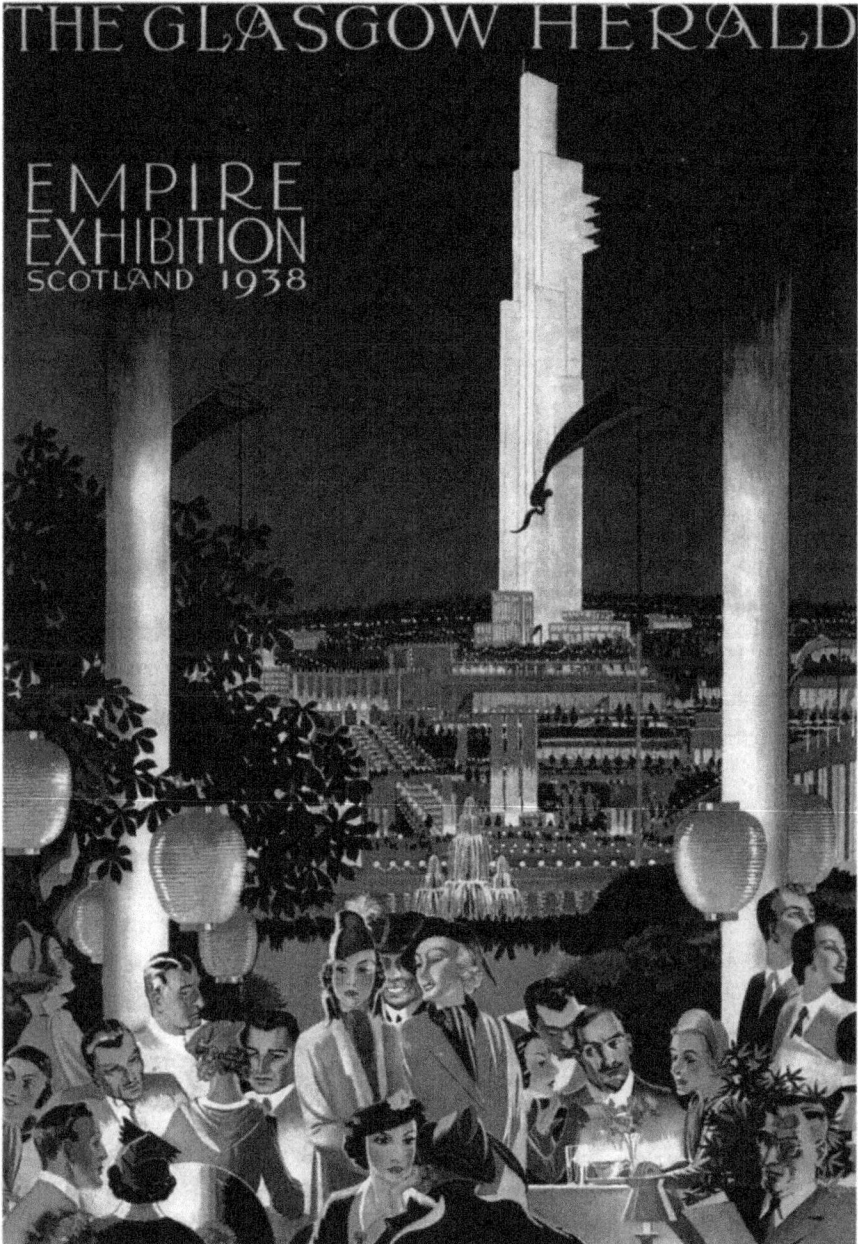

4.11 The Tower of Empire (Thomas Tait), Empire Exhibition, Glasgow 1938. *Glasgow Herald* special issue, *Empire Exhibition, Scotland*, 1938

Tower, as the *Official Guide* described it, 'the exhibition presents the appearance of a city of palaces and pavilions designed in the simple lines and curves typical of modern architecture and knit together by wide avenues: a city of light, spaciousness, spectacle and gaiety'.[85]

The United Kingdom Pavilion was one of the biggest and one of the most admired pavilions in the exhibition, a powerful yet sleekly stylized object (fig. 4.12). Designed by Herbert Rowse, it took the form of four parabolic-vaulted exhibition halls fronting onto a glazed gallery with blocks housing entrance and exit halls at either end. The design had a Beaux Arts logic about its planning but also a knowing disposition of modernist elements like the round-ended volumes of the entrance and exit halls that appeared to suggest dynamic cross-movements away from the essentially symmetrical front. There were also modernist mannerisms: cantilevered concrete canopies, ribbon windows and a colonnade of external concrete ribs that supported the glazed gallery. But the entrance hall itself might also be seen as an updated return to many of the elements in the façade of the Government Pavilion at Wembley. In Glasgow the entrance was framed by two Abyssinian-styled lions and its somewhat imposing frontage was established by sleek curved bastions that projected from either side of the entrance. The concrete ribs of the gallery reappeared in more elongated form to provide mullions and sculpture niches over the entrance. The displays themselves were not primarily focused on the 'heart of empire' idea, instead the halls were devoted to coal, iron and steel, shipbuilding, and 'Fitter Britain', and especially the scientific research in these areas:[86] a range of subjects much nearer to Tallents's ideas than the display at Paris the previous year.[87] The hinge for the turn from the imperial resonances of the outside to the domestic modernizations exhibited inside was the entrance hall sculpture which symbolized, as the *Official Guide* put it, 'the eternal urge within the spirit of man towards mastery of his environment and an improvement in the conditions of his life'.[88] The last thing seen in the pavilion, and placed in its own gallery space, was a large revolving glass globe with the extent of the empire marked in red, a reprise of the maps that dominated other interwar pavilions. The location of this gallery is itself telling. Placed in a round-ended room beyond the exit hall, like an appendix, the globe was visible in enfilade from the entrance hall and down the long, glazed gallery. The globe's room was a reminiscence of the domed Court of Honour with its large floor map in Lutyens's pavilion in Antwerp, and like it was placed outside the main displays of the pavilion. But where Lutyens's Court had implied rites of allegiance, Rowse's suggested a shrine-like or even mausolean space where a precious object was held.

The conjunction of modernism and empire was intended to be unavoidable in Glasgow. Tait saw it as the best way to 'combine dignity and gaiety … to be impressive without being heavy, gay without being cheap'.[89] There were several ways to do this: 'Long, clean lines, without any fussiness, is one. Colour is another.' Buildings were painted in a limited spectrum of colours from pink, red, blue and cream. The stylistic unity was maintained in the street furniture:

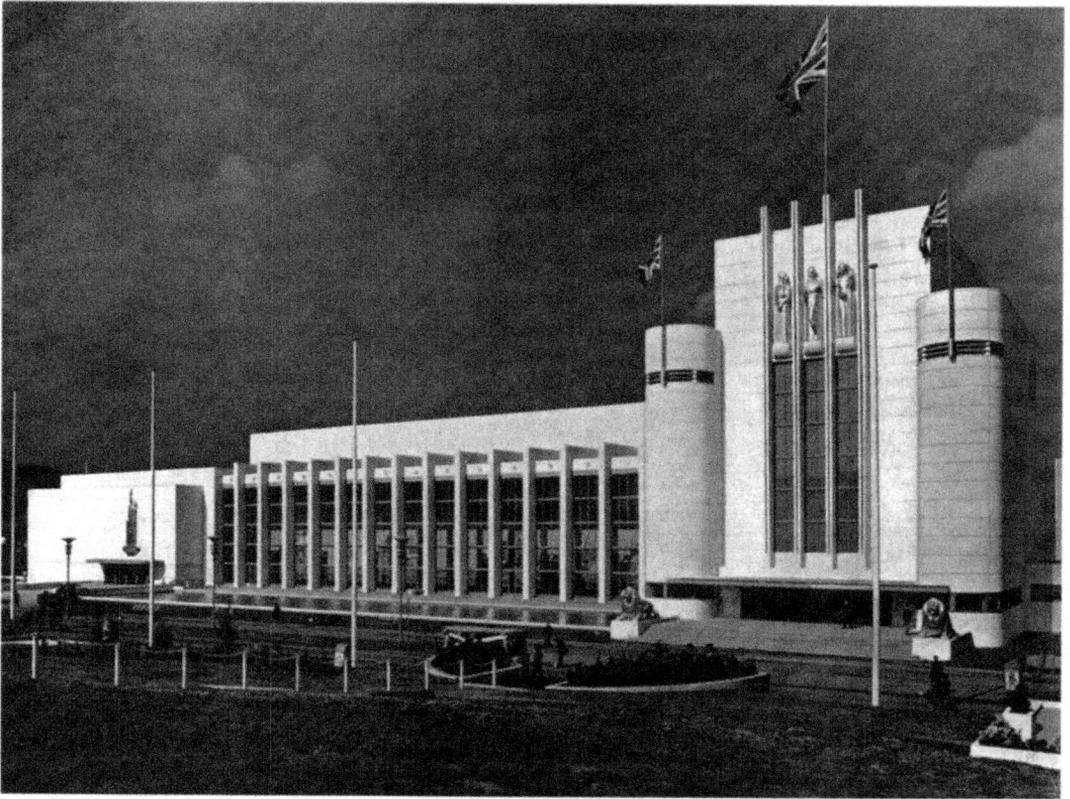

4.12 United Kingdom Pavilion, Empire Exhibition, Glasgow 1938 (Herbert Rowse).
Architectural Review, July 1938

in the kiosks, information stands, signposts, lamps and litter bins. This extended
to matters of construction. Tait was anxious to emphasize the fact that the
buildings were steel framed and prefabricated and could be easily erected and
dismantled. Consequently, it was these conveniences, not a passing fashion,
which inevitably led to buildings that were 'long and low, because light
steelwork lends itself to big spans … [with] great sweeping lines, partly because
steelwork is suited to the purpose and partly to take advantage of the effect of
dignity and lightness which can be so obtained'.[90] And this determination by
materials meant that 'architecture, like politics, is international'.[91] Everything
here seemed to be said, and perhaps designed, with the consciousness of
Wembley as an anti-example behind it.[92] As well as materials, standardization
ruled the size of components and the design of the smaller buildings.[93] The
standard module was manifested, for instance, in the grid of sheathing
materials forming the exterior skin of the United Kingdom Pavilion. So
modernism was directly linked by Tait in Glasgow with modernization, both to
be summoned up as the inevitable accompaniments of empire as a corporate
enterprise: modernity of production, contemporary in appearance.[94]

 Not all of the Glasgow exhibition was modernist, however. The South
Africa Pavilion was in a Dutch colonial style with stepped gables and tiled

roofs, but apparently more discrepantly, a highland village, An Clachan, was situated on a minor tributary of the exhibition to the north-west (fig. 4.13). The village consisted of a concatenation of buildings from far-flung rural parts of Scotland – a 'black house', a 'big house', a smithy, a church and a castle – with their external walls made from plaster casts of old cottages and a scenic painting of a loch to establish their landscape context. Effectively, then, Scotland's own past seemed to be taking the place that had normally been given in international exhibitions to ethnographic reconstructions of non-western cultures. But I want to develop John MacKenzie's suggestion that this village 'was meant to symbolise a historically distinctive genius ... which could be reconstituted for the modern world'.[95] If we understand modernization as part of the agenda behind the exhibit, this is well demonstrated by *The Highlands and the Highlanders*, specially written for visitors to An Clachan and prominently on sale there.[96] Together with essays on 'The Social Life of Clans' and 'Gaelic Literature of Scotland', the book also featured essays on water power, 'Land Settlement and Industry', communications and transport, and 'Economic Possibilities'.[97] Thus the highland village did not offer so much a contrast with the modernity of the rest of the exhibition as a complement to it.[98] Indeed, the village included a model dwelling of the future, intended to show how a cottage might be modernized yet remain in harmony with its highland setting.[99] If the United Kingdom Pavilion still represented the 'heart of empire' and the exhibition as a whole the vigorously modernizing satellites of that centre, with Scotland as the most prominent, then An Clachan stood for the periphery. It stood, to put it differently, for things like roots, identity and memory, the local and the national. But it also stood for the necessary economic development of that periphery and was a reassurance of enduring continuity and stability – the village *and* the empire – despite this process. In other words, it was an exemplary balance that was presented in An Clachan, and one of the audiences for this was the rest of the empire.

The exterior of the British Pavilion at the New York World's Fair of 1939 offered the most severely modernist appearance of any of the interwar pavilions (fig. 4.14). As two buildings, linked by a bridge over a road, the pavilion rose by a sequence of increasingly higher volumes from south to north. The monumental southern entrance followed the Wembley model, but was both more baroque and more abstract, with prancing lions guarding two flights of external stairs screened by an undulating colonnade of vertical panels. All surfaces of the main building were covered with a grid of rectangular panels and the horizontal elements of the building were emphasized by long ranges of ribbon windows establishing a severe and monumental presence. However, inside, both buildings were organized into a complex sequence of differently shaped rooms, a gamut of room shapes much more like a Robert Adams town house: round rooms, apse-ended rooms, rooms with screens of pillars and niches, fan- and kidney-shaped rooms, and rooms with multiple shallow recesses. As the *Architectural Forum* commented, it was 'an attempt to combine British good taste

4.13 An Clachan, Empire
Exhibition, Glasgow 1938.
Architectural Review, July
1938

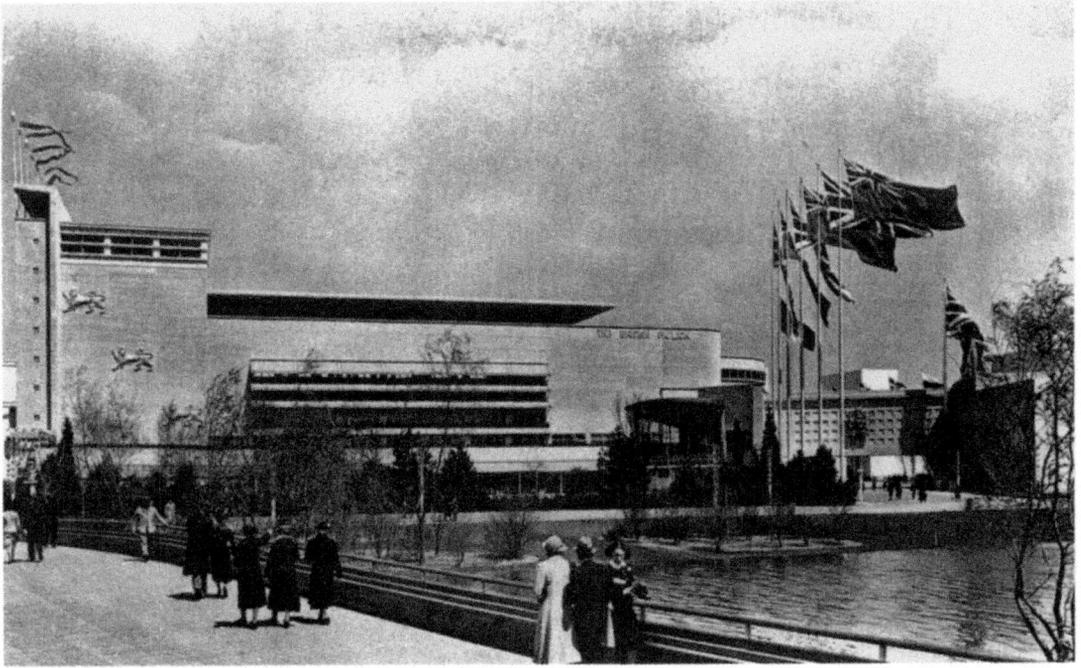

4.14 British Pavilion, New York World's Fair 1939 (Stanley Hall and Easton &
Robertson). *Architectural Review*, August 1939

with totalitarian monumentality'; it was 'good English compromise
architecture' noted the *Builder*.[100]

There was something about the anxiety to create exactly the right kind of
image through architecture and displays, an image that was both dignified
and modern however unfocused those concepts were, that threatened all the
interwar British pavilions with damp hubris, as if a little thunder would
upset all their pretensions. They seem to offer the opportunity to examine the
nature of the 'thickened metal of a weld between nation and empire',[101] and
the emergence of a coherent state-sponsored modernist interpretation of that
weld during a period both of empire's greatest territorial extent and of its
looming dissolution. It was as if the temporary buildings of exhibitions could
be considered 'the experimental spearhead of official architecture'.[102] And yet
by the end of the sequence – if the New York World's Fair is an end – we have
some of the same elements that we had at the beginning, some that have
taken root as the sequence unfolded, some new elements that are inconsistent
with a normal sense of what 'emergence' involves and some that are entirely
discrepant. What is apparent is the increasing centrality of the desired link
between the empire and modernization in industry, transport, education,
town planning and health. Despite the inconsistencies and discrepancies, and
despite a fair amount of incoherent compromise, it was the image of a truly
modern pavilion that had come to stand as a kind of promise of this link. But
'ferro-concrete is fallible', and perhaps steel framing too.

The commonwealth of architecture

In the summer of 1997 the Commonwealth Institute in Holland Park, West London, reopened its galleries to the public after nearly a year's closure. In this year of the handover of Britain's last colony and the fiftieth anniversary of Indian independence, the Institute's updated galleries (the 'Commonwealth Experience') featured 'Interactive World', where hands-on activities revealed the Commonwealth's natural phenomena, and the 'Heliride', a simulated flight over Malaysia's forests, paddy-fields and skyscrapers. The emphasis on travel, adventure and exploration ('a whole world under one roof') was the latest incarnation of an institution that had always struggled to establish itself in the public imagination. For visitors of an older generation, like myself, it is remembered as a place for school visits and lessons in the new Elizabethan geography that by the 1960s had replaced a world map no longer painted pink. Otherwise it is best known as one of the major modernist public buildings to be built in the immediate postwar decades. Its spectacular hyperbolic paraboloid roof, and the rather less spectacular aluminium-sided walls beneath, both propped up by concrete struts or what seem like giant clothes pegs, all might be taken to embody the hope of a new postwar, post-imperial settlement. Of its parent building, the Imperial Institute in South Kensington, nothing now remains save the renamed Collcutt Tower, a lost Victorian lighthouse or folly in the determinedly unostentatious campus of Imperial College. In their foundation, demolition and rebirth, these institutions span a period from the last decades of the nineteenth century to the 1960s, years that also cover the long unravelling of Britain's imperial estate. Generations of home counties schoolchildren have tripped, coach-borne and crocodile file, through these precincts to learn about their place in the world. And, as that world has changed, the lessons of imperial geography have been overlaid by other official models such as the Commonwealth family and multiculturalism. The story of both institutes is not one simply sundered by a sudden change of name and building, but instead one of an almost continuous shifting of policies and presentation as the search for a suitable project was constantly overtaken by the changes of imperial and post-imperial history.

This chapter describes how both institutes set out to represent the world – or at least the British imperium and then the Commonwealth – to a western public as a set of inevitable relations between products, geographies and spaces within the gallery and beyond it. The chapter touches on the displays within these buildings, particularly the relation between the narrative or spatial orders created in the two institutes, the great shifts of rhetoric required, and the consequent re-ordering of their galleries as the larger political situation changed. But the larger concern is with what happens to architecture, and to its relation to display and to other aspects of the built environment, as a metropolis passes from imperial centre through 'British Commonwealth of Nations' figurehead to 'Commonwealth of Nations' member – in other words, those changes within representation that relate to decolonization but also maintain continuities within new guises.[1] As urban objects these institutes were part of various metropolitan scripts or textures. They did not signify in terms only of their own object-world and the world of which they attempted to be representative, but also in terms of the urban space where they and their visitors were positioned. The Imperial Institute and the Commonwealth Institute therefore provide the book ends for this chapter – one taken to be paradigmatic of imperial spatial practices, the other as offering a notional 'commonwealth architecture'. Between these two the chapter presents certain intermediate propositions of the 1950s – amongst them, the Picturesque and antimonumentality – as they were manifested in the Festival of Britain, the replanning of the area around St Paul's in the City of London, and in the new Imperial College scheme. If not necessarily explicitly related to the 'end of empire', these might be taken as a register of various responses, conscious and subconscious, to it.

The Imperial Institute

The Imperial Institute's early history is marked by the search for an identity and function to justify its name, its site and its building.[2] It was set up in part as a monument to Queen Victoria's Jubilee, but more importantly, and in a deliberate echo of the South Kensington Museum's relation to the Great Exhibition, it was to give permanent form to the success of the Colonial and Indian Exhibition of 1886, on whose very site in South Kensington it was built. The Institute was the product of the increasing desire of commercial, industrial and government interests to foster a more self-aware imperialism geared to the systematic exploitation of imperial resources. But although it was conceived as a central clearing-house for the collection and dissemination of information on imperial resources, this was not initially envisaged as an activity solely or even principally focused on objects. It could, for instance, take place in the form of a gentleman's club, through research into materials, or through the distribution of information to schools and industry. The building had to cater for all these functions.

The Institute's building was designed by T. H. Collcutt and built between

1888 and 1894, using brick, terracotta and stone in a flamboyant amalgam of Renaissance styles given some order across its façades by a decorative grid (fig. 5.1). Its long symmetrical frontage faced onto a new road cut through the museum area of South Kensington. This area had become closely identified with imperialism, another one of the symbolically important nodes within the 'heart of empire'. Here, following the Great Exhibition of 1851 on the south side of Hyde Park, two succeeding exhibitions had been held in 1862 and 1886. More permanently, an axis of cultural institutions and monuments had been established running southwards from the Park to Cromwell Road: the Albert Memorial, Albert Hall and the Natural History Museum, with the Victoria and Albert Museum flanking them to the east. Together these celebrated the figureheads of empire and housed the huge collections that embodied its knowledge and cultural capital. At the centre of the new Imperial Institute, behind and above its entrance portal, rose a high tower visible from many points across 'Albertopolis', as this area came to be known. While the entrance and tower were placed in line with the axis of pre-existing imperial buildings, this same placement actually prevented any perception of that axis from being apparent on the ground. It was implied but fully made available only to a god-like viewer.

The Imperial Institute, like most Victorian museums, had all the markers of a space differentiated from its surroundings. These markers – the Institute's non-exhibitionary public spaces – clearly played a crucial part in

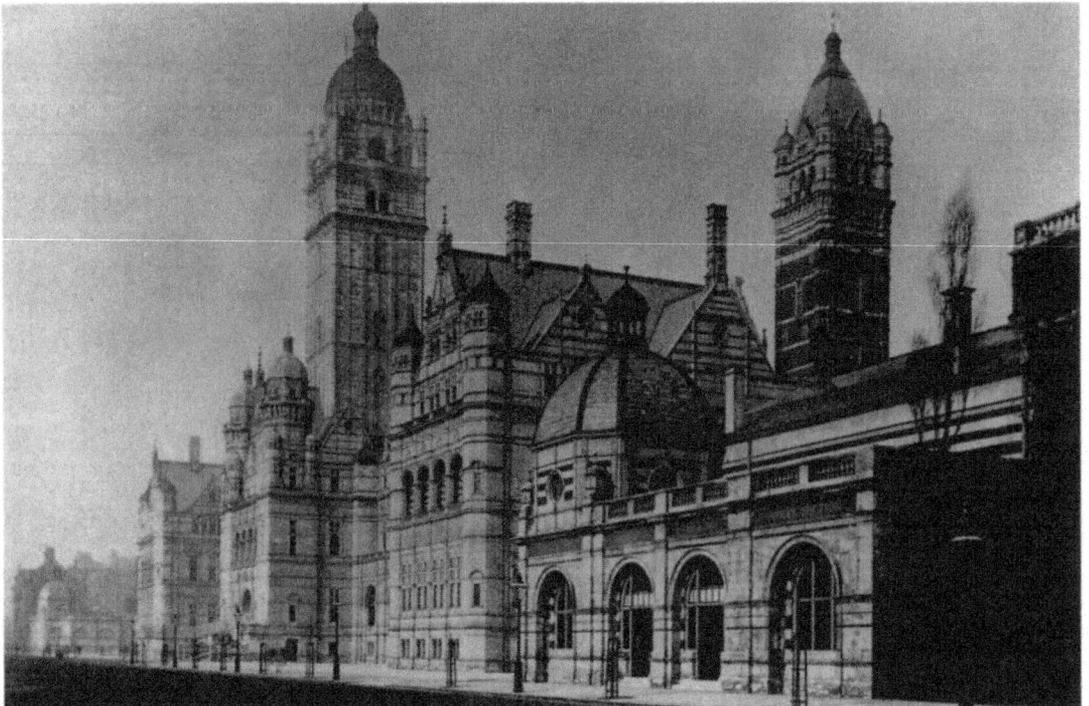

5.1 Imperial Institute, London (T. H. Collcutt, 1888–94)

the perception of the Imperial Institute, but they also established the terms on which the public expression of imperial subjectivity itself was to depend. That is to say, the Imperial Institute constituted its ideal viewers in large part through their experience of its particular temporality and spatiality, indeed through its very materialization of the notion that time and space were separate but intersecting axes of knowledge.

The imperial subject

What I am interested in understanding with the Imperial Institute is both its performative aspect as an institution embodied in a building, and the normative experience of visiting it at particular times in its history. These are, of course, precisely those aspects of display spaces that have concerned recent theoretical accounts of museums.[3] The visitor's experience must have contained all the variables of personal history, as well as the expectations determined by culture and class, and these are properly the subject of sociological analysis. But it was also shaped, positioned and consummated by the sensory and cognitive conditions of the place itself. To think in this way is to reject the idea of architecture and display spaces either as reflections of pre-existing conditions or as mere representations of ideologies.[4] It also enables a rejoining of the architecture of the museum, or a museum-like building, with the spatial disposition of its displays. The 'reading' of building forms is thus experientially inseparable from the 'reading' of curatorial scripts, however separable their original intentions might have been. To describe the Imperial Institute, therefore, as representing through narrative the world of the British Empire is to argue that an imperial subjectivity was conveyed to visitors through the temporal and spatial experience of the Institute itself. A normative mode of visiting was defined by the Institute: certain forms of comprehension were laid out, certain routes were encouraged, whilst other gambits were disallowed. But this should imply neither that the Imperial Institute's narratives were unchanging, nor that they were fluent and seamless.

Inside, the Imperial Institute possessed a surplus of hall and corridor spaces devoted to reception and procession around the building, with the galleries very much treated as adjuncts to these ceremonial spaces. The Great Hall, for instance, was symbolically at the heart of the building in the original conception but functionally only an easily discarded appendix (and in fact never built – instead the temporary hall erected for the opening ceremony in 1893 remained in place until the demolition of the Institute in the 1950s). The Great Hall was to embody the memory of the Institute's inauguration and of its relation to the exhibition hall of the Colonial and Indian Exhibition. It therefore also had strong links with those Durbar Halls that were used to mark the triumphs of the imperial economy and to house theatricalized acts of incorporation.[5] This might be compared, looking forward, with the later Commonwealth Institute, which reformulated its predecessor in dialogue

with the utopian exhibition structures of the Festival of Britain (1951), most notably its popular pavilion, the Dome of Discovery. But in the Commonwealth Institute, as we shall see, the great ritual meeting place was conceived of as inseparable from, indeed as a physically central element of, the spaces of exhibition.

On the Imperial Institute's principal floor a corridor ran the whole length of the building, but the ground floor of the main building demonstrates its surplus spaces even more clearly (fig. 5.2). Here the exhibition rooms were made physically peripheral to the wide corridors. These corridors, with the recess space in the front of the building, occupied nearly half of the depth of the building. Their very scale implied a processional use. Furthermore, as the galleries were arranged in enfilade, movement between them was largely independent of the corridor. What then was the corridor for? Or, for that matter, the entrance steps and hall, the areas under and around the central tower, the intermediate hall, the intended Great Hall beyond it, and all the excessive spaces given over to the staircases?

Suggestive answers to these questions might be found in the early publicity images of the Institute (fig. 5.3). In the first guidebooks and reports about the Imperial Institute its reception spaces were made into the dominant visual record of the building. In the series of engravings that illustrated the first guidebook, for instance, the visitor was imagined as a body in movement on a journey around the building, but the journey did not include the galleries.[6] The stopping-off points were the central tower, the principal entrance, the Great Hall, the vestibule of the Great Hall, the principal (west) stairway to the first and second floors, the principal corridor and a doorway in the corridor of the principal floor. Two engravings followed these: an external detail and an internal view of one of the conference rooms. Otherwise the visitor's only other visual images of the Institute were floor plans. To some extent this curious way of recording the Institute can be explained by the fact that its gallery space was still being allotted and displays had not yet been arranged. But this does not explain the absence of any images either of the galleries or of the objects that might be housed in them. Instead the guidebook pushed the idea of the Institute not only as a place to see in and for itself, but also as a place to be seen in, a place for a particular form of socialization. The Institute was first imagined from a distance as a tower separated from its context and then as a place ideally imagined for slow observant movement up flights of stairs, through grand arched entrances and beneath tall coffered vaults or panelled ceilings. The guidebook tells us that surfaces were made up of diversified materials, carved, polished or otherwise embellished. Echoing the Great Exhibition and the Colonial and Indian Exhibition, their placenames and forms of craftsmanship indicated the world as quarry: there was Hopton Wood and Portland stone, Indian teak, Irish and other colonial marbles, arabesque work, mosaic floors, bronze balusters, wrought-iron grilles, and Derbyshire fossil panels. Such a motley collection of materials can be seen as reinforcing the message of the external architecture: that, like the picturesque silhouette of gables, domes, towers and other surfaces, the materials connoted the vitality and diversity of empire.

GROUND PLAN OF THE INSTITUTE BUILDINGS
SHOWING THE PROVISIONAL ALLOTMENT OF SPACE.
The additional spaces allotted to the various Colonies
for Sample Stores are not indicated hereon

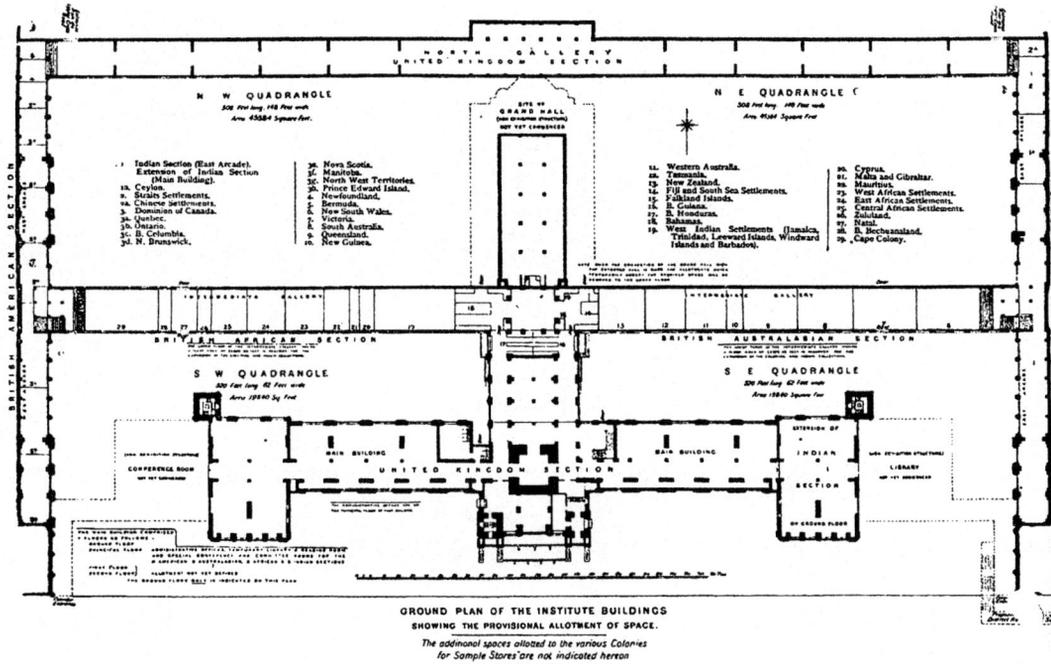

5.2 Imperial Institute, plan

These representations were one facet of the Institute as an information machine and of its role as part of an empire, a 'collective improvisation' united in one dimension by data collection and the vision of an imperial archive.[7] Another facet was the number of ways used to establish contact and discussion with other colonists and colonials in its variously accessible rooms. Above all, to return to the engravings, every space of the building was seen to open onto another, indeed to be incomplete in itself, part of a sequence that led onto, but was never completed by, either some consummating place or some other order of objects. There was always another arch to pass beneath, a half-glimpsed room to reach, another expanse of marble pavement, a staircase to mount, a corridor to pass down, another threshold to cross. Even the Great Hall, which in plan can clearly be seen as a terminal space in the centre of the site, was presented in the engraved view looking back at its point of entry as if its entrance was an exit.

The galleries themselves – represented in the guidebook only in plan – were shaped into a sequence of spaces that was more apparent in its symbolism but just as much lacking in a space that would consummate that symbolism. Like the galleries of the British Museum (laid out between 1823 and 1847) the Imperial Institute's galleries represented a global circuit. They exploited the capacity of architecture to refigure the world as something to be experienced within the spatiotemporal constraints of the western body. And in display spaces what this meant was that the emphatically established

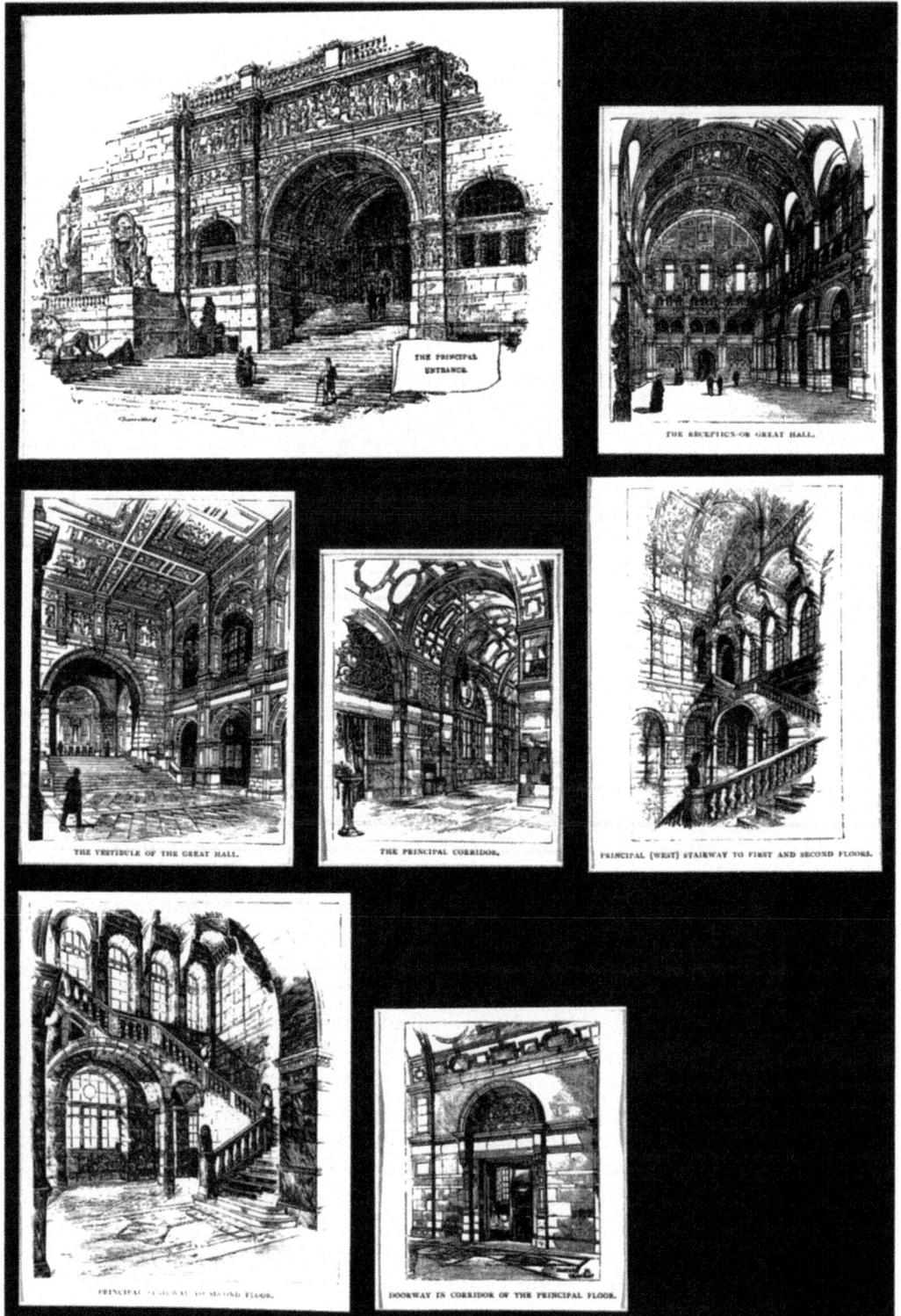

5.3 Imperial Institute, interior views. *The Imperial Institute of the United Kingdom, the Colonies and India*, 1892

borders of the precinct, by creating a sense of imagined segregation, enabled and enhanced the seemingly all-encompassing geographic vision of the galleries within. At the Institute the five continents of the world were mapped upon the primary compass directions of the site: the United Kingdom to the north (as well as the galleries either side of the entrance), British India to the east, British Australasia and British Africa to the south, and British America to the west.[8] One might say, with Tony Bennett, that the experience of the Imperial Institute's reception spaces was an 'exercise in civics'.[9] They were spaces that existed to enable the observation and thereby the self-regulation of behaviour. Once inside the galleries, however, the visitor's experience was to be both more contemplative and more self-aggrandizing.

The public galleries housed the 'Index Collection': a collection cataloguing the natural, industrial and commercial resources of the empire, and embodying those resources through a range of typifying instances. This Index Collection was keyed to a 'commercial collection' of bulk samples stored on the ground floor. Between the two, sample examination rooms were provided where visitors could inspect items they had seen in the galleries. Access to each level of sampling depended on a movement from a distanced aesthetic form of perception to a sensory, especially tactile form of judgement through measurement and inspection. Representation of samples in the Index Collection was thus linked by comprehensible stages through the spaces of the Institute's commercial collection and sample rooms to the greater resource space of the empire.

It was the misplaced desire for the effect of aura in this early approach to display that was the cause of its inadequacy. It was, after all, merely a spectacle of commodities.[10] In the mid-1920s a radical rethink changed the form in which objects were displayed in the Institute's galleries and led to a consequent marginalization of the Institute's role as a research centre. The change, to use the Institute's own terms, was from an 'index collection' to an 'empire story-land':[11] from the attempted taxonomy of goods to an exhibitionary narrative, from a knowledge of resources for their exploitation to a knowledge of resources so as to become good empire subjects. In this displacement of the archive by allegory, what had previously been presented to supply knowledge now existed to be decoded: 'covering over the exploitative and violating aspects of colonialism by ostentatiously pointing at some other rusing thing'.[12] After 1926 the great bulk of samples or indices at the Institute were located in a sample room where they were designated largely for the use of scientific research. The public galleries continued to exhibit a selection of these samples, but the country courts (the change of name from 'section' seems to have occurred at this period) would now be focused on Wembley-inspired dioramas depicting in miniature a typifying scene of the country through a combination of picture and model: an 'oil field in Burma' for instance, or 'cocoa industry on the Gold Coast'.[13] In this new story-land technique each place represented the stages from raw material to finished article, linking the everyday life of the imperial centre – the British

subjects interpellated by the display – to the origins of these western commodities in the exotic life of primary raw materials in the overseas periphery.[14] Above all, the stories shared the trope of harmonious co-operative endeavour binding together 'the interests of the primary producer with those of the merchant, the manufacturer and the consumer'.[15] A newly instructive, narratively coherent and more sensually pleasurable mode of viewing the objects in the galleries had been instigated.

At the Institute the new changes clearly paralleled the new political consensus after the First World War that a 'British Commonwealth of Nations' should replace the fragile British Empire, that rule from the centre or by bodies formed from the centre was to be transformed into a British-led consortium of economically co-operative countries.[16] A 'British Commonwealth' now seemed to have far more benevolent implications of common interest than the empire, with its associations with Roman and even German military might. Thus, for instance, the drift away of white-settler dominions might be forestalled. 'The evolutionary process of the transformation of Empire into Commonwealth ... ', as the historian Nicholas Mansergh has written, 'meant that there was no dividing line between Empire and Commonwealth but instead a protracted process of transition during which the two existed side by side, together appearing ... as neither Empire nor Commonwealth.'[17]

The final change in the Imperial Institute's mode of display took place in the years immediately after the Second World War. The change can be seen either as a last-ditch attempt to reform the Institute in response to Britain's diminished imperial role or as a pre-emptive move in its dissolution and reconstitution as the Commonwealth Institute. Again it parallels another shift in the political consensus, from a belief that Britain led a system of nations to a post-Second World War perception of Britain as one amongst a group of freely co-operating equals – the 'Commonwealth'. The very terms 'empire' and 'imperial', as used in the names of London-based organizations and businesses, went through a sharp decline between 1940 and 1950 (usually 'international' was the favoured replacement).[18] Empire Day became Commonwealth Day in 1958. In 1949 the Imperial Institute became the responsibility of the Ministry of Education, finally recognizing its conversion from commercial and research activities to educational purposes. From 1950 to 1952 Lord Tweedsmuir conducted a Committee of Inquiry on the activities of the Imperial Institute and its relation to the postwar state of British imperialism. Tweedsmuir advocated a final and decisive shift, from 'products to persons',[19] in the Institute's gradual movement from imperial research to Commonwealth educational centre. In the following years a modernization campaign was conducted along the lines of the Tweedsmuir Report. The result was a new Commonwealth story-land in which the polyglot Commonwealth family was ostensibly the primary subject of the display.[20] In practice the new displays seem to have attached ethnographic images to the modernized stories of economic products, barely even redeploying the old materials. Even so, the displays and what they represented and implied had now become radically out of step with their architectural surrounds.

Decolonization and the metropolis

Decolonization is still only just beginning to be studied in terms of its cultural impact upon the metropolis.[21] Independence did not, of course, mark a complete break either for the former colonies or for the colonial power, and colonial cultures might continue in diminished form or, more often, be transformed into areas of incipient neocolonialism. Indeed the first large-scale processes of decolonization in the postwar years took place at the same time as neocolonialism gathered force under the new world monetary order declared by the Bretton Woods Agreements of 1944, which had set up the World Bank and the IMF. Decolonization itself might be understood less as a process than a scattered and sometimes separately occurring group of events, which did not necessarily lead to a common outcome: anticolonial campaigns, constitutional changes, shifts in consciousness, new forms of collaboration and the breakdown of the global colonial order.[22] Although some of these events might be co-ordinated from the metropolis as a kind of 'junction-box',[23] or the metropolis might provide a place for future anticolonial leaders to study and for certain forms of post-colonial culture to emerge, whether the metropolis registered these moves and changes in its built environment is a more intractable subject. A first reaction to this might be to question if the spaces, monuments and buildings of the metropolis could significantly register events that might seem to threaten the metropolis's own standing, especially when these aspects of culture are capital-intensive; demanding of time and investment they are inevitably dominated by the interests of more established forces in society. In the postwar metropolis, amongst the effects on the built environment of decolonization within the empire, there were occasional acts of name-changing of buildings and streets and even the occasional breaking of symbols, though in the main the overt traces of imperial history and the image of the 'heart of empire' remained (and remain still) remarkably unaltered and unchallenged especially by comparison with newly independent ex-colonial cities.[24] There were no monuments marking significant events or people in the processes of decolonization.[25] The idea that architectural form and urban space might themselves be reconceived to redirect the imperial legacy, even to signify post-imperialism, was rare but it can be detected as one of the intentions of the new Commonwealth Institute building and, if less explicitly, of the buildings that replaced the Imperial Institute on its site. Before discussing these schemes, however, I want to tease out some other possible links between decolonization and postwar architecture in Britain. These are links in which decolonization and independence movements hardly figure; the point is rather that dealing with Britain's postwar status and aspirations might mean a process of 'disimperialism': an attempt to bypass the whole empire thing and to establish a different relationship to the 'heart of empire'.[26] This was a path of some consensus: it could include those who simply wanted continuity but without news of disruption, those who would reform empire with a tide of

modernization, and those who might wish it away, seeing it as an irrelevance to 'Modern Britain'.

The idea that architecture, at the heart of an empire, might resonate with the effects of that empire's dismantling, is not one that can be found in the writing of critics and architects, nor indeed in the work of historians. British postwar architecture has been the subject of an increasing number of major historical studies, most notably on schools, public housing and new universities, but none of these studies have regarded Britain's contemporary imperial situation as worthy of much notice. It is as if the immediate problems of reconstruction and the opportunities of the new welfare state had pushed the imperial nexus out of the picture, or as if Britain had emerged from the war standing alone, its imperial self-image as well as its colonial possessions dropping away in the face of self-evident historical logic. To some extent, the Festival of Britain exemplifies this engineered amnesia both in its time and in its place in written history since then.

If the colonies were not excluded from the Festival of Britain, they were certainly marginalized. There were no colonial exhibits and no colonial pavilions in the Festival's main South Bank site. Instead, in a decision made seemingly in order that the colonies would have as little impact as possible on the public consciousness of the Festival, colonial displays were staged at the Imperial Institute. Not only was the Institute, as we have seen, going through a critical re-examination of its role at this time, it was also an entity of the past with no new public face to equate it with the modernist pavilions and planning of the exhibition on the South Bank. So however forward-thinking those displays at the Imperial Institute might be – using photographs and models of new architecture to suggest the rise of new forms of democracy, for instance – they were constrained by their location and had a negligible impact within the Festival.[27]

Elsewhere in the Festival of Britain, especially on its main site, imperial thematics and images generally were kept distanced and have not been commented on since, but a closer analysis can find them at least invoked and sometimes even actively overthrown. The Dome of Discovery and the Royal Festival Hall have usually been seen as buildings that stand for the emergence of modernism into official and public approval, a new empiricism that mixed 'engineering touched with magic' and continental felicities of form.[28] Yet the experience framed or organized by these buildings, and their relation to previous exhibition buildings, indicate a complex relation to the imperial optic. Both the Festival Hall and the Dome drew upon the architectural types, as we saw in the last chapter, that had dominated British national pavilions over the preceding quarter-century: the temple-fronted pavilion and the domed Court of Honour. But although these types are still clearly apparent, they are separated out and stripped of the tendentious link between classicism and empire, most obviously in the matter of style, but also, I want to suggest, in terms of their particular use of space and the experience they expected of their visitors.

The Royal Festival Hall was built as part of the permanent renovation of

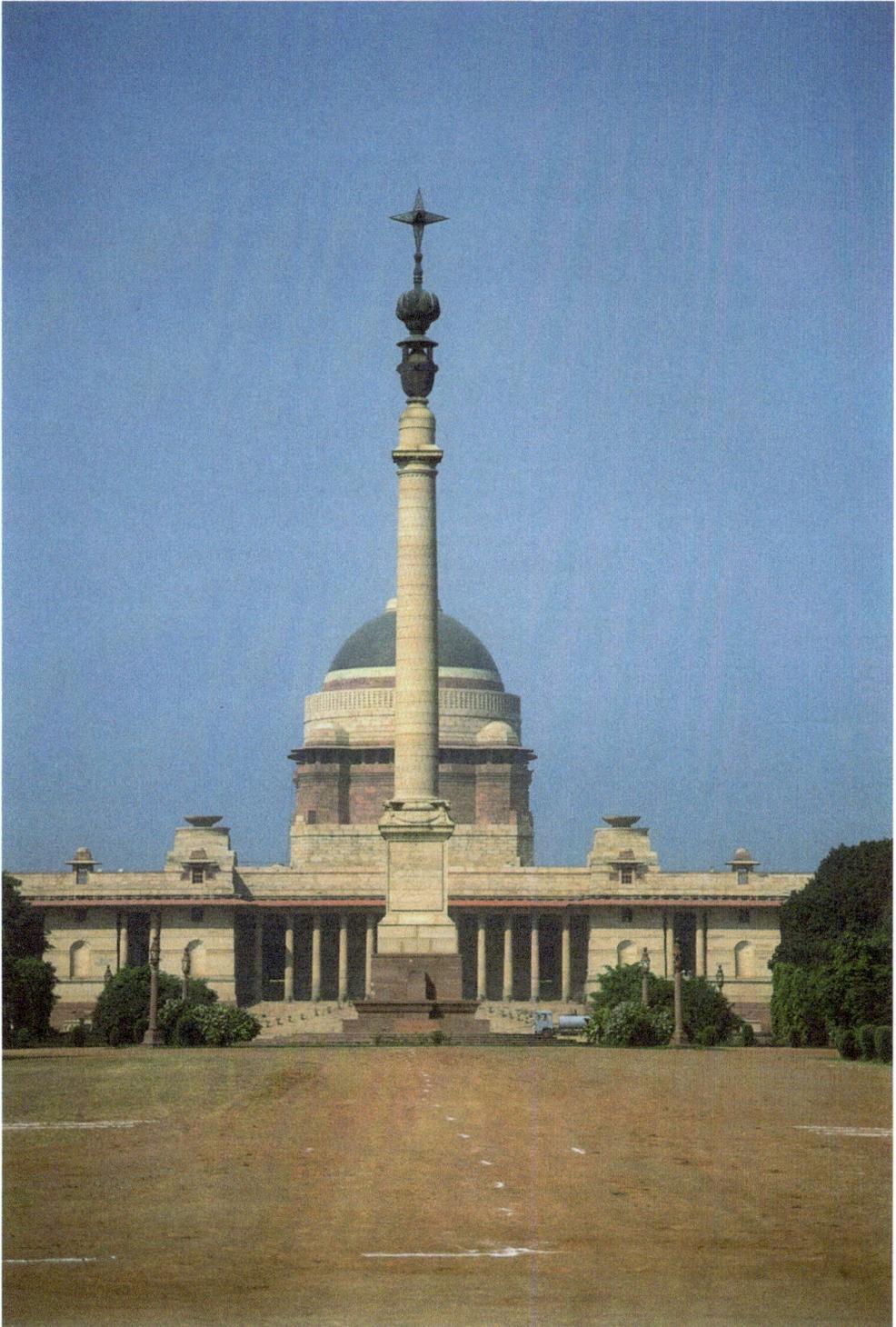

I *Viceroy's House and the Jaipur Column, New Delhi.* © Black, Franwyn / Architectural Association

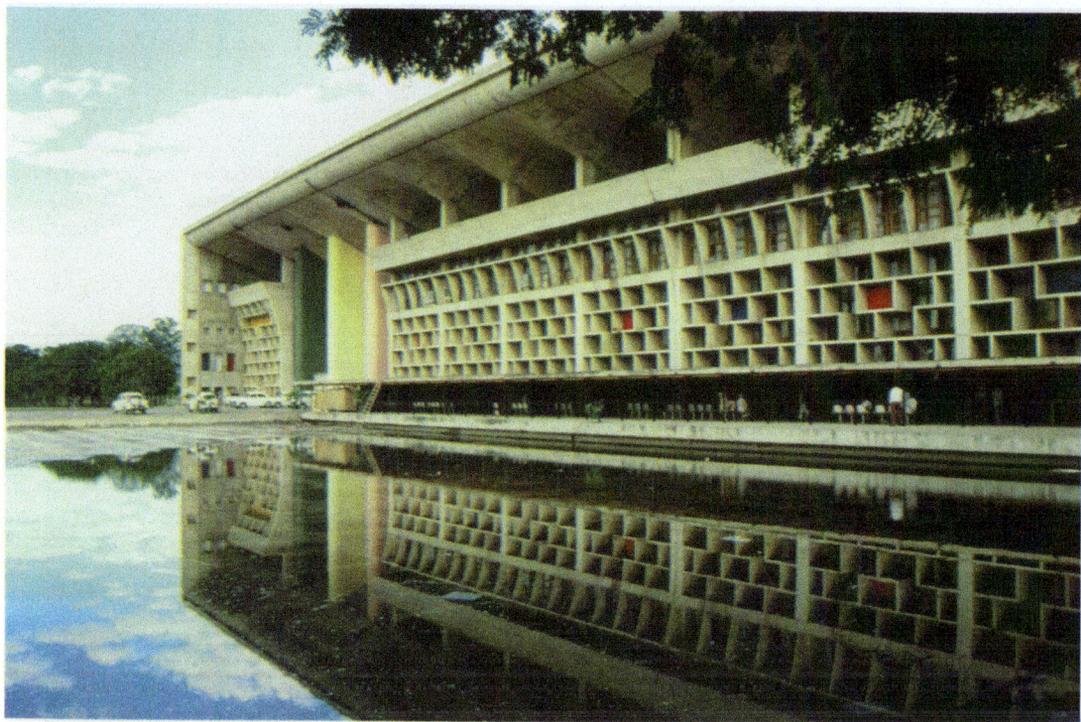

II *The High Court, Chandigarh* – photograph by Maxwell Fry. Jo Newson/RIBA Library Photographs Collection

III *Baghdad Railway Station.* By permission of Wilson, Mason & Partners

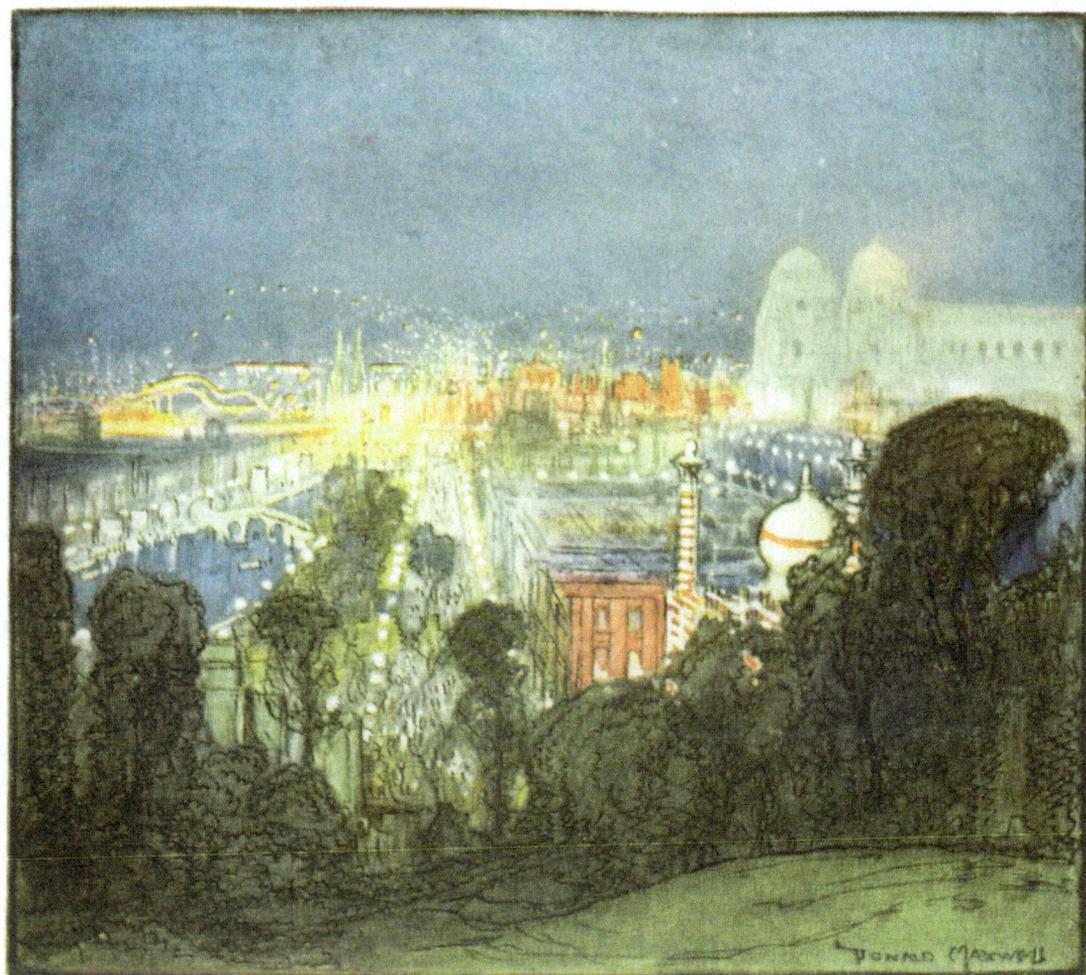

IV *Empire Exhibition, Wembley.* From Donald Maxwell, *Wembley in Colour*, 1924

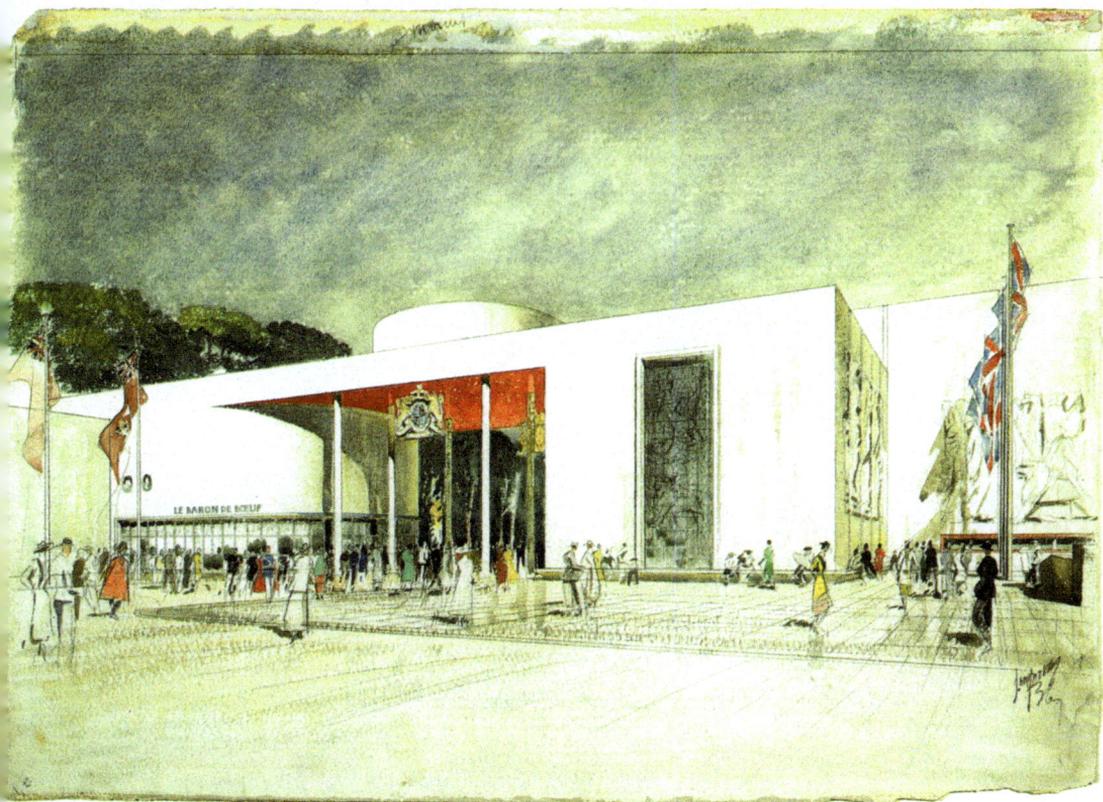

V *British Pavilion, Paris Exhibition, 1937.* RIBA Drawings Collection

VI *The Festival of Britain, 1951.* © Michael Cooke-Yarborough/Twentieth Century Society

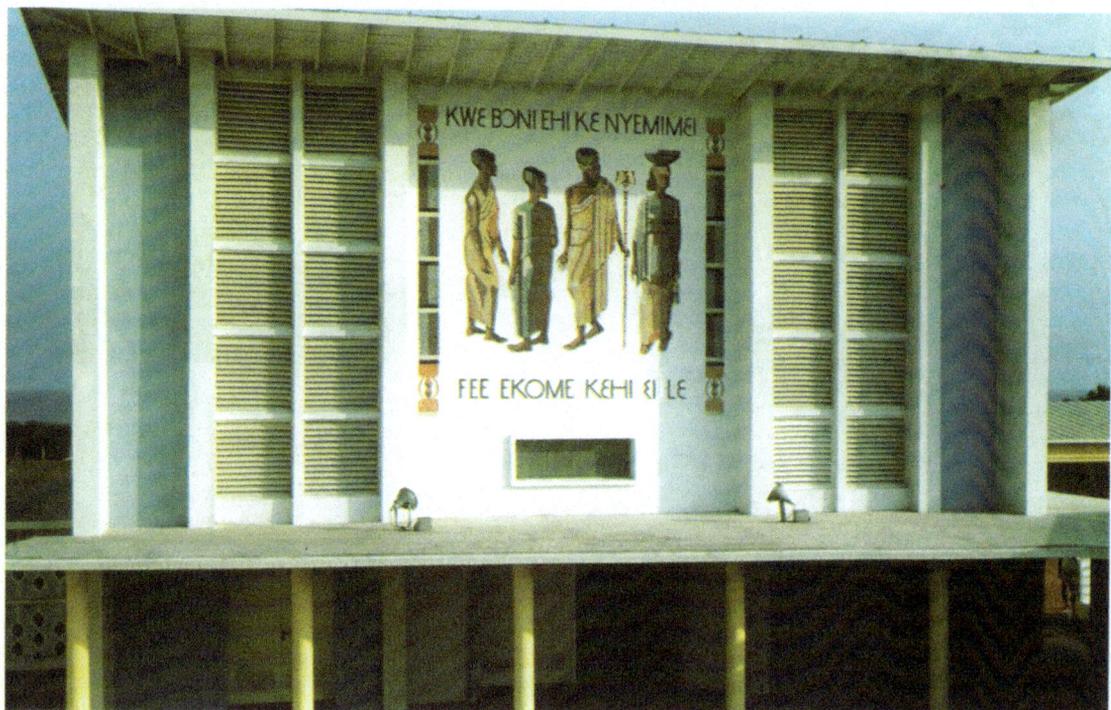

VII *Accra Community Centre, Ghana* – photograph by Maxwell Fry. RIBA Library Photographs Collection

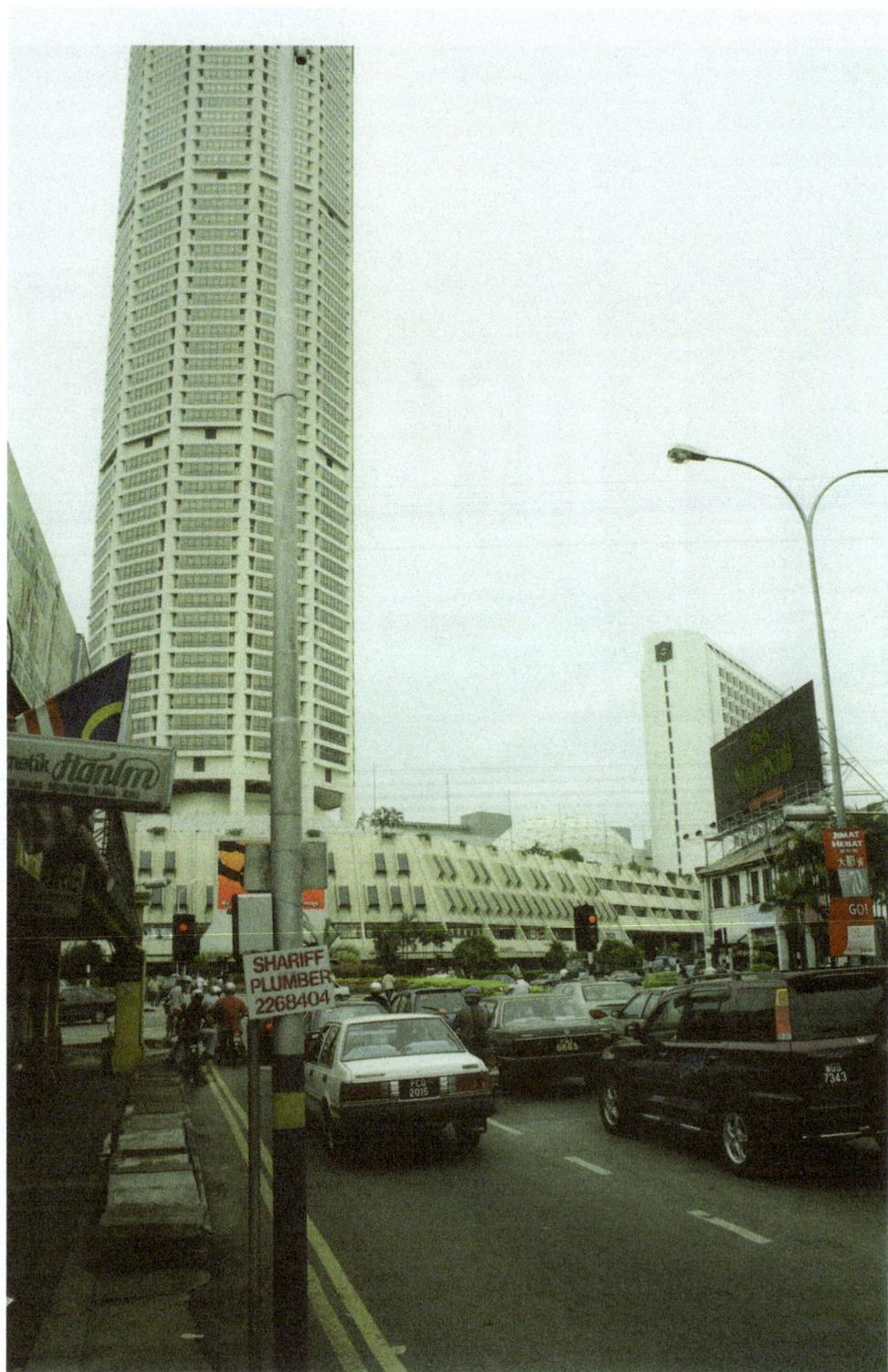

VIII *KOMTAR, Georgetown, Malaysia*. Photograph by the author

the site, and designed by Robert Matthew and Leslie Martin, with Edwin Williams and Peter Moro (fig. 5.4; see plate VI). The Hall was designed as a freestanding volume, glazed on three sides for the circulation spaces on the edges of the building, with a symmetrical front and the curved end of the auditorium projecting above it. The suggestion in the original building of a pediment, of a range of pillars within the glazed front, and even of a space for an inscription or a bas-relief in the curious stone apron directly beneath the auditorium, all indicated the trace memories of the temple front.[29] But inside the building, from its offset entrance to its light-filled spaces, these allusions to the historically charged relations between the visitor and the authority invested in a classical building were entirely eschewed. Instead of an interior formalizing the passage into a dominant auditorium, the designers lifted the auditorium above the main circulation space and this was opened up, from end to end, as a huge foyer offering itself as a spectacle of different levels and different passages through spaces, as well as dramatic vistas onto the river and the surrounding buildings (fig. 5.5). Although this kind of space has become something of a cliché in contemporary architecture, in 1951 it had particular resonances with social democracy. Freedom of space implied social freedoms of access. As Adrian Forty has suggested, the Hall might be seen as a 'theatre of the welfare state': 'a place where … there was the opportunity for the individual subject to enjoy the illusion of his or her own "equal social worth" through the view of others engaged in the identical act'.[30] There was clearly no overt imperial content here, but the kind of subjectivity implied by this space is entirely different from the visiting experience offered by the Imperial Institute, for instance. This issue is also directly relevant to parts of the Festival where empire was more obviously part of the content.

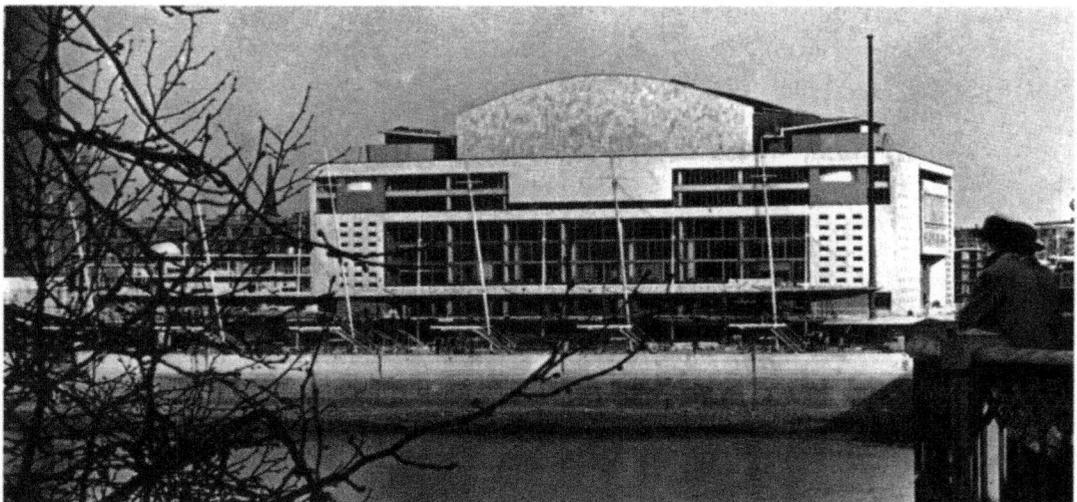

5.4 Royal Festival Hall, London (Matthew, Martin, Williams & Moro, 1951).
Trevor Dannatt, *Modern Architecture in Britain*, 1959

The Dome of Discovery might have evoked a number of the domes discussed in the previous chapter but at the same time it was placed on the ground without a clear directional axis. Designed by Ralph Tubbs, a smooth, low 111-metre (365-foot) diameter dome was supported by a structure of triangular ribs, but because the outer edge of the dome extended far beyond this structure it had the impression of being lightly suspended on a ring of leaning openwork struts. In the words of its guidebook, the structure was 'as adventurous, fantastic and technically triumphant as the history of British Discovery itself'.[31] 'Discovery', of course, had been a prevailing trope in accounts of imperial expansion, hallowed in the Elizabethan ships and other imagery that had decorated those interwar Courts of Honour. To a great extent the displays within the Dome of Discovery domesticated imperial discovery, and what had been its explicit link in the Imperial Institute with economic exploitation, into the 'neutral' and 'educational' sphere of popular science as well as the new model of the Commonwealth family (fig. 5.6).[32] The Dome included sections on the physical world, the land, outer space, the living world, the polar world, the sea and the earth. The section devoted to 'The Land' was the nearest that any part of the South Bank site came to those interwar displays of imperial links in national pavilions discussed in the previous chapter. 'The Land' was an account of how exploration led to the 'development of new lands' involving survey, the control of water, tropical medicine and pest control, but the inherently exploitative element of this was deflected by a display on 'Commonwealth Links' illustrating communication across the Commonwealth ('the great witness of British exploration') and conjuring up a cosy if widespread family ('Our sons and daughters have left Britain and set up their own homes overseas; our adopted children are coming into their own estates.') Yet the spatial experience of these displays within the Dome of Discovery, as indeed of other sections, was far from simple: the route around the interior of the Dome moved across several levels, around the outer perimeter and in and out from the two sections that took up the middle of the space.[33] Indeed I want to suggest that the one thing the Dome as a whole, despite its inherent spatial qualities and its historical typology, did not attempt to provide the visitor with was a sense of totality, a sense of the displays as a whole and, through them, of knowledge as constituting an encompassable whole; unlike the empire that had been represented under such domes previously. The route around the world provided by the Imperial Institute's galleries, or the maps of the world and Courts of Honour of interwar British pavilions, diagrammatized a relation between locations within one overarching system as a relation of power. By contrast, the dark spaces of the Dome of Discovery, with its displays breaking irregularly across the central space, enabled no clear orientation or correlation between the arrangement of the individual displays, the shape of the building and the world beyond it, however implicit this might be in the historical uses of the architectural form.

The South Bank site itself, a neglected section of curving land on the bank of the Thames, part bombsite and part industrial workings, had no imperial

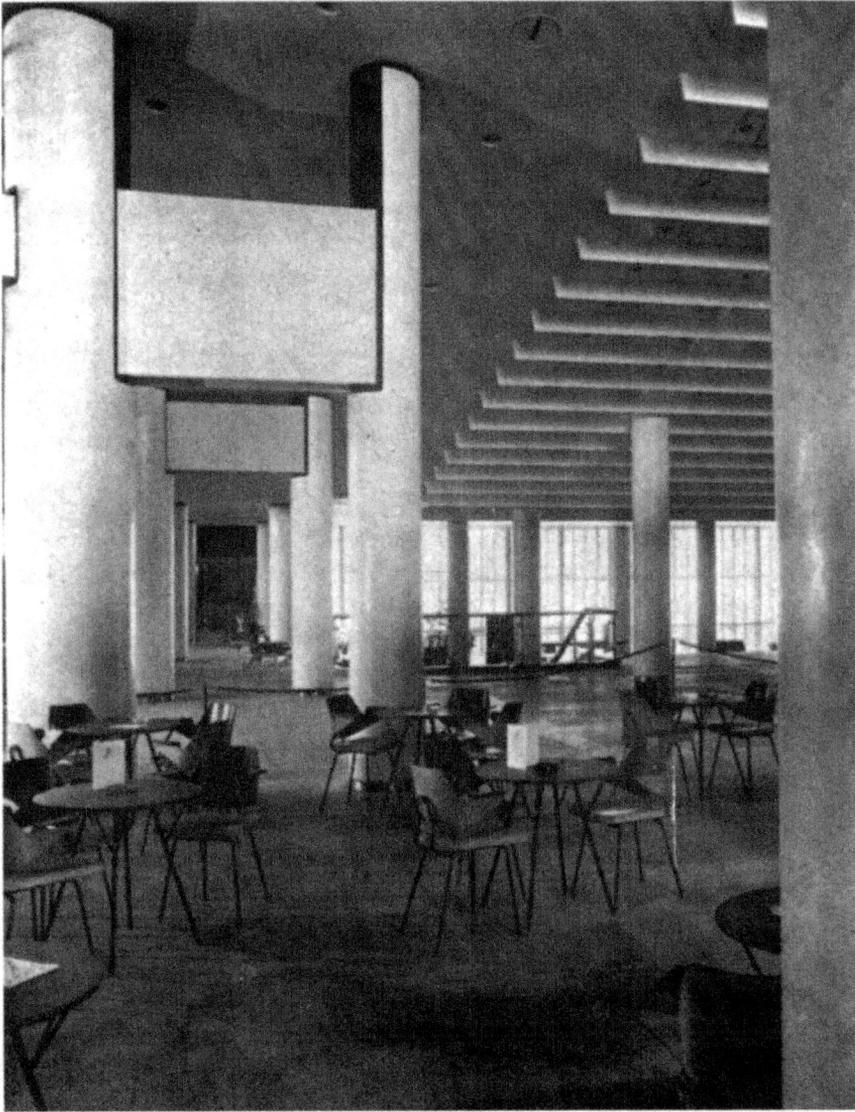

5.5 Royal Festival Hall, London (Matthew, Martin, Williams & Moro, 1951).
Trevor Dannatt, *Modern Architecture in Britain*, 1959

associations (fig. 5.7).[34] Although both the Houses of Parliament and the dome of St Paul's could be seen from it, the site had none of the potent engrained symbolism of South Kensington, for instance. Furthermore, the planning of the South Bank avoided the portentous axialities of other exhibition sites. The story told across the site, the official guidebook carefully advised, had 'a certain deliberate sequence ... [but] this is a free country; and any visitors who, from habit or inclination, feel impelled to start with the last chapter of the whole narrative and then zig-zag their way backwards to the

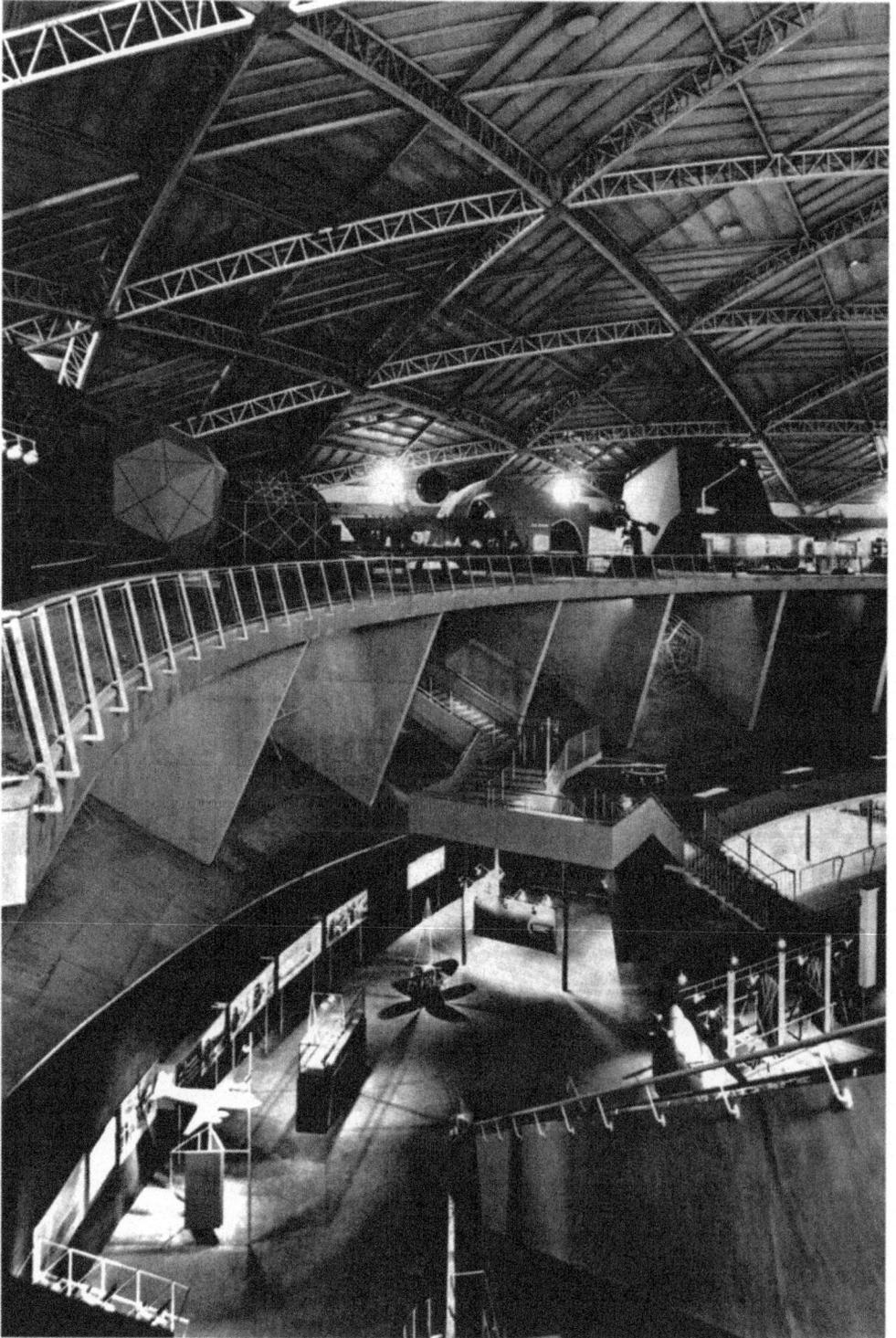

5.6 Dome of Discovery, Festival of Britain 1951 (Ralph Tubbs). Misha Black,
Exhibition Design, 1951

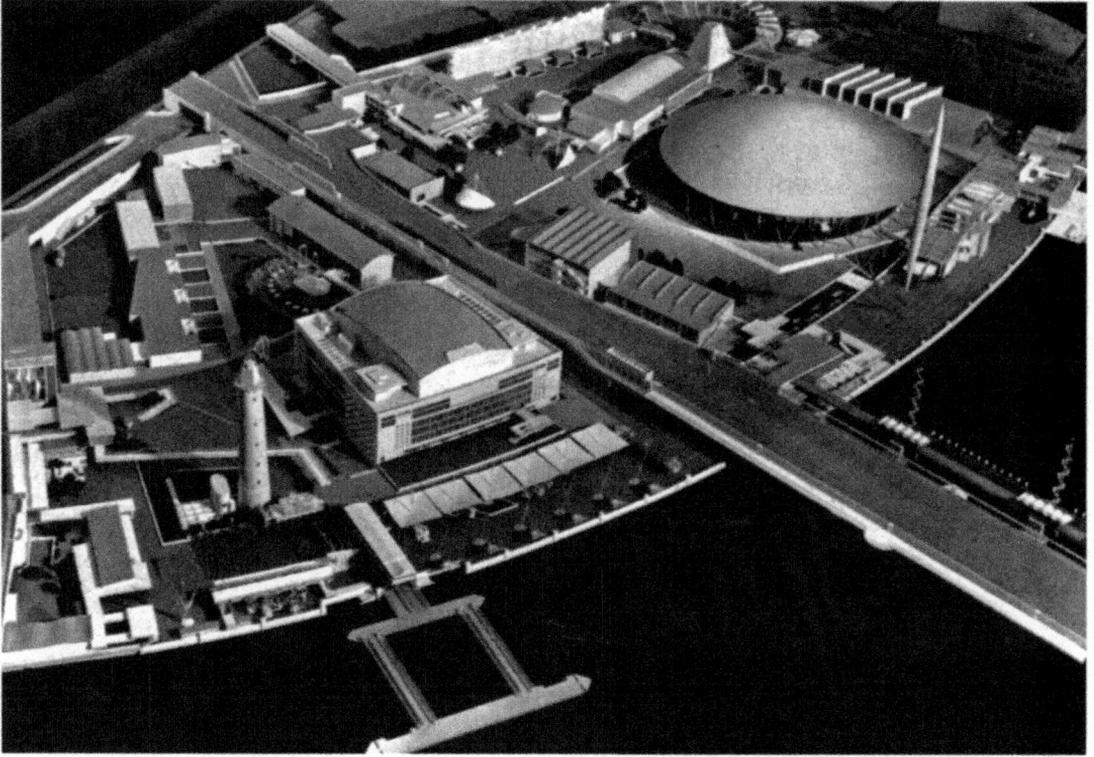

5.7 Festival of Britain, model layout, 1951. Ian Cox, *The South Bank Exhibition*, 1951

first chapter, will be as welcome as anyone else'.[35] And so the recommended route meandered largely around the outer edges of the site, buildings were entered by one shorter end and exited by the other, and even the Dome of Discovery was to be visited along a concentric internal path. There were no strong axes across the site, indeed it was split in two by an existing bridge, and the larger spaces were irregular and informal making the bigger buildings, like the Dome of Discovery and even the symmetrical Festival Hall, seem to float unmoored in the flow of human traffic. They were part of a scenography of controlled disclosure, intended to provoke surprise and delight rather than the order and impressiveness of Beaux Arts planning. The key aesthetic term for the Festival's designers was the Picturesque.

Although the Picturesque in postwar British modernism has not been linked by its historians with the end of empire, it is possible, as I am suggesting, to find this link in the Festival of Britain.[36] In contrast with Wembley, a comparison made by John Summerson and echoed by others, the Festival's 'loosely linked enclosures', its lightness and informality, perhaps even its 'effeminate' character, indicated a new relation to the national self-image.[37] The fact that this picturesque modernism drew upon British eighteenth-century theory and precedents need not mean that in *all* instances the Picturesque must be understood as evoking an essentially land-owning and landscape-loving national character.[38] For Reyner Banham, the Festival's

planning was better seen as the result of an already established modernist debate about monumentality. All of the points made in Sigfried Giedion's 1943 text *Nine Points on Monumentality*, for instance, were borne out in the layout of the Festival site.[39] This debate about monumentality included several non-political arguments (the organicist, the aesthetic, the functional, the individualistic) but for several participants it derived its force and relevance from a perceived identity between political reaction and monumentality, as well as a dissatisfaction with the way that some modernist projects had accepted the authoritarian gestures of totalitarian regimes.[40] Accordingly, it might be said that the Picturesque, or antimonumentality, at the Festival of Britain established a radically different setting for a national celebration from those overtly imperialist gestures of previous exhibitions. As far as I am aware, however, there were no conscious connections made at the time between the Festival's layout and its architecture and the rather messy processes of decolonization, the end of empire. Perhaps this silence indicates a belief that the whole imperial context could be pushed aside, that it would simply sort itself out separate from considerations of the national self-image. It could never be so simple, however. The general election, held in the same summer and meant to reaffirm the Labour Government on the back of the Festival's popularity, was in fact dominated by the Korean War and the Iranian nationalization of British oil assets.[41]

I will turn now, more briefly, to the question of a 'post-imperial' attitude to architecture and planning as it affected two other sites in London. One of the first major postwar developments in London to announce Picturesque principles in its planning was also one of the most symbolically charged locations in the City. The replanning of the partially blitzed precincts around St Paul's was – and remains – as much a task of salving historical sensibilities as of creating high-rent office space bordering on one of the few areas of the City not given over to financial and commercial concerns (fig. 5.8). In William Holford's 1956 scheme, strongly supported by the advocates of the Picturesque at the *Architectural Review*, both the medieval street plan and Beaux Arts schemes for opening up vistas onto the cathedral were rejected. Instead Holford, whose scheme was carried out in the next decade, arranged a group of office blocks of different heights, like still-life elements, to the south and east of the cathedral. The largest gathering of these blocks was to the north-west where they loosely framed a pedestrianized terrace, Paternoster Square, as well as cutting in front of the view of the west end of the cathedral from Ludgate Hill. In Picturesque terms the latter was part of a 'gradual revelation of beauties',[42] whilst the square created a dynamic contrast of volumes opening up again to a partial view of the cathedral. Predictably, Pevsner in his Reith lectures saw Holford's solution as a way of designing 'functionally and Englishly'.[43] In the *Architectural Review* the broader politics of this were sketched out: the Picturesque symbolized English 'allegiance to freedom and liberty' while the monumental or Beaux Arts tradition embodied 'the absolutism and the dictatorship of the French' and the reactionary policies of bodies such as the Royal Academy and the

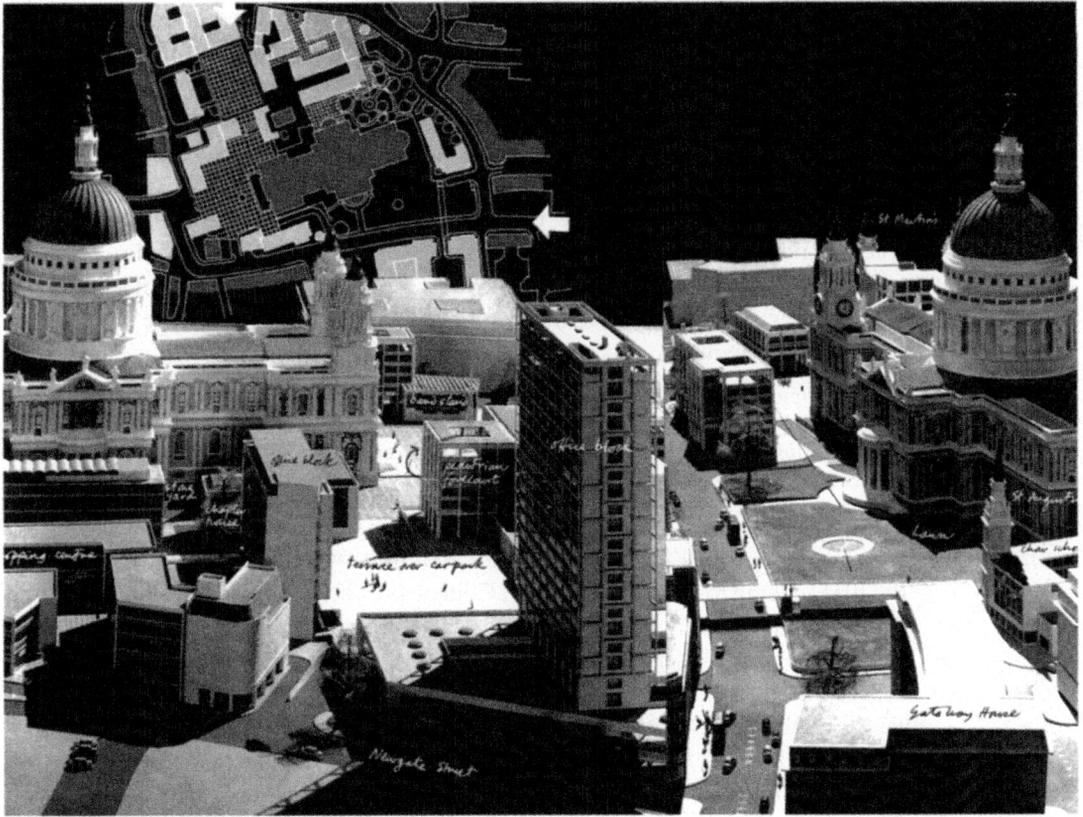

5.8 St Paul's, London, model of planning scheme, 1956 (William Holford).
 Architectural Review, June 1956

Daily Telegraph.[44] 'Freedom' here seemed to be a quality associated with variety: a 'varied skyline', 'variety of viewpoints' and an 'intricately interconnected sequence' of (various) spaces between buildings. It would be hard to claim that there was anything anti-imperial in this, but the different vocabulary of description here from other sites at the 'heart of empire' – associated, as has been shown, with the values of 'order' and 'dignity' – had changed the focus of experience from a quality embodied by certain kinds of architecture to a mode of apprehension located primarily in the viewer. If imperial architecture in the 'heart of empire' had depended for its status on a source of authority in the past to 'temporize itself more grandly',[45] then this new (post-imperial) architecture of the Picturesque seemed to posit the qualities of individual perception as a substitute for historical authority. It was also, as *Country Life*'s support for the scheme shows, a form of compromise that could forge an alliance between politically conservative and aesthetically modernist factions.[46]

The second site had a more direct relation to imperial thematics and returns us to the area around the Imperial Institute. Tweedsmuir had indicated in his 1952 report that effective changes in the Imperial Institute

might necessitate abandoning the old building. In 1953 the expansion of the neighbouring Imperial College (which, of course, still retains this name) made this an attractive proposal. The opposition to this proposal, although it gathered together the first elements of a new conservation movement in Britain (and led to the foundation of the Victorian Society), was largely a failure; partly because Victorian architecture in general was held in low esteem at this time, and partly because the Imperial Institute itself was perceived as not having an urgent function. While some of those who gathered to prevent the demolition of Collcutt's building admitted that the 'proud certainties' of nineteenth-century imperialism 'no longer ring true',[47] others argued that demolition would

make way for something that will not profess in any degree to take over the task of speaking to all the centuries after us of that great ceremonial and that year of the Jubilee. The proposal may of course be political ... it may arise from feelings to which even the word 'Imperial' is an offence.[48]

But as the intended project, the land and most of the buildings were all the government's, statutory sanctions were not required. Announced early in 1956, the first scheme for the new Imperial College buildings planned to clear the site, adding a new axis but retaining the old imperial one – a particular rallying-point for the conservationists (fig. 5.9). 'The great advantage of [the Institute's] demolition', its architects Norman & Dawbarn wrote, 'is that it removes from the plan form an east–west axial barrier and thus permits planning in depth with a sense of space.'[49] Although this approach paid some heed to the old north–south axis in its main alignment, it also opened up a new east–west pedestrian route across the site. For this scheme's supporters, to retain even the old tower would be to keep 'a memorial without function ... a self-conscious and irrelevant relic in a scheme serving a different age'.[50] But this was the concession thrown to the conservationists and the Institute's tower was exempted from demolition. The trade-off was a new scheme announced early in 1958 that retained the tower as an isolated campanile to be stumbled upon in Picturesque fashion perhaps as a monument to a different era, shaped an east–west quadrangle around it, but now entirely ignored the old north–south axis (fig. 5.10). Instead, a modern east–west campus was created, with a pedestrian precinct striking westwards into the heart of the site from Exhibition Road. As with Holford's scheme for St Paul's, blocks of different heights were irregularly distributed around the site according to the new *genius loci* of a post-imperial picturesque modernism.[51]

The Commonwealth Institute

Just as the demolition of the Imperial Institute from 1957 to 1962 offered a sacrifice to the new dispensation, a ritual destruction of a public symbol of the old imperial world-view, so the Commonwealth Institute building provided a chance to replace the worn-out metaphors of empire on a site without the 'active memory' of empire that inhabited South Kensington.[52]

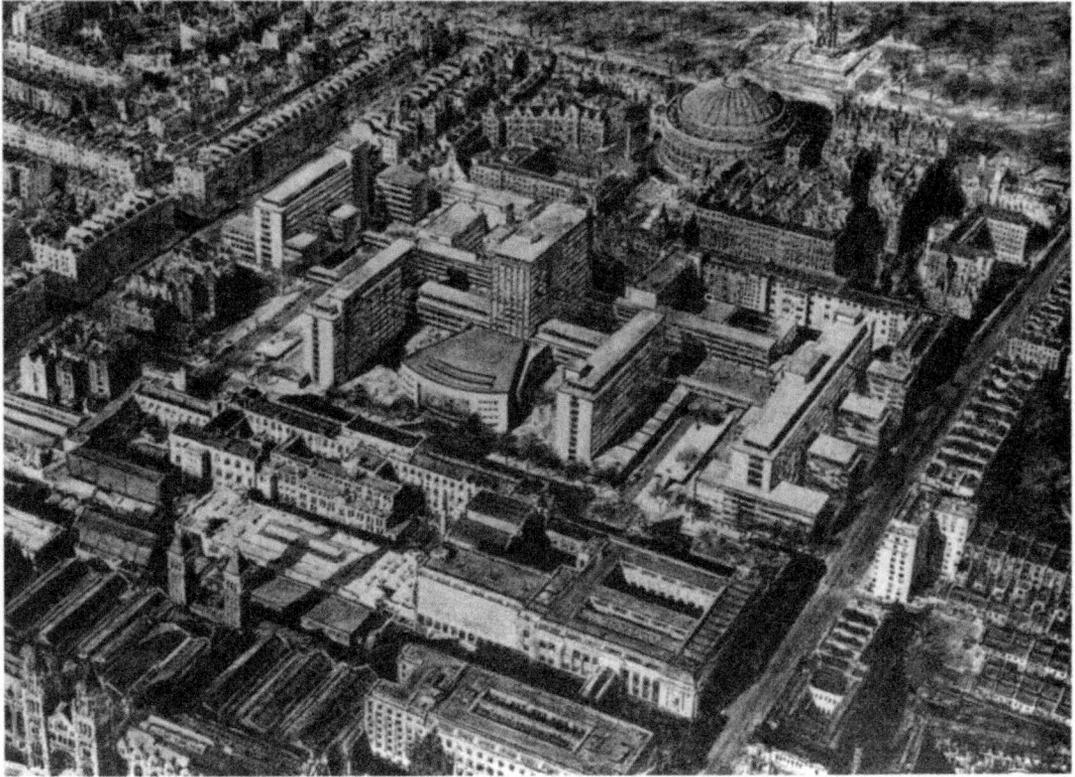

5.9 First scheme for new Imperial College buildings (Norman & Dawbarn, 1956).
Architectural Design, 26 May 1956

The demolition was one of the most visible public signs in London of the end of empire, even the end of a 'British Commonwealth' and its replacement by the, unqualified, 'Commonwealth'. The Commonwealth was a new positioning of Britain in relation to its continuing and former overseas possessions, seen now less as resources than as peoples freely co-operating for a common good: 'It is something absolutely different from an Empire ... ', as the Commonwealth Institute's officers put it, 'it is no more a British Commonwealth than it is a Nigerian or Australian Commonwealth ... We are all equal. It is a scheme for world cooperation ... The Commonwealth is new. It is an experiment, an experiment in human relations.'[53] Or, as S. R. Mehotra wrote in 1963: 'It is concise and comprehensive. It combines tradition and modernity. It means all things to all men.'[54] The Commonwealth was thus a form of reassurance, the continuation of influence without the guilt or 'burden' of empire.

In the broader context, several leading architectural writers sought, largely unavailingly, a new Commonwealth architecture to match these changes, much as a Commonwealth literature was now also being invoked. Pevsner, in a lecture given at the Royal Commonwealth Society, thought that a loose combination of characteristics, using 'digested Western material' appropriate

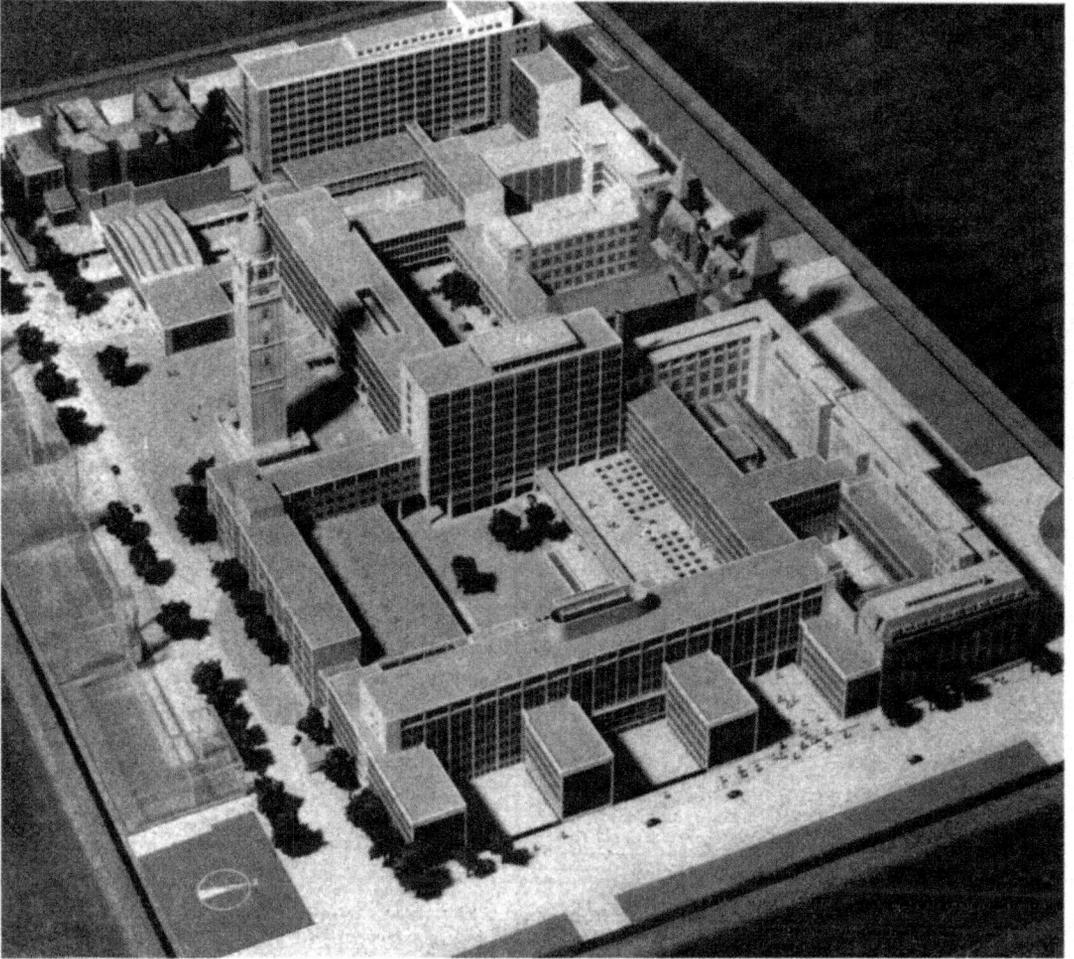

5.10 Final scheme for new Imperial College buildings (Norman & Dawbarn, 1958).
Architects' Journal, 6 February 1958

to climate but 'not choked by tradition', was emerging.[55] J. M. Richards, in a compilation of new buildings across the Commonwealth, found 'architectural vitality': translations of 'an old civilisation to wider spaces' (the dominions) or the assimilation of modernization under British guidance (the colonies).[56] All of these statements, as well as the changes in the Imperial Institute, made empire seem to change smoothly, in a planned and ordered manner,[57] into the benevolent equalities of the Commonwealth. This was also the ideology of the new Commonwealth Institute, the first major symbol of the new entity. It followed that the new building for the Commonwealth Institute must be experimental, that it must take on the modes of modern internationalism and refuse those historic forms of architecture that seemed as debased and obsolete as the empire itself. Yet it might also be argued that the Commonwealth Institute (renamed by Act of Parliament in 1958), while abjuring its predecessor's symbolism, merely updated its materials and

revamped its image; that the Commonwealth was a symbolic redemption of the empire.

The new Institute (built between 1958 and 1962) was located in Holland Park, 3–5 kilometres (2–3 miles) north-west of the museums in South Kensington (fig. 5.11). The architects, Robert Matthew, Johnson-Marshall & Partners, arranged the building into two very different and visually colliding volumes: a square, aluminium-faced and spectacularly roofed building as the main exhibition galleries, and a more nondescript block housing a cinema, art gallery and offices. The design of the main exhibition space was driven first by the idea of a freestanding parkland building and, second, after the spectacular roof shape had been produced, by the concept of the 'tent in the park'.[58] The symbolism of this concept pointed on the one hand to fresh starts, movable ideologies, even an atavistic egalitarianism; it was intended to stand for the unity of the Commonwealth sheltered in a single space and under one roof, as if the peoples of the Commonwealth had come and pitched tent in Holland Park.[59] Furthermore, the park and its inevitably picturesque setting was also exploited to establish an apparently new set of significant co-ordinates for the Institute, in opposition to those of its predecessor. Where the Imperial Institute had re-presented the imperial axis passing through its site, the Commonwealth Institute was conceived as a freestanding, virtually abstract entity autonomously set off against parkland with its public space placed end on towards the road. Where the Imperial Institute drummed up the past, making evident display of the skills of mason, bricklayer and sculptor, the concrete and structural gymnastics of the Commonwealth Institute depended on industrial production and engineering mathematics: most obviously, the elaborate roof of five hyperbolic paraboloids in pre-stressed concrete in contrast to the old building's domes and towers.[60] Where the Imperial Institute had evoked a miscellaneous group of urban institutions and historic structures, the Commonwealth Institute's forms summoned up the ahistorical tent or primitive hut, its structure – suggesting links with the raking struts of recent buildings like the Dome of Discovery – employed the actual bifurcated props of an apparently ad hoc but 'direct' tectonics, and its roof was presented as a billowing canvas floating above the park.

These ways in which the Commonwealth Institute acknowledged but also attempted to distance itself from the Imperial Institute can be found likewise in its re-use of its predecessor's materials. The Imperial Institute, as we have seen, presented its architectural materials as a crafted cultivation of imperial bounty. By contrast, the Commonwealth Institute combined some salvaged tokens of the old Institute with new building materials testifying to the continuing but voluntary support of the Commonwealth. The central platform was paved with marble from the entrance hall of the old building, while various sculpted animals from the entrance spaces were relegated to the new outer walls or the entrance to the car park. Aluminium was donated by Canada, hardwoods by Nigeria and Ghana, and the copper sheeting on the roof was a gift from Northern Rhodesia. The building thus embraced both trace memories of empire and new talismanic evidence of the free co-operation of the Commonwealth family.[61]

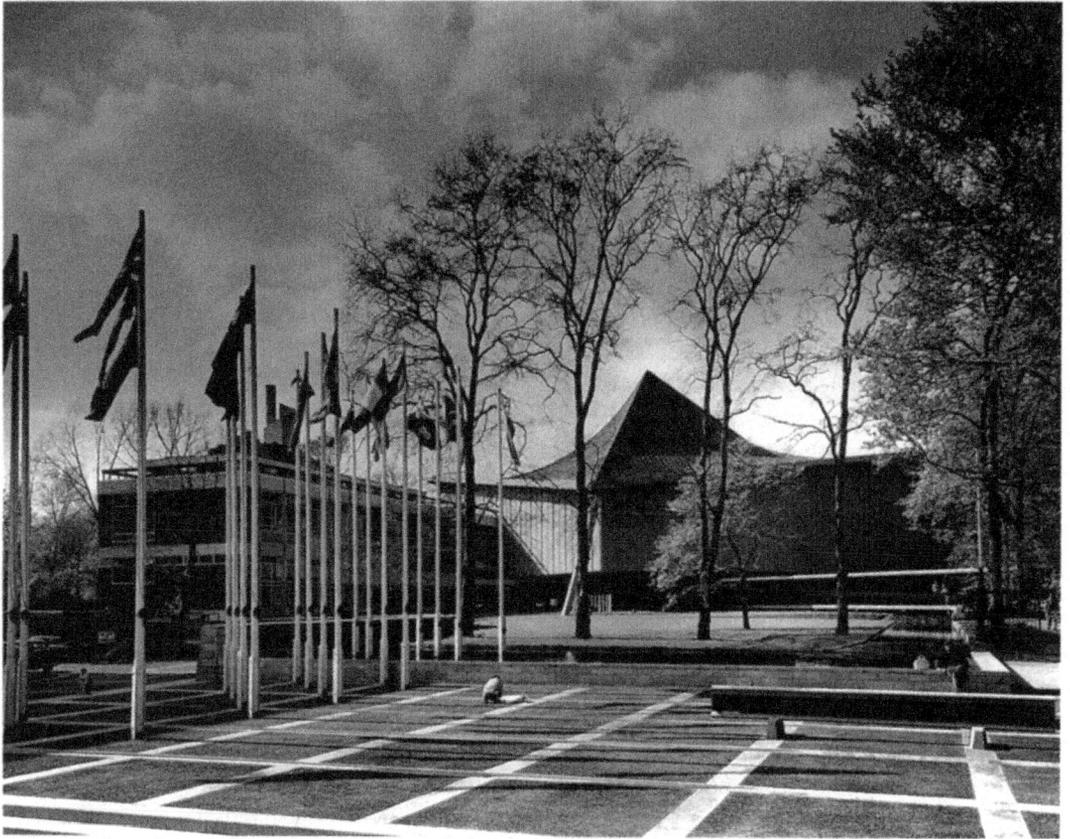

5.11 The Commonwealth Institute (Robert Matthew, Johnson-Marshall & Partners, 1958–62)

The use of materials made a carefully calculated play of affiliation and difference, but it was in its spatial sequence that the new building set out its most revealing relationship to the old Institute. Again, reception and process, or sequence and circuit, were crucial to the building's effects. Now, however, rather than the constant deferral of completion in the Imperial Institute, a point of apparent summation was encountered in the very centre of the building. The Commonwealth Institute announced itself on Kensington High Street through a small raised public plaza with a cluster of flagpoles. The formal route from there into the main exhibition building led underneath a long canopy beside rectangular pools of water, immediately marking the transition into a different spatial realm, the space of the semi-rural pavilion rather than the urban club. As the route passed into the building it turned a dog-leg corner and up a half-flight of steps into an introductory exhibition that initially thematized Britain's relation to the Commonwealth, but in more recent years has been devoted to the history of the Institute itself and the passage from empire to Commonwealth. At this point the visitor turned again, passed over a bridge and suddenly arrived at the very centre of the

exhibition space on a circular and apparently floating marble platform with the sweeping roof canopy above and the three tiers of galleries arranged in panorama around it (fig. 5.12). This was the resolution of the architects' vision of 'the museum as a place of choice', rather than as a place of unrelenting progression in the mode of the Imperial Institute.[62]

The platform, central in both plan and section, had an extraordinary if rather melodramatic eloquence, which was enhanced by the use of highlighted areas against generally low lighting levels. From here the main areas of the building were made visible and all of the exhibits representing the Commonwealth were picked out by the lighting, yet the range of light levels enhanced the complexity of the roof and the apparent variety of the displays.[63] The contrast with the interior of the Dome of Discovery was telling. There it was impossible to see a whole space that was in itself quite simple and there was no single position of authority. At the Commonwealth Institute a lucid position of command was granted in an otherwise highly theatricalized space with a complex roof above. At first it was proposed that the country displays be identified by banners, but since then a range of country symbols have played this role instead, augmented by signposts and glimpses of country names: 'a group of banana trees in the West Indies; a gaily coloured kite flying under the roof above Malaysia; the tall timber trees of Canada; the Islamic domes suspended over the blue-tiled floor in Pakistan; or the model of a Kandyan dancer in Ceylon'.[64] Everywhere was difference: of commodities, landscapes, peoples. Overplaying these individualizing national symbols, an all-embracing unity was established through the very form of the interior space. Older Commonwealth countries were placed on the lower gallery, with African countries in the middle, and the various island territories in the upper gallery, but each was visible from the platform and over all of them hung the great tent-like gesture of the roof. Each country display described a mini-circuit subsidiary to the main spatial organization, a corner of the world through which the visitor passed, viewing that country's geography, history and social organization, but mostly still its economic resources. In the original Rhodesia display, for example, the entrance to this pedagogic sequence was presided over by the old effigies of Livingstone and Rhodes, legacies from the Imperial Institute, and the sequence ended with photographs of modern Rhodesian buildings.[65] The Commonwealth Institute suppressed the actual effects of imperial history, replacing them with progress as the past's determining impetus.

The Commonwealth subject

The circuit of galleries in the old Imperial Institute was originally arranged around a central Great Hall, though the galleries would not have been visible from that space. So, while the Imperial Institute's arrangement implied that the world of empire was laid out around the visitor, it would never have provided the visitor with the actual physical sensation of arriving at a point

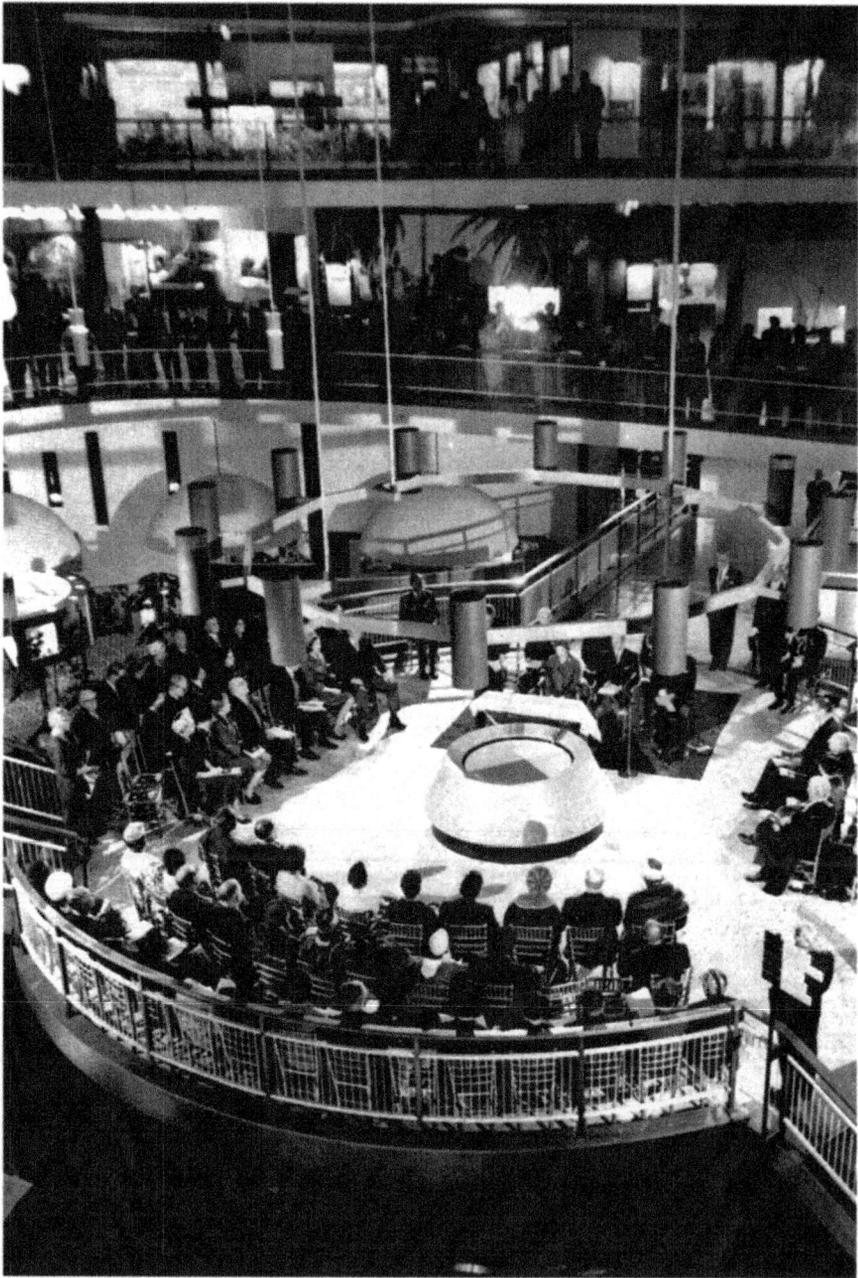

5.12 The Commonwealth Institute – opening ceremony, 1962

of centralized visual control of that imaginary world. In the Commonwealth Institute, however, a major route from the outside into the heart of the building, from the full natural light of the street by stages to the artificially lit world of the galleries, was marked out with irresistible inevitability until it reached its point or space of full consummation. Via this route the visitor

passed the displayed history of the Institute itself and was informed about Britain's relation to the Commonwealth. The visitor entered the central space already interpellated as a British subject comprehending a cognitive world centred on his or her own subjectivity.[66] Britain's place in the Institute was therefore not as yet another display on the circuit of galleries, but a position of centrality, a place where self-representation was absent or redundant; above all a place where vision – the privilege of seeing – was located outside Commonwealth visuality – the subject seen. The Institute's architecture established the visitor as a subject who knew the Commonwealth only by being located within but not as part of its global ring, at a point where all its radii converged. Effectively, to be able to perceive the human essence that was taken to underlie Commonwealth variety, the architecture postulated a God-like being whose benevolent, far-seeing gaze only might divine this essence: a consumer of differences.

By contrast with the Imperial Institute, where a visitor would know the empire by being at the point where all its commercial data converge, a disempowering action had taken place in the Commonwealth Institute which its architecture merely emphasized through the persistent redundancy of its panoptic gestures, the hubristic equation made between gallery space and political geography. Above all there was that sense on arriving at the centre of the exhibition galleries of suddenly acquiring ocular dominance over the world of the Commonwealth. The Dome of Discovery had offered the closest typology here as well as the most relevant credentials as a popular modernist exhibition building. The Dome housed 'a plethoric record of the pre-eminence of the British people in the fields of discovery and exploration, not only by land and sea, but into the nature of the expanding universe'.[67] But the Dome's displays ignored the building's inherent centrality, appearing to disperse displays according to no hierarchy of space, as might befit a democratized People's Palace. The Commonwealth Institute inverted the relation within the Dome of Discovery, so that instead of visitors looking at displays arranged in undefined space neglecting the centre, they now, as Commonwealth subjects, oriented themselves from the centre looking at displays around the periphery of the space.

Writing in 1958 about the near contemporaneous photographic exhibition 'The Family of Man', Roland Barthes discerned 'the ambiguous myth of human "community"' as a central aspect of western humanism.[68] This myth, clearly related to the Commonwealth Institute's figuring of the Commonwealth family in both its displays and its building, functioned according to Barthes in two stages. 'First the difference between human morphologies is asserted ... the image of Babel is complacently projected over that of the world,' then, Barthes argued, 'from this pluralism, a type of unity is magically produced: man is born, works, laughs and dies everywhere in the same way.'[69] Likewise, the Commonwealth Institute spatialized the mythology of multiculturalism while preserving the organic singularity of the host nation: it seemed to speak for the Commonwealth and to a new Commonwealth subject, yet it retained the privileged position of the centre

as that for which the Commonwealth was ordered. The Commonwealth would be the framework for the co-existence of multiple geographies and ethnicities, but it was a framework that assumed a distanced and privileged universal position from which this might be viewed, an 'empty point of universality'.[70] To paraphrase Homi Bhabha, the Institute projected a spurious egalitarianism where different cultures were presented in the same time and within the same universal space.[71] Mimicry was discarded as a form of colonial control in favour of radical but individuated difference; difference offered as mere representative expression of the otherwise demarcated and equalized type. According to Bhabha, 'it is the spatial dimension of distance – *the perspectival distance from which the spectacle is seen* – that installs a cultural homogeneity into the sign of modernity', and thus assimilates discrepancy and difference.[72]

Dialects of internationalism: architecture in Ghana, 1945–66

In 1949 the colonial Gold Coast Government was invited to organize a display for the Festival of Britain. The Festival organizers had suggested a simple theme – 'X, land of varied races' – with the maximum possible human interest, including staffing the exhibition with 'representatives of indigenous peoples'. The Gold Coast Government, however, was proud of its status as running Britain's model colony and of its new constitution of 1946, and rejected these slogans as being in a 'lamentably outmoded genre'. Instead it wanted the theme 'A Democratic Nation in the Making', the centrepiece of which would be a model of the country's new University College, with a diorama of Takoradi Harbour and photographs of new secondary schools, technical schools and teacher training colleges playing a prominent part in a display that would also cover science, health, trade and law and order.[1] Clearly an important aspect of this display of welfare-state imperialism was to use new architecture as image and evidence of state-sponsored modernization in the colony. But the paternalistic control of the pace of change in the Gold Coast was already being challenged by events. In 1948 three African ex-servicemen on a peaceful march had been killed by colonial officers; rioting and looting subsequently broke out resulting in further killings, and the colonial administration reacted by locking up the leaders of the main political party, including the newly returned Kwame Nkrumah. A campaign involving strikes and boycotts forced the administration to bring in a second liberalizing constitution early in 1950 and the ensuing election in February 1951 returned Nkrumah as the continent's first African prime minister. The Gold Coast displays that appeared in the Festival of Britain later that year might be seen, therefore, as symbolic not so much of a 'model colony' but of a situation in which architecture and other elements of infrastructural development were promises of ordered modernization struggling to keep up with a pace of political change no longer under the control of colonial administrators.

This chapter is concerned with a period of about twenty years from the end of the war until 1966. Both dates have particular importance in the modern history of Ghana (or the Gold Coast, as it was known until 1957). The

first because it marks the return of army veterans with high expectations of reform in their country, the second because it marks the coup that toppled Nkrumah, a manifestation largely of disappointment in Africa's first post-colonial regime, a 'national bourgeoisie that ... turned out to be a kleptocracy'.[2] This period of just over twenty years saw the most extraordinary upheavals in Ghana as it changed, in the official British view, from a model colony to a model of decolonization. The change involved sudden shifts in the official schedules as the slow-moving United Gold Coast Convention Party (under Joseph Danquah) was superseded in influence by the more radical Convention People's Party (CPP) (under Kwame Nkrumah), which mobilized a mass following using Gandhian methods. Constitutional adjustments created the impression of a step-by-step handover of power: first in 1946 with 18 of the Legislative Council's 30 seats decided by election; next in 1950 a new Executive Council was formed with a majority of Africans but still responsible to the governor; then in 1954 internal self-government was achieved with an expanded and wholly elected Legislative Council and a cabinet no longer responsible to the governor; and finally in March 1957, after the Parliament had voted for independence in 1956 and the British Parliament had approved it, independence was secured. But there was no vision of phased and inevitable decolonization behind this; in fact constitutional reform was seen by the Colonial Office, until the eve of independence itself, as enabling more effective colonial rule via a transplantation of the particular forms and legalities of British parliamentary democracy.[3] There were also lurches of alliance as the British transferred their attention from the traditional leaders they had previously supported to the new party and its leader, and those leaders in turn sought some arrangement other than control from Accra, the ex-colonial capital and the CPP's base. The formation of the new nation, its birth fixed as the year of independence in 1957, was thus accompanied by several discrepant features: there was the place of the nation in the imaginings as well as the policies of the colonial state; Nkrumah's increasing interest in the greater nation, a Pan-Africa; the wide range of cultures and languages within the new state; and the calls for secession or federation made by those same leaders who had been favoured by the colonial system of indirect rule and who were increasingly co-opted or coerced by Nkrumah.[4]

This chapter attempts to unravel some of the complex relations between modernism, decolonization and independence by looking at some of the architecture built in Ghana during this period. Within this framework the chapter will explore four specific topics. First, the interweaving movements of architectural education and the Africanization of architecture. Second, the search for a 'tropical architecture' amongst postwar colonial modernists, which seemed to reach an exemplary status in West Africa. ('Tropical architecture', both as a pragmatic adaptation to local conditions and as an avowedly non-imperial architecture, was the architectural modality that often came into contemporary view when the two terms, commonwealth and architecture, were spoken of together.) Third, a group of cultural buildings

built in Ghana in the 1950s which were part of the gradual process of British withdrawal: these include schools and university buildings and especially the National Museum opened in 1957 and symbolic of the country's independence achieved in that year. Finally the idea of an architecture of independence will be sketched in some of the projects built during the era of Ghana's first independent government, that of Kwame Nkrumah, from 1957 to 1966.

Much of this material has very clear links with what has already been discussed in previous chapters: architectural schools in Ghana offer a telling contrast with some of the larger themes elaborated in Chapter 1, for instance, and in the discussion of the National Museum links will be made with the 'commonwealth architecture' discussed in the previous chapter. Moreover, by focusing on the careers of Maxwell Fry and Jane Drew, the most influential architects in the country across this period, the chapter takes up the complex and often contradictory movement from an architecture of imperialism to modernist internationalism that is central to this book. But several caveats are necessary. First the periodization of the chapter's organization might imply a step-by-step movement towards independence rather than the complex and overlapping processes and events that actually took place. Also the range of buildings discussed is a much more blatant skimming of a much thinner architectural culture, and one more tangentially related to society as a whole, than has been discussed in most other parts of this book. The architectural culture in question was that of a predominantly white elite until quite some time into the post-colonial period, and though many of their buildings were designed for important reasons of modernization of infrastructure, housing and education, the proportion of the built environment that they represented was tiny. Nevertheless, they symbolized the promise of modernization, suggesting that liberation, progress and decolonization might be mediated through the architectural forms of new institutions. And, of course, in this typical role as the embodiment and housing of institutions, architecture – at least in this period in Ghana – has seemed less susceptible to an understanding based on a post-colonial perspective, and less capable of linkage to the modernist African movements of negritude and Pan-Africanism than the more mobile, less capital-intensive cultures of the novel and visual art.

Training architects in Ghana

Before discussing architecture I want to look at professionalism and architectural education across this period. As an African colony the Gold Coast was considerably behind most parts of the British Empire in providing professional education.[5] Its first engineering school opened only in 1931 (at Achimota College), and its first universities, as we will see, were not established until the mid-century.[6] Africanization as official colonial government policy was formalized in 1949, reversing the de-Africanization

policy of the turn of the century, with the appointment of a Select Committee to plan the progressive Africanization of the civil service over the following ten years, including providing the necessary education and training. Architecture was dominated by British expatriates and until 1958 Ghanaians had to go abroad to study architecture. Inevitably, Africanization of the architectural profession proceeded slowly. PWD records, covering obviously a wider range of personnel than architects, indicate that the number of African officers in senior grades rose gradually in the early and mid-1950s, but even in 1956 overseas officers still dominated and their numbers were actually rising.[7] Only in 1958 did the number of overseas officers in the PWD start to be reduced, whilst the number of African officers continued their upward rise.[8] Gradually in the 1960s Ghanaian architects came into important positions within the profession: O. T. Agyeman in the Ghana National Construction Company (which absorbed the PWD from 1962), Victor Adegbite (who had studied with Nkrumah in the USA) at the State Housing Corporation, Martin Abu-Badu as a founder of Architectural Design Partnership and president of the Ghana Institute of Architects, and John Owusu-Addo at the University of Science and Technology. A Gold Coast Society of Architects had been set up by British architects in 1954, but after independence the Ghana Institute of Architects was formed by Ghanaian architects and after a few years the Society was merged with it.[9] By the early 1970s, the colonial architectural culture had finally been overhauled. But there seemed to be little question with the emergence of Ghanaian architects, and the installation of architectural schools and a professional society, whether the model of a professional architect transposed from the British context was appropriate for conditions in Africa.

Some students from the Gold Coast went abroad to study architecture, particularly to Britain, though increasingly to other countries. Nkrumah, with his own American experience, was sceptical about the universalist claims of western education and its value to African students who adhered to its values.[10] Nevertheless, architectural students seem to have accepted that most elements of their training abroad were not culturally specific. They accepted that modernization required professional specialisms and skills and did not necessarily find the epistemic change violent, at least it was not experienced as such in their own careers. Nor was the idea that colonial authority might be embedded in the profession of architecture itself one that particularly troubled many of them.[11] If this had once been evident it was no longer relevant by the 1950s and 1960s.

Ghana's first architectural school was set up at the College of Science and Technology in Kumasi in 1958 following a United Nations Housing Mission in 1954 and a 1956 report by Robert Gardner-Medwin from the University of Liverpool and J. A. L. Matheson from the University of Manchester.[12] The UN Housing Mission, which included Otto Koenigsberger (as we will see, one of the main exponents of 'tropical architecture'), specifically suggested research into low-cost buildings, and both reports recognized that expatriates would have to staff a research unit and the new school until Ghanaians had been

suitably trained.[13] This would obviously mean a short-term reversal of trends towards Africanization. The research conducted by the new Building Research Unit, set up after the UN Housing Mission, rejected generic as well as formal approaches: the planning of the new town of Tema, for instance, was berated as inadequately researched in terms of its specifically African context and too heavily based on lessons from the English new towns.[14] Instead, with help from the Ford Foundation, the unit employed economists and social anthropologists, as well as planners and architects, to conduct surveys of village planning and housing. However, the question of how this approach was to bear on architectural training at the College of Science and Technology seems not to have been resolved until after 1963. Students, as members of the unit reported, regarded the subject of village housing as 'atavistic and sordid' and there was no place for it in a curriculum that included a course in the European history of architecture dependent on the standard textbook history of Bannister Fletcher.[15] This was symptomatic of a problem embedded in the very notion of professional architectural education, as we saw in Chapter 2. Very little knowledge of indigenous architecture was built into architectural training because the presumption was of a more or less universal architectural culture, and this was the case whether the architect had studied abroad or, by the early 1960s, in Ghana itself. It was also the case with government clients that African precedents were regarded as irrelevant, part of a 'primitive past' on which history had closed.[16] There are no echoes of the 'double end' described in Chapter 2 here. This might seem odd especially given that the 'Asquith Doctrine' that underpinned the new universities in Ghana offered the promise of serving a 'double purpose' of 'refining and maintaining all that is best in local cultures' with providing entry into a 'worldwide community of intellect'.[17] But the appreciation of African architecture, like African art, was riven by a 'two worlds' approach: it was either traditional or modern, with an unbridgeable chasm between the two.[18] Perhaps the contrast was particularly acute in architecture because professionalization came relatively late and because it coincided with decolonization and the need for new nation-states to appear modern.

By 1963, with the course in crisis, the curriculum was reviewed and arrangements made with the AA in London to reshape the course and develop teaching methods and research 'suited to the needs of Ghana'.[19] The AA also provided academic exchanges, accepted Ghanaians onto its tropical architecture course and supplied a new head, John Lloyd, who assembled a cosmopolitan staff including Ghanaian lecturers. Lloyd's aims were to counter the idea that Africa was something to be embarrassed about as well as the constant orientation toward western models encouraged by the RIBA-based syllabus which had no element of tropical design in it. Instead, specifically Ghanaian design problems were chosen and Ghana's climate itself was treated as three distinct regions, live projects were developed and social surveys became the basis of major design projects. Aesthetic disciplines and the history of architecture were entirely discarded in favour of visual,

climatic, social and technological studies within African contexts and a wide-ranging course on the 'History of Cultures'.[20] Thus only from the mid-1960s and after did architectural education begin to consider cultural identity and tradition in a less utilitarian way and to conceive of architecture as something other than 'a slave profession of the elite'.[21]

Tropical architecture

One of the most successful architectural practices working in postwar British West Africa was led by Maxwell Fry and Jane Drew and, through their contacts with architectural writers and publishers, their work was much publicized in Britain. To some extent, indeed, it became iconic of the idea of the postwar empire: its modernization overseen by conscientious 'pioneers' from the metropolis, bringing a claimed scientific attitude to architectural problem-solving and an expertise in the aesthetics of modernism.[22] Fry and Drew had come to Accra early in 1944 when Fry was posted there as an army officer, and they stayed after the war when they were both appointed as town planning advisers, enticed by the prospect of new planning and housing schemes, by the chance to develop reputations as experts in what they came to call 'tropical architecture', as well as the opportunity to design public buildings in the modernist idiom they had developed during the 1930s. In 1951 they were asked to develop the educational programme for the colony and were soon given twenty teacher training colleges to design. By the early 1950s they were designing schools, colleges and universities, community centres, banks, department stores, new villages and housing, all over the Gold Coast, Togo and Nigeria. These included perhaps the most prestigious and most-reproduced commission of all, that for the University of Ibadan in Nigeria. So successful had they been in developing this expertise that in 1951 they were invited to work in the Punjab with Le Corbusier on the most prestigious new city project of that time, Chandigarh. They sought to transcend colonial culture with a cosmopolitan expertise grounded in the functionalist claims of modernist architecture, combining this with their claimed sympathy for the 'beauties of a once closely-adjusted culture' and their identification with the 'new enlightenment' of emerging independence.[23] But they continued to work within the framework of the old colonial empire, and exploited its cross-regional links even as they came across as 'technical aiders', neutral professionals who might help new states bridge the move into independence.

A key element in Fry and Drew's success was their close identification with what they called 'tropical architecture'. This has since been given other names – climatic design, development planning, and so on – and it has largely been treated as a matter of building science and, to a lesser extent, as a collection of elements ('wide eaves, verandas, louvered windows, and perforated walls').[24] Even in the most recent accounts of architecture in Africa, it is regarded as generally a neutral or value-free development, an adaptation

of CIAM design principles for a distinct but broad climatic context: '[it] required an amalgam of traditional environmental controls and modern structural systems – albeit principally to assuage the discomfort of European colonials and travelers'.[25] Here, however, I want to treat 'tropical architecture' as a cultural rather than technical phenomenon, and a cultural phenomenon specific to the postwar decades and Britain's relationship to its imperial legacy. In other words, 'tropical architecture' is understood as a set of claims about the nature of architecture, together with certain (near) silences about what it was not, and those claims are seen as historically determined.

First, it is important to understand the discourse about 'tropical architecture' as largely a metropolitan phenomenon employing an imperial model of dissemination in the sense that its key nodal points were architects, publishers, journals, conferences and architectural schools based in the metropolis, even though many of the participants were international.[26] A significant if little-commented-upon part of its gestation was the Colonial Research Committee set up during the war by the Colonial Office specifically for housing research in the colonies. But the term itself began to be used more extensively after a conference on the subject held in London in 1953, initiated by Adedokun Adeyemi, a Nigerian student at the University of Manchester. Adeyemi's radical agenda was to challenge the notion that an architectural course, whether it claimed to be universal or simply pragmatic, should actually provide a training that had little specific relevance to the countries of origin of its colonial students. However, this agenda was considerably derailed by a conference where all the papers were given by establishment and expatriate architects, educators and government advisers from the metropolis, and overseas students were only amongst the discussants. There was much talk of 'planned development', 'separation of functions', of French colonial models and American New Deal schemes (like the Tennessee Valley Authority), and, in summary, that 'there is no such thing as independence in the scientific and technical fields'.[27] Following the resolution of the conference to establish educational facilities to promote the subject, a Department of Tropical Architecture was formed at the AA. Whether this move actually met the demands voiced by discussants at the conference is still debatable.[28] Certainly, little effect was felt in the other architectural schools in Britain where the majority of Commonwealth students continued to study. There was also the issue of whether a training in tropical architecture was predominantly providing a means by which British architects might renew or continue to maintain their dominant role in colonial or ex-colonial societies.

The Department of Tropical Architecture undoubtedly addressed a pressing need to challenge the standard assumption of universalism in architectural courses and direct them to a particular range of conditions of practice beyond the metropolis.[29] The appeal of the course to Commonwealth architects attests to this as does the practice of focusing teams of students on one common problem. Yet many of the approaches of modernist architectural education were accepted as commonsensical and not challenged. The industrialized school-building project of 1962–3 is a good example of this.

Following basic climatological studies and exercises devised so that students would shed preconceptions (a technique derived from the Bauhaus), teams worked on designing schools for three contrasting situations: Baghdad, Lagos and Delhi (fig. 6.1). The problem was abstracted from specific sociological and historical conditions and became a matter of designing a school that could be mass-produced for these areas. Thus the 'local' particularities of internal courtyards, shell vaults or distinct ventilation systems were married to shared approaches such as modular grid plans and mass manufacture of components.[30] No critique seems to have been conducted of the problems of using the model of an industrialized method of architectural production ('system building'), highly advanced even for Britain, and specifically the pre-fabricated primary schools devised for the particular problems of postwar school building on sites subject to subsidence in Nottinghamshire.[31] At the same time as the course's attention to climatic conditions and local knowledge and, in turn, their relation to globalized technology was prescient, so the emphasis on scientific issues and their technical solutions tended to relegate

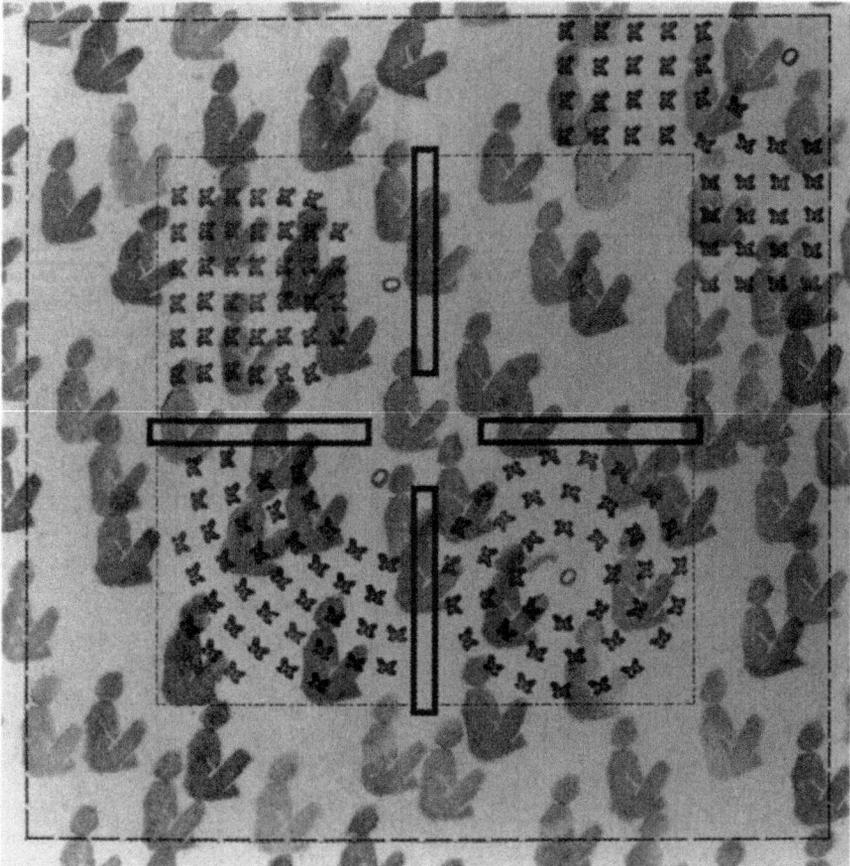

6.1 Industrialized School Building Project for India, Department of Tropical Architecture, AA 1962–3. *Architectural Association Journal*, April 1963

cultural change, including self-awareness of the role of the architect, of the course itself, and even of colonialism, to a marginal or disregarded part of the 'problem'. This was also to occur with 'tropical architecture' in the colonies.

Fry and Drew's book, *Tropical Architecture in the Humid Zone* (1956), offers further evidence of the assumptions underlying 'tropical architecture'. Despite its advocacy of modernist forms, the book reiterates the social, medical and spatial preoccupations of British administrators earlier in the century, particularly with the provision of public parks and open spaces to enable cleansing breezes and the improving contact with nature.[32] There is one passage near the beginning that deserves particular scrutiny:

> We, the authors, are not inhabitants of the tropic zone but have come to it from the temperate zone. We have experienced its climate, lived with its people and dealt with its problems as they have affected our work, but we write not only for those who, like ourselves, live outside the tropics and for whom, therefore, designing is something of an intellectual process; but also for the growing number of those who inhabit these regions and who, by their over-familiarity with the conditions, may be stimulated to re-examine them.[33]

The language here is disarming. It appears to address the most general of readers. It posits what seems a commonsensical equilibrium between the tropical zone and the temperate zone, as if geographic equivalences might now supersede political, social and cultural differences.[34] But it also alludes to a difference in outlook or mentality – between 'intellectual process' and 'over-familiarity with the conditions' – that comes dangerously close to appearing to be geographically determined. That it is saved from this is largely the function of the word 'designing', a key term in the modernist lexicon that refers both to the essential professional function of the architect and to a certain ability – perhaps through the combination of drawing skills and a particular form of judgement imbued by the modernist architect – to question assumptions and seek out problems.[35] Architects have an enormous scope and responsibility. Though they cannot change the new division of labour of westernized production, they can 'aim at building up community life' and they can enable 'the fullest exercise of expanding consciousness … to meet the complicating mechanisms of modern life without sacrificing human freedom and dignity in the process'.[36]

What, in Fry and Drew's view, was 'tropical architecture'? The 'tropics' referred to a broad geographical zone from Peru to the Philippines and the book leaps from place to place within this: including Nigeria, Brazil, Puerto Rico, West Indies and India. Most of the book consists of tips and examples of how to resolve the issue of environmental control and its associated aspects like health, materials and construction. Architects, we are told, should observe the regional vernacular but in order to learn the causes of its form and the principles that animate their resolution rather than simply as forms to imitate. The reason for this was the onset of a new 'technocratic civilisation' involving democracy and monogamy, new comforts and anxieties, new habits and rhythms, and a new individualism.[37] Architecture – 'tropical architecture' – would thus rise above the mosaic of particular

cultures and ethnicities, of histories and traditions, while taking its inspiration from the climate of the region. Fry later called this a 'dialect of internationalism'.[38]

It might be asked how Fry and Drew's book acknowledges the imperial context, especially given that its lessons were intended to be relevant for areas of the world either still under British control or only recently liberated from it. Architects are free of imperial mindsets, Fry and Drew imply: 'By the time the architect comes on the scene, traders, missionaries and governments have exerted their influences for good or ill.'[39] Elsewhere there are references to 'ponderous structures in the grand manner',[40] and the un-ironic assertion that 'whereas what came to be known as the "colonial style" might be fitting for a Governor's palace, it would not do for an oil company's headquarters'.[41] One of the most curious passages in the book occurs when the authors cite a nineteenth-century iron palace prefabricated in Britain and brought out for King Eyambo on the Calabar River in Nigeria to house his 320 wives (fig. 6.2). Although mocked in the caption that accompanies an illustration – 'then, as now, overcrowding due to lack of funds would appear to be one of the chief problems' – its status for Fry and Drew seems to be both as a positive precedent for technological advancement and as a negative example of a

6.2 'The Palace of King Eyambo, Calabar River, Nigeria'. *The Builder*, 13 May 1843, and reproduced in Fry and Drew, *Tropical Architecture in the Humid Zone*, 1956

collusion between western technology and a pre-technocratic society, not democratic and certainly not monogamous.[42] (The contrast, intended or not, comes in the following image of a three-bedroomed house in the new town of Tema.) But again the imperial context of even this example of technology transfer in an iron palace is not alluded to directly.

The short answer to the question of imperial acknowledgement is that there was very little and the reason seems to be that Fry and Drew position 'tropical architecture' as a reconciliation of modernity to the conditions of underdevelopment. As Fry later wrote,

change was in the air, and my own attitude to our work was that it was an instrument of introduction to European life and thought. For good or ill a decision had been made by both parties to the affair ... it was a matter of making the most of the situation given.[43]

Everything of the colonial period – a period now past – was to be distrusted and even discarded without explicitly acknowledging it as belonging to a colonial past, nor the possibility of a continuing colonial presence or a rising neocolonial future.[44] 'Tropical architecture', it was hoped, was not so much post-imperial as beyond imperialism, part of another world-view altogether. It was part of an imagined world where liberation had already happened, without violence and without social unrest, and in which the job now was all to do with modernization, the opening up of another field for architectural territorialization.[45] As the old modernist rallying cry had put it, 'Architecture or Revolution'.

Tropical architecture in Ghana

Historically, 'tropical architecture' had a transitional role in Ghana, as in other West African countries. It was the preferred mode of architecture for the regime under the part-colonial, part-independent arrangement from 1951 to 1957, and it continued through the 1960s. It was practised by most of the expatriate practices that dominated architecture in the country: as well as Fry and Drew (or Fry, Drew, Drake & Lasdun, as they had become), these included Kenneth Scott, Nickson & Borys, and James Cubitt. It was also the mode of architecture adopted for the most publicized new projects in the country at the time when it was, relatively, one of the wealthiest of Britain's colonies: the new school and university buildings as well as buildings like libraries, community centres and museums. As such it was identified predominantly with a welfare-state model of usually public-funded architecture – although private houses were also built – and with building types that were imported by colonialism into the country. However, any relation between colonialism and this form of architecture was disavowed and it was presented both as a neutral or technical affair and as a symbolic matter of building a modern nation. This section will provide a brief survey of the agenda embodied in these buildings by focusing mainly on educational architecture. The following section will analyse the National

Museum in Accra in relation to the idea of the nation at the moment of independence.

As in Britain, so in the Gold Coast, the end of the war saw the beginning of a programme to build new educational establishments. With money from the funds created by two Colonial Welfare Development Acts (passed during the war in Britain explicitly to modernize British colonies and thus help sustain colonial guidance) the British Governor and Nkrumah's Gold Coast government in 1951 launched a two-stage programme as part of an ambitious Five-year Development Plan: first to set up new secondary schools and teacher training colleges, then to build new village schools. Two things should be noted, though, about this money granted from London. First, the amount was perceived as inadequate within the colonies themselves and had to be considerably enhanced. Second, while these funds were 'granted' in London they represented, as an earlier quote observed, but a small proportion of the profits being made in the Gold Coast, particularly in the cocoa industry, and relocated to London.[46]

Fry and Drew certainly had few illusions about the cultural disjunctions implied by their educational briefs, which mostly came from this development plan. The primary school, they wrote, 'is the first means by which governments hope to bring their peoples into the community of democratic civilisations ... where it comes the tribal idea will go, and the chances of a school being completely indigenous in character, built and maintained by the people themselves, fade away'.[47] More broadly, education on British lines was not the most fitting instrument to deal with 'the future of the tropic's teeming millions', but these issues were effectively beyond the power of the architect to change.[48]

Fry and Drew's schools and colleges in West Africa are amongst their most immediately appealing designs and they came to exemplify what was meant by 'tropical architecture'. The buildings used reinforced concrete and cement-block walling, timber and asbestos-cement roofs, and were built by British contractors using African workforces. The humid climate was dealt with by opening the buildings up to cross-ventilation wherever possible using pierced screens, verandahs and covered walkways, and shading was provided by overhanging roofs, *brises-soleils* (sun-breaks) or projecting window surrounds. Their aim was to avoid the image of the colonial school as a place to 'train clerks and overseers' as far as possible and they had some sympathy with the more egalitarian purposes of missionary schools.[49] In their desire to embody the 'corporate idea of a school' they tended not to opt for overall symmetry of buildings but what they called 'a subtler affair of counterpoise and space'.[50] But temple-like fronts, often curving and with double-height pillars, were devised for the assembly halls that acted as the pivotal buildings for these schools and universities, much as they had done in Fry's educational work in Britain.[51] At Aburi, as elsewhere, the assembly hall had a pre-cast concrete screen as a centrepiece and looked down an axis created by a long courtyard with other buildings disposed in parallel but less formally beyond it (fig. 6.3). At the Wesley Girls' School, Cape Coast, this

6.3 Assembly Hall, Aburi College, Ghana (Fry, Drew & Partners, *c.* 1953).
Architectural Design, May 1955

function was played by the church whose curving porch, punctuated by a freestanding water tower acting like a campanile, looked down two rows of dormitories and classrooms forming a quadrangle (fig. 6.4). Here, as in other missionary institutions, the schools funded by the Acts continued to be operated by those groups which had run the education system before the war, particularly the missionary groups, and this may account for the importance of meeting halls or chapels in Fry and Drew's designs. Educational architecture was, then, a way to image community even though the schools' function might continue to be in large part dictated by the need to produce subordinate cadres for the state bureaucracy. The idea of the school as presenting the image of a carefully related but informal grouping of units, with an assembly building punctuating the design and acting as both image and gathering point for the complex, is one that Fry had developed before the war with Walter Gropius in the Impington Village College in Cambridgeshire (1934).

The school buildings attempted to make affinities with tradition without copying it, much in the manner of the 'double end' described in Chapter 2. When they were represented in the British architectural press, photographs or drawings would emphasize their monumental aspects: low viewpoints typically silhouetted African children against the looming forms and dramatically shaded contrasts of the buildings. The freestone walls and simple pillars of Amedzofe Teacher Training College rose like some manifestation of an elemental order (fig. 6.5); the sunbreaking grilles of Adisadel College like some inevitable marriage of concrete and the patterns of fabric design (fig. 6.6). These were Fry and Drew's attempt 'without in any

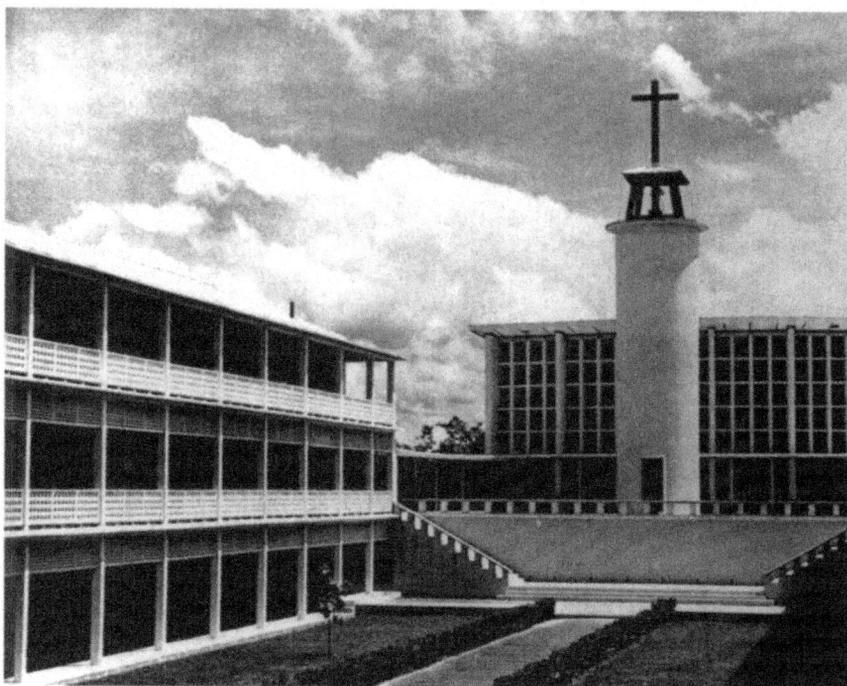

6.4 Wesley Girls' School, Cape Coast, Ghana (Fry, Drew & Partners, *c.* 1953).
Architectural Review, May 1953

sense copying African detail, [to give] a response which is African ...
moulded forms which are rhythmical and strong, not spiky and elegant, but
bold and sculptural'.[52] They also used strong and definite colours, combined
with natural wood and stone. In all these features we can see an echo of Le
Corbusier's interest in the vernacular as a restrained and near-subconscious
result of a long process of assimilation: Fry's term for this was 'instinctive
architecture'.[53] This was, therefore, a kind of primitivism; a conjuring up of
imagined affiliations with a pre-industrial alternative to modernity. It was
also an attempt to figure an essential African quality through ornament that
was to have a few sequels in the region. But unlike India and, as we will see,
Malaysia, a modern national architecture based on historic styles and
precedents was only intermittently considered in Ghana.[54]

It could be argued that universities became the most public expression of
the complexities and contradictions of modernization, and the presence of
modernist architecture, in West Africa. These were the most likely buildings
to receive international publicity and the most obvious evidence of moves
towards independence at a time when universities were claimed in Europe as
the 'institutional archetypes of our age'.[55] Like the schools and colleges they
were in part paid for by the Colonial Development and Welfare Fund, but
their format and location across the region was directed more specifically by
two bodies: the 1943 Asquith Commission on Higher Education in the
Colonies and the Elliot Commission, also appointed in 1943 but more

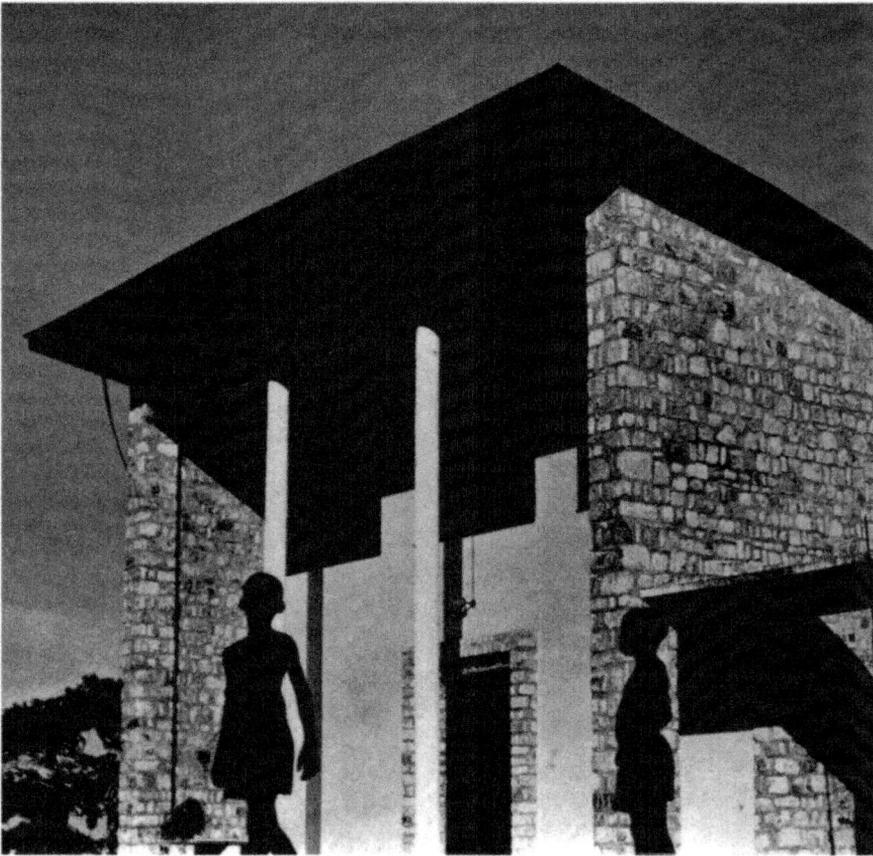

6.5 Assembly Hall, Presbyterian Teacher Training College, Amedzofe, Ghana (Fry, Drew & Partners, *c.* 1953). *Architectural Review*, May 1953

specifically to make recommendations for West Africa. Both commissions viewed higher education as a way of modernizing colonial possessions, or at least as a way to catch up with other European empires, and a means of answering the increasingly clamorous calls for independence. Universities were understood as a stage towards self-government, though the programme for that self-government coming about was only indicated vaguely, at best.[56]

One of the first of the new West African campuses recommended by the Elliot Commission, University College, Ghana, became the 'group of shining white towers' that A. K. Armah used in his novel *The Beautyful Ones Are Not Yet Born* to suggest the longings, enticements and false promises of modernity. The new institution was officially a 'university college' affiliated to the University of London, and its first principals and most of its academic staff until well into the 1960s were European. It was designed by the firm of Harrison, Barnes & Hubbard who had established their reputation on work in the Middle East and the Mediterranean, particularly in Harrison's case for the British Mandate in Palestine. The new university campus (designed and built between 1949 and 1959) was located on rising ground at Legon, a few

6.6 Screen, Adisadel College, Cape Coast, Ghana (Fry, Drew & Partners, c. 1953).
Architectural Review, May 1953

miles outside Accra (fig. 6.7). The site was grand and large and the architects exploited it to the full by arranging the campus as two long lines of pavilion-like buildings parallel to a road rising up the slope for nearly a mile to the university's administrative buildings, which faced back down the axis. While the scale evoked the imperial scenography of New Delhi, the idea of the huge open mall suggested the precedent of Thomas Jefferson's University of Virginia campus, the neoclassical model of an integrated academic community. The combination of both models resulted in a highly ceremonial and hierarchical campus, a self-contained community of scholars physically

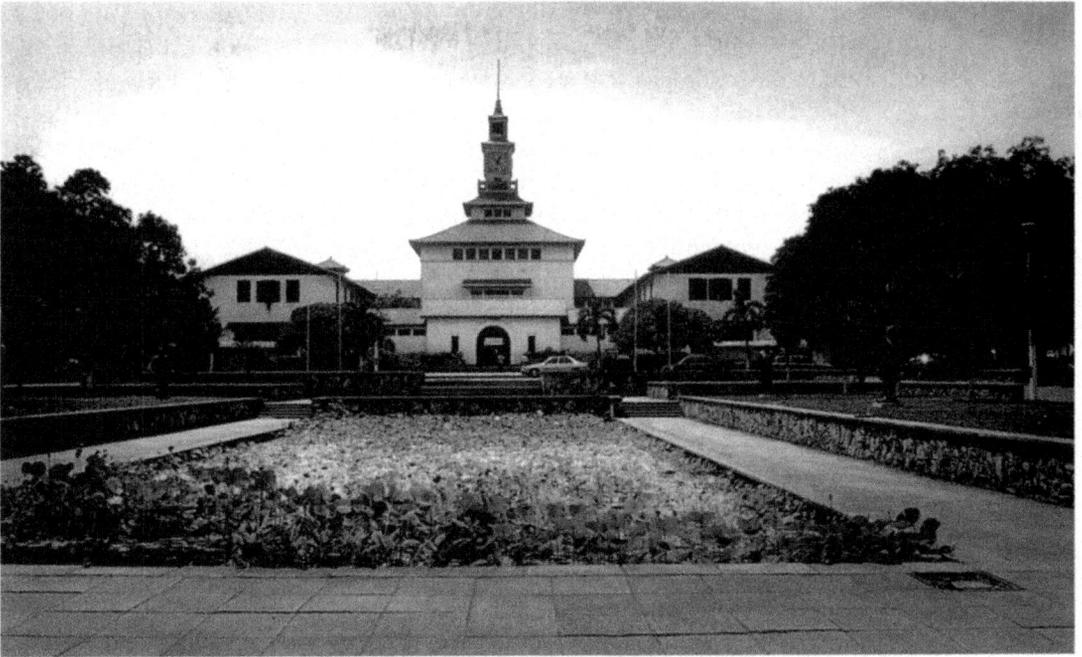

6.7 University College (now University of Ghana), Legon, Ghana (Harrison, Barnes & Hubbard, 1949–59)

detached from the society in which they were located. The architecture of the departments, halls of residence and library buildings marching up the hill, and of the administration buildings at its top, was evocative of Mediterranean settings: pitched tiled roofs, round-arched arcades, white painted stucco, even some Moorish details. The closest West African affiliations to the architecture of the University at Legon were with similar features in the main school buildings of Achimota College, set up in 1927 by the British to train the new African administrative elite.[57] The link was a natural one to make as Achimota was nearby and acted as a sister institution.

A completely different approach to campus planning was devised for the University of Ibadan in Nigeria, founded in 1947 and designed by Fry and Drew. I can only briefly mention it here although this was without doubt the most ambitious and best publicized of all West African institutional complexes in this period, and the architects themselves regarded it as their most substantial achievement.[58] On a large site buildings were predominantly arranged running east–west in a U-shaped configuration to take advantage of the prevailing wind for ventilation.[59] Certainly Ibadan shared with Legon this excessive spreading of buildings, resulting in long walks or ubiquitous taxi services, but differed from the latter's axiality in its use of predominantly open courtyards and their looser grouping across the campus.

These principles were also shared by the College of Science and Technology (made into the University of Science and Technology (UST) in 1961) recommended again by the Elliot Commission and built outside

Kumasi on land granted by the Asante king. Again, the distances covered at UST were huge, following the exaggerated concern for ventilation at Ibadan and based on the assumption of a continuous bus service ferrying students from the halls to the faculties and back. The first layout in 1952 was by Cubitt and Scott, and over the next decade several other master plans (by Arthur Williamson in 1958, G. Christopher in 1960 and John Owusu-Addo in 1965) filled out the lineaments of the campus, a landscape compared at the time to that of English eighteenth-century country houses (fig. 6.8). The main faculty buildings were developed first at one end of an axis, the Great Hall, library and administration matched these at the other end in the 1960s, with the halls of residence on a cross-axis. Cubitts' glass, steel and concrete buildings introduced, according to Udo Kultermann writing in 1963, 'a spirit of uncompromising modernity to Ghana'.[60] They included the staff houses, reproducing a design that had been used by the architects with more success in Kuwait;[61] and the Engineering Laboratory, a place for training the

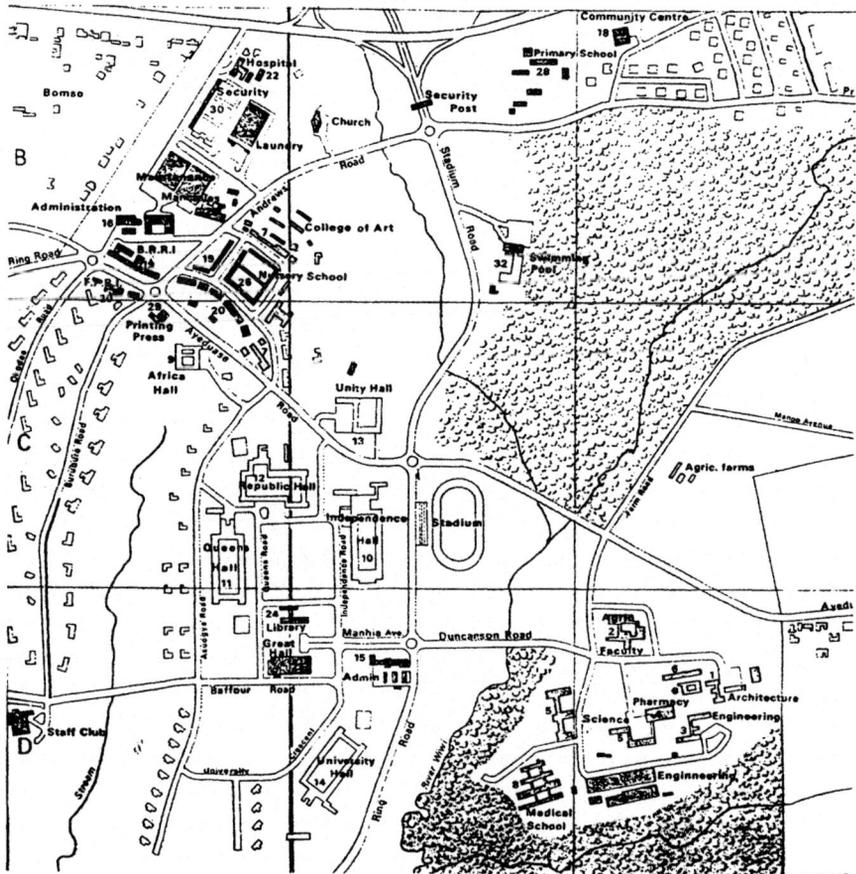

6.8 Plan of University of Science and Technology, Kumasi, Ghana. *UST, Kumasi – Visitors' Guide*, 1995

engineers needed for Ghana's industrial schemes at Tema and the Volta River (fig. 6.9).[62] With its wing-shaped roof-scoops to take in the breeze and draw off warm air by suction, the laboratory immediately became iconic, and much reproduced as evidence of Ghana's modernization. The halls of residence, several built in the mid-1950s, were arranged around courtyards with a dining hall usually placed across them, typical of the pierced, rectilinear but informal concrete buildings with which 'tropical architecture' was identified. But the most emphatic of UST's developments came in the early 1960s (by which time the university had been renamed the Kwame Nkrumah University of Science and Technology) with the development of the central area, including the Great Hall, a theatre and chapel, to join the existing library. Designed by Gerlach & Gillies-Reyburn, these were concrete slabs disposed around an urbanistic concourse, brutalist in their parade of concrete structure and distinguished by horizontally patterned screens on their outer sides, quite distinct from Fry and Drew's referencing of African forms in their screens (fig. 6.10).[63] Unity Hall was added in 1963, designed by John Owusu-Addo and inspired by Le Corbusier's Unité d'habitation (fig. 6.11). Unity Hall offered a different type for the hall of residence with rooms double-banked off a central corridor, which was ventilated at each end, and raised up in a crisp nine-storey slab. This was one of the first and certainly one of the most assertive buildings designed by a Ghanaian modernist architect.[64]

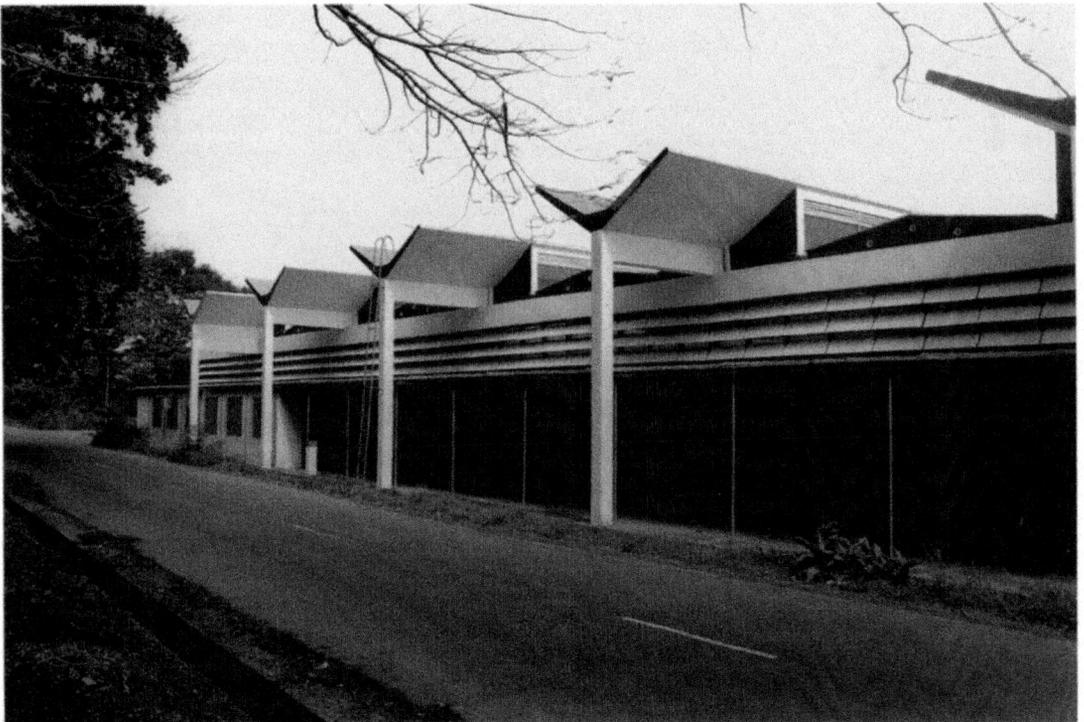

6.9 Engineering Laboratory, UST, Kumasi (James Cubitt & Partners, *c*. 1954)

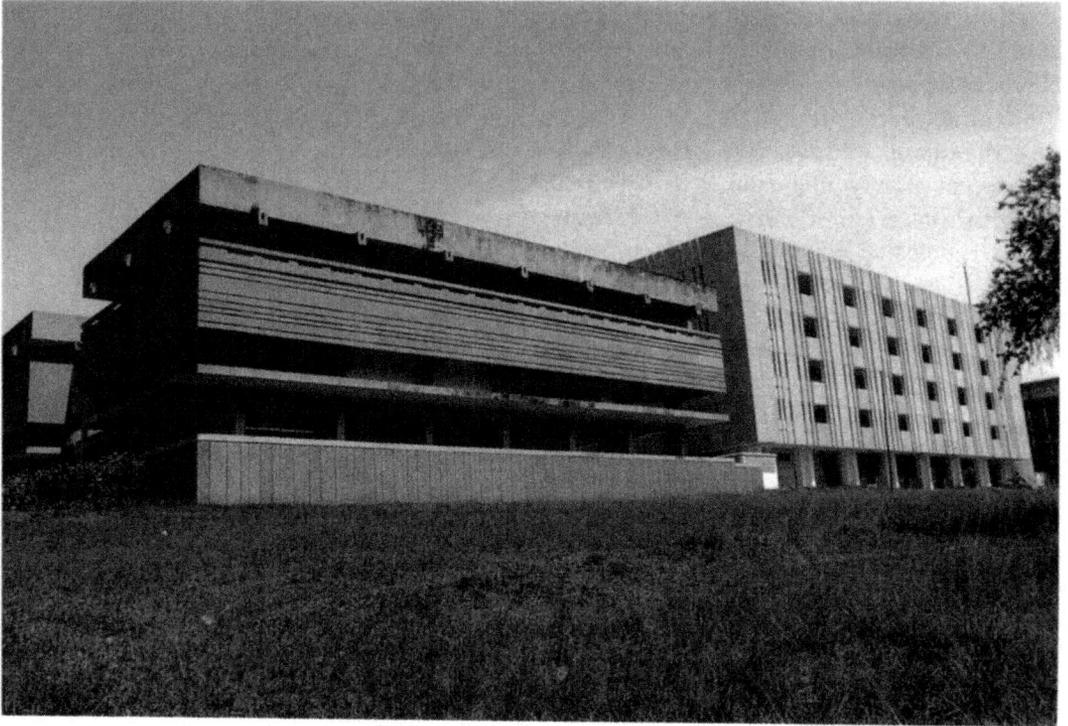

6.10 Great Hall, UST, Kumasi (Gerlach & Gillies-Reyburn, c. 1964)

6.11 Unity Hall, UST, Kumasi (John Owusu-Addo, 1963)

In the picturesque settings created on Legon Hill and at Kumasi, removed from the contradictions of their nearby cities and more extensive even than their contemporary British university equivalents, a fundamental discrepancy would open up between the British rhetoric of academic integrity and distance from political interference and the needs of a rapidly developing newly independent country. Although Harrison, Barnes & Hubbard was exactly the kind of firm from which Fry and Drew made efforts to distinguish themselves, their own attitude to universities had much in common. Fry and Drew described the university function in conventional British terms as 'a privileged community, somewhat removed from the turmoil of life, and devoted to the study of the truth behind the appearance of a wide diversity of things'.[65] Indeed this building type provoked the architects' most elevated claims for the capacities of architecture: universities should be works of art, and in them the architect discovers 'artistic truths and experiences that will enable ... people to understand the deeper meanings of their lives'.[66] Yet these were the buildings and settings that also seemed to embody detachment from contemporary needs and a continuing colonial attitude of special privileges and condescension for some time after independence in 1957.[67] Nkrumah was aware of this problem as early as 1954, both as a vocational and resource matter linked to the economic needs of the country and as a cultural one linked to African traditions.[68] By the late 1950s he and his government had begun to intervene directly to change university practices established on a British model, and to suit them better – as they saw it – to Ghanaian conditions.[69]

In Britain the new universities of the 1960s, designed in the most contemporary modernist idioms and located on campuses usually in bucolic rural settings well outside towns, had become notorious by the late 1960s for their radical student (and, in part, academic) dissent. And the mingling of repulsion for the ivory towers architecture and the political theatrics associated with the new universities led to attacks from many critics, including politicians, on their integrity.[70] This needs to be remembered amidst the predictable judgements that historians have made of Nkrumah's attitude towards Ghanaian universities.

'Tropical architecture' was not limited to educational projects. In the commission for a Community Centre in Accra (1955), Fry and Drew were given one of their most prominent sites (fig. 6.12). Facing away from the sea, the Community Centre was set back from the main road between Christiansborg and Ussher Town, quite near to the Supreme Court and the other main public buildings of colonial Accra. Funded by the British-owned United Africa Company (UAC), with its playground, sports grounds and pool, the Community Centre also represents an attempt to wrest back the association of this central area of the city with colonial leisure in favour of facilities for local people. The UAC, the largest single commercial organization in West Africa, had been a particular target of trade boycotts and arson during the civil unrest of 1947 and 1948 and in the mid-1950s faced increased competition.[71] The Centre has the most formal of fronts, with a

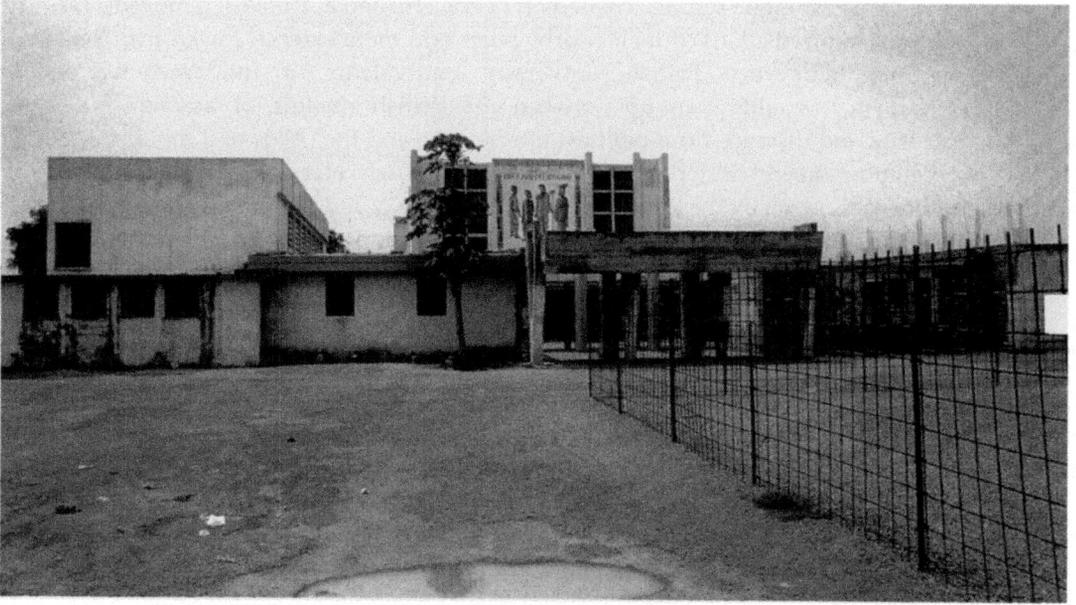

6.12 Community Centre, Accra (Fry, Drew & Partners, 1955)

porticoed entrance arch opening into a colonnaded courtyard and the assembly hall rising beyond. (see plate VII) Above the entrance to the assembly hall is a mosaic depicting four traditionally dressed figures by Kofi Antobam, a Ghanaian artist trained in Britain. The mosaic carries the following text in Ga (the language of the Ga people, local to the Accra area): 'It is good we live together as friends and one people.' The panels of the entrance doors were carved with fishing scenes and images of chiefs with ceremonial umbrellas and staffs. These images are important to the scheme, and indeed the mosaic, which rises above the entrance, can be seen for some considerable distance away. They represent reassuring images of pre-colonial rural life and a unified nation; they imply continuity even if the location, appearance and function of the building they ornament is far from the life depicted in these images. But this was the gift of the UAC and as such the allusions to continuity were a form of pledge, both of economic disinterest and of social stability.

Whilst Fry and Drew opted either for generically 'primitivist' images or for the incorporation of artworks by Ghanaian artists, at least one other way of making reference to Ghana's past can be found in modernist architecture. This is to be found in Kultermann's claim that the UST Engineering Laboratory's externalized structure and wing-shaped roof constructions 'give proof of an attempt to revive traditional local architectural forms'.[72] Kultermann fantasizes. There was certainly no attempt at revival by modernists but his comment typifies their desire to evoke occasional parallels in terms of structure with indigenous building, however different the materials, the method of construction and the resultant forms. In the 1960s

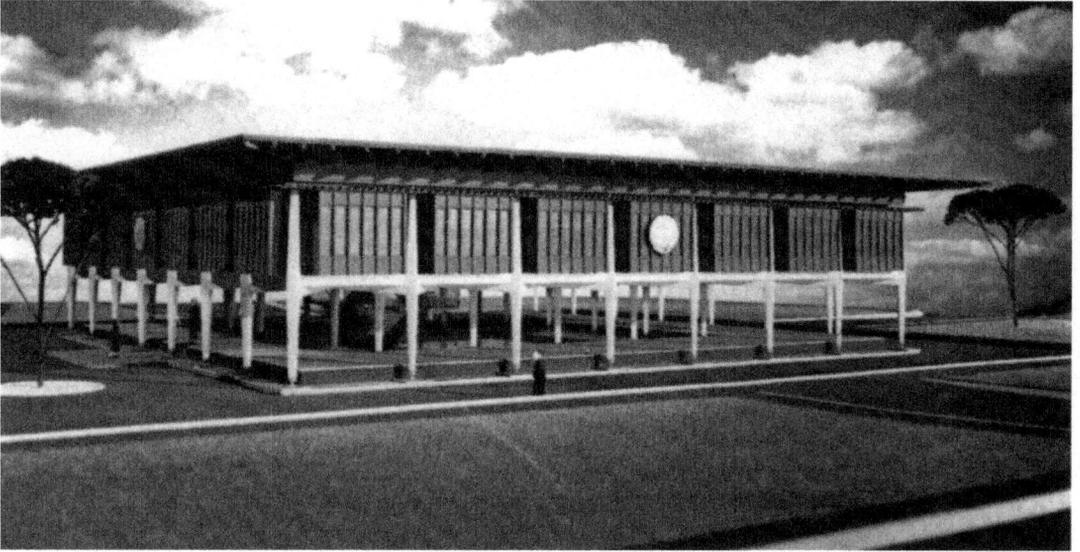

6.13 US Embassy, Accra (Henry Weese, 1956). *Ghana Today*, 18 September 1957

this became a more serious attempt to incorporate an understanding of the anthropology of village life in new town schemes such as the fishing village at Tema.[73] But the potential for absurdity in purely formal parallels is seen in the US Embassy in Accra, designed by Henry Weese in 1956 (fig. 6.13). For the Embassy it was stipulated that Weese design a building that harmonized with the local building tradition. What resulted was a rather elegant modernist box raised from the ground in a tapering reinforced concrete frame that Weese claimed had been inspired by the nineteenth-century palace of the Wa-Na in the northern territories of Ghana.[74] This mud-and-stick palace is a long, low building with regularly spaced buttresses that project in points above its flat roof. Whatever argument there might be about the appropriateness of this building form to the modern city of Accra, Weese's claim that his building had turned the palace upside down for its inspiration was patently ridiculous, even (and especially) if it was true. Yet the association itself had a purpose in evoking kinship and sympathy with Ghana's pre-colonial past, so staking a claim on continuity at the moment of independence.

New museum = new nation

The National Museum, opened to mark independence in March 1957, was a different kind of attempt to address the symbolic issues of this moment. It was an example of 'tropical architecture' and a token of national emergence; it introduced a new building type and a new kind of institution into the country; and it aimed to collect and display Ghana's past diversity of cultures but also to demonstrate their relation to Pan-African identity. The building

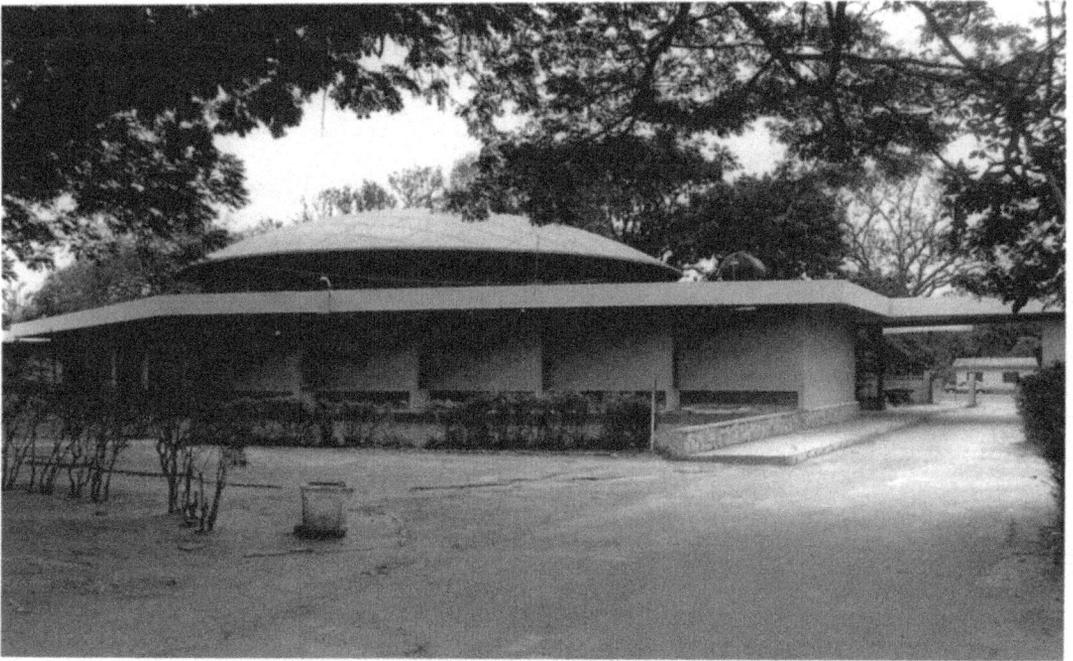

6.14 National Museum, Accra (Fry, Drew, Drake & Lasdun, 1955–7)

was designed by Denys Lasdun who was working for Fry, Drew, Drake & Lasdun when the National Museum commission was given to the firm in 1955 (fig. 6.14).[75] It was located in Accra's wide central area, between the older colonial settlements of Fort James and Ussher Fort (originally British and Dutch possessions) in the west and Christiansborg in the east. This area still had the expansive land use that was an inheritance of its colonial function as an area for bungalow compounds, polo grounds and military parades. In the 1950s its southern part was designated to be redeveloped for cultural institutions and central government functions.[76] It was here on Barnes Road, adjoining the new Accra Polytechnic, National Archives, YWCA and a planned science museum, that the National Museum was built. The siting separated the museum from Accra's commercial and historic neighbourhoods, imparting a sense of social distinction that was heightened by its aura of self-containment, its elemental outline and its eschewal of ornamental accretion.[77] The building itself is a domed concrete structure, with windows set in saw-toothed angles at ninety degrees to the outer wall; a clever solution to the need for cross-ventilation while reducing glare and maintaining extensive wall areas.[78] A high porte cochère shelters visitors, and a low saucer-shaped aluminium dome, with an ambulatory beyond it, covers the central space. Neither the entrance area nor the temporary exhibition area the other side of the dome are sufficient to impose an axis of movement, so that the domed space and its ambulatory prevail: circulation and display space are indistinguishable (fig. 6.15).

The dome, of course, has unavoidable European associations with a range

of monumental functions. And in Britain, as we saw in the previous chapter, it had recently been used in the Dome of Discovery (1951) to house a form of modernist people's palace closely identified with the image of the postwar nation. In Accra its architects justified it as a piece of cutting-edge prefabricated technology.[79] However, the dome was also entirely alien to Accra's architecture and building traditions, as much now as it must have been in the 1950s when the first wave of new modernist structures were being erected in the city. In the context of Accra, therefore, the dome, its location and materials mark out the museum as a separate and special kind of institution, a pantheon of the new nation, but they also distinguish it as both a symbol of modernization and an image without an indigenous history, the preserve of an educated urban elite.

Several concepts were conjoined in the National Museum which both individually and together were relatively new to West Africa. We have already discussed modernism as it was transcribed through 'tropical architecture', but both 'museum' and 'nation' require some comment. Whilst the link between the modern nation-state and the emergence of public

6.15 National Museum, Accra (Fry, Drew, Drake & Lasdun, 1955–7). National Museum and Monuments Board, Ghana

museums is now a standard assumption in studies of museum history, the different reverberations of this link in the colonial and post-colonial contexts are only just beginning to be understood.[80] How far, for instance, can the official versions of nationalism that emerged be traced to what was imagined by the colonial state, and what was the role of national museums in this? The scenario and its dilemmas, as it affected the National Museum in Ghana, might be sketched briefly. A country newly emerging as a nation-state from colonial rule builds a museum as one of its first foundational acts. The museum is itself largely the product of colonial curators and colonial heritage policies, but as a new institution it must represent the new dispensation; it is the *national* museum whose aim is to 'encourage the development of historical consciousness amongst the peoples of the Gold Coast ... an essential and urgent function because of the recent growth of national consciousness'.[81] The new Ghana was a collectivity whose heterogeneity, in Nkrumaist ideology, must be seen to be overarched by a common past and whose common concerns must be seen to outweigh divergent and contradictory interests. In other words, what is being analysed here is a further development from the museum described by Benedict Anderson as an exemplary institution in the imagining of the nation, 'profoundly [shaping] the way in which the colonial state imagined its dominion ... [especially] the legitimacy of its ancestry'.[82] In the National Museum a transition was affected, overwriting this dominion with the idea of the deep historical continuity of the nation, much as the country's new name implied a far longer history and typological prefigurement beyond the preceding colonial period. ('Ghana' was derived from the ancient Sahelian empire of Ghana.) The museum's collections and displays aimed to transcend its colonial past as well as the new nation's divisions: it managed community just as much as it imagined it.[83] As for the architecture of the museum, this could be understood as the museum's main public symbol and image, one which embodied aspirations to nationhood but one which also aspired towards a transhistorical and transcultural figuring of those modernist values of internationalism, formal abstraction and rationalist enlightenment.

Tensions and antagonisms between anticolonial nationalism, colonial modernization and versions of colonial-sponsored nationalism are common to the experience of post-colonial nation-state formation and its newly imagined political communities.[84] As Partha Chatterjee has written of Indian nationalism:

Nationalism denied the alleged inferiority of the colonised people; it also asserted that a backward nation could 'modernise' itself while retaining its cultural identity. It thus produced a discourse in which, even as it challenged the colonial claim to political domination, it also accepted the very intellectual premises of 'modernity' on which colonial domination was based.[85]

Colonial domination harnessed aspirations for independence into a form of national identity that combined compliant local forms of political traditionalism with the needs of economic development. But nationalism has also often asserted, in Ernest Renan's classic formulation, that it is a moral

conscience or spiritual principle: 'it presupposes a past; it is summarized, however, in the present by a tangible fact, namely, consent, the clearly expressed desire to continue a common life'.[86] That common life, for Renan, superseded differences of language, race, religion and geography; it was an invention and as such it needed a new set of cultural technologies, like museums, to promulgate it.[87]

In sum, it might be suggested that the National Museum's architecture is an attempt to figure both modernization and the spiritual identity of the nation.[88] It attempts to identify those who belong, and as such it encompasses continuities and communalities, boundaries and citizens, while absorbing or negating critical differences and multiplicity amongst them.[89] In short it is, to gloss Renan again, an act of forgetting that enables new forms and authorities of remembrance.

If there is a crucial element in this embodiment of a spiritual principle it must be the museum's dome. The dome is not only the main outward image of the museum, it also establishes the phenomenological conditions of the museum space. By contrast with the Dome of Discovery, the spatial layout of the National Museum is allowed to be determined by the dome, as movement around the building involves circling the interior, radiating out from its centre on the main floor and around the outer ambulatory and the gallery above. The architects' publicity for the building presented the display areas as offering flexibility and a range of display modes: it provided 'a variety of spatial arrangements, both in terms of volume and plan form, to suit the display of a heterogeneous range of exhibits', and the varying section heights allowed the disposition of objects in positions related to their size.[90] Despite this, centrality, as both a spatial location and a symbolic quality, is the most obvious element and also, arguably, the most problematic aspect of the museum's design. A centralized circular space seems to provide certain spatial hierarchies but it also poses particular problems of orientation and meaning. Where, for instance, does one start one's route? What is the significance of peripheral location for the displays and, likewise, what are the particular resonances of placement in a radial or concentric display? How can emphasis on any single line of passage across this space not be made to seem arbitrary?[91] And, finally, if spatial centrality signifies symbolic supremacy, is this not an ethnographically specific concept,[92] and if so might the central area of the museum have no particular resonance for some of its visitors? If these questions are posed so that they seem to deny categorical answers it is because the curators who have used these spaces, and even the architects who originally designed them, have never been clear about a way to use them that would not deny the cultural equivalences, under the sign of modernity, on which Ghana's national independence was based. This might also explain the museum's subsequent detachment from the making of public history, its marginal and neglected place in the nation's cultural life.

After independence

There is no doubt that in the period from 1957 to 1966 grandiose architectural projects increasingly became the most common outward image of prosperity, stability and heroic modernization for Nkrumah's regime, whereas earlier, and especially in his first and second terms of office in the 1950s, the emphasis had been on buildings for social services, education and communications, as well as major new projects of industrialization such as the Volta River Project.[93] But in 1958 the government declared a new programme of official building in Accra and by 1965 the new Parliament House, a sports complex, a national theatre, a new railway station, new ministerial buildings and eye-catching new planning schemes were all in progress.[94] Most notoriously, for the conference of the Organisation of African Unity a huge conference complex was built. Known as 'Job 600' this was completed quickly and at the immense cost of £8,000,000 as a kind of platform for Nkrumah's Pan-African ambitions. It included a residential tower with sixty self-contained suites, a conference hall for 1000 people and a banquet hall for 2000.[95] The profits from such prestigious projects inevitably left the country as most construction enterprises were in the hands of foreign firms. As regards architectural skills for this new wave of projects, there was certainly a tendency in the 1960s to turn towards non-British architects, especially eastern Europeans, in the absence of a significant number of experienced African architects: there were a number of German and Yugoslav architects working in the country in the 1960s, Russian architects were brought in to work on the new town of Tema in the early 1960s and the Greek consultants Doxiadis Associates reported on it in 1961 as well as offering their own programme to train Ghanaians in housing and planning.[96]

The most obvious monuments to independence were Independence Arch and the new state house and prime minister's residence. As all three were intended to mark the declaration of independence in 1957, like the National Museum they had been in preparation by the PWD for some time before this date but they all took a startlingly different approach from the Museum. The State House and Prime Minister's Residence were approached by an avenue eight hundred metres (half a mile) long and past a large forecourt with fountains. There was even something Lutyensesque about their arrangements – with a stone first floor, a portico running the length of the first floor and wide eaves (fig. 6.16). Inside they were furnished with Italian marbles, crystal chandeliers, silks and brocades. Imperial associations were even more evident with the Independence Arch (fig. 6.17). This took the form of a monumental Roman triumphal arch some 15 metres (50 feet) high with a coffered soffit, placed on the road between Christiansborg and Ussher Town at the spot where the demonstrating ex-servicemen had been killed in 1948. Nnamdi Elleh has recently suggested that the form of the Arch was a deliberately subversive act: '[it] represents the irony and identity crisis that surround African politics ... a Western trophy in stone has been borrowed to celebrate an African victory over a Western imperial power of the twentieth century'.[97] Such arches had been

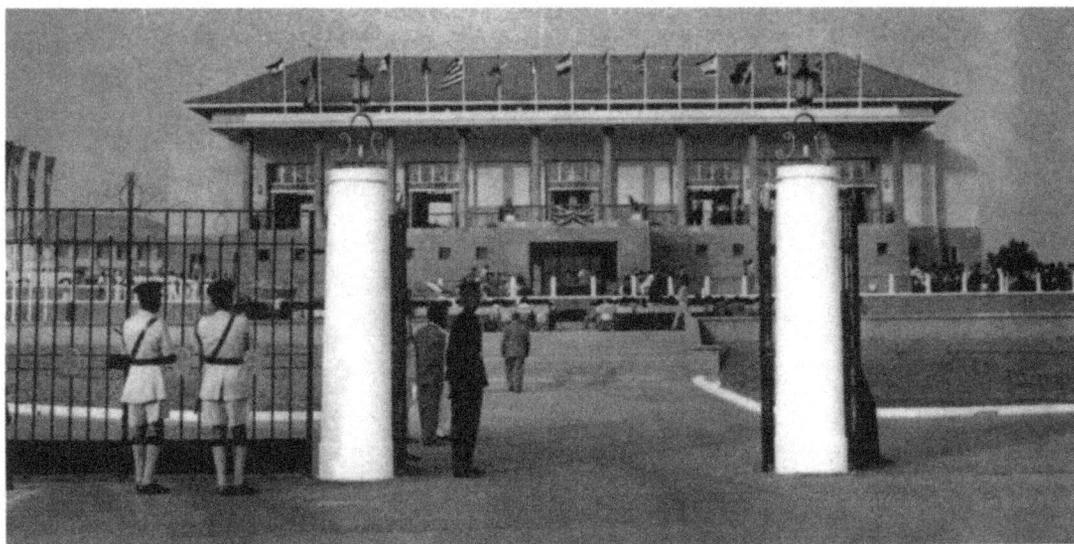

6.16 State House, Accra (Ghana PWD, 1957). *Ghana Today*, 16 October 1957

used not only in the imperial metropolises like Rome, London and Paris, but also in cities like New Delhi. As such, in Elleh's view, the Arch reversed the use of African architecture to celebrate colonial rule, as had happened in the colonial expositions. However, it is unclear if Nkrumah and his supporters would have shared this view. Certainly when it came to state-sponsored monuments to Nkrumah himself, Italian models (such as the monument to Garibaldi) were turned to not with irony but because they represented the image of the ideal nationalist leader.[98] In another incident, when the new Parliament House was discussed Nkrumah showed the Cabinet an image of the Hungarian Parliament House which appeared on the top of a cigarette box presented to him by the Hungarian Trade Mission, and recommended that a near copy of it be made for Accra.[99] But whether with or without irony it is apparent that the Independence Arch marked an act of collective memorialization focused on the site more than the architectural form.

The siting of these new buildings generally followed but also reshaped and reclaimed the colonial disposition of space in Accra. The state house and the residence were located to the north-east of the city in the bungalow area of colonial compounds, whilst the Arch spanned the main coast road between Christiansborg and Ussher Town in the open central area of the city used for colonial leisure. But the Arch was located at a decisive distance away from the old Parliament House and Supreme Court that were both on the edge of Ussher Town, and represented the first move in a transformation of this middle stretch of the coast road into a highly grandiose theatre for independence celebrations and parades including the Black Star Square Arch, finished in time for the visit of the Queen in 1961 and, despite its Soviet aura, designed by British architects in the PWD. The area from the state house south-westwards was also transformed, partly in accord with its zoning for

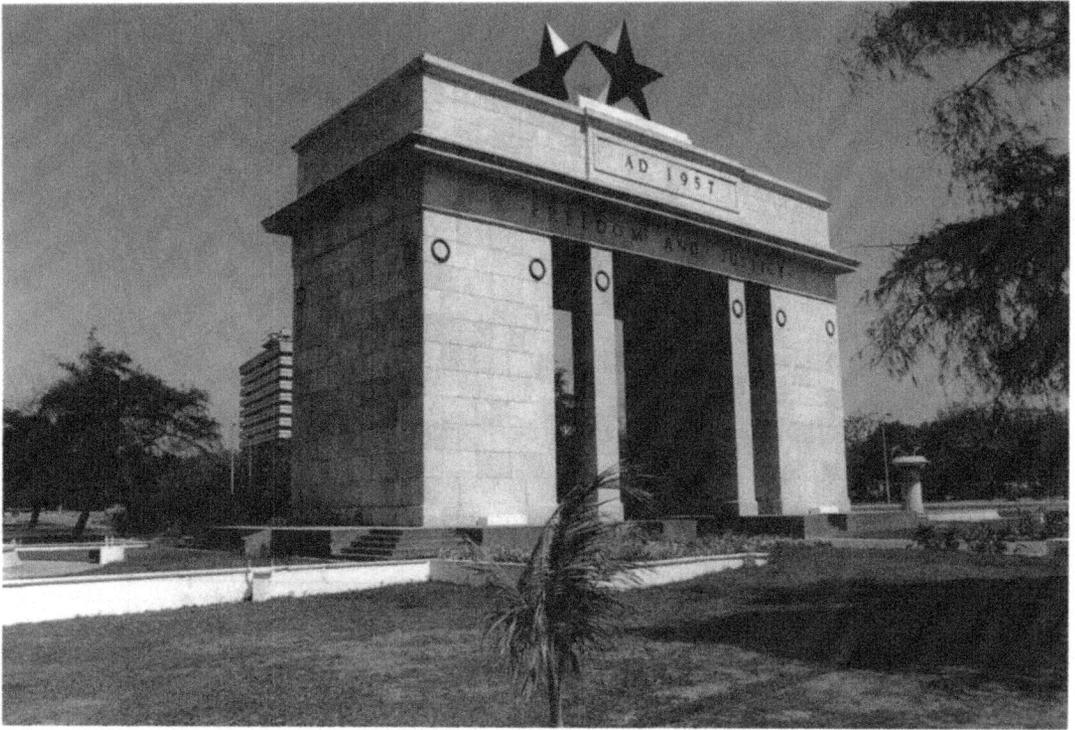

6.17 Independence Arch, Accra (Ghana PWD, 1957)

administrative functions by the colonial government in its 1944 plan for Accra.[100] While some of it married the image of ministerial residences to that of the older colonial residences, in other parts new ministries appeared, justifying the assertion that the architecture of bureaucracy had become the symbolic nucleus of the city.[101]

Frantz Fanon, who was closely familiar with the Ghanaian situation, saw this increasing tendency towards an architecture of grand gestures and 'prestige expenses', as well as the turning in art and architecture to 'castoffs of thought, its skulls and corpses', as key symptoms of the stagnation of a new national bourgeoisie securing its own position whilst turning its back on actual events and the inheritance of underdevelopment. Fanon also decried the leader cult, based on a popular leader who could stabilize the regime, stand for moral power and perpetuate the dominance of one class, whatever the leader's own declarations, and this again was well manifested in Ghana.[102] In these circumstances public architecture, as it framed Accra's central spaces, had shifted away from providing essays in nationhood and paternalism or shrines to modernity. Instead, as modernization produced increasing numbers of empty factories and dubious industrial projects, architecture had retreated to its function as a means of selective public memory and the embodiment of bureaucratic symbol systems. The Faustian pact had been sealed and architecture became the condition of neocolonialism writ large.

The view from Penang Hill: modernism and nationalism in Malaysia

To move from Ghana to Malaysia, as this chapter does after the last, is not just an extreme leap in distance but also a movement between vastly different cultures. Nevertheless, there are points of similarity in the period of late colonialism. They had comparable levels of wealth in the early 1950s and were amongst Britain's richest colonies. After the war, in both countries, the colonial state had come to manage great areas of capital and welfarist development schemes. Their transition to independence was similar too, and not just because they both shared the same year of formal separation from Britain (1957). Most of all they were both nations brought into being from plural societies governed under indirect rule whose national boundaries were determined by the contingencies of colonialism rather than some recognized pre-colonial entity. In the architectural field, however, there were two substantial but revealing differences: first, whereas in Ghana expatriate architects dominated the profession up to independence and for some time after it, in Malaysia indigenous architects had already become prominent before independence and they very much led the riposte to colonialism in architecture; second, and in part following as a consequence of this, in Malaysia architecture was, and still is, seen by many as a critical area for a national cultural expression and so the debates about the relation between modernism and nationalism in architecture were far more extensive and long-lasting than in Ghana or even, arguably, any other part of the ex-empire. This chapter will consider these debates as they were embodied by a few particularly highly charged public buildings, as a matter of dialogue between and within these buildings, as carried through into the architectural culture of journals, training and professional bodies, and as connected to the formation of national post-colonial identities in culture and politics.[1]

For most of this chapter the older name 'Malaya' will be used rather than the current 'Malaysia' because it covers the complex administrative subdivisions of the area up to 1963, when the latter name was adopted, and therefore embraces most of the period of concern here. A little less defensibly 'Malaya' is also used, because of the close cultural connections (especially as professional architectural culture developed), to include Singapore which had

been a Crown Colony and joined the new Malaysia in 1963 but then left it in 1965.[2] Under the British, Malaya was made up of the three Straits Settlements (Penang, Melaka and Singapore), and the nine protected Malay States, of which four constituted the Federated Malay States. Following the war the British attempted to unify the country under direct rule with their plans for a multiracial Malayan Union. But this was a more direct colonial arrangement than had existed previously, removing protectorate status and the power of Malay rulers, and it was opposed most notably by the new United Malays National Organization (UMNO) founded by Dato Onn bin Ja'afar. By 1948 the British had compromised, particularly with the majority Malay population, and formed the Federation of Malaya, retaining the Sultan's sovereignty and with citizenship limited to Malays. The so-called 'Malayan Emergency', a guerrilla war fought by mainly Chinese Communist groups against the British, broke out in 1948 and lasted until 1960. The federal elections of 1955 overwhelmingly returned the Alliance, combining Malay, Chinese and Indian parties, led by Tunku Abdul Rahman, and it was to this same Alliance that leadership of the country passed when the British were forced to cede independence – or *Merdeka* – more quickly than they had envisaged in 1957. Independence left Malaya with Malay as the official language and Islam as the state religion but a majority Malay population who had influence but little economic power, while the country's economy as a whole was dependent on rubber growing and tin mining still largely in ex-colonial hands.

In terms of architecture, colonial Malaya retained an extraordinary variety of forms of building production: vernacular practices in the rural and outlying areas; the craft traditions and building typologies of Islamic architecture; the construction methods and building forms of Chinese and South Indian communities; and the rising dominance, in the cities especially, of western practices of professional architecture and engineering, the product mainly of the PWD, expatriate architects and big practices that might have offices in several other cities across South-east Asia.[3] Even in the interwar period there seems to have been a higher proportion of registered Asian architects than in other parts of the empire.[4] But a racial division of labour existed: Asian architects worked for Asian clients, European architects mostly for expatriate clients; and Asian architects until the 1960s were predominantly Chinese. Expatriates came from a wider range of countries, perhaps, than in other parts of the empire. Australia in particular, both for its architectural training and its architectural influence, had an important role. The architectural opportunities really began to beckon on the mainland in the 1950s – and with them the need for more architects and technicians – whereas Singapore was already more advanced in its modernization.[5] Despite Kuala Lumpur's status as the colonial administrative centre, it was still lacking in modern facilities: in 1950 there were 'no traffic lights, two hotels with waterborne sanitation and the airport terminal was a thatched hut'.[6] In the next two decades, however, the economy expanded rapidly and as it did so the building industry became both more homogeneous and better geared to the global supply of materials, methods and architectural discourse.

Two buildings can initiate the discussion, both of them direct products of the larger political events already outlined. The first is Federal House, built in Kuala Lumpur to the designs of Berthold Iversen and S. H. Van Sitteren following victory in an architectural competition of 1951 (fig. 7.1). Federal House contained government offices for the new federated administration, as well as accommodation for the PO Savings Bank and Radio Malaya. For its architecture and its site, the building is particularly relevant here. Its triangular site was in close proximity to the colonial administrative buildings erected fifty years before in the Indo-Saracenic style, with all that that style had attempted to say about imperial knowledge and synthesis of past cultures.[7] This was a juxtaposition picked up in the official guidebooks of the time.[8] The area had been intensely developed as a government quarter by the British since the late nineteenth century, with government offices and public buildings, hospitals, barracks, a parade ground and clubs. Since independence the central part of this area in particular has added extra layers to its function as a *lieu de mémoire*, or symbolic site, with the *padang*, once an English cricket field, now renamed Merdeka Square and the recent addition of one of Prime Minister Mahathir's *grands projets*, the tallest flagpole in the world.[9] Federal House, however, was not calculated as a contribution to the historical claims made elsewhere in the area, rather the reverse. It was a T-shaped, eight-storey building turned away from the *padang*: one block housed offices, the other, public spaces. Its design juxtaposed blank brick and

7.1 Federal House, Kuala Lumpur (Berthold Iversen and S. H. Van Sitteren, 1951)

stone walls with a mix of glazing and green Vitrolite panels on its south-facing sides. A line of nautical windows punctuated the wall beside the entrance, thin horizontal fins provided shade, whilst the (originally) curved concrete roofs above sheltered Radio Malaya. Without the ostentation of the older government buildings, let alone their Orientalism, Federal House aimed for an image of a discretely elegant and modernized bureaucracy.

In 1963, nearly six years after Malaya had gained independence, a new Parliament building was completed on a piece of parkland eight hundred metres (half a mile) from the old centre of colonial Kuala Lumpur, a site without the resonance of the area around Federal House (fig. 7.2). Designed in 1960 by Ivor Shipley, an Australian-born architect working for the PWD, the project had first been mooted in 1956 although an international competition had been abandoned when it proved impossible to formulate a brief.[10] The complex consists of two units: an eighteen-storey tower block housing offices, and a two-storey slab containing the Senate and the House of Representatives. Both the block and the slab are characterized by the regular matrices of concrete screens around them, a device familiar from 'tropical architecture'. They have not received any particular articulation here, unless the overlapping pineapple-skin or armadillo pattern on the tower or the projection of part of the screen as pinnacles on the slab could be said to have local significance.[11] It would be easy to find similar buildings anywhere in the world at this time. What could not be found anywhere, though, was the roof that projected from one part of the podium and sheltered the House of Representatives. Consisting of eleven acutely angled or pleated concrete pinnacles, it is a distant reminiscence of the multiple roofs, steep pitches and emphatic gable ends of traditional houses elsewhere on the peninsula. Shipley had visited both New Delhi and Chandigarh as part of his research for the Parliament building, but what he learnt in India were not aesthetic lessons, from either Lutyens or Le Corbusier, but the importance of keeping the upper and lower houses in proximity, with members sharing most facilities.[12] Both houses were also planned in the Westminster manner with government and opposition in parallel rows of seating facing across a central well and a Speaker at right-angles to them. But it was the Representatives, not the members of the Senate, who were given the pleated, concertina-like roof, an abstracted and modernized throwback to the *kampongs* of rural Malaysia. Political legitimacy is obviously what is at stake in the Parliament building. It seems to want to establish itself as pre-colonial and Malay in identity: the Parliament of *bumiputra* (sons of the soil), moderns and democrats, all at the same time. Unlike Federal House, it was not enough that the Parliament symbolized a new era by presenting a modernized alternative to colonialism. It also had to indicate its historical patrimony, to construct its authority in the name of the nation.

7.2 Parliament building, Kuala Lumpur (Ivor Shipley for the PWD, 1960)

The 'Malayan'

The British had some investment in encouraging the development of a national style of architecture in Malaya. A fascination – variously amateur, academic and bureaucratic – in historic Malayan cultures was a feature of the last decades of colonial power, in Malaya as in Ghana. The historian Sir Richard Winstedt wrote *History of Malaya* (1935) and *The Malays: A Cultural History* (1950); officers in the Malayan civil service like Melvin (later Mubin) Sheppard and Walter Linehan published articles on the history of Malaya in the *Journal of the Malayan Branch of the Royal Asiatic Society*; others collected what they called 'Malay folk literature'. Much of this work was typical of the Orientalist desire to record cultures dying out in the face of modernization, but there was also a complementary movement to induce a new culture before the inevitable new nation came into being. Towards the end of his stay in Malaya the novelist Anthony Burgess, who worked as a teacher there, composed a somewhat fanciful farewell gift:

Sinfoni Melayu, a three-movement symphony which tried to combine the musical elements of the country into a synthetic language which called on native drums and xylophones as well as the instruments of the full Western orchestra. The last movement ended with a noble processional theme, rather Elgarian, representing independence. Then, over a drum roll and before the final chord in C major, the audience was to rise and shout 'Merdeka!'[13]

The desire to engineer cultural synthesis should be seen in relation to the Malayan Emergency that dominated British policy towards Malaya in the immediate postwar period. Certainly when Sir Gerald Templer took over as high commissioner and commander-in-chief after the assassination of Sir Henry Gurney in 1951, the new regime, bolstered by a leader who now combined civil and military power, adopted a 'hearts and minds' policy of promoting Malayan nationalism as a counter to the Chinese Communist groups that threatened to destabilize the country. As Templer wrote,

The Emergency cannot be won by guns and barbed wire alone but only by capturing the hearts of the people ... one of the ways to do this, is by making them conscious of the greatness of their cultures, and showing them how these cultures have in the past contributed and will still contribute to the building up of this Malayan Nation.[14]

Templer saw the building of the multicultural and multiracial nation under British guidance – using the English language and British notions of cultural heritage – as a necessary condition for entry into the Commonwealth and then for full independence, but as 'this Malayan nation does not exist. It has got to be formed.'[15] Templer expanded information services to proselytize the new nationhood (including radio broadcasts on Malayan history), he increased the powers of self-government in local councils, encouraged the formation of the Malayan Historical Society in 1953, and his concern for the lack of Malayan content in the school curriculum led to the publication of textbooks like *Malayan Fables* and *Heroes of Malaya*.[16] This 'vision of cultural fusion' was also carried over into British accounts of the country's arts and crafts.[17] In all these ways the policy of Malayanization aimed to promote nationalism as an integrated cultural and political phenomenon, a bulwark against extra-nationalist ideologies like Communism and against intra-nationalist communalism.[18] It was an attempt to control the momentum of social change as well as the form taken by nationalist imaginings.

At least two of Templer's nation-building projects had a direct relation to architecture. In a speech to the Penang Settlement Council Templer advocated a system of listing historic structures in order to research and to preserve them, and he was especially concerned that British colonial buildings – the embodiment of a 'proud ... connection' – should be listed.[19] In 1953 he lectured to a meeting of the Federation of Malaya Society of Architects and regaled his listeners with the demand for 'some kind of distinctive Malayan style of architecture ... Perhaps something on the lines of the old Menangkabau roof with the pointed and sloping ends.'[20] 'What I am after', Templer stated, 'is trying to get something Malayan in front of the eyes of the people who are going to become the Malayan nation ... [with] something of the effect of a flag or a language as a focussing point for their belief in themselves as a united nation.'[21] In the pursuit of a new consciousness, an architecture that could be understood as 'Malayan' would help to elevate the populace above ethnic interests towards a positive nationalism. It is worth noting that in the 1950s this idea, or indeed any form of national expression in architecture, was not necessarily shared by Malayan

clients. UMNO's own headquarters building in Kuala Lumpur, where this might be most expected, was actually one of the few buildings at this time in the country to take on the classic forms of 1920s European modernism (fig. 7.3).

Templer's nation-building campaign was, of course, an attempt to transfer a European sense of the nation into a South-east Asian context, taking the colonial as the normative and acting as the arbiter of acceptable forms of political legitimacy.[22] The vision here was one of cultural fusion under the sign of the nation as a greater, transcending ideal: the attempt to establish a new Malaya. Templer's project was, as T. N. Harper has argued, a myth of Malayanization, 'but in essence fusion meant Anglicisation'.[23] However, there are other possible narratives here as well. One is what Gayatri Spivak has called 'the palimpsest of precolonial and postcolonial continuity ruptured by the imperfect imposition of an Enlightenment episteme'.[24] Independence marked, for the Alliance that dominated Malayan politics after 1955, not just the coming into being of a new fused nation but also the disinterment of pre-colonial sovereignty, the reaffirmation of a ruptured continuity. Unsurprisingly, the 'Malayan' was perceived as part of colonial culture but this did not achieve popular support. In the end 'the devices of colonial state-building became tools to plague their inventors' heads', resulting in an upsurge of religious and ethnic identities as well as movements of cultural reconstruction including 'the reformulation of the Malay language as an agent of national mobilisation'.[25]

Modernizing nationalism

As in other fields, the 1950s saw a revival of interest in vernacular architecture in Malaya. *PETA*, the country's main architectural journal, published articles on 'Malay Timber Buildings', 'Sakai Houses' and 'Two Minangkabau Timber Houses', all of which were intended to inform debate on an appropriate national style.[26] Elsewhere, studies were published of 'The Basic Malay House' in 1956[27] and 'Four Historic Malay Timber Buildings' in 1962.[28] There was little, however, on Chinese architecture, perhaps because this was not understood as indigenous.[29] Although it appeared to some commentators that British architects seemed more interested in local building traditions than Malayan architects were, that impression was undoubtedly wrong and probably a product of access to publishing resources as much as a political desire – common, as we have already seen with Ghana, in other parts of the late-colonial empire – to be seen to be 'in sympathy' with local tradition.[30] For modernist architects, whether British or Malayan, the study of traditional building tended to reinforce the idea that architecture was so integrated with its particular and historically bound technical and social conditions of production that only the most general of principles could be discerned from past practices and examples.

The British Council building, built in 1956, might be understood as an

7.3 UMNO building, Kuala Lumpur (Y. T. Lee, 1955)

attempt to merge traditional elements within what was otherwise a modern building (fig. 7.4). In a sense the attempt was rather too obvious, for here was an institution whose very modus operandi was the promotion of benevolent British cultural interest (exchanges, English language teaching, exhibitions),

a form of national projection – though the term was rarely used by this time – within the Commonwealth and even an anticipated post-colonial framework. Tellingly, the building was located on a hilly site given by the ruler of Selangor just off one of the main old colonial routes into the centre, Victory Avenue (now known as Jalan Sultan Hishamuddin), between the National Museum and the sequence of colonial Indo-Saracenic buildings – the railway station, the Railway Administration building, the PWD building, the General Post Office – that led to the *padang*, the State Secretariat, St Mary's Church and the Selangor Club. In just these same years Kuala Lumpur was being transformed from a colonial administrative capital to a cultural junction box for the new nation, and an essential part of this new role was to be equipped with the necessary architecture of civic cultural life. Designed by K. C. Duncan of the PWD, the British Council is a combination of the softer populist modernism of postwar Britain (often known as 'people's detailing' and typified by its use of a range of materials) and a pitched, slightly horned roof supported by steel trusses. The concrete frame was revealed and infilled with local stone and painted concrete panels while the curving porch on the entrance front was fronted by an array of wooden joists. The structural technology is new, therefore, and undisguised while the other elements play the role of ornament.

It is in the context of 'Malayan' buildings like the British Council,

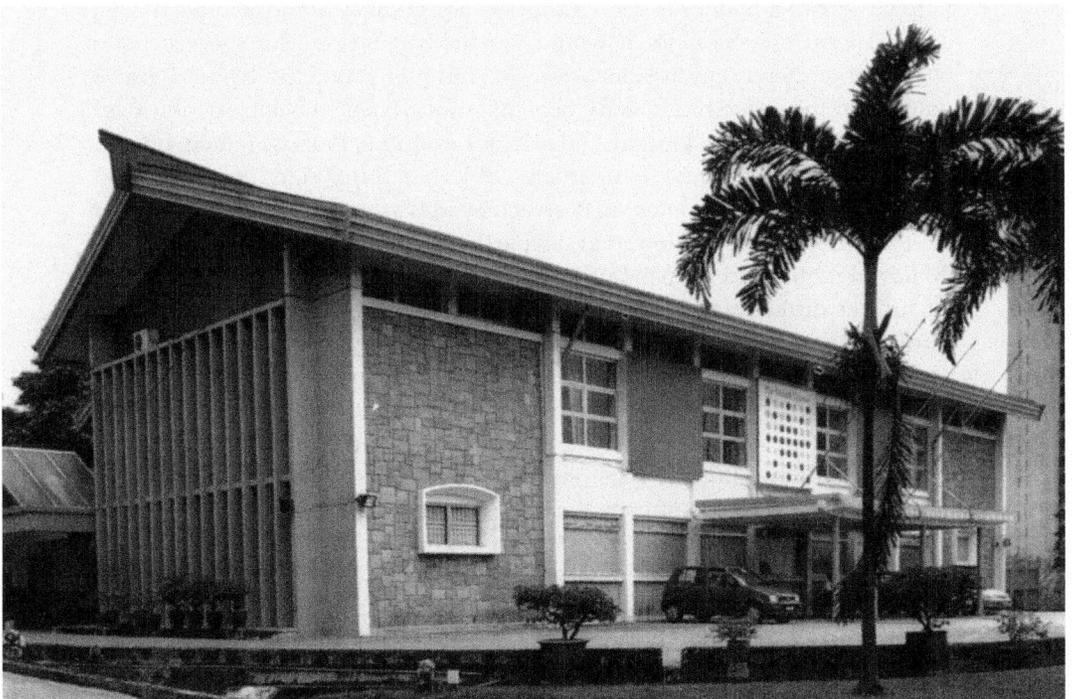

7.4 British Council building, Kuala Lumpur (K. C. Duncan, 1956)

modernist buildings like the new airport terminal with its Brasilia-inspired awnings, and mixtures of the two like the Language and Literacy Agency (1959) with its two modernist slabs, one of which was fronted by a mosaic with nationalist subjects, that the debates over a nationalist form of architecture must be seen. These debates were a prominent feature of much talk about architecture at this time, from government circles, through journalism, to architects themselves. Indeed it would be hard to find any other post-colonial country where the issue of an architecture for independence was more extensively discussed. The official, post-independence view on this was probably expressed by the Deputy Prime Minister, Tun Abdul Razak, at an architectural exhibition in 1959: 'I would like to see some Malayan touch in our new buildings. It may be Malayan motifs in decoration, it may be a mural of a Malayan scene, it may be just the line of a roof.'[31] At the other extreme, for Julius Posener, a German architect who had worked with Peter Behrens in Berlin and came to Kuala Lumpur to direct the new architectural school, no compromise was necessary, indeed the local traditions were 'thin … [with] few viable local prototypes'.[32] Modernism was ubiquitous, inevitable and already international: 'Today, we are building our Brazil Air Terminals, English curtain walls, Düsseldorf fire stations … Dutch, English and Chinese have brought the houses they are used to and built them here, with some adaptation. And we, today, are doing the same thing, and we need not be ashamed of it.'[33] Modernism was therefore doubly foreign, existing neither in local traditions nor in those of the colonial power, even if local inflections of it would inevitably develop. But these debates were not of merely professional concern. Templer's and Tun Abdul Razak's interest in this issue has already been mentioned, and the subject spilt over into more mainstream journals. In 1960, for example, *Progress* (an offshoot of *Straits Times*) headlined one article 'Still No Sure Sign of a National Architecture'. What had not yet been achieved was the rather vague hope for 'a pattern of construction that is particularly Malayan, that will have Malayan motifs and forms'. But it also seemed that an almost impossible set of further desiderata were needed: 'its inspiration should be the Malayan climate, the Malayan pattern of living, the unity of many peoples and cultures and the limited traditions that exist'.[34] The myriad range of current styles and the easy importation of fashions from abroad made the prospects bleak; nevertheless there was the odd good example such as the British Council building. But the most substantial suggestion was for a school of architecture that would obviate the need for budding architects to go abroad – and thus absorb foreign trends – for any part of their training. Prospects for the promotion of the Malay language and Malayan music were slightly better – 'Malay Official Language by 1964' and 'No Malayan Music Yet, But it's on the Way', read two other headlines in the same issue.

The National Museum

Although this section is devoted to the National Museum, the most revivalist of public buildings of this period, it is useful to remember that, although the discussion here is limited to public buildings, the most prominent building in Kuala Lumpur of the early 1960s was the ultra modernist Lee Yan Lian building, built in 1960 to designs by E. H. Cook (fig. 7.5). This was the tallest building in the city at the time and it was also the most knowing; a veritable bestiary of contemporary modernist devices, from an angled entrance to a double range of square windows in a black-tiled wall, projecting service

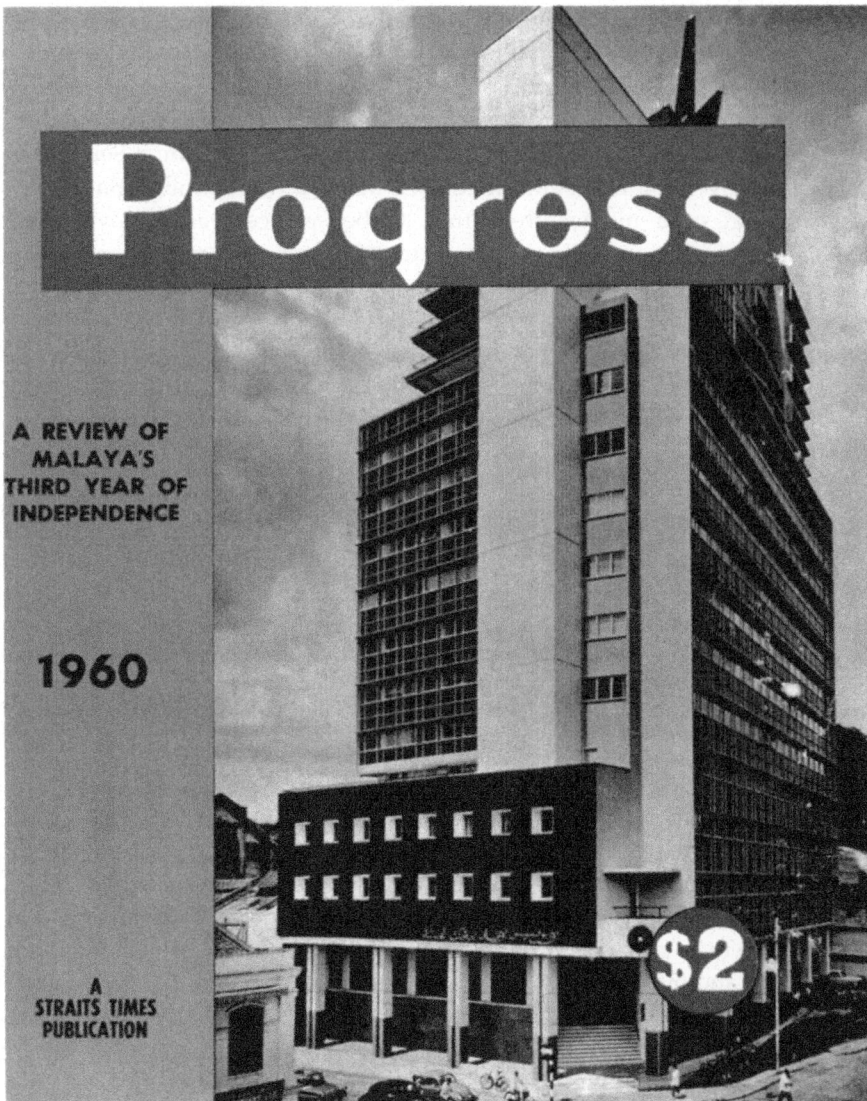

Progress

A REVIEW OF MALAYA'S THIRD YEAR OF INDEPENDENCE

1960

A STRAITS TIMES PUBLICATION

$2

7.5 Lee Yan Lian building, Kuala Lumpur (E. H. Cook, 1960). *Progress*, August 1960

units, hooded windows and angular sculptural forms on the roof. It was this building that was chosen by contemporary guidebooks to represent the city's contemporaneity and it was chosen for the cover of the same issue of *Progress* that had bewailed the lack of a national architecture.[35]

Amongst the most important projects promoted by Templer in his cultural crusade was the National Museum. The old Selangor Museum had been wrecked by Allied bombs in an attack on the nearby railway yards in 1945. Templer saw the reinstatement of a museum as one of his most urgent tasks, enabling the colonial state to appear, as Benedict Anderson has put it, 'as the guardian of a generalized, but also local, Tradition'.[36] By early 1953 a temporary building had been erected to house the collections. Templer's conception of the museum was as a shrine to national cultural heritage as well as an inspiration to contemporary Malayan crafts. Although Templer's museum was little more than a shed, the idea that an existing vernacular example might serve as a model for a museum building can be found in another Templer initiative, the Negeri Sembilan State Museum at Seremban, established by Templer's cultural adviser, Mervyn (later Mubin) Sheppard. Here a ruin of a nineteenth-century timber palace was removed and reconstructed to provide the new museum.[37] This removal and repositioning of a Malayan house as the container for a colonial project of cultural reconstitution offered a key precedent for what would happen with the National Museum after independence.

The prospect of building a national museum was not returned to until cabinet approved the project in 1958, and the Prime Minister, Tunku Abdul Rahman, became personally identified with it. The PWD architect, Ivor Shipley, prepared a modernist design 'square on plan and [consisting] of a series of galleries on several levels built around an atrium'.[38] Sheppard, who worked as Director of Museums after independence, was appalled by this design:

It showed no trace of Malayan or oriental culture in spite of the stimulus which might have been derived from the Railway Station, railway offices and the Secretariat. The British architect dismissed my protest with a 'that's what you're going to have' reply, adding that Malay-style architecture was only suitable for small timber buildings.[39]

Sheppard appealed to Prime Minister Tunku Abdul Rahman who gave him permission to consult another architect and ask him to prepare 'Malay-style designs' for him to consider.[40] Ho Kok Hoe was the architect to whom Sheppard turned. Ho was also a painter noted for his nationalist subjects, but Sheppard's interest in him was due to Ho's cultivation of Malayan arts and crafts. The two proceeded on a tour of the north of the country for inspiration, and out of this Ho produced a design inspired by the Balai Besar, an audience hall in Alor Setar, Kedah, and other features from traditional Malay timber palaces.[41]

The National Museum that resulted was cruciform, consisting of galleries on two levels either side of a double-height entrance hall (fig. 7.6). In this basic arrangement it was curiously reminiscent of the old Selangor Museum

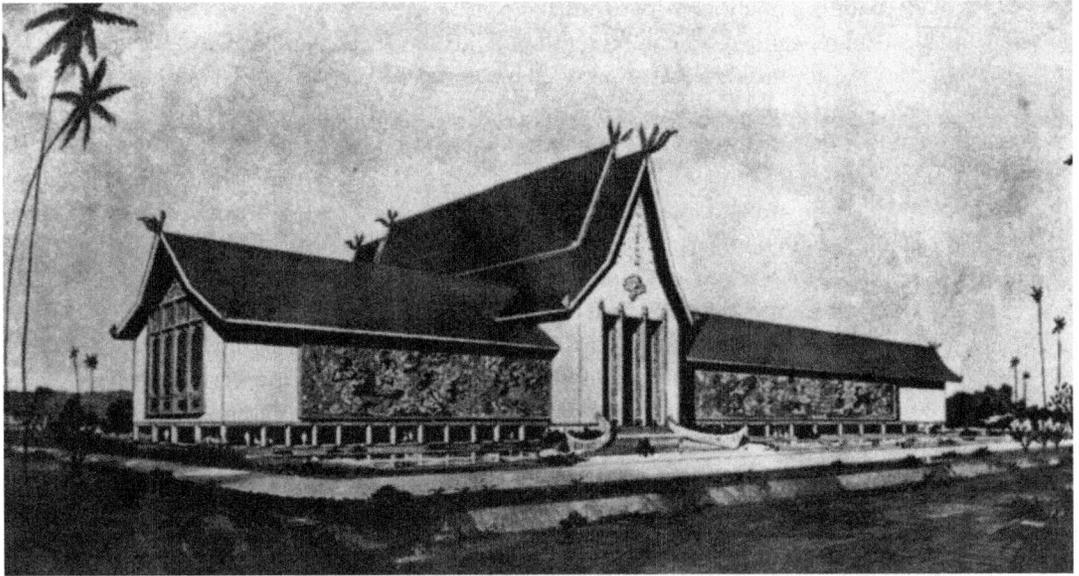

7.6 National Museum, Kuala Lumpur (Ho Kok Hoe, 1958–60). *Progress*, August 1960

that had stood on the site. The galleries originally displayed Malayan culture and history on the first floor, and natural history and economic activities on the second floor. These displays were intended to be directed at 'multi-racial Malaysians … to forge national unity'.[42] But on its exterior the building depended predominantly on Malay prototypes. The roofs were two-tiered and double-pitched, their gables ended in scissor-like eaves and the whole building might have seemed to be supported by twenty-six concrete pillars if these were not so evidently inadequate for the mass above them and actually formed a colonnade in front of the recessed ground floor. Either side of the entrance front two long mosaics designed by Cheong Lai Tong depicted traditional crafts and events from Malaya's history. For the ornamental details the museum employed Nik Zainal Abidin, an expert on wood carving and metalwork in Kelantan, who produced pre-cast concrete screens using Malay motifs for the windows at either end of the building and above the entrance, panels for the wooden doors ('I wished to preserve examples of a disappearing craft at the entrance to the building', Ho wrote),[43] carved beams for the roof of the main hall and carvings for the ceremonial gallery. The result, together with Ho's design of the main structure, was certainly ambitious – a kind of proclamation of Malayanization, in which the scale of traditional domestic architecture is inflated into the public and urban scale of modern civic space and in which decorative details devised for one medium are crudely translated into another, the whole uncertain whether it was reiterating its Malay prototypes as folk-memory or reinstating them as living practice.[44] The museum was the first in a series of major public buildings, neo-vernacular in style and inflated in scale. But despite its overwhelmingly Malay sources, the fact that the architect was Chinese and that the displays

inside were planned from the start to include Chinese sections, meant that the museum echoed the inbuilt ethnic imbalance as well as the official aspirations to multiracialism that characterized Tunku Abdul Rahman's regime.

There is something programmatic in the National Museum's architectural conception, as if some set of procedures for imitatory revivalism was being followed, some transplanted, reproduced and now obligatory Arts and Crafts Movement were being dutifully installed. Benedict Anderson, in his by now classic study of nationalism, took museums as one of his three exemplary institutions in the formation of the nation-state. Nations had to image themselves as sovereign, inherently limited, and antique; indeed this 'antiquity' was 'the necessary consequence of "novelty"'.[45] As we saw in the previous chapter, Anderson regarded museums as having a crucial role in legitimizing the ancestry of the colonial state. In Malaya it is very clear – as the central position of Sheppard, bridging the transition and carrying Orientalist ideas over into the new museum, demonstrates – that the genealogy of official nationalism can be traced to what Anderson calls the 'imaginings of the colonial state'. The architecture of the museum played a central role in the transference of this nationalism from colonial rule to the independent state. In a move that recalls the (literally) removed Malay palace that became the Negeri Sembilan State Museum at Seremban, an imagined or ideal Malay house is conjured up by the architecture. In a country without museums before colonial rule, recourse to the traditional Malay house offered a way of apparently overleaping the colonial period to provide the necessary typological precedent and the delusion of freedom from dependence. It is typological in two interrelated senses, as a prefiguring of the house of (national) culture, and, according to that architectural tradition where typology means culturally specific ur-sources (like the primitive hut), as the source or essential type of good architecture. By contrast, in the National Museum, Ghana, the new nationalism had typological precedents but, according to the design of the museum, no matching architectural and culturally specific form for them.

These twin meanings of its typology also suggest the reasons why the Malay house has continued to inform public building in the country. By 1999, for example, three such buildings had been erected in short succession near each other on Kuala Lumpur's inner ring road, the Jalan Tun Perak: the National Library, the National Theatre (fig. 7.7) and the National Art Gallery.[46] Though making little claim to the revivalist pretensions of the National Museum, in each the roof is the dominant element, whether multiple, overlapping or cone-shaped, and in each the scale is inflated to meet the challenge of the neighbouring freeway. The cultural enclave that they attempt to create is also an appropriation of formerly colonial space, an area previously taken up by civil servants' bungalows, but this it seems is hardly relevant to their architecture. The architecture of the National Museum represented a wished-for resistance to modernity and modernism and a peculiarly colonial and post-colonial form of redemption, a reaching

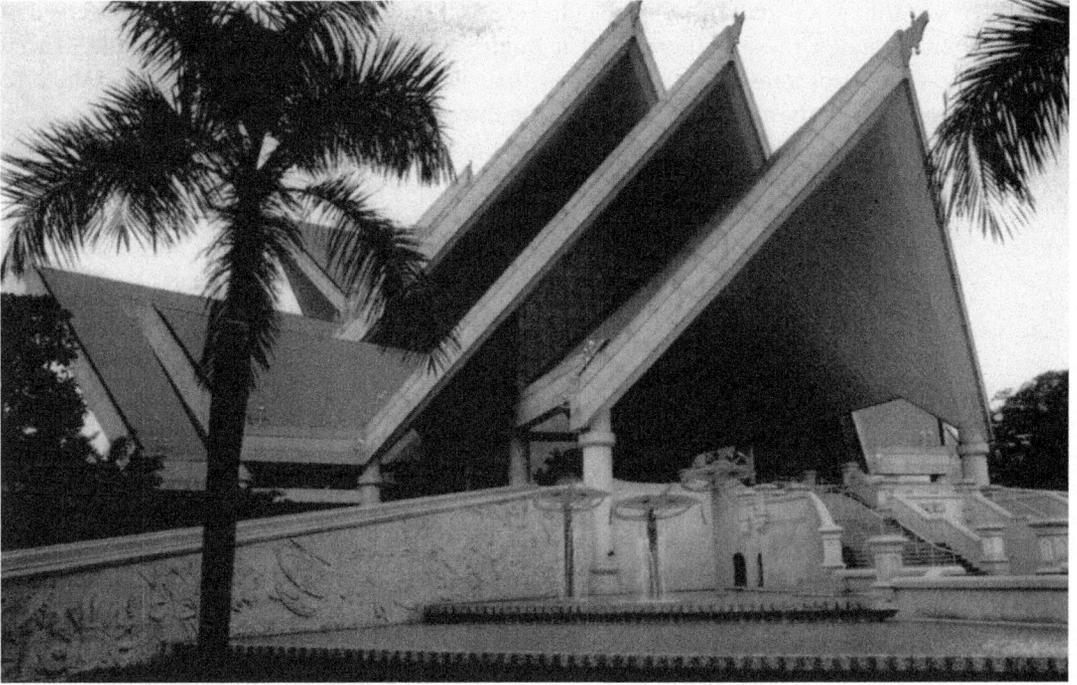

7.7 National Theatre, Kuala Lumpur (ADC Akitek Sdn, 1993)

for 'national culture' as opposed to 'universal civilisation'.[47] Yet its traditionalism was itself a contribution 'brought into being', as Frederic Jameson has argued more broadly, 'by the very activities of the modernisers themselves', and it remained comprehensible under the dualistic terms and narratives established by colonialism. This reactive traditionalism is not part of the new Jalan Tun Perak buildings. The choice between tradition and modernism has itself now become outmoded; the contradictions apparent between modern forms of national identity and the refusal of modernity in the name of tradition have now seemingly become unsustainable. Instead these buildings' neo-traditionalism is post-modern, it is chosen in circumstances where there is no other to the modern, no place of resistance to assimilation or 'nonmodern residuality'.[48]

Modernism as post-colonialism

The debates about nationalism in architecture during the 1950s must have seemed irrelevant to many Malayan architects of a younger generation. T. N. Harper has pointed out that the British project of Malayanization needed to find its strongest constituency in the 'embryonic Asian middle class of the colonial towns' if it was to succeed.[49] This was the same narrow bourgeoisie from which the new architects were emerging and the choice for them was not between the cultural fusion of the 'Malayan' or sectarianism, but between

sectarianism with its associated cultural traditions or an internationalism that transcended these matters. And if they opted for the latter course it was essential to transcend the cultures they left behind as well as the local elements of the culture they joined. The three architects who later formed the Malayan Architects Co-Partnership were exemplary of those who chose this course.

Before the late 1950s, when RIBA exam-based professional courses were started at Singapore Polytechnic and the Technical College, Kuala Lumpur,[50] training programmes in Malaya aimed to produce technicians who could work for expatriate professionals. Aspirant architects before this time had no choice but to study outside the country, and most of them went to either Britain or Australia. The most notable of these architects up to the 1950s was probably Ng Keng Siang, who had studied at the Bartlett School, London, in the 1930s, joined Swan and Maclaren's practice in 1937 and went on to run the biggest one-man practice in Singapore and to design several important buildings in the city for the Chinese business community, notably the Asia Building (1954) and Nanyang University (1955), using Chinese detailing within modernistic schemes. Chen Voon Fee, Lim Chong Keat and William Lim were all of a younger generation than Ng Keng Siang: Lim Chong Keat (from 1950 to 1955) and Chen Voon Fee (from 1952 to 1954) studied architecture at Manchester University, while Lim was at the AA, which Chen joined after dropping out of Manchester. But all three produced thesis projects on Malayan subjects.[51] Of the contemporary architecture in Britain that impressed them the Festival of Britain stood out, especially the Royal Festival Hall, and the work of Killick & Partridge, and Denys Lasdun; and of historical precedents the Bauhaus, Mies van der Rohe and Le Corbusier were most admired.[52] All three architects met at the Conference on Tropical Architecture in 1953 (discussed in Chapter 6) which was, according to Chen, the turning point in their work – the moment when they could first see their role as post-colonial architects on returning to Malaya.[53] Lim Chong Keat's intervention at that conference can stand for their shared position:

Malaya is developing in the direction of a synthetic nationhood which will be followed by a synthetic culture with an architecture composed of a conglomeration of various styles. There is no solution to this kind of situation, which is common to many of the under-developed countries, unless a basic approach to architecture is made.[54]

Or, as he stated a decade later:

If [nationalist] tendencies are unchecked, there is a real danger in many of the developing nations that architectural development would become a stylised expression, based on the myth of cultural independence, instead of taking root as a progressive discipline that can offer newer and better technological and aesthetic solutions.[55]

When all three architects had returned to Singapore in 1960 and formed the Malayan Architects Co-Partnership, their age and their exposure to an international architectural culture abroad meant that their modernism seemed to come without colonial baggage. Furthermore, their absence from

Malaya in the crucial years of the 1950s made them impatient with the debate about nationalism in architecture and, at least in Chen's case, usefully ignorant of both traditional and modernist architecture in the country.[56] Thus after Chen had absorbed the teaching of Alison and Peter Smithson at the AA he could extend their principles with a moral authority to Malaya, regardless of the anthropological concepts that laced their theories in Britain. That did not necessarily mean that he and his fellow architects lacked pride in their country but rather that they felt that nationalism was an irrelevant set of representational codes for architecture within modernity; and their private clients were young professionals who held many of the same views.[57] The architect's true metier, in the words of Lim Chong Keat, was a 'universal language' of forms and shapes, a 'rational comprehension of planning ... and the architectonics of enclosing space', and a 'sensitivity to tradition as well as future possibilities'.[58] Architecture, in short, was not something that had audiences (except perhaps for fellow architects): it had users. At its core was a discipline to which one should be true wherever one practised.[59]

The period when the architecture of these first 'national architectural professionals' emerged coincided with what has been called, specifically referring to Singapore, 'that brief moment in the sixties, [when] there seemed to be a close fit and correspondence between the modernists' call for a *tabula rasa* to a similar notion put forth by the modern independent State. For like the architectural modernist, the modern State and its agencies made it their ambition to realise the new "citizen", the new "social" and the new reified "economics".'[60] The choice of the title Malayan Architects Co-Partnership signalled the group's intent and its sympathy with these ambitions, and it was also intended to imply a Pan-Malayan identity.[61] Like the Architects Co-Partnership in Britain or Gropius's Architects Collaborative in the USA, with whom Lim Chong Keat had been in touch when he studied in the USA following his time at Manchester, the title immediately proclaimed both modernism and a team product above the whims of individual expression. The practice's architecture came to be characterized by its ethical qualities of legible structural expression – with very apparent structural grids, and clear distinction between frame and infill – as well as their alertness to the historic contexts of their sites. The toughness and integrity of this aesthetic was relieved by elegant compositions that eschewed symbol or ornament in favour of rectilinear and planar arrangements of forms. Identity was not something to be somehow inherited or bolted on but discovered through a rigorous scrutiny of the conditions of the building, its place and time, as well as its materials and programme.

The Singapore Conference Hall and Trade Union House was constructed at the same time as the Parliament building, to the designs of the Malayan Architects Co-Partnership (fig. 7.8). Like the Parliament building the conference hall brought a new building type to the country, but unlike its contemporary – both because of its location in Singapore and because of its function – it did not require allusions to national culture. The only building of this period in Singapore that was built with these national allusions was

the short-lived National Theatre with its Minangkabau roof shapes, built in 1963 to designs by the Alfred Wong partnership (and demolished in 1986). To win the international competition for the Conference Hall announced in 1961, the Malayan Architects Co-Partnership had to beat expatriate architectural firms in the region like Palmer and Turner, international practices like Cubitts and Raglan Squire, and established Chinese architects such as E. J. Seow. Their design was certainly impressive, integrating the two main functions of the brief into one building centred on a shared foyer with a reflecting pool and flanking staircases, and with roof gardens and more pools elsewhere. This enabled the brief to be articulated as a prominent conference hall surrounded by spaces that enable public movement and spectacle in a manner that recalls both the 'egg-in-a-box' form and the social democratic and post-colonial freedoms of the Royal Festival Hall.[62] The elevations of the building took the principle of modernist spatial interpenetration to its logical conclusion in the humid climate, with a flat cantilevered roof slab and giant columns harbouring a variety of open and glazed spaces, as well as projecting and contained terraces. In this way, some of the principles of the Malay house might be discerned, and perhaps even a memory of it in the extensive use of local timber on the interior, without any representation of it as image. Visible from the waterfront, the building became one of the first markers of what Brenda Yeoh has called Singapore's 'bid for modernity'; the

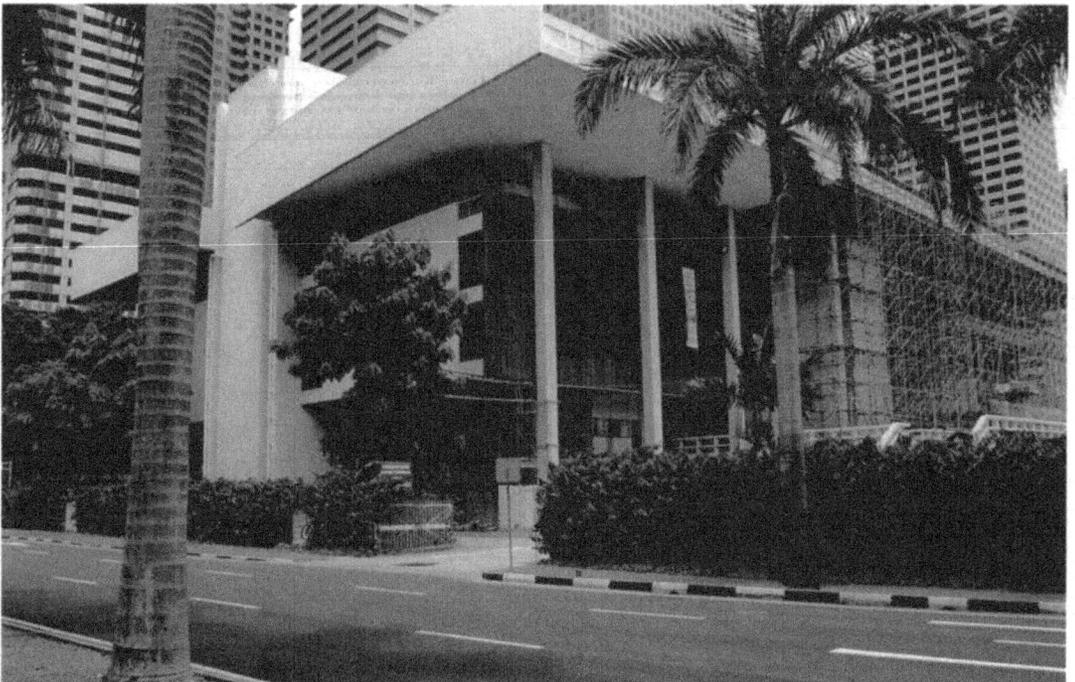

7.8 Singapore Conference Hall and Trade Union House, Singapore (Malayan Architects Co-Partnership, 1961)

metamorphosis of a 1950s city of slums, squats and colonial edifices to a 'global city of skyscrapers'.[63]

The view from Penang Hill

On its eastern side Penang Hill looks down onto Georgetown and across the sea to the Malaysian peninsula. The hilltop provided a place of cooling breezes for the location of colonial convalescent bungalows and a point of visual authority from which British artists could organize the view laid out around them. Today it offers a spectacle of Georgetown's massive urban development, upwards and outwards in the last thirty years, from the scrum of developers' towers, to the muscular new ecological skyscrapers of the Hamzah and Yeang office, past colonial Georgetown to the new Penang Bridge connecting the island to the mainland, the longest bridge in Asia and as much a product of Prime Minister Mahathir Mohamad's politics of gesture and gigantism as an umbilical cord to the rest of the country.[64] In amongst these developments, still possessing one of the tallest towers in the city and one of its most distinctive shapes, is the Kompleks Tun Abdul Razak or, as it is better known, Komtar (fig. 7.9).

Komtar was built as a new urban centre for Georgetown, a 'people's centre', and although this aspect seems not to have been explicitly articulated in its development, I will argue that it was a project of manifestly post-colonial urbanism. Colonial Georgetown spread southwards from Fort Cornwallis, which dominated the north-eastern corner of the island where its *padang* offered a cleared parade ground. It was in the grid of streets laid down to the south that the various monuments and institutions of colonial life were established. Architecturally and symbolically most notable here were the group of buildings consisting of St George's Church (built between 1817 and 1819) (fig. 7.10), the circular monument in front of it to Captain Francis Light (1817) who established the East India Company on the island and, across Light Road, the Palladian Supreme Court. This axial arrangement of buildings combined secular and religious authority with a monument to the founder of British rule on Penang. All three were classical structures designed as a group of freestanding geometrical forms that embodied the classical types of the *templum*, the *tholus* and the *regia*. Though rarely so beautifully positioned and related, similar arrangements can be found in ex-British colonial cities across the world.

Komtar consists of another set of subtle geometric forms disposed in close proximity. Designed by Architects Team 3, formed with Lim Chong Keat when the Malayan Architects Co-Partnership broke up in 1967, it was started in 1974 but only finished in a curtailed form in the mid-1980s. It was, however, originally conceived as early as 1962.[65] Part of the aim of the complex was to draw regeneration into a declining part of the city with relatively low density by the provision of much-needed office and civic amenities, but it was also intended to re-orient the spatial geography of the

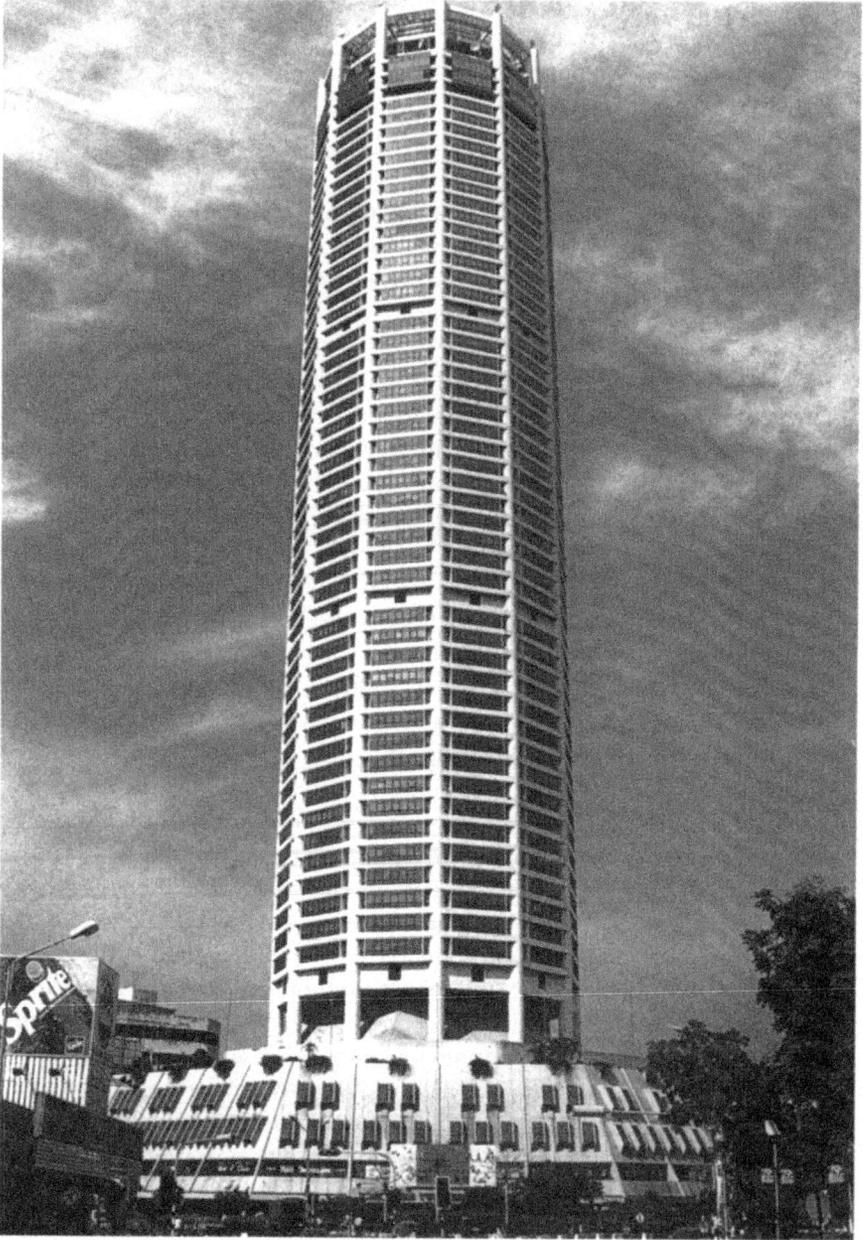

7.9 Kompleks Tun Abdul Razak (Komtar), Georgetown, Malaysia (Architects Team 3, 1974–85)

city's local government and commercial sectors. A further aim was to control the commercial development of the city and to re-establish an appropriate civic decorum within its urban forms. Komtar took over a long, triangular site – phase 1 of the original plan – beyond and to the south-west of the colonial grid. Phases 2 to 5, which were not developed, were to provide flats, offices, a hotel and a new state assembly building. The area built under phase

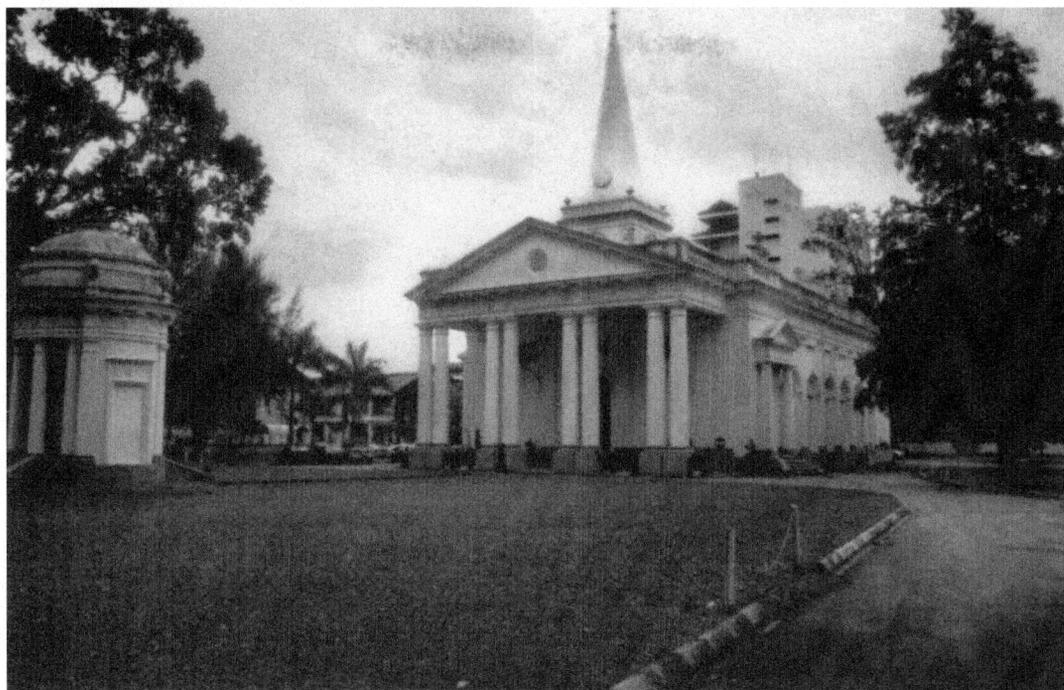

7.10 St George's Church and Monument to Francis Light, Georgetown, Malaysia (Captain Robert Smith, 1817–19 and 1817)

1 was occupied by a 65-storey polygonal tower, a separate 17-storey block of flats, a wedge-shaped 4-storey podium, and, topping the podium, a geodesic dome housing a multi-purpose auditorium. The idea was to bring together the city's most demotic and most elevated functions: a bus and fire station were located at ground level with car parks and fruit stalls; shopping arcades and offices filled the podium's intermediate levels; from the top of the podium the tower contained local government offices and the rest of the podium's upper level was made into a roof garden, an area for leisure and culture with cinemas, a residents' club, coffee lounge, reflecting pools and the multi-purpose hall sheltered by the geodesic dome (fig. 7.11). Working for local government or other statutory bodies in this tower was to be an experience of passing back and forth through the city's multifarious life and, even when elevated above it, to be constantly reminded of one's duties and responsibilities to the city laid out below.[66] (see plate VIII) Included in the same megastructure, the civic sphere was to encompass anything from a hawkers' centre to exhibition halls and health amenities. From the top of the podium the scheme was intended to cascade down towards the north-east, enabling a monumental processional route onto the cultural level of the complex. Living around the complex was to be part of a 'controlled social programme to ensure that there is an integrated community to help demonstrate a new way of living within a central urban area'.[67] Although I have used the term to describe the complex, technically or at least according

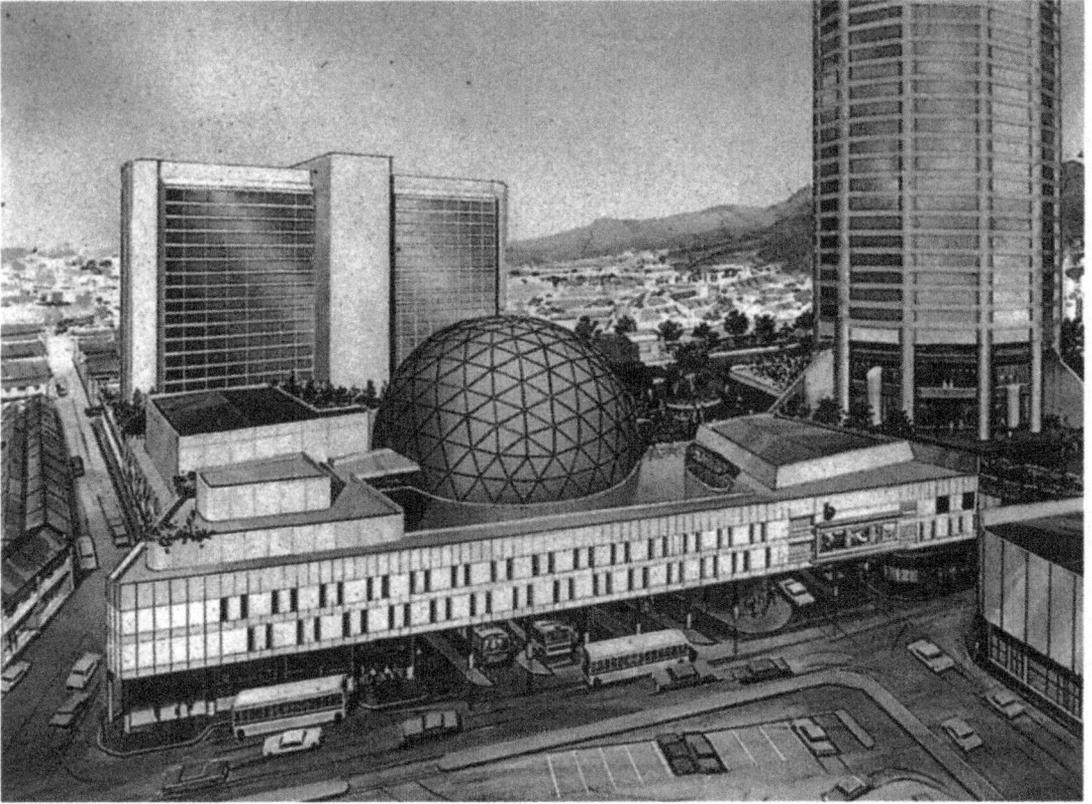

7.11 Kompleks Tun Abdul Razak (Komtar), Georgetown, Malaysia (Architects Team 3, 1974–85). *Geodesic Dome – Kompleks Tun Abdul Razak, c. 1985*

to the definitions provided by Reyner Banham in his book of the same name, Komtar was not a megastructure.[68] While it housed all the functions of a city Komtar did not enclose them in a single envelope or landscape-like feature, its units were not fitted within a larger framework, and the scheme was phased for development rather than conceived as having unlimited add-on extensions. Furthermore, although its composition was loosely informal, its major components were each conceived as having finite and absolute formal presence. It enabled ludic and interactive possibilities in what have been referred to as the demotic elements of the programme; effectively, it defined urbanity as the very mixing of diverse groups and functions, the co-presence of the commercial and the public spheres. Komtar also encompassed aspirational or ideal elements that, in this interpretation, firmly established its prime reactive relationship as with the classical built forms of colonial control. Despite its modernist vocabulary, its arrangement of separate buildings on a shared podium reached back to a rather older, monumental tradition of the relation of buildings to their settings and even – dare one say it – to a tradition of decorum and architectural character.[69]

Although one of the most marked aspects of Komtar is its lack of national symbolism, that does not mean it is 'ultrainternationalist', or actively

denying the specific architectural contexts of Georgetown.[70] The riposte to the old colonial centre is, like those colonial buildings themselves, made in a pure geometrical language of transcendence, one that is always expressive of its architectonic means and never revivalist. This is not so much a renouncing of colonialism but a dialogue with it over its claims to be universal and a reworking of those claims in favour of another approach. The tower itself is supported by twelve round piers that extend its full height and elegantly articulate the outer skin of the building with their projecting convexities. Its length is divided vertically into three sections and capped by a form of attic created by stepping back the office façades between the piers. Perhaps the geodesic dome is most exemplary of this new approach to the universal. Designed by Buckminster Fuller, the original inventor of the form, the dome is a structure entirely held up by the tension of its visible triangular components. But Fuller's domes did not merely provide light and efficient shelter, they also had an ambivalent relationship to the economic and political dominance of the USA in the postwar decades. On the one hand they, together with much of Fuller's work, were acclaimed by many (including at least one of the key members of the team working on Komtar) as utopian structures offering radical new engineering solutions to problems of shelter and sustainability. On the other hand, two of Fuller's best clients were the US Air Force and the Marine Corps,[71] and it was a geodesic dome that provided the prestigious container for US Pavilions at the International Trade Fair in Kabul in 1956, at the Moscow World's Fair in 1959 and at the Montreal Exposition in 1967.[72] 'The Geodesics', Robert Marks has pointed out, 'dramatized American ingenuity, vision, and technological dynamism.'[73] Fuller's geodesic domes, like his Dymaxion map, were part of a vision of a world of supranational co-operation, a world of rational communications and technologies free of the ties of custom and the animosities of history; for this very same reason they were also available for subsumption under a new, American-led world order or empire. It is unlikely that the latter was an association that Komtar's planners wanted to make – or were even aware of – when Fuller was commissioned to design the dome: indeed the chief minister at the time called it an 'invention for the benefit of mankind'.[74] It is more likely that for its architects the dome was regarded as the consummation of principles that were behind the complex anyway (Fuller was a consultant for the whole project from 1974 until his death in 1983), and that for its political sponsors the dome was both a form that stood for secular aspirations and a prestigious object, one that would speak not of ethnic heritage and subservience to climate, and therefore possibly of the 'Third World',[75] but would instead attract international attention to the revitalization of Georgetown.

Komtar forms a deliberately open-ended conclusion to this chapter. Like most ambitious modernist architecture, it was both utopian in its programme and critical in its relationship to history and the urban context. These do not necessarily make for harmonious or easily ameliorative architectural and social interventions; those, it seems, are the project of a

nationalist suturing of a torn continuity. Without this delusive imagining, Komtar engages with a different and unavoidable past whilst refusing to accept easy forms of continuity. In that sense it defines what a post-colonial building might be.

Conclusion

Discrepant cosmopolitanism

Is there an exemplary place that allows us to look down on post-imperial London in a similar way to that offered from Komtar onto Georgetown; one that uses displacement as a mode of reinvigorated perception? Is there a viewing position in any way equivalent to the familiar imperial vistas like that taken by Neils Lunn when he pictured *The Heart of the Empire* (1904) as the bustling streets of the City's financial hub overlooked by the dome of St Paul's, or like the one offered to those exhibition visitors in Glasgow by the Tower of Empire from which they could observe the colonial pavilions and the palaces of industry and engineering, or indeed like that given to the directors of the APOC by Britannic House or the banking executives of the HSBC by Foster's building? If there is, it is an anxious position offering fractured views; it is a place of vulnerability and of half-muted symbolic function; one of heightened visibility rather than the safely covert vision or even Olympian scopic power of those other viewing positions. One such place might be the minaret of the Central London Mosque in Regent's Park (fig. 8.1).

But the minaret's elevated position is hard-won. The physical and cultural displacement of peoples brings with it the struggle for new architectural spaces and renewed or at least newly inflected symbols of identity. The visual tropes of colonial architecture – the Gothic church among the palm trees, even the white hotel on the hilltop – become uncannily reassembled in the post-imperial metropolis as the minarets rise above the bungalows and the Bengali restaurant faces the Mecca bingo-hall. Such conjunctions have been amongst the most powerful visual effects in the public formation of the Muslim diaspora as well as of the wider presence of immigration in post-imperial British society.[1] They bring what was mostly a set of juxtapositions that took place in the colony – first between affirmations of Englishness and a complaisant locale, and then between a progressive modernism and a remaindered history – back to the old 'heart of empire'.[2] The diaspora mosque has a particularly acute position here. To adopt James Clifford's words, the diaspora mosque can be seen as 'a signifier, not simply of transnationality and movement, but of political struggles to define the local,

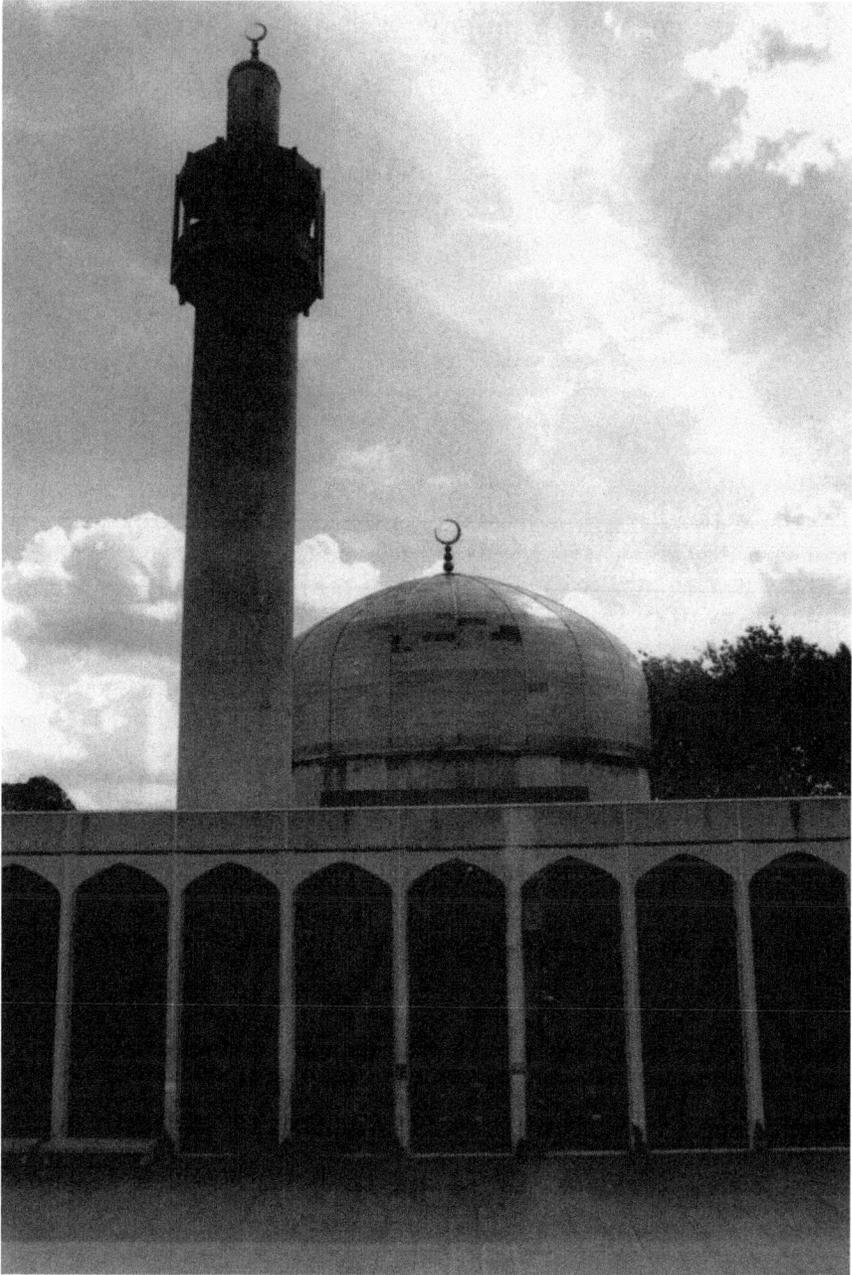

8.1 Regent's Park Mosque, London (Sir Frederick Gibberd, 1969–77)

as distinctive community, in historical contexts of displacement'.³ Such mosques offer an implicit challenge to preconceptions of the nation-space, refusing to sit easily either within some notion of transplanted traditionalism or within linear histories of assimilation and development.⁴

The Regent's Park Mosque is not typical of mosques in Britain, indeed the

very idea of a typical British mosque or even a typology of 'Muslim space' in the diaspora is highly problematic.[5] Since its completion in 1977, the mosque has often been described as the most important building of its kind in Britain. This is probably due to its declared intention of symbolizing accord between nations,[6] to its visibility in a prestigious location near to the commercial and cultural centre of London, the old 'heart of empire', and to the relatively high sums lavished on its building, including an international competition for its design and the employment of a prominent British architect. Yet its highly rhetorical combination of certain long-established signs of modernity and traditionalism proved to be as unattractive to the professional architectural press as to certain sectors of the Muslim population.

Although the idea of a mosque had been mooted in the 1920s it was not seriously promoted until Nashat Pasha, Egyptian ambassador to London, and Lord Lloyd, former High Commissioner to Egypt, began to campaign for it during the Second World War. Lloyd argued that the project would help cement Muslim support for the Allied war effort. A site was purchased from British government funds in 1944 on the edge of Regent's Park, using an existing building for an Islamic cultural centre. In 1947 a trust was constituted by the ambassadors of thirteen Muslim governments, but various delays ensued including the withdrawal of Egyptian funds due to the Suez Crisis in 1956. When a design was eventually produced in 1959, the work of the Egyptian architect General Ramzy Omar, it was rejected by the London County Council and the Fine Arts Commission because it was deemed inappropriate to its context.

The perceived contextual problems of this first design for the Regent's Park Mosque continued when the project was relaunched in 1969. These tensions can be found reflected in the British architectural press, which reviewed the various designs, engaging and subsuming them into a historicist view of architectural development. An international competition was launched in 1969 and attracted over fifty entries, the majority from Islamic countries.[7] No reviewer could find a worthy design amongst these entries, mainly, it seems, because no design could be deemed to have fully reinterpreted the mosque tradition according to modernist principles. Even the most modernist design, the second-placed entry with a billowing shell dome and a soaring minaret by the Istanbul-based Yasar Marulyali and Levent Aksut, only appeared to be legitimate from the outside. In fact, so the *Architects' Journal* opined, 'the most meaningful modern religious buildings are those which are rethought from the outside image inwards'.[8] The measure here was not just the modernist notion of form being generated out of function, but also a more recent radical and interdenominational movement that aimed to re-appraise Christian church design in the light of modernist principles and that had received great support in the architectural press in the 1960s. This 'new reformation', as it was called, was critical of what it understood as the formal vestiges of merely conventional liturgy and symbolism in church design.[9] It aspired to make function and symbolism indissoluble, to place, as Reyner Banham explained it, 'the conceptual stages

of church design on the same intellectual and imaginative footing as applies in the most forward areas of secular architecture at present'.[10] The mosque competition entries were also judged on these rationalist criteria, with reviewers discarding the many 'exercises in intricate historical detail',[11] and vainly seeking a new design analysis of the functions of a mosque.

In this mode of interpretation the winning design by Sir Frederick Gibberd was clearly a compromise between modernist and traditionalist approaches. On the one hand Gibberd had achieved a scenographic staging of Islam that matched the eclecticism of John Nash's stucco-faced terraces nearby: 'The shade of Prinny ... must delight in the prospect of a stately Indo-Saracenic dome floating over a cool white colonnade of Persian pointed arches among the planes of his royal park.'[12] Implicit in this attitude was the common belief that Nash's architecture embodied a quintessential 'Englishness', a native sense of the Picturesque summoning forth the *genius loci* impervious to the more recent challenges of imperial decline – unlike the other forms of modern picturesque discussed in Chapter 5.[13] On the other hand there were certain elements in Gibberd's design that, if not proclaiming a hard-edged modernism, were definitely modern. The large, initially clear glazing of the windows around the mosque, and the pre-cast concrete and standardly framed treatment of the elevations, even despite their four pointed arches, both give the clue to Gibberd's approach and certainly the way that it was understood by these commentators. Here, not dissimilar to the new churches, was modular, extendible and relatively open planning. Gibberd provided auxiliary prayer spaces on three sides of the main hall as well as below it.[14] He used modern construction and modern materials and the mosque's exterior was claimed to be the direct expression of the plan. But here also was ... decor. 'Of course, you cannot put the decor to one side', bewailed the editorial in the *Architectural Review*, 'It is not the fact that it is decorated that upsets us, or even that it is recognisably traditional in appearance, but the fact that there is no internal logic which ties the decor to the structure behind it. This makes it (at least for architects) a frivolous building.'[15]

It is this very indeterminate position, neither wholly modern nor wholly respectful of tradition, which came up again and again in reviews of the Regent's Park Mosque. Gibberd was accused of 'pasticherie' and said to have 'lost his nerve'.[16] He had produced 'a literal rendition of Islamic features ... executed in a cardboard model style, [in which] structural elements are used to provide non-structural symbolism, [with] arbitrarily selected patterns and forms from a variety of styles'.[17] But it was also pointed out that the horseshoe-shaped gallery that, in Gibberd's winning design, originally projected over the prayer hall was a religious solecism, since in Islamic religious space women are not usually permitted to stand above or in front of men (fig. 8.2).[18]

Behind all of these comments lie issues that are bound up with a more historically particular as well as a more political understanding of the production of space than the search for essentialism that has often directed studies of modern mosques. The design and construction period of Regent's

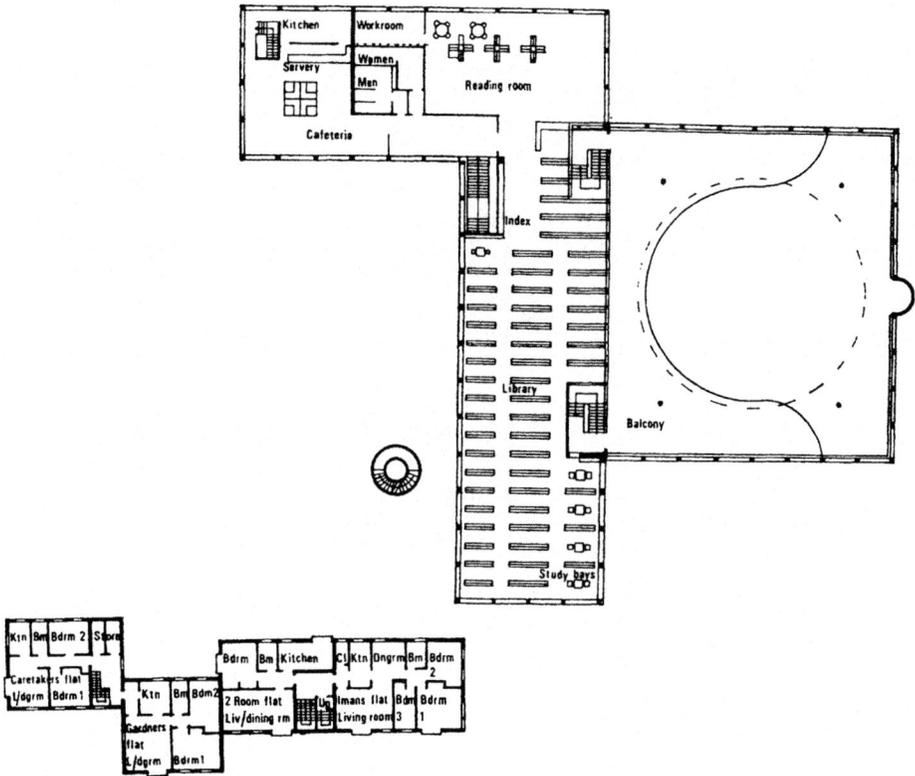

8.2 Regent's Park Mosque, London – plan of competition design (Sir Frederick
Gibberd, 1969). *Building*, 17 October 1969

Park Mosque covers important changes in the political and economic
relationships between oil-rich Middle Eastern states and oil-dependent
western countries after the oil-price rise of 1973. It could thus be seen, and
indeed was seen at the time, as a building that represented the 'gold rush' of
British and other western architects and construction companies working for
Middle Eastern clients, that return to an area of the world in which British
architects had once, only some three decades before, held paramount
influence.[19] Indeed it was regarded by some not just as a *product* of this gold
rush but as representing the kinds of compromises that were bound to result
from it. Furthermore, although its construction might be understood as a
symbolization of religious tolerance and even political alliance, this was
brokered over a set of more particular geographical interests. The clients, for
instance, consisted of the various and changing ambassadors representing
Muslim nations in Britain. The site, on Crown property and zealously
watched over by various conservation bodies, required that certain
proprieties be observed. Thus, following the historical and architectural
importance of Nash's nearby terraces, it was argued that the mosque should
be in character with Nash's work,[20] that it should be disciplined within, or

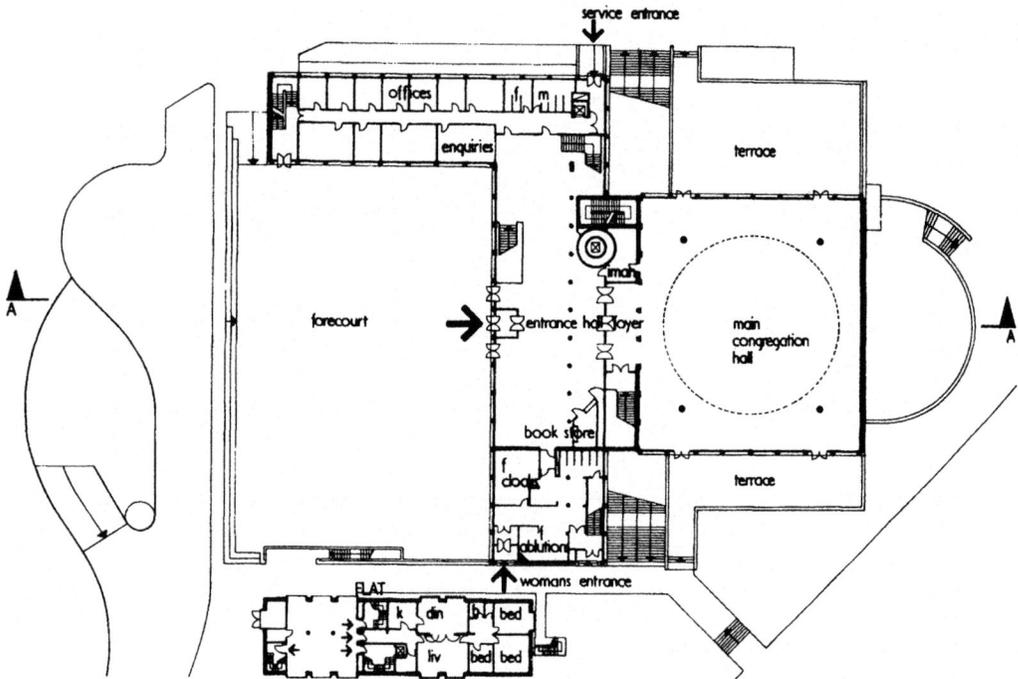

8.3 Regent's Park Mosque, London – plan of revised design (Sir Frederick Gibberd, 1969–77). *Architects' Journal*, 10 August 1977

'mimic', this form of picturesque eclecticism and not challenge its boundaries.

One particularly interesting incident occurred around the issue of the orientation to Mecca required of any mosque. In the original brief Mecca was incorrectly located and so Gibberd's design, following this misorientation, was placed right up against the building line. When the mistake was realized Gibberd had to rotate his complex on the narrow triangular site and to win permission to break the building line (fig. 8.3). At about the same time the building committee – made up of the various Muslim ambassadors – decided that the *mihrab*, or directional niche, should not further impinge on the building line and therefore should not project outside the main cube of Gibberd's prayer hall.[21] It was this decision, resulting in the design of a wooden *mihrab* that is not integrated into the building's structure, that has also led to misplaced criticisms that the architect did not understand the role of the *mihrab*.[22]

The abandonment of the built-in *mihrab* indicates the most interesting of all the components that went into the making of the Regent's Park Mosque. The decisive factor in its final appearance was neither Gibberd's understanding of Islamic architecture, nor the influence of local property owners and conservation groups and their pressure to conform with the 'genius of the place'. Instead the most influential of the interested

communities was the extra-national and cosmopolitan one represented and envisaged by the Muslim ambassadors. To focus on this influence shifts understanding away from those oppositions that dictated appreciation of the building and that presented its designs as the result of several stark options: principles *or* pastiche; modernism *or* traditionalism; the West *or* the East. Instead, the building can be seen as 'ecumenical' in form. Part of the brief required that 'the Muslim community of London ... be inspired by the visual effect of the mosque as being reflective of traditional mosques in which they had worshipped in their own countries'.[23] It followed from this that in order to satisfy disparate groups Gibberd's winning design reduced its elements of cultural specificity, and these were further refined away by the building committee's recommendations. Amongst these, it was urged that the dome should be made more prominent and the minaret should not rise out of a pool but be joined more closely with the main structure (it also lost its specifically Turkish form in the first design), as well as the changes to the *mihrab* and balcony already mentioned.[24] Without such specifics, and with no desire to factionalize by embodying a fundamentalist view of Islamic practice, the Regent's Park Mosque aimed for Pan-Islamic symbolization through salient but generalized images of Islam. Thus the minaret had a signal function but it was not that of the call to prayer but the *idea* of the call to prayer in Muslim tradition. In other words a romantic colonial-era Orientalism – the gilded dome, the rows of arches, and the minaret – had returned but for different reasons, and these were also the cause of its uncanny effect. Arguably the mosque design was less about forging a dialogue between cultures, divergent traditions or different religious practices, and more about proposing that there were no good grounds for *not* having such a dialogue; it was not a traditional or tropical architecture but a temperate architecture, both culturally and climatically. Either this or pretending that there was no need to have a dialogue because oppositions had been erased. It was thus a 'discrepant cosmopolitanism' that was manifested here,[25] neither the polychromatic culture of the international consumer as described in Chapter 4 nor the pan-imperial or Commonwealth modernism that is discussed in other parts of this book.

The diaspora mosque is one of the most visible but also one of the most disjunctive and inassimilable manifestations of the ex-colonial within the metropolis. If, as James Clifford suggests, 'the nation-state, as common territory and time, is traversed and, to varying degrees, subverted by diasporic attachments',[26] then the mosque embodies one of the most visible articulations of diaspora identity in built form. Almost unavoidably, then, diaspora mosques are also overdetermined cultural forms. At once both stereotypical and symptomatic, they represent 'the locus and locution of cultures caught in the transitional and disjunctive temporalities of modernity'.[27]

So it is to the minaret in the Regent's Park Mosque that we turn for a position from which to view the post-imperial metropolis. It is a mute platform, because one result of the influence of conservation bodies in the

area was that while a minaret was built no prayer would ever be called from it. It is also, it seems, regarded as a platform of some offensive potency, if the actions of security personnel in searching and occupying the minaret during the recent visit of a US President to a neighbouring garden is any indication. But from this minaret the view can sometimes seem as if the 'heart of empire' continues to beat. In the immediate foreground are the curves of Nash's roads, the bosky clumps of his picturesque park and the cream stucco of his eclectically styled terraces. Further away lies the present incarnation of the Royal Zoological Society's collecting activities, an imperial archive of Regency giraffe houses, Edwardian bear terraces and modernist aviaries and penguin pools. And beyond the park to the south is the pencil-thin shape of the British Telecom Tower, another kind of minaret paying token homage to the networked world and futuristic imaginings of the 1960s.

Notes

Preface

1. See T. Eagleton, F. Jameson and E. Said, *Nationalism, Colonialism and Literature*, 1990; H. J. Booth and N. Rigby, eds, *Modernism and Empire*, 2000.

Chapter 1

1. The word appears in the title of Part 3 of W. Curtis, *Modern Architecture Since 1900* (third edition), 1996.
2. H.-R. Hitchcock, *Architecture*, 1977 (first published 1958), p. 556. In other statements Hitchcock revealed his awareness, if not equivocation, about the links between modernism and continuing 'cultural empires': ibid., p. 565.
3. Of recent accounts see, for instance, J. R. Gold, *The Experience of Modernism*, 1997.
4. This polarity is repeated in Thomas R. Metcalf, 'Architecture of the British Empire', *OHBE*, 5, p. 592.
5. See, for instance, F. Driver and D. Gilbert, eds, *Imperial Cities*, 1999. The exceptions here are certain works on French colonial architecture and urbanism, including the work of Le Corbusier for Algiers: see P. Rabinow, *French Modern*, 1989; G. Wright, *The Politics of Design in French Colonial Urbanism*, 1991; and M. MacLeod, 'Le Corbusier and Algiers', *Oppositions*, 19/20, Winter/Spring 1980, pp. 57–70. Tellingly, however, this work has not continued into the period of decolonization.
6. On modernism and language see A. Forty, *Words and Buildings*, 2000, pp. 77–8.
7. For a useful discussion of these theoretical and political positions particularly in the writings of Frantz Fanon, Ashis Nandy and others, see R. J. C. Young, *Postcolonialism*, 2001, especially pp. 339–45.
8. M. Berman, *All That is Solid Melts into Air*, 1983, p. 232. Berman is describing nineteenth-century St Petersburg.
9. See A. Roy, 'Traditions of the Modern', *Traditional Dwellings and Settlements Review*, 12:11, Spring 2001, pp. 7–9.
10. I see imperialism and colonialism as intimately related, but Edward Said's distinction is a good guide: ' "imperialism" means the practice, the theory and the attitudes of a dominating metropolitan centre ruling a distant territory; "colonialism", which is almost always a consequence of imperialism, is the implanting of settlements on distant territory', E. Said, *Culture and Imperialism*, 1994, p. 8.
11. Michel Foucault's writing is obviously the source for this theorizing, particularly his *Archaeology of Knowledge* (1969). For a particularly useful discussion of this book in relation to post-colonial theory, see Young, 2001, pp. 395–410.
12. In 1900 there were 20,000 colonial administrators in London, apart from their uncounted clerks and advisers: P. L. Garside, 'West End, East End: London, 1890–1940', in A. Sutcliffe, ed., *Metropolis 1890–1940*, 1984, p. 236.
13. A. D. King, *Global Cities*, 1990, p. 60.
14. See A. D. King, *The Bungalow*, 1984.
15. See S. Constantine, *Buy and Build*, 1986.
16. R. Home, *Of Planting and Planning*, 1997, pp. 214–15.
17. I. Baucom, *Out of Place*, 1999, p. 172. See also A. D. King, *Urbanism, Colonialism, and the World Economy*, 1990, pp. 154–5.

18. See, for example, M. H. Port, *Imperial London*, 1995.
19. See, for example, G. Stamp, ed., *AD Profiles 13, London 1900*, 1978, 48. As Lynne Walker has noted, the Entente Cordiale of 1904 and the subsequent Franco-British Exhibition of 1908 had important architectural repercussions, especially in the way that French neoclassicism was seen as one link between contemporary Britain and imperial Rome: L. Walker, 'Architecture and Design', in J. Beckett and D. Cherry, eds, *The Edwardian Era*, 1987, p. 118. See also J. Schneer, *London 1900 – The Imperial Metropolis*, 1999, pp. 18, 23–4.
20. On this issue see Schneer, 1999, p. 22.
21. See D. Schubert and A. Sutcliffe, 'The "Haussmannization" of London? The Planning and Construction of Kingsway–Aldwych, 1889–1935', *Planning Perspectives*, 11, 1996, pp. 117, 128. For the City as heart of empire see J. M. Jacobs, *Edge of Empire*, 1996; on the rebuilding of the Bank of England see I. Black, 'Imperial Visions: Rebuilding the Bank of England, 1919–39', in F. Driver and D. Gilbert, eds, *Imperial Cities* 1999.
22. See L. Nead, *Victorian Babylon, Imperial Cities*, 2000, pp. 201–202.
23. N. Pevsner (revised by B. Cherry), *The Buildings of England – London I The Cities of London and Westminster*, 1985, pp. 346, 367.
24. Ibid.
25. Quoted in Port, 1995, p. 18.
26. King, 1990, p. 82.
27. Port, 1995, p. 366.
28. For The Mall and the Victoria Memorial see T. Smith, ' "A grand work of noble conception": the Victoria Memorial and Imperial London', in F. Driver and D. Gilbert, eds, 1999.
29. *The Times*, 9 November 1920, p. 12.
30. *The Times* (supplement), 12 November 1920, p. 1, and *The Times*, 11 November 1920, p. 14. For these processions see Victoria Moody, 'Feathers and Granite: Discourses of National Identity in Memorials to the Dead of the 1914–1918 War', unpublished Ph.D. thesis, University of Manchester, 2000, pp. 126–7.
31. See I. S. Black, 'Rebuilding "The Heart of Empire": Bank Headquarters in the City of London, 1919–1939', *Art History*, 22:4, November 1999, pp. 598–9.
32. On this new plutocracy and their London houses see J. M. Crook, *The Rise of the Nouveaux Riches*, 1999, especially Chapter 4.
33. L. Tickner, *Modern Life and Modern Subjects*, 2000, p. 190.
34. Editorial, 'Imperialism and Architecture', *Builder*, 103, 27 September 1912, p. 345.
35. See Schneer, 1999.
36. See Home, *Of Planting*, 1997, especially Chapters 2 and 3; A. D. King, 'Writing Colonial Space', *Comparative Studies in Society and History*, 37:3, July 1995, p. 549.
37. See F. Driver and D. Gilbert, 'Heart of Empire? Landscape, Space and Performance in Imperial London', *Environment and Planning D: Society and Space*, 16, 1998, pp. 11–28.
38. For New Delhi see R. G. Irving, *Indian Summer*, 1981; T. R. Metcalf, *An Imperial Vision*, 1989; N. Evenson, *The Indian Metropolis – A View Toward the West*, 1989; I. Vale, *Architecture, Power and National Identity*, 1992; and A. D. King, *Colonial Urban Development*, 1976.
39. On the Residence see R. Fuchs and G. Herbert, 'Representing Mandatory Palestine', *Architectural History*, 43, 2000, p. 299; on Lusaka see J. Collins, 'Lusaka: Urban Planning in a British Colony, 1931–64', in G. E. Cherry, ed., *Shaping an Urban World*, 1980; on the other examples see later chapters in this book.
40. *Builder*, 103, 27 September 1912, p. 345. On the 'tropicalization' of English architecture for colonial settings see Baucom, 1999, p. 84.
41. H. Bhabha, *The Location of Culture*, 1994, p. 111.
42. King, 1976, pp. 267–71. For the city's development since 1947 see King, 1990, pp. 46–50.
43. See Bhabha, 1994, p. 115.
44. See Evenson, 1989, pp. 169–72. J. Lang, M. Desai and M. Desai, *Architecture and Independence*, 1998, pp. 171–2.
45. For Chandigarh see N. Evenson, *Chandigarh*, 1966; Arts Council of Great Britain, *Le Corbusier – Architect of the Century*, 1987; R. Walden, ed., *The Open Hand*, 1977; S. von Moos, *Le Corbusier – Elements of a Synthesis*, 1982; and Vale, 1992.
46. In fact, the reasons for choosing a European architect were largely economic, and Le Corbusier was engaged with his cousin, Pierre Jeanneret, and the two British architects Maxwell Fry and Jane Drew to join the already-appointed American planner Albert Mayer.
47. Quoted in Vale, 1992, p. 106.
48. For Corbusier's measured appreciation of Lutyens and for his admiration of colonialism see Moos, 'The Politics of the Open Hand: Notes on Le Corbusier and Nehru at Chandigarh', in Walden, ed., 1977, pp. 436, 444.
49. Quoted in Arts Council, 1987, p. 291.
50. Moos in Walden, ed., 1977, p. 428.
51. C. Correa, 'Chandigarh: The View from Benares', in H. Allen Brooks, ed., *Le Corbusier*, 1987, p. 198.
52. See Roy, 2001, p. 15.
53. G. A. Atkinson, 'British Architects in the Tropics', *Architectural Association Journal*, 59, June 1953, pp. 7–20.
54. Ibid., p. 9.
55. Ibid., p. 18.

56. Ibid., p. 17.
57. The strategy can be dated back to 1929: see John MacKenzie, 'The Persistence of Empire in Metropolitan Culture', in S. Ward, ed., *British Culture and the End of Empire*, 2001, p. 29.
58. B. Davidson, *The Black Man's Burden*, 1992, p. 199.
59. G. Orwell, *Burmese Days*, 1935, pp. 40ff.
60. Ibid., p. 34.
61. H. Bhabha, 'Of Mimicry and Man', in *The Location of Culture*, 1994, p. 87.
62. See D. Matless, *Landscape and Englishness*, 1998.
63. A. K. Armah, *The Beautyful Ones Are Not Yet Born*, 1969.
64. Ibid., p. 12.
65. Ibid., pp. 12–13.
66. Ibid., pp. 77–9.
67. Ibid., p. 117.
68. Berman, 1983, pp. 235–6.
69. Armah, 1969, p. 13.
70. R. Araeen, 'A New Beginning – Beyond Postcolonial Cultural Theory and Identity Politics', *Third Text*, 50, Spring 2000, p. 6.
71. N. Elleh, 'Architecture and Nationalism in Africa, 1945–1994', in Okwui Enwezor, ed., *The Short Century*, 2001, p. 235.
72. S. Sassen, 'The New Centrality: The Impact of Telematics and Globalization', in William S. Saunders, ed., *Reflections on Architectural Practices in the Nineties*, 1996, p. 210.
73. Shirley Wong, 'Colonialism, Power, and the Hongkong and Shanghai Bank', in I. Borden, J. Kerr, J. Rendell and A. Pivaro, eds, *The Unknown City*, 2001, pp. 160–74.
74. Ibid., p. 164.
75. Ibid., p. 172.
76. These characterizations are borrowed from P. J. Cain and A. G. Hopkins, *British Imperialism*, 1993, especially pp. 241–8.
77. See F. H. H. King, *The Hongkong Bank in the Period of Development and Nationalism, 1941–1984*, 1991, p. 904.
78. On the relation between colonial cities and world cities see King, 1990, pp. 18ff, 33–52.
79. M. Hardt and A. Negri, *Empire*, 2000, pp. 31–2.
80. This account of the building is based on the following sources: *Architecture and Urbanism – Norman Foster: 1964–1987*, May 1988; the special issue of *Architectural Review*, 179, April 1986; special issue of *Architects' Journal*, 22 October 1986; and I. Lambot, ed., *Norman Foster, Foster Associates – Buildings and Projects Volume 3 1978–1985*, 1989.
81. *Architecture and Urbanism – Norman Foster: 1964–1987*, May 1988, p. 214.
82. Ibid., p. 215. On the East–West city see A. Abbas, *Hong Kong – Culture and the Politics of Disappearance*, 1997, p. 71.
83. Z. Zhang, S. S. Y. Lau and H. Y. Lee, 'The Central District of Hong Kong', *Architecture and Urbanism*, 322, 1997, p. 15.
84. Lambot, ed., 1989, p. 192.
85. *Architecture and Urbanism – Norman Foster: 1964–1987*, May 1988, p. 214; *Architectural Review*, 179, April 1986, p. 102.
86. *Architectural Review*, April 1986 p. 56.
87. Sassen, 1996, pp. 208–9.
88. The phrase is from M. Castells, 'Globalization, Flows and Identity', in W. Saunders, ed., *Reflections on Architectural Practices in the Nineties*, 1996, p. 200.
89. Ibid., p. 201.
90. Sassen, 1996, p. 208.
91. Ibid.

Chapter 2

1. Iraq was not fully independent of British control or client regimes until the revolution of 1958.
2. See T. R. Metcalf, *An Imperial Vision*, 1989, pp. 236–8. For Baghdad railway station see The *Builder*, 176, 29 April 1949, pp. 521–3; *Building*, 18, July 1948, pp. 203–4; and *Building*, 23, December 1953, p. 466.
3. The *Banker*, February 1934, p. 172.
4. Ibid., pp. 173–5.
5. RIBA Archive 12.2.8, Box 2.
6. See A. Mayhew, *Education in the Colonial Empire*, 1938. The common hierarchy placed the 'white dominions' and possibly India above the so-called Crown Colonies, Protectorates and Mandated Territories.
7. For the continuation of many of these features into the 1970s see Pertubuhan Akitek Malaysia, *Meeting to Discuss the Needs, Problems and Policy on Architectural Education in Malaysia*, 1976, pp. 25–31.
8. B. Anderson, *Imagined Communities*, 1991, p. 115.
9. A. D. King, *Global Cities*, 1990, pp. 126–8.

10. P. Oliver, 'Perfected Needs: Vernacular Architecture for Education', *Habitat International*, 7:5/6, 1983, p. 380.
11. University of Liverpool Archives S3177.
12. See L. Budden, *The Book of the Liverpool School of Architecture*, 1932, plates 89 and 90.
13. Interview with Mohamed Makiya, 27 October 1998.
14. Mukhtar later designed the Iraqi pavilion at the 1937 Paris Exhibition, and in 1938 became head of the Architecture Department in the Baghdad Public Works Department. There had been two other Iraqi students at Liverpool before Makiya – Madhat Ali Madaloom and Jaffar Allawi: ibid.
15. Makiya had graduated in mathematics and been faced with a choice between training for the oil industry or architecture when he had a chance to take advantage of the Ministry of Education's mission abroad for students: ibid.
16. Ibid.
17. Ibid. The trip was devised by William Eden whose approach was laid out in a series of articles on 'The English Tradition in the Countryside', *Architectural Review*, 77, March, April, May 1935, pp. 87–94, 142–52 and 193–202.
18. U. Kultermann, 'Contemporary Arab Architecture', *Mimar*, 5, July–September 1982. Some reflections on Makiya's position in Ba'thist Iraq can be found in S. al-Khalil, *The Monument: Art, Vulgarity and Responsibility in Iraq*, 1991.
19. See M. Crinson and J. Lubbock, *Architecture – Art or Profession?*, 1994; J. Sharples, ed., *Charles Reilly and the Liverpool School of Architecture 1904–1933*, 1996; A. Powers, 'Edwardian Architectural Education', *AA Files*, January 1984, pp. 59–89.
20. See Crinson and Lubbock, 1994, pp. 65–75.
21. C. Reilly, *Scaffolding in the Sky*, 1938, pp. 208–9.
22. Modernism in an English context could be a Regency revival: this is the argument in A. Powers, 'C. H. Reilly: Regency, Englishness and Modernism', *Journal of Architecture*, 5, Spring 2000, pp. 47–63. See also G. E. Cherry and L. Penny, *Holford*, 1986, pp. 47ff.
23. Michael Shippobottom, 'Charles Reilly and the First Lord Leverhulme', in Sharples, ed., 1996, p. 46.
24. R. Home, *Of Planting and Planning*, 1997, p. 46.
25. Paul Rabinow, *French Modern*, 1989, p. 211.
26. Ibid., pp. 235–7. I am grateful to Michael Hebbert for letting me see his forthcoming work on the history of urbanism. The word itself probably derived from Ildefonso Cerdá's coinage in his *Teoría General de la urbanización*, 1868–71.
27. University of Liverpool Archives D247.
28. Ibid. Adshead opposed this to the 'affectation' of picturesque town planning, citing Camillo Sitte as its chief advocate. He made his case in formal rather than rational terms.
29. I am thinking here particularly of his interest in pre-colonial planning and in the role of women in planning: see Home, *Of Planting*, 1997, pp. 50–51.
30. Cherry and Penny, 1986, p. 63.
31. W. Holford, 'The Work of the Liverpool School', *Journal of the Town Planning Institute*, 25, November 1938, p. 16.
32. Home, *Of Planting*, 1997, p. 46; J. Coleman, 'The Liverpool Connection and Australian Planning and Design Practice 1945–1985', in R. Freestone, ed., *The Australian Planner*, 1993.
33. Home, *Of Planting*, 1997, p. 180; Reilly, 1938, p. 40. The role of the Colonial Office in setting up architectural schools in the empire deserves further research. The architectural school at the University of Hong Kong, for instance, was set up in 1948 with financial support from the Colonial Office 'who were anxious to consolidate British influence in the Far East in the field of technical education': J. M. Richards, *Memoirs of an Unjust Fella*, 1980, p. 222.
34. Sharples, 1996, p. 27.
35. E. Said, *Orientalism*, 1979, p. 44.
36. T. R. Pasha, *Egyptian Service 1902–1946*, 1949, p. 23.
37. D. M. Reid, *Cairo University and the Making of Modern Egypt*, 1990, pp. 18–19; see also Earl of Cromer, *Modern Egypt*, 1911, pp. 872–4.
38. J. S. Szyliowicz, *Education and Modernisation in the Middle East*, 1973, p. 109.
39. Ibid., pp. 122–3.
40. J. Heyworth-Dunn, *An Introduction to the History of Education in Modern Egypt*, 1938, pp. 143–4.
41. Ibid., pp. 318, 350.
42. D. M. Reid, 'Education and Career Choices of Egyptian Students, 1882–1922', *International Journal of Middle East Studies*, 8, 1977, p. 372.
43. See Crinson and Lubbock, 1994, Chapter 2.
44. C. Issawi, *Egypt at Mid-Century*, 1954, p. 41.
45. R. Tignor, *Modernization and British Colonial Rule in Egypt, 1882–1914*, 1966, p. 339.
46. I am grateful for Rebecca Foote for this information, based on her work in the University of Liverpool Archives.
47. RIBA Archive 7.1.2 vol. 3.
48. Information based on a letter from Omar El Hakim to Joseph Sharples, 14 April 1996.
49. He published his thesis as 'Alexandria – its Town Planning Development' in the *Town Planning Review*, 5:4, December 1933, pp. 232–48.
50. University of Liverpool Archives, S3182, S3185, A3167.
51. *Prospectus of the School of Architecture University of Liverpool*, 1921–2, p. 4.

52. Ibid.
53. See also M. Danby, 'Architectural Education in Africa and the Middle East', *Architectural Education*, 2, 1983, p. 15.
54. Alan Powers, 'Liverpool and Architectural Education in the Early Twentieth Century', in Sharples, ed., 1996, p. 9. Powers's more recent work has softened this judgement: see Powers, 2000.
55. Julien Gaudet, the great codifier of Beaux Arts theory at the time of Liverpool's emergence, may have beckoned to other cultures in his text but all his illustrated examples were classical: J. Gaudet, *Eléments et théories de l'architecture*, 1915, vol. 1.
56. A. Colquhoun, 'The Concept of Regionalism', in G. B. Nalbantoglu and C. T. Wong, eds, *Postcolonial Space(s)*, 1997, p. 13.
57. Ibid., pp. 15–17.
58. Ibid., p. 22.
59. Ibid., pp. 17–18.
60. Ibid., p. 14.
61. A. Colquhoun, 'Rationalism: A Philosophical Concept in Architecture', in *Modernity and the Classical Tradition*, 1989, p. 62.
62. Ibid., pp. 62–5; see also Rabinow, 1989, pp. 47–57, 67–9. 'Sentiment' was itself a highly loaded term, often used by colonial administrators to indicate a generalized sense of the views of the colonized: see, for instance, R. G. Irving, *Indian Summer*, 1981, p. 174.
63. See Rabinow, 1989, pp. 200–202, 275–6; Metcalf, 1989, Chapter 3.
64. See V. Prakash, 'Identity Production in Postcolonial Indian Architecture: Re-Covering What We Never Had', in Nalbantoglu and Wong, eds, 1997, p. 47. See also James Fitch, 'Vernacular Paradigms for Post-Industrial Architecture' and Y. Aysan and N. Teymur, 'Vernacularism in Architectural Education', both in M. Turan, ed., *Vernacular Architecture*, 1990.
65. See Werner Szambien, 'Durand and the Continuity of Tradition', in R. Middleton, ed., *The Beaux-Arts and Nineteenth-Century French Architecture*, 1982, pp. 19–33.
66. Rykwert writes '[Durand's theory] proposes a wholly unhistorical, wholly aprioristic approach to design, in which the procedure of the architect is wholly autonomous, and the past a mere repository of conventions': Joseph Rykwert, 'The Ecole des Beaux-Arts and the Classical Tradition', in Middleton, ed., 1982, p. 16. Substitute 'region' for 'past' and you have the reasoning of the regionalist-universalist double end. See also A. Vidler, 'The Idea of Type', *Oppositions*, 8, Spring 1977, pp. 94–115.
67. Colquhoun, 1997, pp. 21–2.
68. This is the argument made in R. Ilbert and M. Volait, 'Neo-Arabic Renaissance in Egypt 1870–1930', *Mimar*, 13, July–September 1984, pp. 26–34. The road of *Kultur* does not necessarily only lead to the 'chauvinist movements' of racial purity, as Colquhoun seems to believe: Colquhoun, 1997, p. 16.
69. These phrases are borrowed from G. C. Spivak, *The Post-Colonial Critic*, 1990, pp. 102, 109.
70. See G. C. Spivak, *A Critique of Postcolonial Reason*, 1999, pp. 266–9, 318–19, n. 10.
71. D. M. Reid, 'The Rise of Professions and Professional Organizations in Modern Egypt', *Comparative Studies in Society and History*, 16, 1974, p. 28.
72. E. Bertram King, 'The Allied Societies', in J. A. Gotch, ed., *The Growth and Work of the RIBA 1834–1934*, 1934, p. 51.
73. Ibid.
74. Ibid., p. 55.
75. Ibid., p. 57.
76. See Crinson and Lubbock, 1994, Chapter 2.
77. Bertram King, 1934, p. 65.
78. RIBA Archive 8.1.2.
79. Bertram King, 1934, p. 65.
80. *RIBA Kalender*, 1934–5.
81. RIBA, *International Congress on Architectural Education*, 1925, p. xv.
82. RIBA Archive 7.1.4, 1.3.39.
83. RIBA Archive 12.2.8, Commonwealth Committee Minutes, 20 July 1959.
84. RIBA Archive 12.2.8, Report of Commonwealth Conference. The 1963 Conference of Commonwealth Architectural Societies was far more radical in its agenda and membership, and with the Commonwealth Association of Architects it instigated the first substantial shift away from RIBA-centred systems: RIBA Archive 12.2.8.
85. RIBA Archive 7.1.2, Board of Architectural Education Minutes.
86. C. R. Knight, 'Architectural Education in the British Empire', *Journal of the Royal Institute of British Architects*, 45, 22 November 1937, p. 66.
87. RIBA Archive 7.1.4. See also P. Batey, 'Town Planning Education As It Was Then', *The Planner*, 79, April 1993, pp. 25, 33.
88. University of Hong Kong, *Senate Report on Architectural Education December 1954*, 1954, p. 2.
89. See J. Lang, M. Desai and M. Desai, *Architecture and Independence*, 1998, pp. 140–3. Indian-headed firms gradually built up in the first three decades of the century.
90. P. Mitter, 'The Formative Period (Circa 1856–1900): Sir J.J. School of Art and the Raj', *Marg*, 46:1, September 1994, pp. 1–4.
91. H. J. Billimoria, 'The Origin and Growth of the Indian Institute of Architects', *Journal of the Indian Institute of Architects*, January 1942, pp. 203–4.
92. N. Evenson, *The Indian Metropolis*, 1989, p. 165.
93. See 'Exhibition of Students' Work at the Sir J. J. School of Art, Bombay', *Journal of the Indian*

Institute of Architects, January 1941, pp. 85–9; see also C. Batley, 'Schools of Architecture: 1 – The School of Architecture at the Government School of Art, Bombay', *Journal of the Royal Institute of British Architects*, 37, 21 June 1930, pp. 592–7.

94. 'Exhibition of Students' Work at the Sir J. J. School of Art, Bombay', *Journal of the Indian Institute of Architects*, January 1941, pp. 85–9; Batley, 1930, pp. 594, 596.
95. Billimoria, 1942, pp. 203–8.
96. *Marg*, 2:3, 1947, pp. 4–7.
97. Evenson, 1989, p. 166; Lang, Desai and Desai, 1998, p. 144.
98. See A. D. King, *Colonial Urban Development*, 1976, p. 279.
99. Compare, in a different context, Spivak, 1999, p. 11.
100. Evenson, 1989, p. 181.
101. Ibid., pp. 183–4.
102. J. Habermas, *Legitimation Crisis*, trans. T. McCarthy, 1975.
103. RIBA Archive 8.1.2, Practice Standing Committee; 7.1.2, Board of Architectural Education Minutes; 7.1.4, 25 April 1938.
104. In Australia, for instance, a Registration Act was passed in 1921, a decade before Britain, and in Malaysia a similar Architects Ordinance (protecting both title and practice) was passed in 1926.

Chapter 3

1. M. and R. Farmanfarmaian, *Blood and Oil – Memoirs of a Persian Prince*, 1999, pp. 184–5.
2. Ibid., p. 69.
3. The British owned the Imperial Bank of Persia, responsible for the issue of banknotes up to 1930.
4. A. Sampson, *Seven Sisters*, 1975, p. 54.
5. J. H. Bamberg, *The History of the British Petroleum Company, Volume 2, The Anglo-Iranian Years, 1928–1954*, 1994, p. 384.
6. *Naft*, 7, July 1931, p. 16.
7. *Naft*, 11, October 1935, p. 7.
8. BP 59011. In 1929 the total population was estimated at 60,000: ibid.
9. A. D. King, *Urbanism, Colonialism and the World Economy*, 1990, p. 118.
10. Ibid., pp. 118, 120–4.
11. International Labour Organisation, *Labour Conditions in the Oil Industry in Iran*, 1950, p. 5.
12. Farmanfarmaian, 1999, p. 86.
13. Ibid., p. 88.
14. On the latter see A. J. Christopher, *The British Empire at its Zenith*, 1988, p. 103; and R. Home, *Of Planting and Planning*, 1997, pp. 135–9.
15. J. Abu-Lughod, 'Culture, "modes of production", and the changing nature of cities in the Arab world', in J. A. Agnew, J. Mercer and D. E. Sopher, eds, *The City in Cultural Context*, 1984, p. 109.
16. A. D. King, *Colonial Urban Development*, 1976, p. 59. These and other comments on the British way of life in Abadan are based on interviews with Peter and Hetty Brackley and Philip Beauchamp.
17. Lord Gladwyn, *The Memoirs of Lord Gladwyn*, 1972, p. 21.
18. Further sub-distinctions are apparent in various company documents – 'The Indian is satisfied with a more lower standard of living accommodation [than the Iranians]', for instance: BP 67627, p. 53.
19. BP 67267.
20. Bamberg, 1994, pp. 246–7.
21. BP 53217, 68186.
22. 'Quality', for example, might mean not building cheaper bungalows in which bedrooms opened directly onto sitting-rooms: BP 67590. The general policy was criticized by the International Labour Organisation and the British labour attaché in Iran: see International Labour Organisation, 1950; FO 371/61984.
23. For contemporary criticism see L. P. Elwell-Sutton, *Persian Oil*, 1955. Elwell-Sutton, a former AIOC employee, became broadcasting attaché to the British Legation in Tehran.
24. *Naft*, 1, July 1924.
25. *Architectural Review*, 57, 1925, p. 185.
26. M. Richardson, 'A Lost Skyscraper', *Thirties Society Journal*, 6, 1987, pp. 3–7.
27. This is how they are described in A. S. G. Butler, *The Architecture of Edwin Lutyens*, 1950, vol. 3, p. 24.
28. *APOC Magazine*, 1:5, July 1925, pp. 3–4.
29. Farmanfarmaian was amongst one group of five to six students sent to study petroleum engineering at Birmingham University in the 1930s. Interestingly, he had originally wanted to study architecture, like his brother, in Paris: Farmanfarmaian, 1999, pp. 69, 73.
30. For Wilson see RIBA Biog File; and C. H. Lindsey Smith, *JM The Story of an Architect*, privately published, no date.
31. M. Richardson, *Sketches by Edwin Lutyens*, 1994, p. 104; Interview with Hamish Wilson, 15 March 1996.
32. Lindsey Smith, p. 63.

33. R. Home, 'Town Planning and Garden Cities in the British Colonial Empire, 1910–1940', *Planning Perspectives*, 5, 1990, pp. 23–4.
34. Ibid., pp. 25–6. Home cites Lusaka, Kaduna, Port Harcourt, Enugu Jos, and even New Delhi.
35. See, for example, BP 29198.
36. See *Naft*, 8, March 1932, p. 32. The façade of this building was partly redesigned by the British-trained Iranian architect Aghai Elgar: BP 54561.
37. *Naft*, 8, March 1932, p. 32.
38. N. Evenson, *The Indian Metropolis*, 1989, pp. 149–50; J. Abu-Lughod, *Rabat*, 1980.
39. BP 59011.
40. Ibid.
41. Wilson sent a copy of Julian Huxley's book on the Tennessee Valley Authority to one of the company's directors in October 1943, noting 'it is really an amazing piece of work and though it is very different in many respects from the problems we have to face in Abadan, it does have a bearing on it in the broad principles': BP 68848.
42. BP 49673.
43. Ibid.
44. J. Collins, 'Lusaka: Urban Planning in a British Colony, 1931–64', in G. E. Cherry, ed., *Shaping an Urban World*, 1980.
45. G. Herbert and S. Sosnovsky, *Bauhaus on the Carmel and the Crossroads of Empire*, 1993.
46. Home, 1990, p. 32.
47. BP 49673. There were also fears of actual epidemics spreading from the 'town' with arguments made for isolating the British staff and against a racially mixed area: BP 67590. According to David Williams, entry into Bawarda was restricted to residents and their servants.
48. BP 49673. Wilson designed the nursing quarters to have separate sitting-rooms, dining-rooms, kitchens and even entrances for Iranian and European nurses.
49. BP 67698; Interview with Hamish Wilson, 15 March 1996.
50. BP 49673.
51. International Labour Organisation, 1950, p. 72.
52. BP 67590.
53. BP 67627, p. 50.
54. Ibid., p. 51.
55. BP 49673.
56. International Labour Organisation, 1950, p. 33.
57. For a contemporary account of these events see N. Kemp, *Abadan*, 1953.
58. International Labour Organisation, 1950, p. 31.
59. Lindsey Smith, p. 49.
60. For these reflections on Abadan's current state I am grateful to David Williams.

Chapter 4

1. P. Greenhalgh, *Ephemeral Vistas*, 1988, p. 56.
2. For British national pavilions before this period see ibid., pp. 123–5.
3. There have recently been some substantial studies of the latter, notably Z. Celik, *Displaying the Orient*, 1992; P. A. Morton, *Hybrid Modernities*, 2000; J. Lagae, 'Displaying Authenticity and Progress', *Third Text*, 50, Spring 2000, pp. 21–32.
4. M. Roche, *Mega-Events and Modernity*, 2000, p. 63.
5. *Architectural Review*, 55, June 1924, p. 204.
6. No reason can be found in the archival documents for this location. Originally the government exhibit was to be in the Palace of Industry but its display became too large for its intended space: PRO BT 60/14/2. No decision on the site was made until May 1923: PRO BT 60/5 Part 2.
7. *Pocket Guide to the Empire Exhibition at Wembley*, 1924, pp. 2 and 3.
8. P. Abercrombie, 'The Planning of the British Empire Exhibition – A Symbolical Lay-Out', *The Architects' Journal*, 59, 28 May 1924, p. 903.
9. Ibid., p. 904.
10. Ibid.
11. *Architectural Review*, 55, June 1924, p. 215.
12. *Pocket Guide to the Empire Exhibition at Wembley*, 1924, p. 4.
13. *Guide to the Exhibits in the Pavilion of His Majesty's Government*, 1924, pp. 7–8.
14. L. Weaver, *Exhibitions and the Arts of Display*, 1925, p. 88.
15. PRO BT 60/14/2.
16. *Guide to the Pavilion of His Majesty's Government*, 1925.
17. 'How are the dominant dominated, and those who have builded this enduring Empire become the imitators of those whose empires are in the dust?': *Architectural Review*, 55, June 1924, p. 217.
18. Ibid., p. 215.
19. *Pocket Guide to the Empire Exhibition at Wembley*, 1924, p. 2.
20. Republished in V. Woolf, *The Crowded Dance of Modern Life*, 1993. For Woolf's anti-imperialism see also D. Cannadine, *Ornamentalism*, 2001, pp. 147–8, 153; and Elleke Boehmer, '"Immeasurable

strangeness" in imperial times: Leonard Woolf and W. B. Yeats', in H. J. Booth and N. Rigby, eds, *Modernism and Empire*, 2000, pp. 107–8.

21. Woolf, 1993, pp. 39–40.
22. Ibid., p. 40.
23. Ibid., p. 41.
24. Ibid.
25. Ibid., p. 42.
26. T. Vijayaraghavacharya, *The British Empire Exhibition, 1924 – Report by the Commission for India for the British Empire Exhibition*, 1924, p. 21.
27. Ibid., pp. 23–5. On the Devonshire Declaration see D. Wylie, 'Confrontation over Kenya', *Journal of African History*, 18, 1977. Further trouble occurred in 1925 when the exhibition was extended, with the Legislative Councils unwilling to vote for extra funds: PRO T 172/1462. For Arab objections to the Palestine Pavilion as a Zionist enterprise see R. Fuchs and G. Herbert, 'Representing Mandatory Palestine', *Architectural History*, 43, 2000, p. 308.
28. T. Gronberg, *Designs on Modernity*, 1998, pp. 12, 36.
29. Ibid., p. 23.
30. *Builder*, 129, 24 July 1925, p. 134.
31. *Builder*, 128, 22 May 1925, p. 788.
32. *Architectural Review*, 58, July 1925, p. 3.
33. *Building News*, 128, 15 May 1925, p. 357.
34. *Builder*, 128, 22 May 1925, p. 788.
35. This understanding of cosmopolitanism is based on T. Brennan, 'Cosmopolitan Vs International', *New Left Review*, 7 second series, January/February 2001, pp. 75–84; and M. Nava, 'The Cosmopolitanism of Commerce and the Allure of Difference', *International Journal of Cultural Studies*, 1:2, 1998, pp. 163–96.
36. *Builder*, 138, 30 May 1930, p. 1038; PRO T 161/485.
37. These scenes could include, from West Africa, both the 'Courtyard of the Emir's Palace at Kano' and a 'View of Takoradi Harbour': PRO CO 554/88/5. Of the imperial possessions only West Africa, East Africa and the Federated Malay States participated.
38. See Morton, 2000; and H. Lebovics, *True France*, 1992, Chapter 2.
39. PRO BT 60/38/1; Lebovics, 1992, p. 63. In fact several colonial nations did participate, notably Belgium, Italy, the Netherlands, Portugal and the USA. French thinking here seems to have been along the lines of a 'colonial holy alliance', anti-Bolshevik, anti-nationalist insurrection, and perhaps still anti-German: ibid., pp. 83–5.
40. *Empire Exhibition, South Africa 1936*, 1936, p. 6.
41. *Empire Exhibition: South Africa*, Johannesburg, 1936.
42. See P. J. Cain and A. G. Hopkins, *British Imperialism*, 1993, pp. 132–4.
43. See, for instance, *Guide to the Pavilion of His Majesty's Government of the United Kingdom*, 1936, p. 5.
44. There was at least one performance in this space: 'Bushmen See British Pavilion, Women Dance Before Bust of the King', reported the *Rand Daily Mail*, 15 November 1936.
45. *Official Catalogue of the Empire Exhibition, South Africa, 1936*, 1936.
46. *Guide to the Pavilion of His Majesty's Government of the United Kingdom*, 1936, p. 3.
47. *Rhodesia Herald*, 18 September 1936.
48. *Star*, 18 September 1936.
49. *South Africa*, 25 January 1936.
50. *Rand Mail*, 18 November 1936.
51. Kingsley Martin, *Editor: A Volume of Autobiography, 1931–45*, 1968.
52. The best secondary accounts of the exhibition are in J. D. Herbert, *Paris 1937 Worlds on Exhibition*, 1998; and Hayward Gallery, *Art and Power*, 1996. Neither pays much attention to the British Pavilion.
53. Although many colonial governments were invited, the British government gave out the message that this was an exhibition 'in which the colonies would not be particularly interested': PRO BT 60/38/1. Australia and South Africa both eventually contributed pavilions. Dawn Ades claims that the British Pavilion was 'funded by a Maharajah', but the claim is unsourced and I have not been able to find any evidence for it: Hayward Gallery, 1996, p. 61, n. 21. There was actually an unofficial pavilion from Palestine, the Pavilion of Israel in Palestine: PRO CO 323/1500/13.
54. PRO BT 60/38/1.
55. RIBA Hi 0/61/4.
56. See C. Barman, *The Man Who Built London Transport*, 1979, pp. 175–6. Michael Saler sees the pavilion as evidence of a sea change in Pick's aesthetics, away from modernism: M. Saler, *The Avant-Garde in Interwar England*, 1999, pp. 158–9.
57. The RIBA was responsible for this. For their reaction to the concept see *Journal of the Royal Institute of British Architects*, 44, 5 December 1936, p. 111.
58. Frank Pick, Foreword to catalogue of the pavilion, in PRO BT 57/19. For Pick, English life embraced Scotland, Wales and Northern Ireland.
59. C. H. Reilly, Letter to the Editor, *The Times*, 19 July 1937.
60. PRO BT 57/21.
61. On this issue see Saler, 1999, pp. 141–2.
62. Ibid., p. 158. A modernist critic like H.-R. Hitchcock could fault the design for its moderation: *Architectural Forum*, 67, September 1937, p. 168.

63. RIBA Hi 0/63/1. Inevitably the distinction was missed by many: 'the shell should have been in keeping with some suggestion of national tradition ... Instead of which ... it might have been designed by the foreign ultra-modernists': *Morning Post*, 16 January 1937.
64. An absence commented on in the *Listener*, 28 July 1937.
65. On the Spanish Pavilion see Marko Daniel, 'Spain: Culture at War', Hayward Gallery, 1996, pp. 63–8.
66. *Daily Express*, 6 August 1937.
67. Quoted in Barman, 1979, p. 193.
68. *Journal of the Royal Institute of British Architects*, 44, 17 July 1937, p. 911.
69. *Marseille Libre*, 12 September 1937; PRO BT 60/40/2.
70. See *Revue Mensuelle de l'Association des Anciens Élèves de l'École des Hautes Études Commerciales*, 54, October 1937, pp. 58–9.
71. *Daily Express*, 6 August 1937; *New Statesman*, 31 July 1937; *Southern Daily Echo*, 20 July 1937.
72. PRO BT 61/62/8.
73. Weak arguments were presented against the notion that the displays were non-intellectual and upper-class biased: PRO BT 57/19.
74. *Country Life*, 24 July 1937, p. 93. This was written by Christopher Hussey before he had seen the pavilion: RIBA Hi 0/63/1 Pick-Hill, 9 August 1937.
75. *Architects' Journal*, 26 August 1937, p. 329.
76. J. M. Richards, 'The Problem of National Projection', *Architectural Review*, 82, September 1937, pp. 104–5.
77. Quoted in P. M. Taylor, *The Projection of Britain*, 1981, p. 104. Tallents later helped to plan the 1937 pavilion as a member of the committees for travel, lectures and photography: RIBA Hi 0/61/4.
78. S. Tallents, *The Projection of England*, reprint of 1932 edition, 1955, p. 25.
79. Ibid., p. 34.
80. Tallents would have known Pick through the latter's work at the Empire Marketing Board in the 1920s; indeed Tallents has a good claim to be included amongst the 'medieval modernists', for whom Pick was a pivotal figure, as defined by Michael Saler: Saler, 1999.
81. For general accounts of the Empire Exhibition, Glasgow, see B. Crampsey, *The Empire Exhibition of 1938*, 1988; P. and J. Kinchin, *Glasgow's Great Exhibitions 1888, 1901, 1911, 1938, 1988*, 1988; C. McKean, *The Scottish Thirties*, 1987.
82. J. MacKenzie, ' "The Second City of the Empire" ', in F. Driver and D. Gilbert, eds, *Imperial Cities*, 1999, p. 230.
83. See, for instance, the *Imperial Review*, 5:5, May–June 1938. To mention India's absence would be, perhaps, to admit that the exhibition's various claims to be a comprehensive survey were spurious.
84. On this structure see *Empire Exhibition, Scotland – 1938. Official Guide*, 1938, pp. 107–9; and Thomas Tait, 'The Empire Exhibition, Glasgow, 1938 – A Retrospect', *Quarterly Illustrated of the Royal Incorporation of Architects in Scotland*, 60, April 1939, pp. 9–11.
85. *Empire Exhibition, Scotland – 1938. Official Guide*, p. 109.
86. See *Guide to the Pavilion of H. M. Government of the United Kingdom*, 1938.
87. The display designer was Misha Black. After the Paris debacle responsibility was given to the Department of Scientific and Industrial Research for three of the halls and the Ministry of Health for the fourth. Of course, the programme set in Glasgow was different from Paris. At the former, engineering and industry were catered for in separate pavilions and the United Kingdom Pavilion could concentrate on representing the government's work; at the latter the British Pavilion was the only pavilion for British products.
88. *Guide to the Pavilion of H. M. Government of the United Kingdom*, 1938, p. 9. Some reviewers found this entrance hall the most imperial element in the pavilion – 'it reminds one of a Governor's palace in India': *Hamburger Fremdenblatt*, 31 May 1938.
89. T. S. Tait, 'Planning the Empire Exhibition', *SMT and Scottish Country Life*, May 1938, p. 88.
90. Ibid., p. 89.
91. Tait, 1939, p. 6.
92. The comparison was, of course, made by critics: see J. M. Richards's review in *Architectural Review*, 84, July 1938, pp. 3–10.
93. Tait wrote about this standardization in his article 'The Empire Exhibition', pp. 5–6. It was also much commented on in *Architectural Review*, 84, July 1939, pp. 4–5.
94. Other writers linked modernism with native antecedents in the work of C. R. Mackintosh and 'Greek' Thomson: see *Glasgow Herald – Empire Exhibition, Special Number*, 28 April 1938, p. 19.
95. MacKenzie, 1999, p. 229.
96. *An Clachan – The Highland Village – Official Guide*, 1938.
97. The Highlands Committee, *The Highlands and the Highlanders*, 1938.
98. Although my conclusions here are different from those of Colin McArthur who regards the rural discourse in the exhibition as 'regressive and politically disabling', I am indebted to his description of the discourses conjured up by the exhibition: C. McArthur, 'The Dialectic of National Identity', in T. Bennett, C. Mercer and J. Woollacott, eds, *Popular Culture and Social Relations*, 1986. I also depart from Paul Greenhalgh's argument that such villages were 'ideologically difficult ... for the British to create, as they raised issues as to the status of ... Scotland in relation to the colonies of the empire': Greenhalgh, 1988, p. 107. Even if it may be arguable in the case of Scottish and Irish villages in previous exhibitions, it seems entirely inappropriate in the case of Glasgow to assert that this is an example of the creation of

difference 'in order for the English to be able to differentiate themselves and rule': ibid.

99. *Empire Exhibition, Scotland – 1938. Official Guide*, pp. 121–2.
100. *Architectural Forum*, 70, June 1939, p. 446; *Builder*, 12 May 1939, p. 892.
101. B. Anderson, *Imagined Communities*, 1991, p. 88.
102. *Architectural Review*, 113, January 1953, p. 58.

Chapter 5

1. On this nomenclature see S. R. Mehotra, 'On the Use of the Term "Commonwealth"', *Journal of Commonwealth Political Studies*, 2:1, 1963, pp. 1–16. See also W. David McIntyre, 'The Commonwealth', *OHBE*, 5, pp. 558–70.
2. M. Worboys, 'The Imperial Institute', in J. MacKenzie, ed., *Imperialism and the Natural World*, 1990, pp. 164–6. For secondary literature on the Imperial Institute see also W. Golant, *Image of Empire*, 1984; J. MacKenzie, *Propaganda and Empire*, 1984; and F. H. W. Sheppard, general ed., *Survey of London Volume 38 – The Museums Area of South Kensington and Westminster*, 1975.
3. C. Duncan, *Civilising Rituals*, 1995; T. Bennett, *The Birth of the Museum*, 1995.
4. This way of understanding architecture is also influenced by Lefebvre's concept of 'social space': see H. Lefebvre, *The Production of Space*, trans. D. Nicholson-Smith, 1991, especially pp. 142–3.
5. See B. Cohn, 'Representing Authority in Victorian India', in E. Hobsbawm and T. Ranger, eds, *The Invention of Tradition*, 1983, pp. 165–209; and H. Jyoti, 'City as Durbar', in N. AlSayyad, ed., *Forms of Dominance*, 1992, pp. 83–105.
6. Imperial Institute, *The Imperial Institute of the United Kingdom, the Colonies and India*, 1892; for early reports see PRO 30/76/9.
7. See T. Richards, *The Imperial Archive*, 1993, p. 3.
8. Aden is an interesting example of the way that the Imperial Institute had to be constantly responsive to changes in imperial status. In 1935, as its status changed from being governed by British India to becoming a Crown Colony, so it had to be given a court of its own and a place at the north end of the east gallery: PRO 30/76/98. By the 1920s the overall organization was changed and no longer fitted so neatly over compass directions: the United Kingdom collections were now withdrawn from the gallery circuit, and those of African and Mediterranean possessions were moved into the north gallery.
9. Bennett, 1995, p. 102.
10. For a critical review of these early displays see W. T. Furse, 'The Work of the Imperial Institute', *Journal of the Royal Society of Arts*, 74, 1 May 1926, p. 654. Furse had become Director in 1923.
11. H. A. F. Lindsay, *An Empire Story-Land*, Imperial Institute guidebook from the late 1930s: see PRO 30/76/314. Lindsay succeeded W. T. Furse as Director in 1934.
12. G. Spivak, *A Critique of Postcolonial Reason*, 1999, p. 411.
13. H. Spooner, 'The Exhibition Galleries', *Bulletin of the Imperial Institute*, 41:1, Jan–March 1943, p. 68; Furse, 1926, p. 655; MacKenzie, 1984, pp. 133–4.
14. Spooner, 1943, p. 72.
15. Ibid., pp. 72–3.
16. See Mehotra, 1963, pp. 11–13; M. Beloff, *Imperial Sunset, Volume One: Britain's Liberal Empire 1897–1921*, 1987, pp. 122–9.
17. N. Mansergh, *The Commonwealth Experience*, 1982, vol. 2, pp. 242–3.
18. A. D. King, *Global Cities*, 1990, pp. 83–5.
19. *Report of the Committee of Enquiry into the Imperial Institute*, 1952, p. 2.
20. See the article by Kenneth Bradley, the new Director: 'The Imperial Institute', *Journal of the Royal Society of Arts*, 1957, pp. 879–80. The movement from specimens to people can also be found in the development of several colonial museums during this period and since independence.
21. See S. Howe, *Anticolonialism in British Politics*, 1993; J. M. Jacobs, *Edge of Empire*, 1996; S. Ward, ed., *British Culture and the End of Empire*, 2001. In Bill Schwarz's paper 'South Africa in the English Imagination: Smuts in 1956', given at the 'Imperial Cities' conference, Royal Holloway College, 2–3 May 1997, Schwarz details the complex discourses at play in Epstein's statue to Jan Smuts in Parliament Square. This was unveiled in 1956 during the Suez Crisis, and to make room for it the Buxton Memorial Fountain, a Victorian memorial to the emancipation of slaves, was moved to the less prestigious site of Victoria Tower Gardens.
22. John Darwin, 'Decolonisation and the End of Empire', *OHBE*, 5, pp. 542–4.
23. The term is from Nicholas Owen, 'Critics of Empire in Britain', *OHBE*, 4, p. 202.
24. See, for instance, B. Yeoh, 'Street-naming and nation-building', *Area*, 28:3, 1996, pp. 298–307.
25. Bill Schwarz, 'Afterword', in F. Driver and D. Gilbert, eds, *Imperial Cities*, 1999, p. 272.
26. The term 'disimperialism' was coined by Peter Lyon in 'Transfer and Transformation: An Introduction', in P. Lyon and J. Manor, eds, *Transfer and Transformation*, 1983, pp. 1–2.
27. The Imperial Institute displays are not even mentioned in the standard secondary source for the Festival, M. Banham and B. Hillier, eds, *A Tonic to the Nation*, 1976. For correspondence concerning one colonial government's involvement in the Festival, that of the Gold Coast, see PRAAD RG 3/1/60.
28. L. Esher, *A Broken Wave*, 1981, pp. 303–4.

29. Modifications to the Hall in the mid-1960s considerably altered the first two of these features: see J. McKean, *The Royal Festival Hall*, 1992.

30. A. Forty, 'Being or Nothingness', *Architectural History*, 38, 1995, p. 32.

31. I. Cox, *The South Bank Exhibition – A Guide to the Story it Tells*, 1951, p. 89. The contractors were Costains, who advertised themselves through the Dome's image and the names of their offices across the empire.

32. This account of the displays is based on Cox, 1951, pp. 40–62.

33. J. M. Richards described the 'confusion of the displays on the ground floor … planned without any apparent relationship to the circular form of the building': *Architectural Review*, 110, August 1951, p. 124.

34. The site was briefly considered for an Indian museum in 1910: *Building News*, 15 July 1910, p. 79.

35. Cox, 1951, p. 8.

36. For accounts of the Picturesque in British modernism see R. Banham, 'Revenge of the Picturesque', in J. Summerson, ed., *Concerning Architecture*, 1968; M. Glendinning and S. Muthesius, *Tower Block*, 1994, Chapter 17. Jane M. Jacobs has discussed the relation between the Picturesque and the 'heart of empire' but she sees the result as a 'domesticated memory of empire constructed in opposition to a demonised European other': Jacobs, 1996, p. 49. As I will argue, this does not take account of the proximity between the Picturesque and antimonarchical debates in European and British modernism, as well as the way in which the Picturesque could be presented as a post-imperial urbanism by contrast not with modernism but with Beaux Arts planning (a still relevant presence in the British scene).

37. John Summerson, 'Introduction', in T. Dannatt, *Modern Architecture in Britain*, 1959, p. 19. J. M. Richards made a more general comparison with the vistas and axiality customary in exhibitions: J. M. Richards, *Memoirs of an Unjust Fella*, 1980, p. 241. Lionel Brett was one influential contemporary who called the architecture 'effeminate': L. Brett, 'Detail on the South Bank', *Design*, 32, August 1951, pp. 3–7.

38. The prime exponent of this view at the time was Nikolaus Pevsner both in *Architectural Review*, of which he was one of the editors, and in his Reith lectures of 1955, published as *The Englishness of English Art*, 1964.

39. R. Banham, 'The Style: "Flimsy … Effeminate"?', in Banham and Hillier, eds, 1976, pp. 192–3.

40. For a discussion of these debates see G. Baird, *The Space of Appearance*, 1995, pp. 131–64.

41. It was, of course, won by the Conservative Party. See A. Forty, 'Festival Politics', in Banham and Hillier, eds, 1976, p. 37.

42. N. Pevsner (revised by B. Cherry), *The Buildings of England – London I The Cities of London and Westminster*, 1985, p. 286.

43. Pevsner, 1964, p. 188.

44. The Editors, 'St. Paul's', *Architectural Review*, June 1956, pp. 295–8.

45. Spivak, 1999, p. 410, n. 128.

46. C. Hussey, 'Model for St. Paul's Precinct', *Country Life*, 22 March 1956, pp. 538–9.

47. C. Hussey, 'Save the Imperial Institute', *Country Life*, 23 February 1956, p. 229.

48. *Journal of the Royal Institute of British Architects*, January 1956, p. 87. Schwarz has argued that with the new immigration in the late 1950s, the older language of the 'tribunes of white supremacy' was revived: Schwarz, 'South Africa'.

49. *Architect and Building News*, 22 March 1956, p. 271.

50. *Journal of the Royal Institute of British Architects*, April 1956, p. 239.

51. *Architects' Journal*, 6 February 1958, pp. 197–8.

52. I owe this phrase to Jane M. Jacobs who uses it in her analysis of Bank Junction in the City of London: Jacobs, 1996, p. 40.

53. *Annual Report of the Commonwealth Institute*, London, 1963, p. 8. See also K. Bradley, 'The New Commonwealth Institute', *Commonwealth Journal*, November–December 1961, pp. 1–5. The Commonwealth Institute was listed as II-starred in October 1988, only the second building to be listed under the thirty-year rule. This demonstrates an acceptance of the building as significant for both its architectural and its social aims, and protects it from the fate of its predecessor.

54. Mehotra, 1963, p. 13.

55. N. Pevsner, 'Architecture in the Modern Commonwealth', *Journal of the New Zealand Institute of Architects*, 30, 1963, pp. 161–4.

56. J. M. Richards, ed., *New Buildings in the Commonwealth*, 1961, pp. 7–8.

57. An instance of the use of 'Commonwealth' as a banner for active divestment of metropolitan control in architectural culture can be found in the Conference of Commonwealth and Overseas Architectural Societies of 1963: see RIBA Archive 12.2.8, Box 1.

58. The phrase was Stirrat Johnson-Marshall's: see Andrew Saint, 'Commonwealth Institute, Holland Park, R.B. of Kensington and Chelsea', unpublished paper, 1988. Saint writes 'This vision fitted in well with Johnson-Marshall's philosophy of architecture, which was that buildings should be simple in concept, untrammelled by pretentious design theories of architectural personality, "user friendly", informal, geared to youth, educational and flexible.' For the sequence of design ideas see letter and attached notes from Roger (Lord) Cunliffe to Andrew Saint, 10 May 1988, in English Heritage file 'Commonwealth Institute, Holland Park, Kensington and Chelsea'.

59. Interview with Peter Newnham, 24 April 1999. I owe this idea also to Andrew Saint.

60. For examples of the use of hyperbolic paraboloids and other exotic roof shapes at this time see *Architects' Journal*, 134, 11 October and 8 November 1961, pp. 603–8, 887–92.

61. *Commonwealth Institute: A Handbook*, 1965, p. 16.

62. Letter from Cunliffe to Saint.
63. That this was the approved route and desired mode of perception is made clear in several contemporary accounts: see Bradley, 1961; M. Brawne, 'Commonwealth Institute, South Kensington', *Architectural Review*, 133, April 1963, pp. 260–6.
64. *Commonwealth Institute: A Handbook*, 1965, p. 26.
65. In more recent years some of these statues have been moved to the entrance passage where they are clearly intended to connote a memory of the empire as the historic past.
66. 'That stellar concave spreading overhead, softly absorbed into me, rising so free interminably high, striking east, west, north, south – and I, though but a point in the centre below, embodying all': Walt Whitman quoted in W. R. Lethaby, *Architecture, Mysticism and Myth*, Macmillan, 1892, p. 71.
67. *Country Life*, 27 April 1951, p. 1272. James Gardner, the designer of these displays, was also one of the chief designers for the Festival of Britain.
68. R. Barthes, *Mythologies*, 1973, p. 100.
69. Ibid.
70. S. Zizek, 'Multiculturalism, or, the Cultural Logic of Multinational Capitalism', *New Left Review*, 225, September/October 1997, p. 44. Zizek's argument at this point is that contemporary or post-colonial multiculturalism is 'the form of appearance of its opposite, of the massive presence of capitalism as *universal* world system': ibid., p. 46.
71. H. Bhabha, *The Location of Culture*, 1994, p. 245.
72. Ibid., p. 243.

Chapter 6

1. PRAAD RG 3/1/60.
2. K. A. Appiah, *In My Father's House*, 1992, p. 242.
3. D. Austin, 'The British Point of No Return?', in P. Gifford and W. R. Louis, *The Transfer of Power in Africa*, 1982, p. 231. See also C. L. R. James, *Nkrumah and the Ghana Revolution*, 1977, pp. 53–60, 157.
4. On decolonization in Ghana see D. Austin, *Politics in Ghana 1946–1960*, 1966; D. Apter, *Ghana in Transition*, 1972; B. Lapping, *End of Empire*, 1985. On Nkrumah's attitude to traditional leaders see R. Rathbone, *Nkrumah and the Chiefs*, 1999.
5. On the nineteenth-century background to this, including the alienation of Africans from their homelands following training in the West, see B. Davidson, *The Black Man's Burden*, 1992, pp. 41–7.
6. For engineering training see C. K. Graham, *The History of Education in Ghana*, 1976, p. 95.
7. *Annual Report of the Public Works Department for the Year 1956–7*, 1958, Appendix A 3. British dominance within this category seems to have receded by the early 1960s: Correspondence with Hannah Schreckenbach, 2 August 2000. For Africanization of British businesses in Ghana see J. F. Milburn, *British Business and Ghanaian Independence*, 1977. For Nkrumah's views on Africanization see K. Nkrumah, *The Autobiography of Kwame Nkrumah*, 1957, pp. 147–51.
8. *Annual Report of the Public Works Department for the Year 1957–8*, 1959, Appendix A 3.
9. 'A Short History of the GIA', *Ghana Architect*, 1, January–June 1993, p. 6.
10. K. Nkrumah, *Consciencism*, 1964, pp. 2–4.
11. Interview with John Owusu-Addo, 20 April 2000; see also Appiah, 1992, pp. 9, 92.
12. G. Pitcher, *The Knot of Wisdom*, 1976, p. 5.
13. W. E. Duncanson, *A Personal Account of the Early Days of Kumasi College of Technology*, 1978, pp. 28–9. The Building Research Unit was established in 1959: see 'Research', *Interbuild*, 7–8, December 1961, pp. 16–20.
14. Ibid., p. 17.
15. Ibid., p. 20.
16. Correspondence with Hannah Schreckenbach, 2 August 2000.
17. G. Bing, *Reap the Whirlwind*, 1968, p. 353.
18. S. L. Kasfir, *Contemporary African Art*, 1999, p. 134.
19. Pitcher, 1976, p. 22.
20. Interview with John Owusu-Addo, 20 April 2000; Michael Lloyd, 'Design Education in the Third World', *Habitat International*, 7, 1983, pp. 367–75; J. Lloyd, 'Intentions' and L. Christians, 'Teaching History', both in *Arena*, 82, July–August 1966, pp. 40, 56.
21. Michael Lloyd, 1983, quoting Buckminster Fuller's comment on a visit to Kumasi, p. 375.
22. See, for instance, Otto Koenigsberger's salute to Jane Drew in S. Flower, J. Macfarlane and R. Plant, eds, *Jane Drew Architect*, 1986, p. 48.
23. M. Fry, *Art in a Machine Age*, 1969, p. 141; Flower et al., eds, 1986, p. 65.
24. G. Wright, 'The Ambiguous Modernisms of African Cities', in O. Enwezor, ed., *The Short Century*, 2001, p. 230. Although Anthony D. King has found usage dating back to 1869, the consistent use of the term 'tropical architecture' is a modernist phenomenon: A. D. King, *Urbanism, Colonialism, and the World Economy*, 1990, p. 61.
25. A. D. King, 1990. This characterization of the users for 'tropical architecture' seems unduly narrow – certainly many of Fry and Drew's buildings were to be used by the new African middle-class elites, and in addition there was much bread-and-butter work for villages.

26. Here my understanding differs from King who sees 'tropical architecture' as a colonial institution that was 'present in neither the metropolitan, indigenous, nor "intervening" society': ibid., p. 34.
27. A. Foyle, ed., *Conference on Tropical Architecture 1953*, 1954.
28. Interview with Lim Chong Keat, 14 October 2000.
29. This account of the conference is reliant on P. I. Wakely, 'The Development of a School', *Habitat International*, 7:5/6, 1983, pp. 337–46.
30. 'Department of Tropical Studies', *Architectural Association Journal*, 78, April 1963, pp. 303–7.
31. On these schools see A. Saint, *Towards a Social Architecture*, 1987, Chapter 6. For a related critique of this same project at the Department of Tropical Studies see P. Oliver, 'Perfected Needs', *Habitat International*, 7:5/6, 1983, pp. 377–9.
32. See, for instance, F. D. Lugard, *The Dual Mandate in British Tropical Africa*, 1922.
33. M. Fry and J. Drew, *Tropical Architecture in the Humid Zone*, 1956, p. 19.
34. Later Fry even argued that climate determined the habits, customs and even religions of peoples in this zone: M. Fry, 'West Africa', in J. M. Richards, ed., *New Buildings in the Commonwealth*, 1961, p. 104.
35. For an excellent discussion of the ramifications of 'design' for modernism see A. Forty, *Words and Buildings*, 2000, pp. 136–41.
36. Fry and Drew, 1956, pp. 26, 24.
37. Ibid., p. 53.
38. Fry, 1961, p. 104. For an attempt to apply Fry and Drew's book to Malaya see J. Posener, 'Architecture in Malaysia', *PETA*, 2:1, July 1957, pp. 1–9.
39. Fry and Drew, 1956, p. 25.
40. Ibid., p. 166.
41. Ibid.
42. Ibid., p. 72.
43. Fry, 1961, p. 103.
44. Pertinently, Fry used the term 'colonial building' in 1944 when calling for the involvement of the Building Research Station in the Gold Coast as an ideal location for its study: PRAAD RG 5/1/3. The term does not appear to have been used by him after this to refer to the contemporary architecture with which he was involved. A little later, in 1950, the BRS began to publish its regular *Colonial Building Notes*, to be renamed from 1958 *Overseas Building Notes*.
45. A comparison might be made with contemporary modernization theory which, reinforcing a bipolar modality, focused on the transformation of traditional societies into modern ones: see A. G. Hopkins, 'Development and the Utopian Ideal', *OHBE*, vol. 5.
46. A. Boahen, *Ghana*, 1975, pp. 152, 156.
47. Fry and Drew, 1956, p. 190.
48. Ibid., p. 189.
49. Ibid., p. 188; M. Fry, 'African Experiment: Building for an Educational Programme in the Gold Coast', *Architectural Review*, 113, May 1953, pp. 299–300.
50. Fry and Drew, 1956, p. 193.
51. See M. Fry, 'The Architecture of Education', in J. B. Drew, ed., *Architects' Year Book*, 1945, pp. 107–19.
52. J. B. Drew, 'Recent Work By Fry, Drew, Drake & Partners and Fry, Drew, Drake & Lasdun in West Africa', *Architectural Design*, 25, May 1955, p. 139.
53. Fry, 1969, p. 8.
54. See, for instance, H. N. A. Wellington, 'The Use of Adinkra Symbolism in Architecture', *The Ghana Architect*, 1:2, January–December 1995, p. 4; and G. W. Intsiful, 'Paying Attention to Tradition', *BASINnews*, 12, August 1996, pp. 5–7.
55. Joseph Rykwert writing in 1968, quoted in S. Muthesius, *The Postwar University*, 2000, p. 251.
56. F. Agbodeka, *A History of the University of Ghana*, 1998, p. 8.
57. Ibid., pp. 4–5, 20–21.
58. I can only attribute the lack of publicity given to the architecture of University College, Ghana to its apparently *retardataire* design. Kultermann dismisses it as 'uninteresting from an architectural point of view ... [it] can be regarded as a romantic failure in the grand manner': U. Kultermann, *New Architecture in Africa*, 1963, p. 17.
59. S. Hitchins, ed., *Fry Drew Knight Creamer – Architecture*, 1978, p. 62.
60. Kultermann, 1963, p. 16.
61. Duncanson, 1978, p. 10. Duncanson refers to suspicions by the Council that they were being taken for a ride by the architects – 'in the prevailing atmosphere engendered by approaching Independence, it was unfortunate that UK consultants should be seen in such a bad light': ibid., p. 12.
62. See Kultermann, 1963, p. 103; *Architectural Design*, 24, January 1954, p. 4; Richards, ed., 1961, p. 114.
63. For this central area see the *West African Builder and Architect*, 4:3, May/June 1964, pp. 44–51; and ibid., 8:1, January–February 1968, pp. 17–22.
64. Owusu-Addo was trained at Regent Street Polytechnic from 1952 to 1957, he then worked for Kenneth Scott in London and moved to Scott's Accra office in 1960: Interview with John Owusu-Addo, 20 April 2000.
65. Fry and Drew, 1956, p. 202.
66. Ibid.
67. For a vivid first-hand account of such attitudes at University College, Ghana in the 1960s see M. Angelou, *All God's Children Need Travelling Shoes*, 1987.

68. E. Ashby, *Universities: British, Indian, African*, 1966, pp. 245–6.
69. For the University of Ghana, renamed in 1961, see ibid., pp. 327–32; for UST see Pitcher, 1976, pp. 53–5. See also B. Davidson, *Black Star*, 1989, pp. 162–3.
70. See Muthesius, 2000, pp. 174–86.
71. D. K. Fieldhouse, *Merchant Capital and Economic Decolonization*, 1994, pp. 321, 326, 416–17. On the Community Centre see *Architect and Building News*, 197, 24 February 1950, pp. 185–6.
72. Kultermann, 1963, p. 16.
73. H. Schreckenbach, 'Ghana: Alte und neue Wohnbauformen', *Baumeister*, April 1966, pp. 407–12.
74. *Ghana Today*, 1:15, 18 September 1957, p. 7. See also *Architectural Record*, 121, June 1957, pp. 198–201. For US State Department policy in embassy architecture at this time see J. C. Loeffler, 'Building Abroad/Borrowing Identity', in T. Cruz and A. Boddington, eds, *Architecture of the Borderlands*, 1999.
75. Responsibility for the design was handed to Lasdun because of Fry and Drew's commitment to work at Chandigarh: personal communication with Sir Denys Lasdun, 19 January 2000.
76. See Ministry of Housing, *Accra – A plan for the town*, 1958.
77. Ornament was planned, however. One drawing is marked 'Walls and open ends of jags to be partially ornamented with artificial panels and casts and grilles respectively (from moulds now being made in Ashanti and Kwahu)': Ghana Museums and Monuments Commission, PRO BF 57/11 P&D.
78. The development of the design can be followed in drawings kept by the Ghana Museums and Monuments Commission, especially PRO BF 57/10 P&D and PRO BF 57/11 P&D, which show that Lasdun's original design was considerably modified by architects in the PWD. Development was phased, with an extension housing offices and storage space designed in 1958: PRO BF 57/22 P&D.
79. *Architectural Review*, 121, June 1957, p. 442.
80. For recent approaches see R. G. Fox, ed., *Nationalist Ideologies and the Production of National Cultures*, 1990; and some of the articles in P. G. Stone and B. L. Molyneux, eds, *The Presented Past*, 1994; F. E. S. Kaplan, *Museums and the Making of Ourselves*, 1995; A. Gaugue, *Les états Africains et leurs Musées*, 1997; T. Barringer and T. Flynn, eds, *Colonialism and the Object*, 1998.
81. A. W. Lawrence and R. Merrifield, 'The National Museum of Ghana', *Museums Journal*, 57, July 1957, p. 88.
82. B. Anderson, *Imagined Communities*, 1991, p. 164.
83. I have explored the development of the collections and displays in 'Nation-Building, Collecting and the Politics of Display: The National Museum, Ghana', *Journal of the History of Collecting*, November 2001.
84. See Anderson, 1991.
85. P. Chatterjee, *Nationalist Thought and the Colonial World*, 1986, p. 30.
86. E. Renan, 'What is a nation?', in Homi Bhabha, ed., *Nation and Narration*, 1990, p. 19. On Anderson and Renan's contrasting approaches to the place of memory in nationalism see I. Baucom, *Out of Place*, 1999, pp. 52–4.
87. This argument is developed in C. Duncan, *Civilising Rituals*, 1995, Chapter 1.
88. For an interesting parallel argument about the new Nigerian city of Abuja see Namdi Elleh, 'Architecture and Nationalism in Africa, 1945–1994', in O. Enwezor, ed., *The Short Century*, 2001, pp. 239–41.
89. 'The nation appears progressive … insofar as it poses the commonality of a potential community. Part of the effects of the nation in subordinated countries has been the unification of diverse populations, breaking down religious, ethnic, cultural and linguistic barriers': M. Hardt and A. Negri, *Empire*, 2000, pp. 106–7.
90. *Architectural Design*, 28, February 1958, p. 78.
91. For a curator's critique of these spaces see Lawrence and Merrifield, 1957, p. 91.
92. This question would seem to suggest a comparative study using, for example, traditional housing or squatter settlement in Ghana.
93. A. Boahen, *Ghana* 1975, pp. 173–8. For a parallel account of modernism under Nkrumah see J. B. Hess, 'Imagining Architecture', *Africa Today*, 47:2, Spring 2000, pp. 35–60. Hess identifies modernism solely with Nkrumah's administration, ignoring its links to the colonial project of 'welfare and development'.
94. Ministry of Housing, 1958, p. 4.
95. T. P. Omari, *Kwame Nkrumah*, 1970, pp. 106, 127.
96. PRAAD RG 5/1/237.
97. N. Elleh, *African Architecture*, 1997, p. 295.
98. PRAAD RG 5/1/98. Nkrumah also admired Mazzini: see Nkrumah, 1964, pp. 56–7. Elleh has suggested that the Arch manifests a post-colonial inferiority complex: Elleh, 2001, p. 237.
99. PRAAD RG 5/1/382.
100. PRAAD CSO 20/12/20; Ministry of Housing, 1958, p. 1; M. Fry, 'Town Planning in West Africa', in J. Drew, ed., *Architects Year Book: 2*, 1947.
101. L. Tiger, 'Bureaucracy and Urban Symbol Systems', in H. Miner, ed., *The City in Modern Africa*, 1967, p. 187. Tiger, however, seems unaware of the fact that the area had been zoned for administrative purposes by the colonial government just after the war.
102. F. Fanon, *The Wretched of the Earth*, 1968, pp. 164–6, 225.

Chapter 7

1. Although he does not discuss Malaysia, L. Vale's *Architecture, Power and National Identity*, 1992, especially Part Two, offers parallel discussion for many of the issues raised in this chapter.
2. From 1931 the Institute of Architects of Malaya covered Singapore and British Malaya. For this period see A. Milner, *The Invention of Politics in Colonial Malaya*, 1995, and T. N. Harper, *The End of Empire and the Making of Malaya*, 1999.
3. For good coverage of these traditions see Chen Voon Fee, ed., *The Encyclopedia of Malaysia – Volume 5 Architecture*, 1998.
4. Of 70 architects registered in Georgetown and Singapore following the 1926 Architects' Ordinance, 39 were European and 31 were Asian. Most of the latter were informally trained, self-taught or worked their way up as draughtsmen: Jon Sun Hock Lim, 'Colonial Architecture and Architects of Georgetown (Penang) and Singapore, Between 1786 and 1942', unpublished Ph.D. thesis, National University of Singapore, 1990, p. 174. See also Seow En Jin, 'Architectural Development in Singapore', unpublished Ph.D. thesis, University of Melbourne, 1974.
5. On shortages of trained architects see Federation of Malaya, *Annual of the PWD for the Year 1954*, 1956, p. 8. Some of this need was due to the Emergency, but by 1954 there was a boom in rubber prices and the building industry took off.
6. Raymond Honey, letter to the author, 20 September 1999.
7. On Indo-Saracenic see T. R. Metcalf, *An Imperial Vision*, 1989.
8. 'There is variety a plenty … fully representative of the East and West and ancient and modern', ran the caption beside pictures drawing on this contrast in *The Federation of Malaya*, 1955. The contrast is also made in *Straits Times Annual*, 1958, p. 6.
9. For a development of Pierre Nora's concept of *lieux de mémoire* in a post-colonial architectural context see Z. Celik, 'Colonial/Postcolonial Intersections: *Lieux de mémoire* in Algiers', *Third Text*, 49, Winter 1999–2000, pp. 63–72. On cricket fields in the empire as *lieux de mémoire* see I. Baucom, *Out of Place*, 1999, pp. 18–19.
10. See I. Shipley, 'The Parliament Building of Malaysia', *Journal of the Commonwealth Parliamentary Association*, 2 April 1965, p. 177. For the opening ceremony speech, lauding the building as symbolizing 'our highest ideals of democracy', see *Malaya*, December 1963, pp. 11–16.
11. Shipley has written that 'the shapes of the external units are a nod in the direction of the early colonial buildings in Kuala Lumpur': Ivor Shipley, letter to the author, 27 November 2000. This seems to be a rather far-fetched link to the pinnacled rooflines of some of the Indo-Saracenic buildings in the city.
12. Shipley, 1965, p. 178.
13. A. Burgess, *Little Wilson and Big God* (first published 1987), 1988, p. 416. The idea was reworked in his novel *Beds in the East* (1959), where the symphony was given to a young Chinese composer.
14. Quoted in S. D. R. Singam, 'Sir Gerald Templer's work for a Cultural Revival in Malaya', *Malayan Historical Journal*, 2, 1955, p. 131.
15. G. Templer, 'Building a Malayan Nation', *Straits Times Annual*, 1954, p. 23.
16. J. Cloake, *Templer*, 1985, p. 285.
17. Harper, 1999, p. 276. For a typical example see V. Purcell, *Malaysia*, 1965.
18. Anthony Milner has pointed out that there was no word for politics in Malay before the twentieth century, and that politics itself was a new custom or discourse: Milner, 1995, p. 2.
19. Singam, 1955, p. 135.
20. Ibid.
21. Undated newspaper cuttings, reproduced in Lim Chong Keat, 'Architecture in Malaya', University of Manchester B. Arch. thesis, 1954. According to some sources Templer recanted quickly on this demand: Ivor Shipley, letter to the author, 27 November 2000. One architect who was at the meeting commented, 'Some people went away and produced curved roofs, but our general line was "Well, you can't really tell architects what to do"': Interview with Raymond Honey, 23 October 1999.
22. Harper, 1999, p. 311.
23. Ibid.
24. G. C. Spivak, *A Critique of Postcolonial Reason*, 1999, p. 239.
25. Harper, 1999, p. 275.
26. *PETA*, 1:1, June 1955, pp. 2–8; 1:2, November 1955, pp. 2–16; 2:2, March 1958, pp. 1–14.
27. *Malayan Branch of the Royal Asiatic Society*, 29:3, August 1956.
28. *Federation Museums Journal*, 7, 1962, pp. 86–93.
29. See, however, 'Chinese Building in Malaya', *PETA*, 1:3, June 1956. The relevance of Chinese architecture to Malaysian national identity is still an unresolved and officially veiled issue: see R. Holod and H.-U. Khan, *The Mosque and the Modern World*, 1997, p. 259, n. 25.
30. 'It may seem paradoxical, but it is largely true that the local British architect cares more about a tropical architecture – and certainly no less about a "Malayan" one – than his Asian colleague': Julius Posener, 'Malaya', in J. M. Richards, ed., *New Buildings in the Commonwealth*, 1961, p. 194. Two of the most important young Malayan architects at the time Posener wrote this had already produced unpublished studies of Malayan architecture: see Baharuddin Bin Abu Kassim, 'Malayan Timber Houses in Malaya', University of Manchester B. Arch. thesis essay, 1956, and Lim Chong Keat, 'Architecture in Malaya', University of Manchester B. Arch. thesis essay, 1954.
31. *Progress*, August 1960, p. 44.

32. Posener, 'Malaya', in Richards (ed.) 1961, p. 193.
33. *PETA*, 2:1, July 1957, p. 7.
34. *Progress*, August 1960, p. 43.
35. For the guidebooks see A. J. G. Papineau, *Guide to Kuala Lumpur*, 1962, pp. 6, 49; *Guide to Kuala Lumpur and Facts of Malaya*, 1962, p. 53.
36. B. Anderson, *Imagined Communities*, 1991, p. 181.
37. M. Sheppard, *Taman Budiman*, 1979, pp. 194–5.
38. Ivor Shipley, letter to the author, 24 January 2000. No trace of the design has survived.
39. Sheppard, 1979, pp. 226–7.
40. Ibid., p. 227.
41. Ibid. It should be noted that the Balai Besar, although it has a Malay roof and eaves, was actually built in 1904 out of a mixture of European and South-east Asian features.
42. Shahrum bin Yub, 'The National Museum of Malaysia', *Arts of Asia*, September–October 1982, p. 69.
43. Ho Kok Hoe, 'Ancient Skills and Traditional for the National Museum', *Federation Museums Journal*, 7, 1962, p. 94.
44. On the logical impossibility of the 'infralocal' or vernacular revival see Vale, 1992, pp. 272–3.
45. Anderson, 1991, p. xiv.
46. See *Architecture Malaysia*, January/February 1999, pp. 10–17.
47. The phrases are from Paul Ricoeur's classic essay 'Universal Civilisation and National Cultures', in *History and Truth*, 1965. Kenneth Frampton made much use of Ricoeur's argument in his influential essay 'Towards a Critical Regionalism: Six Points for an Architecture of Resistance', in H. Foster, ed., *Postmodern Culture*, 1985. It seems odd, though, and perhaps another example of modernism's blindness to colonialism, that Frampton fails to comment on the explicit situating of Ricoeur's argument in the context of the anti-colonial liberation and independence of his time. On typological moments and redemption in the context of nationalism see also Baucom, 1999, pp. 52–5.
48. This argument and its quotations come from Frederic Jameson's essay 'The Antinomies of Postmodernity', in M. Hardt and K. Weeks, eds, *The Jameson Reader*, 2000, p. 245.
49. Harper, 1999, p. 282.
50. See 'Architectural Training at the Kuala Lumpur Technical College', *PETA*, 4:2, June 1963, pp. 12–13; Jabatan Senibina, 'The Development of Architectural Education in U.T.M.', *Majallah Akitek*, 4:75, December 1975, pp. 16–21.
51. Interestingly, in the light of his work on Komtar, discussed later in this chapter, Lim Chong Keat's thesis was on 'A Cultural Centre for Penang'. Hisham Albakri (Sheffield University) and Baharuddin Bin Abu Kassim (Manchester), who both later became prominent architects in Malaya, were also studying in Britain at this time.
52. Interview with Chen Voon Fee, 10 October 2000; Interview with Lim Chong Keat, 14 October 2000.
53. 'We were very clear of our role as Malayans ... We became aware that we had to do something relevant in the context of the country': Interview with Chen Voon Fee, 10 October 2000.
54. A. Foyle, ed., *Conference on Tropical Architecture 1953*, 1954, p. 77. The comment is wrongly attributed to William Lim: Correspondence with Lim Chong Keat, 2 August 2001.
55. Lim Chong Keat, 'Cultural Development', paper delivered at the Conference of Commonwealth and Overseas Architectural Societies, 1963: RIBA Archive 12.2.8, Box 1, p. 9.
56. Interview with Chen Voon Fee, 10 October 2000.
57. Ibid.
58. 'Interview – Lim Chong Keat – The Designer', *Majallah Akitek*, 2:78, June 1978, pp. 112–18.
59. Hisham Albakri's attitude was completely different. For him studying in England was inevitably to learn place-specific knowledge, because architecture is always place specific: Interview with Hisham Albakri, 12 October 2000.
60. B. W. C. Thai, 'Architecture in Singapore: A Sketch', in *Contemporary Singapore Architecture*, 1998, p. 255. The phrase 'national architectural professionals' is from 'Interview – Lim Chong Keat – The Designer', p. 12.
61. 'A Conversation with Chen Voon Fee', *Majallah Akitek*, 4:78, December 1978, p. 12. This was a period when expatriate firms began to change their names to be more acceptable to clients.
62. Lim Chong Keat has called this a 'natural and unselfconscious' connection. He himself had attended some 300 concerts there during his stay in Britain: Correspondence with Lim Chong Keat, 2 August 2001. For the competition designs see *RUMAH – Journal of the Singapore Institute of Architects*, 5 October 1962, pp. 9–17.
63. B. Yeoh, 'Unravelling "History in Place"', in *Contemporary Singapore Architecture*, 1998, pp. 259–60. There was also a housing drive launched in 1959 under the Singapore Improvement Trust, as part of the Five-Year programme of Lee Kuan Yew's People's Action Party.
64. For Mahathir's cultural politics see Z. Sardar, *The Consumption of Kuala Lumpur*, 2000, especially pp. 194–5, 226–36.
65. *Komtar Kompleks Tun Abdul Razak Pulau Pinang*, 1985 (?), unpaginated.
66. Interview with Lim Chong Keat, 14 October 2000.
67. *Asian Building and Construction*, September 1975, p. 13.
68. R. Banham, *Megastructure*, 1976, p. 8.
69. As Banham recognized, directly in relation to the prehistory of megastructures, such complexes had been justified in the strand of the modernism-and-monumentality debate promulgated by Sigfried Giedion: Banham, 1976, pp. 34–5.

70. Vale, 1992, p. 272.
71. M. Pawley, *Buckminster Fuller*, 1990, pp. 124–5, 132.
72. Robert Marks notes 'A signal feature of the dome's "informational" value, at Kabul, was the fact that the dome attracted far greater attention than all the other exhibits including the Russian and the China Communist': R. Marks, *The Dymaxion World of Buckminster Fuller*, 1960, p. 59.
73. Ibid.
74. *Geodesic Dome – Kompleks Tun Abdul Razak Pulau Pinang*, 1985 (?), p. 3.
75. For an expression of these fears in the Singapore context see Alfred H. K. Wong, 'A Brief Review of Our Recent Architectural History', in *Contemporary Singapore Architecture*, 1998, p. 252.

Conclusion

1. In adopting the term 'diaspora' of the Muslim populations in Britain I recognize that the term now extends beyond the sense of national dispersal to encompass the experiences of immigration and displacement amongst communities of refugees, exiles and expatriates, even the waxing and waning of diasporism as allegiances change. To use this term is to indicate shared experiences of separation and transnationalism (what James Clifford calls 'multi-locale attachments') *across* the highly differentiated elements of the Muslim population in Britain. On this and other issues see J. Clifford, 'Diasporas', *Cultural Anthropology*, 9, 1994, pp. 302–38. Clifford insists on the 'routing of diaspora discourses in specific maps/histories' rather than the use of the diaspora as a master trope for the displacements of modern identities. See also A. Brah, *Cartographies of Diaspora*, 1996.
2. On this see J. M. Jacobs, *Edge of Empire*, 1996, Chapter 3.
3. Clifford, 1994, p. 308.
4. For a fuller discussion of these issues see my article 'The Mosque and the Metropolis', in M. Roberts and J. Beaulieu, eds, *Orientalism and its Interlocuters*, 2002.
5. The best-known example of a mosque re-using older religious space in Britain is the mosque in Brick Lane in the East End of London. This took over a building which was originally erected in the late seventeenth century as a Huguenot church, used as a Methodist chapel in the nineteenth century, then converted into a Jewish synagogue in 1898, and from 1976 taken over by the local Bangladeshi community: see Jacobs, 1996, Chapter 4; J. Eade, 'Nationalism, Community and the Islamization of Space in London', in B. Metcalf, ed., *Making Muslim Space in North America and Europe*, 1996, pp. 218–23. For 'Muslim space' see Barbara Metcalf's introduction to that volume and my critique of it in 'The Mosque and the Metropolis' 2002. Of the 600 or so mosques serving some one-and-a-half million Muslims in Britain only about 150 are purpose-built. Of the rest many have adapted residences for religious purposes, whilst others have taken over church buildings, cinemas or factories: *The Guardian*, 20 March 1996. However, the numbers may be difficult to estimate accurately: see R. Home, 'Building a Mosque in Stepney', *Rising East*, 1, 1997, p. 66.
6. For its early history see I. Serageldin and J. Steele, eds, *Architecture of the Contemporary Mosque*, 1996, pp. 165–6; R. Holod and H.-U. Khan, *The Mosque and the Modern World*, 1997, p. 230; and F. Gailani, *The Mosques of London*, 1999, pp. 38–40.
7. See *Architects' Journal*, 150, 22 October 1969, pp. 988–90.
8. Ibid., p. 990.
9. P. Hammond, ed., *Towards a Church Architecture*, 1962, p. 11. See also P. Hammond, *Liturgy and Architecture*, 1960. In the Anglican Church this was simply known as the 'Liturgical Movement'.
10. R. Banham, 'A Modern Church on Liturgical Principles', *Architectural Review*, 128, December 1960, p. 400.
11. *Architects' Journal*, 150, 22 October 1969, p. 990.
12. Ibid., p. 989.
13. See, for instance, N. Pevsner, *The Englishness of English Art*, 1956.
14. Complementing the existing architecture, a third wing of offices has been recently added to close the mosque's forecourt.
15. *Architectural Review*, 162, September 1977, p. 145.
16. *Home and Garden*, 32, September 1977, p. 70; *Building*, 233, 15 July 1977, p. 48.
17. *Architects' Journal*, 166, 10 August 1977, p. 269.
18. *Building*, 233, 15 July 1977, p. 48.
19. See *Architects' Journal*, 162, 13 August 1975, pp. 326–30; *Journal of the Royal Institute of British Architects*, 83, June 1976, pp. 14–17; *Building Design*, 354, 8 July 1977, pp. 8–9. The building was even reviewed in *Middle East Construction*, 2, May 1977, pp. 55–9.
20. A very similar set of circumstances seems to have affected the building of the Oxford Centre for Islamic Studies, which has been opposed by Oxford Colleges and conservation groups on the grounds that its dome and tower would have a 'serious impact' on the town's historic skyline: *The Guardian*, 14 August 1999, p. 8.
21. *Architects' Journal*, 166, 10 August 1977, p. 266.
22. *Times Higher Education Supplement*, 9 January 1998. Gibberd's *mihrab* was replaced in the 1980s by the present brass *mihrab*.
23. *Architects' Journal*, 166, 10 August 1977, p. 259.
24. Ibid., p. 266.

25. The phrase is from J. Clifford, 'Travelling Cultures', in L. Grossberg, C. Nelson and P. Treichler, eds, *Cultural Studies*, 1992.
26. J. Clifford, 1994, p. 307.
27. H. Bhabha, *The Location of Culture*, 1994, p. 251.

Select bibliography

Abbas, Ackbar, *Hong Kong – Culture and the Politics of Disappearance*, Minneapolis: University of Minnesota Press, 1997.

Abercrombie, Patrick, 'The Planning of the British Empire Exhibition – A Symbolical Lay-Out', *The Architects' Journal*, 59, 28 May 1924, pp. 903–5.

Abu-Lughod, Janet, *Rabat: Urban Apartheid in Morocco*, Princeton: Princeton University Press, 1980.

——, 'Culture, "modes of production", and the changing nature of cities in the Arab world', in J. A. Agnew, John Mercer and David E. Sopher, eds, *The City in Cultural Context*, Boston: Allen and Unwin, 1984.

Agbodeka, Francis, *A History of the University of Ghana – Half a Century of Higher Education (1948–1998)*, Accra: Woeli, 1998.

AlSayyad, Nezar, ed., *Forms of Dominance: On the Architecture and Urbanism of the Colonial Enterprise*, Aldershot: Avebury, 1992.

——, ed., *Hybrid Urbanism: On the Identity Discourse and the Built Environment*, Westport, Conn. and London: Praeger, 2001.

Anderson, Benedict, *Imagined Communities*, London and New York: Verso, 1991.

Angelou, Maya, *All God's Children Need Travelling Shoes*, London: Virago, 1987.

Appiah, Kwame Anthony, *In My Father's House: Africa in the Philosophy of Culture*, London: Methuen, 1992.

Apter, David, *Ghana in Transition*, Princeton: Princeton University Press, 1972.

Araeen, Rasheed, 'A New Beginning – Beyond Postcolonial Cultural Theory and Identity Politics', *Third Text*, 50, Spring 2000.

Architecture and Urbanism – Norman Foster: 1964–1987, May 1988.

Armah, A. K., *The Beautyful Ones Are Not Yet Born*, London, Ibadan, Nairobi: Heinemann, 1969.

Arts Council of Great Britain, *Le Corbusier – Architect of the Century*, London: Arts Council, 1987.

Ashby, Eric, *Universities: British, Indian, African – A Study in the Ecology of Higher Education*, London: Weidenfeld and Nicolson, 1966.

Atkinson, G. A., 'British Architects in the Tropics', *Architectural Association Journal*, 59, June 1953, pp. 7–20.

Austin, Dennis, *Politics in Ghana 1946–1960*, Oxford: Oxford University Press, 1966.

Baird, George, *The Space of Appearance*, Cambridge, Mass. and London: MIT, 1995.

Bamberg, J. H., *The History of the British Petroleum Company, Volume 2, The Anglo-Iranian Years, 1928–1954*, Cambridge: Cambridge University Press, 1994.

Banham, Mary and Hillier, Bevis, eds, *A Tonic to the Nation: The Festival of Britain 1951*, London: Thames and Hudson, 1976.

Banham, Reyner, 'A Modern Church on Liturgical Principles', *Architectural Review*, 128, December 1960, p. 400.

——, 'Revenge of the Picturesque: English Architectural Polemics, 1945–1965', in John Summerson, ed., *Concerning Architecture*, London: Penguin, 1968.

——, *Megastructure: Urban Futures of the Recent Past*, London: Thames and Hudson, 1976.

Barman, Christian, *The Man Who Built London Transport: A Biography of Frank Pick*, Newton Abbot: David and Charles, 1979.

Barringer, Tim and Flynn, Tom, eds, *Colonialism and the Object: Empire, Material Culture and the Museum*, London: Routledge, 1998.

Barthes, Roland, *Mythologies*, St Albans: Paladin, 1973.

Batley, Claude, 'Schools of Architecture: 1 – The School of Architecture at the Government School of Art, Bombay', *RIBAJ*, 37, 21 June 1930, pp. 592–7.

Baucom, Ian, *Out of Place: Englishness, Empire and the Location of Identity*, Princeton: Princeton University Press, 1999.

Beloff, Max, *Imperial Sunset, Volume One: Britain's Liberal Empire 1897–1921*, Basingstoke: Macmillan, 1987.

Bennett, Tony, *The Birth of the Museum*, London: Routledge, 1995.

Berman, Marshall, *All That is Solid Melts into Air: The Experience of Modernity*, London: Verso, 1983.

Bhabha, Homi, *The Location of Culture*, London and New York: Routledge, 1994.

Billimoria, H. J., 'The Origin and Growth of the Indian Institute of Architects', *Journal of the Indian Institute of Architects*, January 1942, pp. 203–4.

Bing, Geoffrey, *Reap the Whirlwind: An Account of Kwame Nkrumah's Ghana From 1950 to 1966*, London: MacGibbon and Kee, 1968.

Black, Iain S., 'Rebuilding "The Heart of Empire": Bank Headquarters in the City of London, 1919–1939', *Art History*, 22:4, November, 1999.

Boahen, Adu, *Ghana: Evolution and Change in the Nineteenth and Twentieth Centuries*, London: Longman, 1975.

Booth, Howard J. and Rigby, Nigel, eds, *Modernism and Empire*, Manchester: Manchester University Press, 2000.

Bradley, Kenneth, 'The Imperial Institute', *Journal of the Royal Society of Arts*, 1957, pp. 879–80.

——, 'The New Commonwealth Institute', *Commonwealth Journal*, November–December 1961, pp. 1–5.

Brah, A., *Cartographies of Diaspora: Contesting Identities*, London: Routledge, 1996.

Brawne, Michael, 'Commonwealth Institute, South Kensington', *Architectural Review*, 133, April 1963, pp. 260–6.

Brennan, Timothy, 'Cosmopolitan Vs International', *New Left Review*, 7 second series, January/February 2001, pp. 75–84.

Brett, Lionel, 'Detail on the South Bank', *Design*, 32, August 1951, pp. 3–7.

Budden, Lionel, *The Book of the Liverpool School of Architecture*, Liverpool and London: University Press and Hodder and Stoughton, 1932.

Burgess, Anthony, *Little Wilson and Big God* (first published 1987), Harmondsworth: Penguin, 1988.

Butler, A. S. G., *The Architecture of Edwin Lutyens*, London: Country Life, 3 vols, 1950.

Cain, P. J. and Hopkins, A. G., *British Imperialism: Crisis and Deconstruction, 1914–1990*, London and New York: Longman, 1993.

Cannadine, David, *Ornamentalism: How the British Saw Their Empire*, London: Penguin, 2001.

Castells, Manuel, 'Globalization, Flows and Identity: The New Challenges of Design', in William S. Saunders, ed., *Reflections on Architectural Practices in the Nineties*, New York: Princeton Architectural Press, 1996.

Celik, Zeynep, *Displaying the Orient: Architecture of Islam at Nineteenth-Century World's Fairs*, Berkeley and Los Angeles: University of California Press, 1992.

——, 'Colonial/Postcolonial Intersections: *Lieux de mémoire* in Algiers', *Third Text*, 49, Winter 1999–2000, pp. 63–72.

Cerdá, Ildefonso, *Teoría General de la urbanización*, 3 vols, Madrid, 1868–71.

Chatterjee, Partha, *Nationalist Thought and the Colonial World – A derivative discourse*, London: Zed Books, 1986.

Chen Voon Fee, ed., *The Encyclopedia of Malaysia – Volume 5 Architecture*, Singapore: Archipelago Press, 1998.

Cherry, Gordon E. and Penny, Leith, *Holford: A Study in Architecture, Planning and Civic Design*, London and New York: Mansell, 1986.

Christians, Lutz, 'Teaching History', *Arena*, 82, July–August 1966, p. 56.

Christopher, A. J., *The British Empire at its Zenith*, London: Croom Helm, 1988.

Clifford, James, 'Travelling Cultures', in L. Grossberg, C. Nelson and P. Treichler, eds, *Cultural Studies*, New York: Routledge, 1992.

——, 'Diasporas', *Cultural Anthropology*, 9, 1994, pp. 302–38.

Cloake, John, *Templer: Tiger of Malaya*, London: Harrap, 1985.

Cohn, Bernard, 'Representing Authority in Victorian India', in E. Hobsbawm and T. Ranger, eds, *The Invention of Tradition*, Cambridge: Cambridge University Press, 1983.

Collins, John, 'Lusaka: Urban Planning in a British Colony, 1931–64', in Gordon E. Cherry, ed., *Shaping an Urban World*, London: Mansell, 1980.

Colquhoun, Alan, 'Rationalism: A Philosophical Concept in Architecture', in *Modernity and the Classical Tradition: Architectural Essays 1980–1987*, Cambridge, Mass: MIT, 1989.

——, 'The Concept of Regionalism', in G. B. Nalbantoglu and C. T. Wong, eds, *Postcolonial Space(s)*, New York: Princeton Architectural Press, 1997.

Constantine, Stephen, *Buy and Build: The Advertising Posters of the Empire Marketing Board*, London: HMSO, 1986.

Contemporary Singapore Architecture, Singapore: Singapore Institute of Architects, 1998.

Correa, Charles, 'Chandigarh: The View from Benares', in H. Allen Brooks, ed., *Le Corbusier*, Princeton: Princeton University Press, 1987.

Cox, Ian, *The South Bank Exhibition – A Guide to the Story it Tells*, London: HMSO, 1951.

Crampsey, Bob, *The Empire Exhibition of 1938: The Last Durbar*, Edinburgh: Mainstream, 1988.

Crinson, Mark, *Empire Building: Orientalism and Victorian Architecture*, London: Routledge, 1996.

——, 'Abadan: Planning and architecture under the Anglo-Iranian Oil Company', *Planning Perspectives*, 12:3, July 1997, pp. 341–59.

——, 'Imperial Story-lands: Architecture and display at the Imperial and Commonwealth Institutes', *Art History*, 22:1, March 1999, pp. 99–123.

——, 'Nation-Building, Collecting and the Politics of Display: The National Museum, Ghana', *Journal of the History of Collecting*, November 2001, pp. 231–50.

——, 'The Mosque and the Metropolis', in Mary Roberts and Jill Beaulieu, eds, *Orientalism and its Interlocuters*, Durham, N. C.: Duke University Press, 2002.

Crinson, Mark and Lubbock, Jules, *Architecture – Art or Profession? 300 Years of Architectural Education in Britain*, Manchester: University of Manchester Press, 1994.

Cromer, Earl of, *Modern Egypt*, London: Macmillan, 1911.

Crook, J. Mordaunt, *The Rise of the Nouveaux Riches*, London: John Murray, 1999.

Curtis, William, *Modern Architecture Since 1900* (third edition), London: Phaidon, 1996.

Danby, Miles, 'Architectural Education in Africa and the Middle East', *Architectural Education*, 2, 1983, pp. 15–25.

Dannatt, Trevor, *Modern Architecture in Britain*, London: Batsford, 1959.

Davidson, Basil, *Black Star: A View of the Life and Times of Kwame Nkrumah*, Boulder, San Francisco and London: Westview, 1989.

——, *The Black Man's Burden: Africa and the Curse of the Nation-State*, Oxford: James Currey, 1992.

Drew, Jane B., 'Recent Work By Fry, Drew, Drake & Partners and Fry, Drew, Drake & Lasdun in West Africa', *Architectural Design*, 25, May 1955, p. 139.

Driver, Felix and Gilbert, David, 'Heart of Empire? Landscape, Space and Performance in Imperial London', *Environment and Planning D: Society and Space*, 16, 1998, pp. 11–28.

——, eds, *Imperial Cities: Landscape, Display and Identity*, Manchester: Manchester University Press, 1999.

Duncan, Carol, *Civilising Rituals: Inside Public Art Museums*, London: Routledge, 1995.

Duncanson, W. E., *A Personal Account of the Early Days of Kumasi College of Technology*, Kumasi: University Press, 1978.

Dupays, Paul, *Voyages autour du monde: Pavillons étrangers et pavillons coloniaux à l'exposition de 1937*, Paris: Henri Didier, 1938.

Eade, John, 'Nationalism, Community and the Islamization of Space in London', in Barbara Metcalf, ed., *Making Muslim Space in North America and Europe*, Berkeley, Los Angeles and London: University of California Press, 1996, pp. 218–23.

Eagleton, Terry, Jameson, Frederic and Said, Edward, *Nationalism, Colonialism and Literature*, Minneapolis: University of Minnesota Press, 1990.

Elleh, Nnamdi, 'Architecture and Nationalism in Africa, 1945–1994', in Okwui Enwezor, ed., *The Short Century: Independence and Liberation Movements in Africa 1945–1994*, London: Prestel, 2001.

——, *African Architecture: Evolution and Transformation*, New York: McGraw-Hill, 1997.

Elwell-Sutton, L. P., *Persian Oil: A Study in Power Politics*, London: Lawrence and Wishart, 1955.

Enwezor, Okwui, ed., *The Short Century: Independence and Liberation Movements in Africa 1945–1994*, London: Prestel, 2001.

Esher, Lionel, *A Broken Wave: The Rebuilding of England 1940–80*, London: Allen Lane, 1981.

Evenson, Norma, *Chandigarh*, Berkeley and Los Angeles: University of California Press, 1966.

——, *The Indian Metropolis – A View Toward the West*, New Haven and London: Yale, 1989.

Fanon, Frantz, *The Wretched of the Earth*, New York: Grove Press, 1968.

Farmanfarmaian, Manucher and Roxane, *Blood and Oil – Memoirs of a Persian Prince*, London: Prion, 1999.

Fieldhouse, David K., *Merchant Capital and Economic Decolonization: The United Africa Company, 1929–1987*, Oxford: Clarendon Press, 1994.

Flower, Sile, Macfarlane, Jean and Plant, Ruth, eds, *Jane Drew Architect*, Bristol: Bristol Centre for the Advancement of Architecture, 1986.

Forty, Adrian, 'Being or Nothingness: Private Experience and Public Architecture In Post-War Britain', *Architectural History*, 38, 1995.

——, *Words and Buildings: A Vocabulary of Modern Architecture*, London: Thames and Hudson, 2000.

Fox, Richard G., ed., *Nationalist Ideologies and the Production of National Cultures*, Washington DC: American Anthropological Association, 1990.

Foyle, Arthur, ed., *Conference on Tropical Architecture 1953*, London: University College, 1954.

Frampton, Kenneth, 'Towards a Critical Regionalism: Six Points for an Architecture of Resistance', in Hal Foster, ed., *Postmodern Culture*, London: Pluto, 1985.

Freestone, R., ed., *The Australian Planner*, Sydney: University of New South Wales, 1993.

Fry, Maxwell, 'The Architecture of Education', in Jane B. Drew, ed., *Architects' Year Book*, London: Paul Elek, 1945.

——, 'Town Planning in West Africa', in Jane Drew, ed., *Architects' Year Book: 2*, London: Paul Elek, 1947.

——, 'African Experiment: Building for an Educational Programme in the Gold Coast', *Architectural Review*, 113, May 1953, pp. 299–300.

——, *Art in a Machine Age*, London: Methuen, 1969.

Fry, Maxwell and Drew, Jane, *Tropical Architecture in the Humid Zone*, London: Batsford, 1956.

Fuchs, Ron and Herbert, Gilbert, 'Representing Mandatory Palestine: Austen St Barbe Harrison and the Representational Buildings of the British Mandate in Palestine, 1922–37', *Architectural History*, 43, 2000 pp. 281–333.

Furse, W. T., 'The Work of the Imperial Institute', *Journal of the Royal Society of Arts*, vol. 74, 1 May 1926, p. 654.

Gailani, Fatima, *The Mosques of London*, Henstridge: Elm Grove Books, 1999.

Garside, Patricia L., 'West End, East End: London, 1890–1940', in A. Sutcliffe, ed., *Metropolis 1890–1940*, London: Mansell, 1984.

Gaudet, Julien, *Eléments et théories de l'architecture*, vol. 1, Paris: Libraire de la construction moderne, 1915.

Gaugue, Anne, *Les états Africains et leurs Musées: La mise en scène de la nation*, Paris: L'Harmattan, 1997.

Gifford, Prosser and Louis, Wm. Roger, *The Transfer of Power in Africa: Decolonisation, 1940–1960*, New Haven: Yale, 1982.

Glendinning, Miles and Muthesius, Stefan, *Tower Block: Modern Public Housing in England, Scotland, Wales and Northern Ireland*, New Haven and London: Yale, 1994.

Golant, William, *Image of Empire. The Early History of the Imperial Institute, 1887–1925*, Exeter: University of Exeter Press, 1984.

Gold, John R., *The Experience of Modernism: Modern Architects and the Future City, 1928–53*, London: Spon, 1997.

Gotch, J. A., ed., *The Growth and Work of the RIBA 1834–1934*, London: RIBA, 1934.

Graham, C. K., *The History of Education in Ghana*, Tema: Ghana Publishing Corporation, 1976.

Greenhalgh, Paul, *Ephemeral Vistas: The Exposition Universelles, Great Exhibitions and World's Fairs, 1851–1939*, Manchester: Manchester University Press, 1988.

Gronberg, Tag, *Designs on Modernity: Exhibiting the City in 1920s Paris*, Manchester: Manchester University Press, 1998.

Habermas, Jurgen, *Legitimation Crisis*, trans. Thomas McCarthy, Boston: Beacon Press, 1975.

Hammond, Peter, *Liturgy and Architecture*, London: Barrie and Rockliff, 1960.

——, ed., *Towards a Church Architecture*, London: The Architectural Press, 1962.

Hardt, Michael and Negri, Antonio, *Empire*, Cambridge, Mass. and London: Harvard University Press, 2000.

Harper, T. N., *The End of Empire and the Making of Malaya*, Cambridge: Cambridge University Press, 1999.

Hayward Gallery, *Art and Power: Europe Under the Dictators 1930–45*, London: South Bank Centre, 1996.

Herbert, G. and Sosnovsky, S., *Bauhaus on the Carmel and the Crossroads of Empire: Architecture and Planning in Haifa during the British Mandate*, Jerusalem: Yad Itzhak Ben-Zvi, 1993.

Herbert, James D., *Paris 1937 Worlds on Exhibition*, Ithaca and London: Cornell University Press, 1998.

Hess, Janet Berry, 'Imagining Architecture: The Structure of Nationalism in Accra, Ghana', *Africa Today*, 47:2, Spring 2000, pp. 35–60.

Heyworth-Dunn, J., *An Introduction to the History of Education in Modern Egypt*, London: Luzac, 1938.

Highlands Committee (The), *The Highlands and the Highlanders*, Glasgow: The Highlands Committee, 1938.

Hitchcock, Henry-Russell, *Architecture: Nineteenth and Twentieth Centuries*, Harmondsworth: Penguin, 1977 (first published 1958).

Hitchins, Stephen, ed., *Fry Drew Knight Creamer – Architecture*, London: Lund Humphries, 1978.

Ho Kok Hoe, 'Ancient Skills and Traditional for the National Museum', *Federation Museums Journal*, 7, 1962.

Holford, W., 'The Work of the Liverpool School', *Journal of the Town Planning Institute*, 25, November 1938.

Holod, Renata and Khan, Hasan-Uddin, *The Mosque and the Modern World: Architects, Patrons and Designs Since the 1950s*, London: Thames and Hudson, 1997.

Home, Robert, 'Town Planning and Garden Cities in the British Colonial Empire, 1910–1940', *Planning Perspectives*, 5, 1990, pp. 23–37.

——, 'Building a Mosque in Stepney: Ethnic Minorities and the Planning System', *Rising East*, 1, 1997.

——, *Of Planting and Planning: The Making of British Colonial Cities*, London: Spon, 1997.

Howe, Stephen, *Anticolonialism in British Politics: The Left and the End of Empire, 1918–1964*, Oxford: Clarendon, 1993.

Hussey, C., 'Save the Imperial Institute', *Country Life*, 23 February 1956, p. 229.

——, 'Model for St. Paul's Precinct', *Country Life*, 22 March 1956, pp. 538–9.

Ilbert, Robert and Volait, Mercedes, 'Neo-Arabic Renaissance in Egypt 1870–1930', *Mimar*, 13, July–September 1984, pp. 26–34.

International Labour Organisation, *Labour Conditions in the Oil Industry in Iran*, Geneva, 1950.

Intsiful, G. W., 'Paying Attention to Tradition', *BASINnews*, 12, August 1996, pp. 5–7.

Irving, Robert G., *Indian Summer: Lutyens, Baker and Imperial Delhi*, New Haven: Yale, 1981.

Issawi, Charles, *Egypt at Mid-Century*, Oxford: Oxford University Press, 1954.

Jabatan Senibina, 'The Development of Architectural Education in U.T.M.', *Majallah Akitek*, 4:75, December 1975, pp. 16–21.

Jacobs, Jane M., *Edge of Empire: Postcolonialism and the City*, London and New York: Routledge, 1996.

James, C. L. R., *Nkrumah and the Ghana Revolution*, London: Allison and Busby, 1977.

Jameson, Frederic, 'The Antinomies of Postmodernity', in Michael Hardt and Kathi Weeks, eds, *The Jameson Reader*, Oxford: Blackwells, 2000.

Jyoti, Hosagrahar, 'City as Durbar: Theater and Power in Imperial Delhi', in Nezar AlSayyad, ed., *Forms of Dominance: On the Architecture and Urbanism of the Colonial Enterprise*, Aldershot: Avebury, 1992.

Kaplan, Flora E. S., *Museums and the Making of Ourselves*, Leicester: Leicester University Press, 1995.

Kasfir, Sidney Littlefield, *Contemporary African Art*, London: Thames and Hudson, 1999.

Kemp, Norman, *Abadan – A First-Hand Account of the Persian Oil Crisis*, London: Allan Wingate, 1953.

Khalil, Samir, al-, *The Monument: Art, Vulgarity and Responsibility in Iraq*, London: André Deutsch, 1991.

Kinchin, P. and J., *Glasgow's Great Exhibitions 1888, 1901, 1911, 1938, 1988*, Wendlebury: White Cockade, 1988.

King, Anthony D., *Colonial Urban Development*, London: Routledge and Kegan Paul, 1976.

——, *The Bungalow: The Production of a Global Culture*, London: Routledge and Kegan Paul, 1984.

——, *Global Cities*, London: Routledge, 1990.

——, *Urbanism, Colonialism, and the World Economy*, London: Routledge, 1990.

——, 'Writing Colonial Space', *Comparative Studies in Society and History*, 37:3, July 1995, pp. 541–54.

King, Frank H. H., *The Hongkong Bank in the Period of Development and Nationalism, 1941–1984*, Cambridge: Cambridge University Press, 1991.

Kultermann, Udo, *New Architecture in Africa*, London: Thames and Hudson, 1963.

Lagae, Johan, 'Displaying Authenticity and Progress: Architectural Representation of the Belgian Congo at International Exhibitions in the 1930s', *Third Text*, 50, Spring 2000, pp. 21–32.

Lambot, Ian, ed., *Norman Foster, Foster Associates – Buildings and Projects Volume 3 1978–1985*, Hong Kong: Watermark, 1989.

Lang, Jon, Desai, Madhavi and Desai, Miki, *Architecture and Independence: The Search for Identity – India 1880 to 1980*, Delhi: Oxford University Press, 1998.

Lapping, Brian, *End of Empire*, London: Granada, 1985.

Lawrence, A. W. and Merrifield, Ralph, 'The National Museum of Ghana', *Museums Journal*, 57, July 1957, pp. 88–95.

Lebovics, Herman, *True France: The Wars Over Cultural Identity, 1900–1945*, Ithaca and London: Cornell University Press, 1992.

Lefebvre, Henri, *The Production of Space*, trans. D. Nicholson-Smith, Oxford: Blackwells, 1991.

Lethaby, W. R., *Architecture, Mysticism and Myth*, New York: Macmillan, 1892.

Lloyd, John, 'Intentions', *Arena*, 82, July–August 1966, p. 40.

Lloyd, Michael, 'Design Education in the Third World', *Habitat International*, 7, 1983, pp. 367–75.

Loeffler, Jane C., 'Building Abroad/Borrowing Identity', in T. Cruz and A. Boddington, eds, *Architecture of the Borderlands*, London: Academy Editions, 1999.

Louis, Wm. Roger, ed., *The Oxford History of the British Empire*, Oxford: Oxford University Press, 5 vols, 1998–9.

Lugard, F. D., *The Dual Mandate in British Tropical Africa*, Edinburgh and London: W. Blackwood, 1922.

Lyon, Peter and Manor, James, eds, *Transfer and Transformation: Political Institutions in the New Commonwealth*, Leicester: Leicester University Press, 1983.

McArthur, Colin, 'The Dialectic of National Identity: Glasgow Empire Exhibition of 1938', in Tony Bennett, Colin Mercer and Janet Woollacott, eds, *Popular Culture and Social Relations*, Milton Keynes: Open University Press, 1986.

McKean, Charles, *The Scottish Thirties: An Architectural Introduction*, Edinburgh: Scottish Academic Press, 1987.

McKean, John, *The Royal Festival Hall*, London: Phaidon, 1992.

MacKenzie, John, *Propaganda and Empire: The Manipulation of British Public Opinion, 1880–1960*, Manchester: Manchester University Press, 1984.

——, '"The Second City of the Empire": Glasgow – imperial municipality', in Felix Driver and David Gilbert, eds, *Imperial Cities*, Manchester: Manchester University Press, 1999.

MacLeod, Mary, 'Le Corbusier and Algiers', *Oppositions*, 19/20, Winter/Spring 1980, pp. 57–70.

Mansergh, Nicholas, *The Commonwealth Experience*, London: Weidenfeld & Nicolson, 2 vols, 1982.

Marks, Robert, *The Dymaxion World of Buckminster Fuller*, Carbondale: Southern Illinois University Press, 1960.

Martin, Kingsley, *Editor: A Volume of Autobiography, 1931–1945*, London: Hutchinson, 1968.

Matless, David, *Landscape and Englishness*, London: Reaktion, 1998.

Mayhew, Arthur, *Education in the Colonial Empire*, London: Longmans, 1938.

Mehotra, S. R., 'On the Use of the Term "Commonwealth"', *Journal of Commonwealth Political Studies*, 2:1, 1963, pp. 1–16.

Metcalf, Barbara, ed., *Making Muslim Space in North America and Europe*, Berkeley, Los Angeles and London: University of California Press, 1996.

Metcalf, Thomas R., *An Imperial Vision: Indian Architecture and Britain's Raj*, London: Faber and Faber, 1989.

Middleton, Robin, ed., *The Beaux-Arts and Nineteenth-Century French Architecture*, London: Thames and Hudson, 1982.

Milburn, Josephine F., *British Business and Ghanaian Independence*, London: C. Hurst and Co., 1977.

Milner, Anthony, *The Invention of Politics in Colonial Malaya – Contesting Nationalism and the Expansion of the Public Sphere*, Cambridge: Cambridge University Press, 1995.

Ministry of Housing, *Accra – A plan for the town*, Accra: Ministry of Housing, 1958.

Mitter, Partha, 'The Formative Period (Circa 1856–1900): Sir J.J. School of Art and the Raj', *Marg*, 46:1, September 1994, pp. 1–4.

Moos, Stanislaus von, *Le Corbusier – Elements of a Synthesis*, Cambridge, Mass.: MIT, 1982.

Morton, Patricia A., *Hybrid Modernities: Architecture and Representation at the 1931 Colonial Exposition, Paris*, Cambridge, Mass. and London: MIT, 2000.

Muthesius, Stefan, *The Postwar University: Utopianist Campus and College*, New Haven and London: Yale University Press, 2000.

Nalbantoglu, G. B. and Wong, C. T., eds, *Postcolonial Space(s)*, New York: Princeton Architectural Press, 1997.

Nava, Mica, 'The Cosmopolitanism of Commerce and the Allure of Difference: Selfridges, the Russian Ballet and the Tango 1911–1914', *International Journal of Cultural Studies*, 1:2, 1998, pp. 163–96.

Nead, Lynda, *Victorian Babylon: People, Streets and Images in Nineteenth-Century London*, London and New Haven: Yale, 2000.

Nkrumah, Kwame, *The Autobiography of Kwame Nkrumah*, Edinburgh: Thomas Nelson, 1957.

——, *Consciencism*, London: Heinemann, 1964.

Oliver, Paul, 'Perfected Needs: Vernacular Architecture for Education', *Habitat International*, 7:5/6, 1983, pp. 377–83.

Omari, T. P., *Kwame Nkrumah: Anatomy of an African Dictatorship*, London: Hurst, 1970.

Orwell, George, *Burmese Days*, London: Gollancz, 1935.

Papineau, A. J. G., *Guide to Kuala Lumpur*, Singapore: Papineau, 1962.

Pasha, Thomas Russell, *Egyptian Service 1902–1946*, London: John Murray, 1949.

Pawley, Martin, *Buckminster Fuller*, London: Trefoil, 1990.

Pertubuhan Akitek Malaysia, *Meeting to Discuss the Needs, Problems and Policy on Architectural Education in Malaysia*, Kuala Lumpur: PAM, 1976.

Pevsner, Nikolaus, *The Englishness of English Art*, London: The Architectural Press, 1956 (republished Harmondsworth: Penguin, 1964).

——, 'Architecture in the Modern Commonwealth', *Journal of the New Zealand Institute of Architects*, 30, 1963, pp. 161–4.

——, (revised by Bridget Cherry), *The Buildings of England – London I The Cities of London and Westminster*, Harmondsworth: Penguin, 1985.

Pitcher, George, *The Knot of Wisdom: A Chronicle of the University of Science And Technology 1951–1976*, Kumasi: University of Science and Technology, 1976.

Port, M. H., *Imperial London: Civil Government Building in London 1850–1915*, New Haven and London: Yale, 1995.

Posener, Julius, 'Architecture in Malaya', *PETA*, 2:1, July 1957, pp. 1–9.

Powers, Alan, 'Edwardian Architectural Education: A Study of Three Schools of Architecture', *AA Files*, January 1984, pp. 59–89.

——, 'C. H. Reilly: Regency, Englishness and Modernism', *Journal of Architecture*, 5, Spring 2000, pp. 47–63.

Prakash, V., 'Identity Production in Postcolonial Indian Architecture: Re-Covering

What We Never Had', in G. B. Nalbantoglu and C. T. Wong, eds, *Postcolonial Space(s)*, New York: Princeton Architectural Press, 1997.

Purcell, Victor, *Malaysia*, London: Thames and Hudson, 1965.

Rabinow, Paul, *French Modern: Norms and Forms of the Built Environment*, Cambridge, Mass.: MIT, 1989.

Rathbone, Richard, *Nkrumah and the Chiefs: The Politics of Chieftancy in Southern Ghana, 1951–1960*, Oxford: James Currey, 1999.

Reid, Donald M., 'The Rise of Professions and Professional Organizations in Modern Egypt', *Comparative Studies in Society and History*, 16, 1974, pp. 24–57.

——, 'Education and Career Choices of Egyptian Students, 1882–1922', *International Journal of Middle East Studies*, 8, 1977, pp. 349–378.

——, *Cairo University and the Making of Modern Egypt*, Cambridge: Cambridge University Press, 1990.

Reilly, Charles, *Scaffolding in the Sky: A Semi-Architectural Autobiography*, London: Routledge, 1938.

Renan, Ernest, 'What is a nation?', in Homi Bhabha, ed., *Nation and Narration*, London: Routledge, 1990.

Richards, J. M., 'The Problem of National Projection', *Architectural Review*, 82, September 1937, pp. 104–105.

——, ed., *New Buildings in the Commonwealth*, London: Architectural Press, 1961.

——, *Memoirs of an Unjust Fella*, London: Weidenfeld and Nicolson, 1980.

Richards, Thomas, *The Imperial Archive: Knowledge and the Fantasy of Empire*, London and New York: Verso, 1993.

Richardson, Margaret, 'A Lost Skyscraper', *Thirties Society Journal*, 6, 1987, pp. 3–7.

——, *Sketches by Edwin Lutyens*, London: Academy Editions, 1994.

Ricoeur, Paul, 'Universal Civilisation and National Cultures', in *History and Truth*, Evanston: Northwestern University Press, 1965.

Roche, Maurice, *Mega-Events and Modernity: Olympics and Expos in the Growth Of Global Culture*, London: Routledge, 2000.

Roy, Ananya, 'Traditions of the Modern: A Corrupt View', *Traditional Dwellings and Settlements Review*, 12:11, Spring 2001, pp. 7–19.

Royal Institute of British Architects, *International Congress on Architectural Education*, London: RIBA, 1925.

Said, Edward, *Orientalism*, New York: Vintage, 1979.

——, *Culture and Imperialism*, London: Vintage, 1994.

Saint, Andrew, *Towards a Social Architecture: The Role of School Building in Post-War England*, London and New Haven: Yale University Press, 1987.

Saler, Michael, *The Avant-Garde in Interwar England: Medieval Modernism and the London Underground*, New York and Oxford: Oxford University Press, 1999.

Sampson, Anthony, *Seven Sisters: The Great Oil Companies and the World They Made*, London: Hodder and Stoughton, 1975.

Sardar, Ziauddin, *The Consumption of Kuala Lumpur*, London: Reaktion, 2000.

Sarin, Madhu, *Urban Planning in the Third World – The Chandigarh Experience*, London: Mansell, 1982.

Sassen, Saskia, 'The New Centrality: The Impact of Telematics and Globalization', in William S. Saunders, ed., *Reflections on Architectural Practices in the Nineties*, New York: Princeton Architectural Press, 1996.

Schneer, Jonathan, *London 1900 – The Imperial Metropolis*, London and New Haven: Yale University Press, 1999.

Schreckenbach, H., 'Ghana: Alte und neue Wohnbauformen', *Baumeister*, April 1996, pp. 407–12.

Schubert, Dirk and Sutcliffe, Anthony, 'The "Haussmannization" of London? The Planning and Construction of Kingsway–Aldwych, 1889–1935', *Planning Perspectives*, 11, 1996, pp. 115–44.

Serageldin, Ismaïl and Steele, James, eds, *Architecture of the Contemporary Mosque*, London: Academy Editions, 1996.

Shahrum bin Yub, 'The National Museum of Malaysia', *Arts of Asia*, September–October 1982, p. 69.

Sharples, Joseph, ed., *Charles Reilly and the Liverpool School of Architecture 1904–1933*, Liverpool: Liverpool University Press, 1996.

Sheppard, F. H. W., general ed., *Survey of London Volume 38 – The Museums Area of South Kensington and Westminster*, London: GLC, 1975.

Sheppard, Mubin, *Taman Budiman: The Memoirs of an Unorthodox Civil Servant*, Kuala Lumpur: Heinemann, 1979.

Shipley, Ivor, 'The Parliament Building of Malaysia', *Journal of the Commonwealth Parliamentary Association*, 2 April 1965, pp. 176–81.

Singam, S. Durai Raja, 'Sir Gerald Templer's work for a Cultural Revival in Malaya', *Malayan Historical Journal*, 2, 1955.

Smith, C. H. Lindsey, *JM The Story of an Architect*, privately published, (no date).

Smith, Tori, '"A grand work of noble conception": the Victoria Memorial and Imperial London', in Felix Driver and David Gilbert, eds, *Imperial Cities: Landscape, Display and Identity*, Manchester: Manchester University Press, 1999.

Spivak, Gayatri Chakravorty, *The Post-Colonial Critic: Interviews, Strategies, Dialogues*, New York and London: Routledge, 1990.

——, *A Critique of Postcolonial Reason: Toward a History of the Vanishing Present*, Cambridge, Mass. and London: Harvard University Press, 1999.

Spooner, H., 'The Exhibition Galleries', *Bulletin of the Imperial Institute*, 41, January–March 1943, p. 68.

Stamp, Gavin, ed., *AD Profiles 13, London 1900* (1978), 48.

Stone, Peter G. and Molyneux, Brian L., eds, *The Presented Past: Heritage, Museums and Education*, London and New York: Routledge, 1994.

Sultani, Khalid, 'Architecture in Iraq between the two world wars 1920–1940', *The International Magazine of Arab Culture*, 2/3, 1982, pp. 93–105.

Szyliowicz, Joseph S., *Education and Modernisation in the Middle East*, Ithaca and London: Cornell University Press, 1973.

Tait, Thomas S., 'Planning the Empire Exhibition', *SMT and Scottish Country Life*, May 1938, p. 88.

——, 'The Empire Exhibition, Glasgow, 1938 – A Retrospect', *Quarterly Illustrated of the Royal Incorporation of Architects in Scotland*, 60, April 1939, pp. 5–14.

Tallents, Sir Stephen, *The Projection of England*, reprint of 1932 edition, London: Olen Press, 1955.

Taylor, Philip M., *The Projection of Britain: British Overseas Publicity and Propaganda 1919–1939*, Cambridge: Cambridge University Press, 1981.

Templer, Sir Gerald, 'Building a Malayan Nation', *Straits Times Annual*, 1954.

Thai, Bobby Wong Chong, 'Architecture in Singapore: A Sketch', in *Contemporary Singapore Architecture*, Singapore: Singapore Institute of Architects, 1998.

Tickner, Lisa, *Modern Life and Modern Subjects: British Art in the Early Twentieth Century*, London and New Haven: Yale, 2000.

Tiger, Lionel, 'Bureaucracy and Urban Symbol Systems', in Horace Miner, ed., *The City in Modern Africa*, London: Pall Mall Library, 1967.

Tignor, Robert, *Modernization and British Colonial Rule in Egypt, 1882–1914*, Princeton: Princeton University Press, 1966.

Turan, Mete, ed., *Vernacular Architecture: Paradigms of Environmental Response*, Aldershot: Avebury, 1990.

University of Hong Kong, *Senate Report on Architectural Education December 1954*, Hong Kong: University of Hong Kong, 1954.

Vale, Lawrence, *Architecture, Power and National Identity*, New Haven and London: Yale University Press, 1992.

Vidler, Anthony, 'The Idea of Type: The Transformation of the Academic Ideal, 1750–1830', *Oppositions*, 8, Spring 1977, pp. 94–115.

Wakely, Patrick I., 'The Development of a School: An Account of the Department of Development and Tropical Studies of the Architectural Association', *Habitat International*, 7:5/6, 1983, pp. 337–346.

Walden, Russell, ed., *The Open Hand: Essays on Le Corbusier*, Cambridge, Mass.: MIT, 1977.

Walker, Lynne, 'Architecture and Design', in Jane Beckett and Deborah Cherry, eds, *The Edwardian Era*, London: Phaidon and Barbican Art Gallery, 1987.

Ward, Stuart, ed., *British Culture and the End of Empire*, Manchester: Manchester University Press, 2001.

Weaver, Lawrence, *Exhibitions and the Arts of Display*, London: Country Life, 1925.

Webb, Aston, ed., *London of the Future*, London: Fisher Unwin, 1922.

Wellington, H. N. A., 'The Use of Adinkra Symbolism in Architecture', *The Ghana Architect*, 1:2, January–December 1995, p. 4.

Wong, Alfred H. K., 'A Brief Review of Our Recent Architectural History', in *Contemporary Singapore Architecture*, Singapore: Singapore Institute of Architects, 1998.

Wong, Shirley, 'Colonialism, Power, and the Hongkong and Shanghai Bank', in Iain Borden, Joe Kerr, Jane Rendell and Alicia Pivaro, eds, *The Unknown City: Contesting Architecture and Social Space*, Cambridge, Mass. and London: MIT, 2001.

Woolf, Virginia, 'Thunder at Wembley' (1924), republished in Virginia Woolf, *The Crowded Dance of Modern Life*, London: Penguin, 1993.

Worboys, Michael, 'The Imperial Institute: The State and the Development of the Natural Resources of the Colonial Empire, 1887–1923', in John MacKenzie, ed., *Imperialism and the Natural World*, Manchester: Manchester University Press, 1990.

Wright, Gwendolyn, *The Politics of Design in French Colonial Urbanism*, Chicago and London: University of Chicago Press, 1991.

——, 'The Ambiguous Modernisms of African Cities', in Okwui Enwezor, ed., *The Short Century: Independence and Liberation Movements in Africa 1945–1994*, London: Prestel, 2001.

Wylie, Diana, 'Confrontation over Kenya: The Colonial Office and its Critics, 1918–1940', *Journal of African History*, 18, 1977.

Yeang, Ken, *The Architecture of Malaysia*, Amsterdam and Kuala Lumpur: Pepin Press, 1992.

Yeoh, Brenda, 'Street-naming and nation-building: Toponymic inscriptions of nationhood in Singapore', *Area*, 28:3, 1996, pp. 298–307.

——, 'Unravelling "History in Place"', in *Contemporary Singapore Architecture*, Singapore: Singapore Institute of Architects, 1998.

Young, Robert J. C., *Postcolonialism: An Historical Introduction*, Oxford: Blackwell, 2001.

Yub, Shahrum bin, 'The National Museum of Malaysia', *Arts of Asia*, September–October 1982, pp. 60–69.

Zhang, Z., Lau, S. S. Y. and Lee, H. Y., 'The Central District of Hong Kong: Architecture and Urbanism of a Laissez-Faire City', *Architecture and Urbanism*, 322, 1997, pp. 3–16.

Zizek, Slavoj, 'Multiculturalism, or, the Cultural Logic of Multinational Capitalism', *New Left Review*, 225, September/October 1997.

In addition to the publications listed above, the following sources are also referred to:

Exhibition guides

Pocket Guide to the Empire Exhibition at Wembley, 1924, London: Bownan, Mason, Willis and Payne, 1924.

Guide to the Exhibits in the Pavilion of His Majesty's Government, Wembley: British Empire Exhibition, 1924.

Guide to the Pavilion of His Majesty's Government, London: British Empire Exhibition, 1925.

Empire Exhibition, South Africa 1936, London: E. J. Day, 1936.

Empire Exhibition: South Africa 1936, Johannesburg, 1936.

Official Catalogue of the Empire Exhibition, South Africa, 1936, Johannesburg, 1936.

Guide to the Pavilion of His Majesty's Government of the United Kingdom, Johannesburg: Empire Exhibition, South Africa, 1936.

Empire Exhibition, Scotland – 1938. Official Guide, Glasgow: Empire Exhibition, 1938.

Guide to the Pavilion of H. M. Government of the United Kingdom, Glasgow: Empire Exhibition, 1938.

An Clachan – The Highland Village – Official Guide, Glasgow: Empire Exhibition, 1938.

Guide to Kuala Lumpur and Facts of Malaya, Kuala Lumpur, 1962.

Journals

AA Files
AD Profiles
Africa Today
APOC Magazine
Architect and Building News
Architects' Journal
Architectural Association Journal
Architectural Design
Architectural Education
Architectural Forum
Architectural History
Architectural Record
Architectural Review
Architecture and Urbanism
Architecture Malaysia
Area
Art History
Arts of Asia
Asian Building and Construction
Banker
Baumeister
Builder
Building
Building Design
Building News
Bulletin of the Imperial Institute
Commonwealth Journal
Comparative Studies in Society and History
Country Life
Cultural Anthropology
Daily Express
Design
Environment and Planning D: Society and Space
Federation Museums Journal
Ghana Architect
Ghana Today

Glasgow Herald
Guardian
Habitat International
Hamburger Fremdenblatt
Home and Garden
Imperial Review
Interbuild
International Journal of Cultural Studies
International Journal of Middle East Studies
Journal of African History
Journal of Architecture
Joural of Commonwealth Political Studies
Journal of the Commonwealth Parliamentary Association
Journal of the History of Collecting
Journal of the Indian Institute of Architects
Journal of the Royal Institute of British Architects
Journal of the Royal Society of Arts
Journal of the Town Planning Institute
Listener
Majallah Akitek
Malaya
Malayan Branch of the Royal Asiatic Society
Malayan Historical Journal
Marseille Libre
Middle East Construction
Mimar
Morning Post
Museums Journal
Naft
New Left Review
New Statesman
Oppositions
PETA
Planning Perspectives
Progress
Quarterly Illustrated of the Royal Incorporation of Architects in Scotland
Rand Daily Mail
Rand Mail
Revue Mensuelle de l'Association des Anciens Élèves de l'École des Hautes Études Commerciales
Rhodesia Herald
Rising East
RUMAH – Journal of the Singapore Institute of Architects
SMT and Scottish Country Life
South Africa
Southern Daily Echo
Star
Straits Times Annual
The International Magazine of Arab Culture
The Planner
The Times
Third Text
Thirties Society Journal
Times Higher Education Supplement

Town Planning Review
Traditional Dwellings and Settlements Review
West African Builder and Architect

Other sources

RIBA Archives
University of Liverpool Archives
BP archives
PRO archives
PRAAD archives

Index

Illustrations are indicated by italicized numbers

For Product Safety Concerns and Information please contact our EU
representative GPSR@taylorandfrancis.com Taylor & Francis Verlag GmbH,
Kaufingerstraße 24, 80331 München, Germany

Printed and bound by CPI Group (UK) Ltd, Croydon, CR0 4YY